Point of Purchase

Point of Purchase

Marta Serrats

COLLINS | DESIGN

An Imprint of HarperCollins*Publishers*

POINT OF PURCHASE
Copyright © 2006 by COLLINS DESIGN and maomao publications

First Edition:
Published by mao mao publications in 2006
Via Laietana 32, 4.º Of. 104
08003 Barcelona, Spain
Tel.: +34 932 687 270
Fax: +34 932 680 425
mao@maomaopublications.com
www.maomaopublications.com

English language edition first published in 2006 by:
Collins Design
An Imprint of HarperCollins*Publishers*
10 East 53rd Street
New York, NY 10022
Tel.: (212) 207-7000
Fax: (212) 207-7654
collinsdesign@harpercollins.com
www.harpercollins.com

Distributed throughout the world by:
HarperCollins*Publishers*
10 East 53rd Street
New York, NY 10022
Fax: (212) 207-7654

Publisher:
Paco Asensio

Editorial Coordination:
Marta Serrats

Translation:
Jay Noden

Art Direction:
Mireia Casanovas Soley

Layout:
Zahira Rodríguez Mediavilla

Library of Congress Cataloging-in-Publication Data

Serrats, Marta.
 Point of Purchase / Marta Serrats.— 1st ed.
 p. cm.
 ISBN-13: 978-0-06-089351-4 (hardcover)
 ISBN-10: 0-06-089351-6 (hardcover)
 1. Display of merchandise. I. Title.
 HF5845.S47 2006
 659.1'57—dc22

 2006002972

>Introduction

Commercial Logic and Point of Purchase

The accelerated rate of growth experienced by the retail industry in recent decades has led this sector to develop a complex system of techniques to encourage purchases at the sales point itself. The variety, sophistication, and creativity of these techniques reflect not only the impressive advances achieved by the commercial sector but also the fast pace at which this sector has evolved in such a short time.

Prior to the economic well-being and the consolidation of modern commerce achieved in the industrial West after the Second World War, many retailers were already intuitively using a variety of techniques to make their sales points more profitable. These techniques were based on experience, detailed knowledge of clientele, and a controlled scale regarding the commercial establishments. They later became the theoretical basis of modern marketing, merchandising, and the point-of-purchase (POP) disciplines, familiar today in the world of commercial space design.

Among these techniques, POP encompasses the diverse range of elements that are implemented at the sales point with the aim of converting the passive observer into an active buyer. For this reason, they are generally known as *POP material.*

POP in Commercial Practice and Theory

The presence of POP elements in the marketplace is the result of the evolution of commercial practices, such as the growing supply of goods and services, the stiff competition among products and brands, and the consolidation of the self-service sales system, as much in large commercial spaces as for smaller establishments.

First, there is a wide range of products today offering the same price, quality, and performance levels. The boom experienced by outlet and discount establishments in recent years testifies to this excess supply. Under these market conditions, the main factor in deciding to buy one product instead of another is the way it is displayed. This is why POP material must be capable of presenting products quickly, appealingly, and effectively. Second, in a highly competitive environment in which there is so much similarity among products and a wide variety of brands, one key to commercial success is differentiation. POP material plays a vital role in creating both product and brand identities that clearly distinguish themselves from competitors in terms of the product's or brand's physical, sensory, and emotional attributes. Finally, the widespread use of self-service as the common platform for retail buying and selling means that the customer has direct contact with the product and its features. This

requires that the retail space and commercial strategy employed be adapted to a situation in which the seller and the sales pitch have practically disappeared. In this context, POP material functions as seducer, informer, and provider of products in a direct way, without the intervention of a third party or intermediary.

In light of the constant evolution of modern commercial practices, disciplines such as marketing, merchandising, and point of purchase arose. This development of commercial theory is continuous and remains ever attentive to cyclic changes resulting from consumer behavior in different markets. Thus, commercial theory is regularly subject to reexamination.

The main objective of marketing is to sell a particular product effectively, that is, to increase its *turnover*. Thus, the product's characteristics, its price range, the means of distribution, and the methods used to promote it are evaluated according to a traditional "4P" approach (product, positioning, price, and promotions). As an integral part of marketing, merchandising aims at presenting the product or service to the potential buyer in the best possible physical and emotional context, by means of the selection, implementation, and display at the sales point. Point of purchase is the facet of merchandising that strategically plans for and stimulates purchasing decisions in the commercial environment.

It is important to clarify that, despite obvious differences between actual commercial practice and the various theoretical disciplines derived from it, both approaches aim to modify the traditional concept of the purchase, transforming it from a daily necessity into a leisure activity. Because this activity consumes proportionally more free time in contemporary life, the environment in which it takes place must be designed on the basis of a global commercial logic that regards the purchase as an active, unique, and pleasurable experience.

POP Material

We have defined POP as a generic and complex concept whose field of action is the area where purchasing decisions are made at the sales point itself and whose development depends on the behavior of the consumer at the sales point—especially impulse buying and those "unplanned purchases." It is an established fact that more than 50 percent of purchasing decisions are made inside the store; therefore, the ability of the POP material to attract buyers is crucial in increasing this percentage through a real increase in the number of sales per unit.

POP material can assume a wide variety of formats, dimensions, and styles, ranging from a simple label stating the name, description, and price of the product to an entire promotional kiosk. The most popular POP materials among buyers—and those used most frequently by professionals—are flyers, brochures, display racks, posters and signage, countertop displays, freestanding displays, demonstration modules, kiosks, shelves, storage shelves, product islands, and props. Props consist of special items that

both highlight and create a sense of reality about the good or service being sold, and they might include, for example, trophies, sports equipment, and team photographs to simulate a collegiate atmosphere.

The extensive range of POP formats is as much a function of the different types of commercial environments in which they are deployed and the diverse *target markets* at which they are aimed as it is a function of the seemingly infinite variety of specific instances of each product type for which they are used. These POP formats are fluid enough to accommodate the new demands of a dynamic and evolving marketplace as well as proposals and solutions coming from designers competing for market share. One expects to find obvious differences between POP materials used for different retail categories such as food, clothing, and domestic appliances, or between those used for diverse target markets such as children, teenagers, and adults. What is surprising, however, is the progressive increase of such differences for nearly identical products—for example, in the jeans market, where one brand might use POP material to allude to the warm, rural, and wild North American West while another references the cold, urban, and sophisticated world of contemporary metropolises.

This simple example demonstrates that in the complex world of commercial space—and in particular that of POP material—no official design patterns or parameters exist. Each project constitutes a new world to be planned, designed, and tested at the sales point—remaining subject to regular revision to avoid becoming obsolete and losing that competitive edge.

Display POP

Most of the material selected for this book is aimed at presenting designs and projects that stand out for the particular creativity of the POP material, especially in display mounts and the way they display products as objects of desire. The mission of POP materials is to substitute the passive display of a product or service with an active display, using any technique that makes it more appealing.

A product's capacity to attract is a key factor in achieving higher sales. This capacity depends, in part, on the location of the product within the commercial space, which means both the actual arrangement of displays at the sales point as well as the distribution of the products on the display itself.

Displays can be arranged in several established formats. *Straight racks* give customers the freedom to choose their own path through a retail space and allow for a more efficient use of space. They are also cheaper to maintain. *Herringbone arrangements* permit customers to view diverse displays and products, and increase impulse buying. Their main disadvantage is their inefficient use of space. Free arrangements give the retail space a bazaar-like atmosphere and convey an image that clearly differentiates products from their competition; however, they require custom-built displays, considerably increasing their cost.

Displays consist of levels, at which products are presented. The function of the upper level (eyes), also known as the *perception level*, is to attract and keep the attention of the consumer; it is the most commonly used level. The middle level (hands) is most comfortable for the customer to reach. At the lower level (feet), the product is barely perceived, if at all, because of the effort involved to see or retrieve it. A fourth level might be considered the extra-upper level (hat), which is a nonselling level because

products are beyond the reach of the customer. This level is reserved for products of nonstandard size or for publicity purposes. Statistics have proven that certain products sell better, depending on the level at which they are displayed. The fees that manufacturers routinely pay to display their products at a particular level confirm this. Percentages of sales at a given level are distributed as follows: hat height, 10 percent; eye height, 50 percent; hand height, 25 percent; and foot height, 15 percent.

Obviously, eye-level displays are the most profitable and are used to stimulate impulse purchases as well as for promotional products, house brands, and, in general, more attractive products or those the distributor wants to sell through an intensive use of visual stimuli. In the realm of human perception, sight represents almost 85 percent of the information we receive daily, and according to studies, it is responsible for 78 percent of purchasing decisions. Thus, a whole visual language, consisting of colors, textures, lighting, graphic art, and specific styles, is employed to create expressive, captivating, and functional POP displays, in order to entice customers into purchases.

Despite the undeniable leading role of visual factors in the process of commercial seduction, the other senses are beginning to play a part in the design of more complex and cutting-edge display systems, where sound, touch, and smell now also participate. The human body is designed to process millions of sensations in a split second, so the task of POP materials is to calculate the most effective combination of sensory perceptions through which to sell product X to target market Y in shop Z.

Pablo Soto

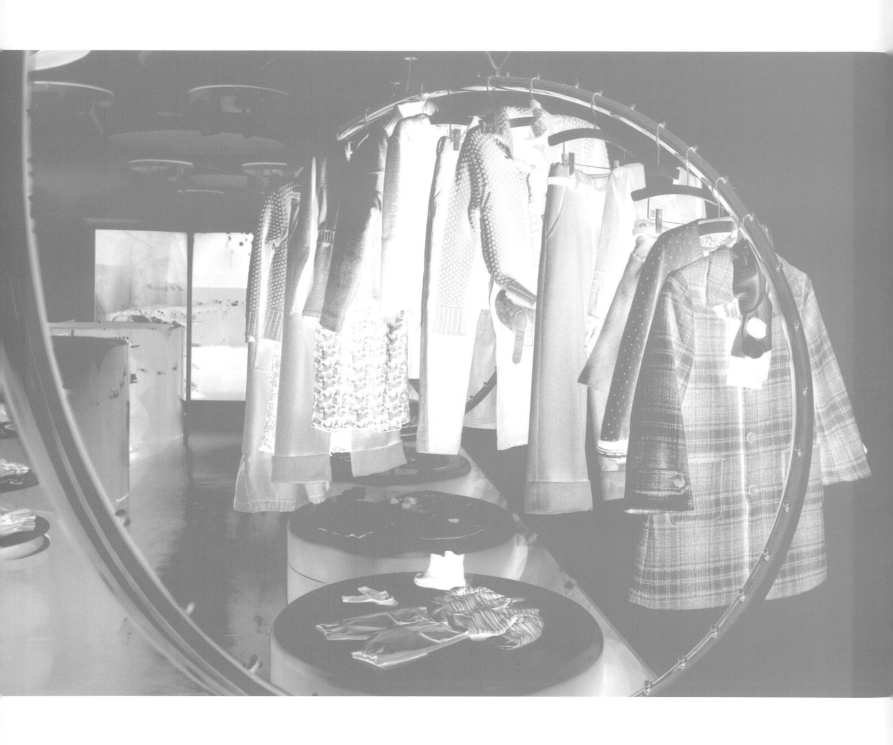

> Hang

This chapter includes a selection of the best flexible systems characterized by hanging fixtures that have double the capacity of straight hangers—made of Perspex, metal, or wood, and multifunctional, all of them are examples of resourceful ways to hang a particular item for display. These projects explore the expressive possibilities of the display medium, with examples that show the versatility of hangers used to display items to the buyer and achieve the final objective: the purchase.

> Guys & Dolls

Architects: Sybarite

Location: London, UK

Photography: Adrian Myers

Before developing the initial concepts for this project, Sybarite decided that the best way to understand the essence of what Guys & Dolls was meant to be was to put themselves in the shoes of children and, more important, put themselves at children's height to experience their perspective of the world's colors and shapes. Children regard the world as enormous, and they feel a great curiosity for everything that surrounds them; that is why it is so easy to attract their attention using bright colors and simple designs.

Using this idea, Sybarite decided to place giant pieces of colored Lego in the center of the space of Guys & Dolls. All the elements that make up the environment of this shop have a circular shape: spiral stairs and hangers, circular drawers, cylindrical changing rooms—all based on the idea of spatial dynamics and flexibility. This concept is also applied to the shop's logo, likewise designed by Sybarite. On opening the door of the shop, children enter a magical world of shapes and colors where the circular units stand out, concealing drawers and displaying clothes at children's height. Meanwhile, adults can admire the styles displayed on the spiral hangers, which have up to three times the capacity of straight hangers and constitute a versatile display system.

The materials used to construct this space were specially selected to reinforce safety and prevent children from injury. The flooring is made from rubber, and all the display elements and furniture have rounded edges.

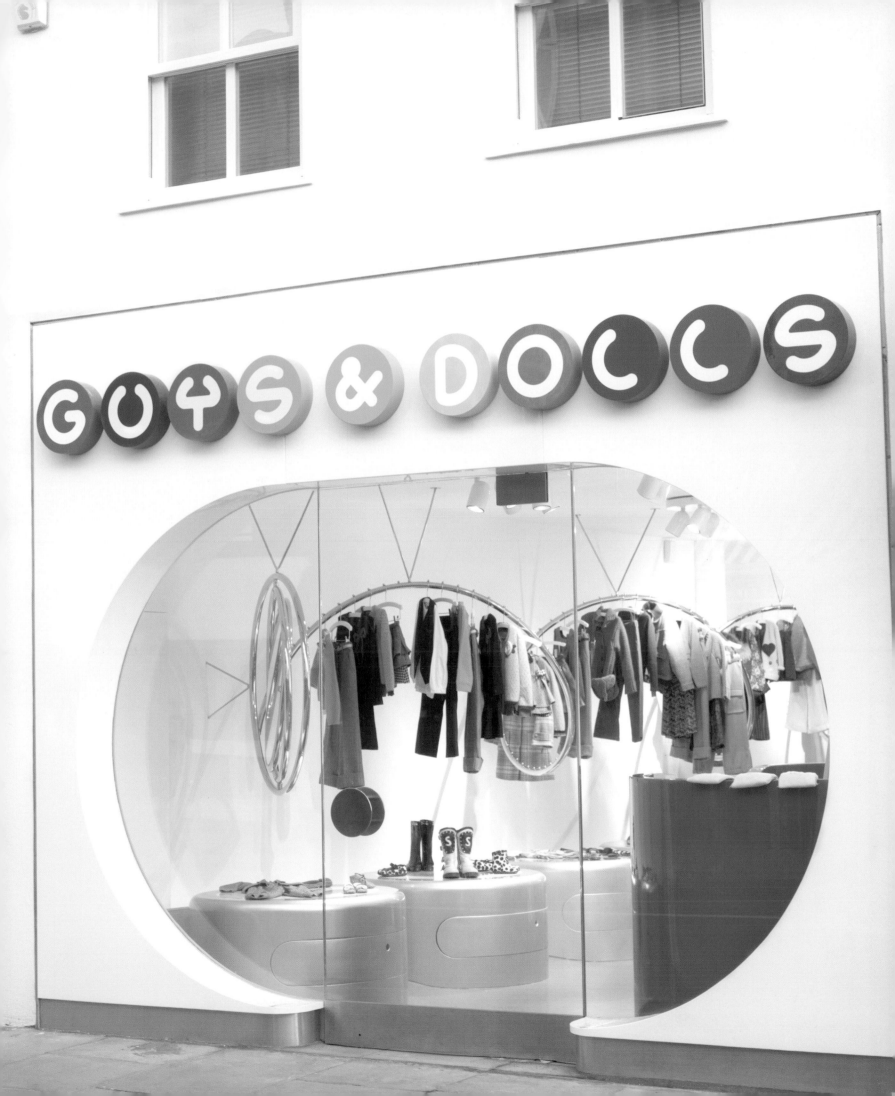

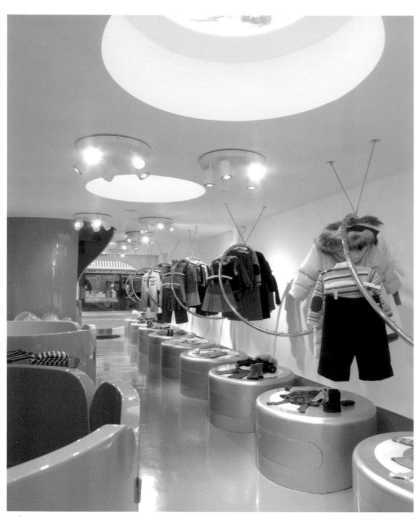

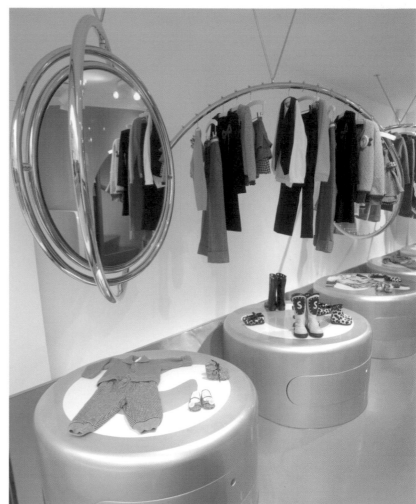

> The use of spiral hangers, which triple the capacity of straight hangers, creates a flexible display system.

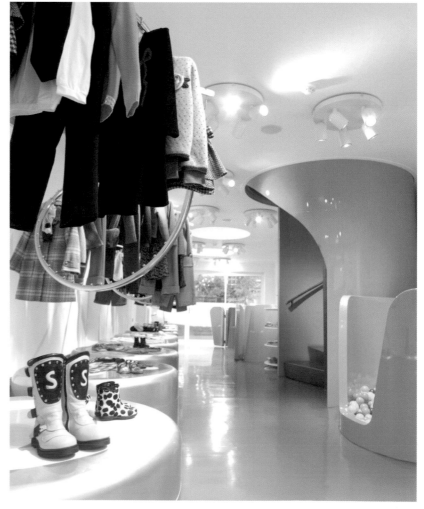

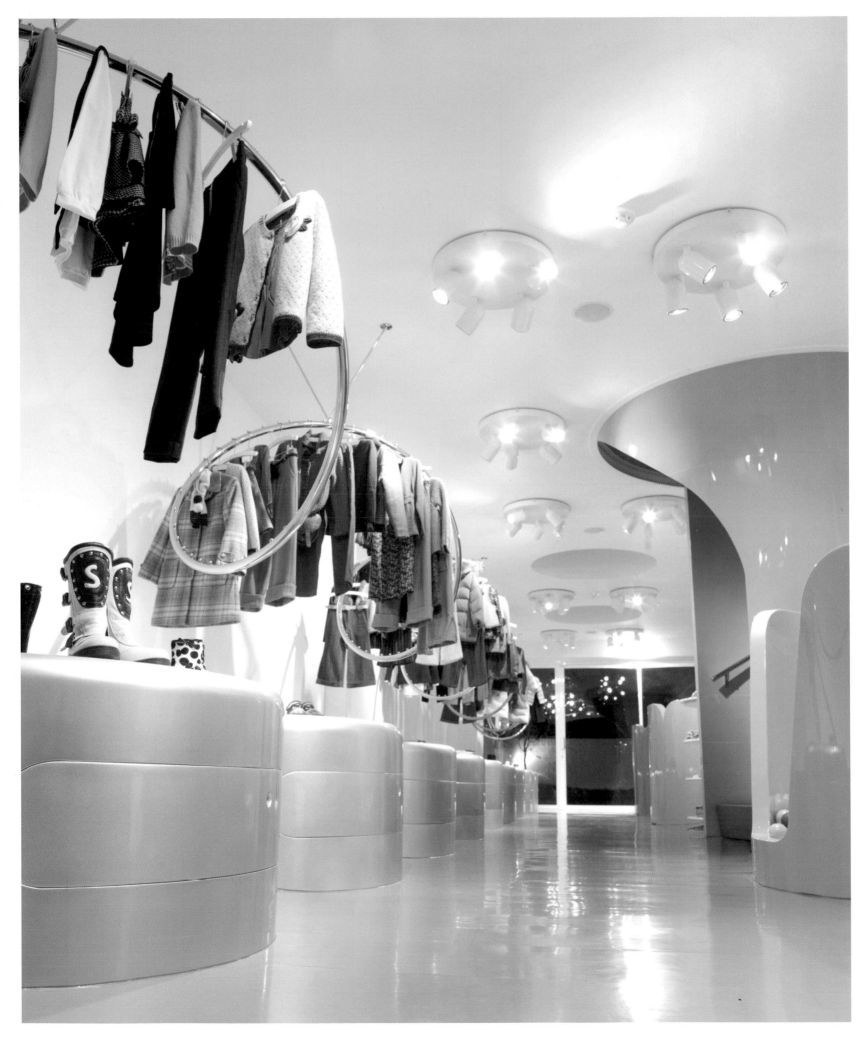

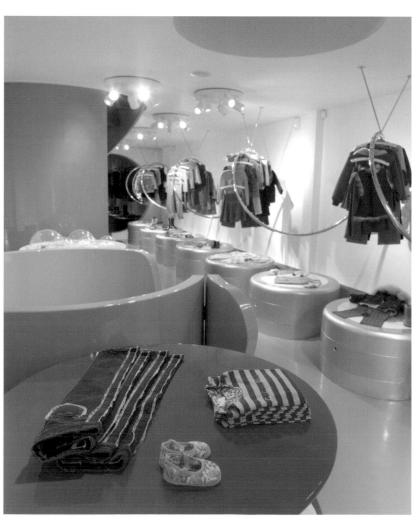

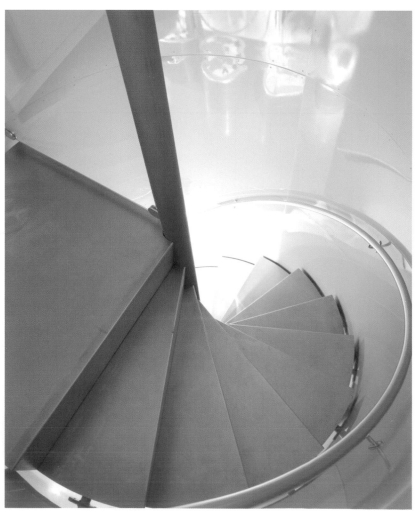

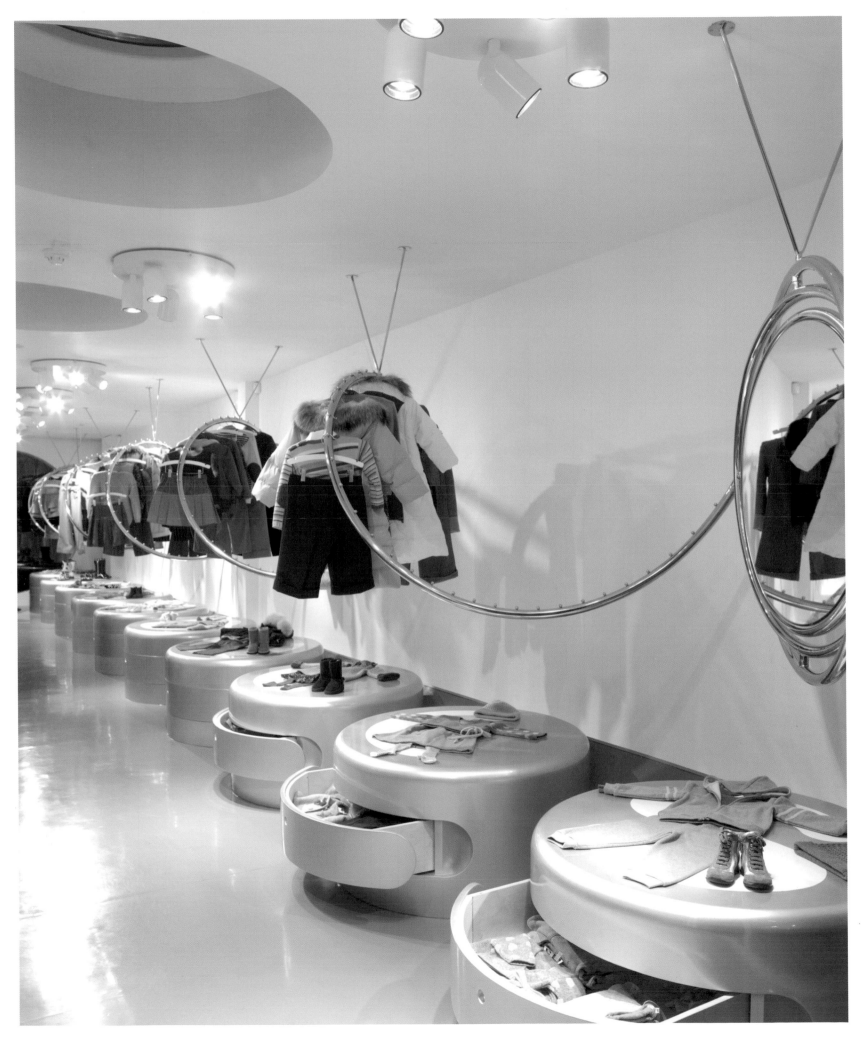

>Men at Work

Architects: Bearandbunny
Location: Eindhoven, Netherlands
Photography: Arjen Schmitz

Bearandbunny, the studio of Dutch designers Carlijin Kriekaard and John Maatman, is responsible for the Men at Work shop located in Eindhoven, which sells contemporary brands such as Gsus, Whatever, and Miss Sixty. The initial concept was based on the idea of chaos—an accumulation of different functions and products within the same space. The result was a flexible shop where buyers can try on clothes freely and find what they are looking for through different sales points, each with its own display system. This idea of displaying products in different ways and maintaining an organized chaos similar to that of a marketplace generates a dynamic space that distinguishes itself from conventional retail establishments. The intention was to create an imperfect shop, where buyers discover the products by following their instincts, prompted by various stimuli produced by the unique product displays.

Visitors access the shop through an entrance tunnel, which makes it seem like they are entering a club. In fact, the store resembles a bazaar, with different shops at the same location. Inside, current fashions are displayed on a catwalk. Purses and carryall bags of all sorts hang from the ceiling by wires, as if they were floating in the middle of the accessories area, where the walls are papered in photographs. Other products are displayed behind a curved tennis net. The architects have also designed a space reserved for a DJ, who livens up the shop with the latest sounds from the music scene.

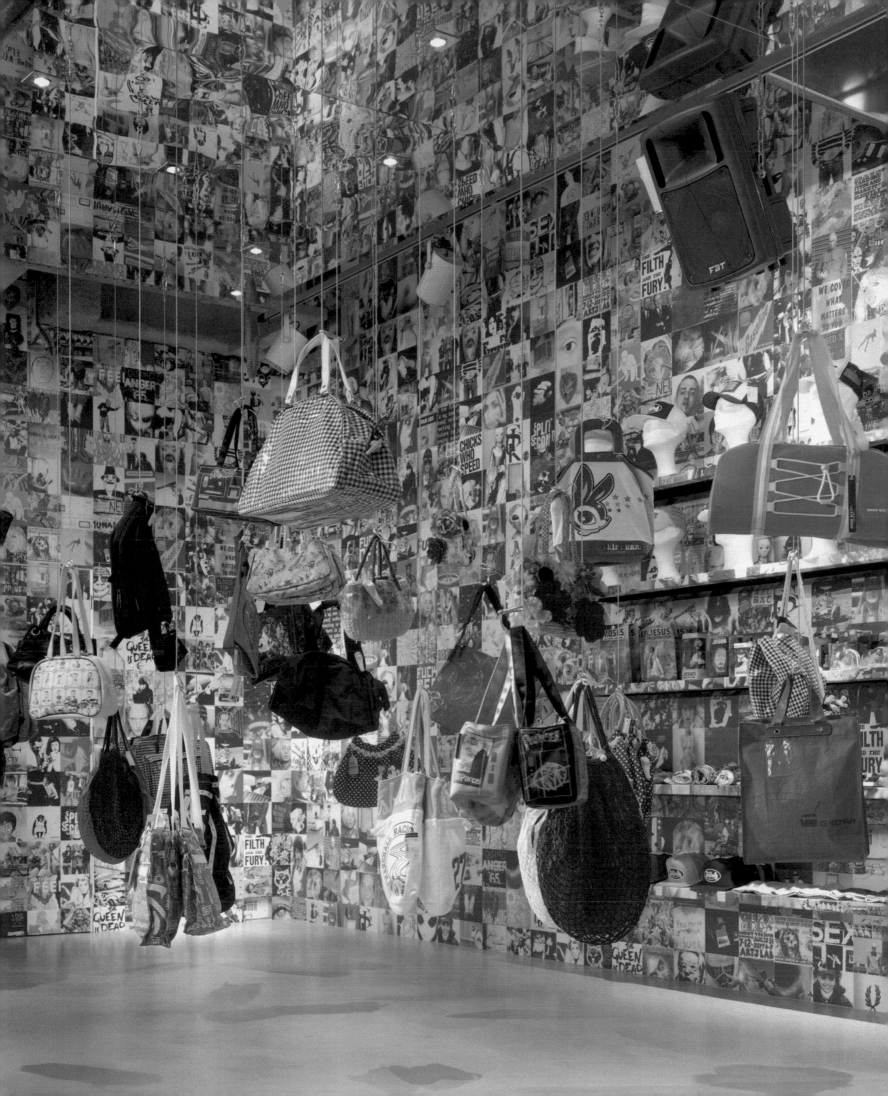

> Reflecting the chaotic arrangement of a bazaar, Men at Work brings different brands together in the same space. The clothes are displayed in an untraditional way, at different sales points.

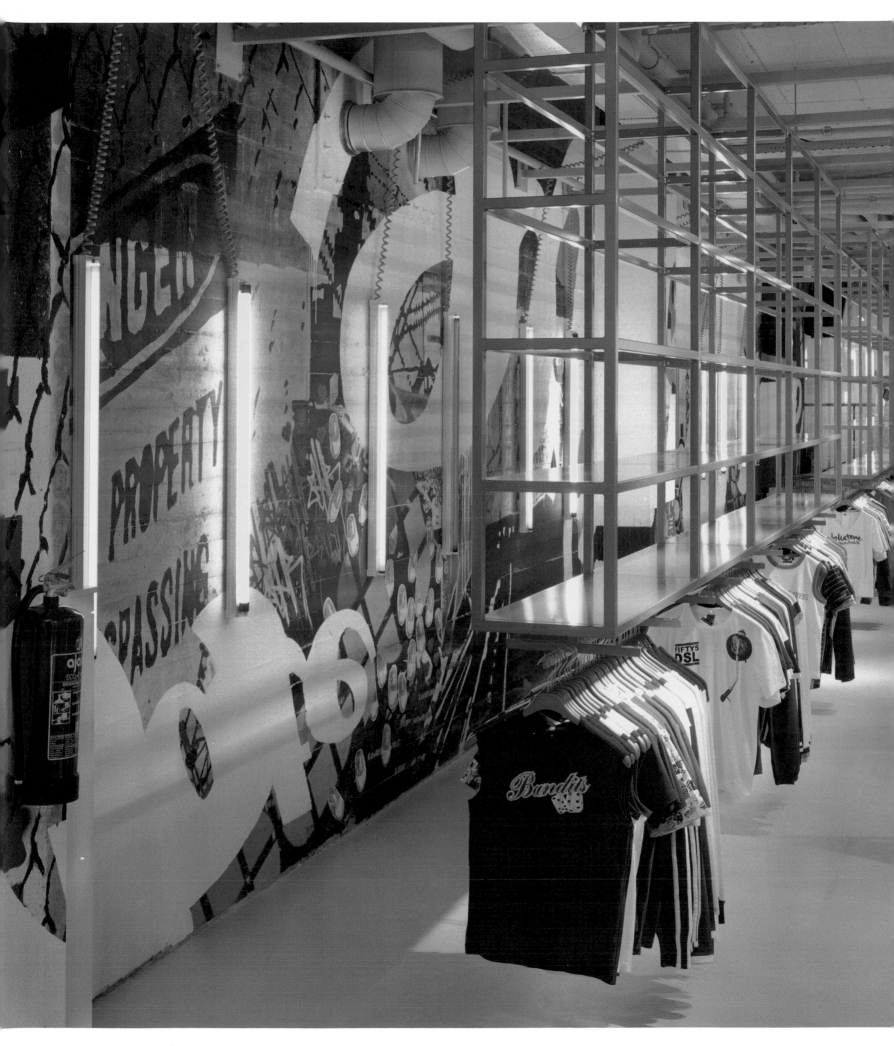

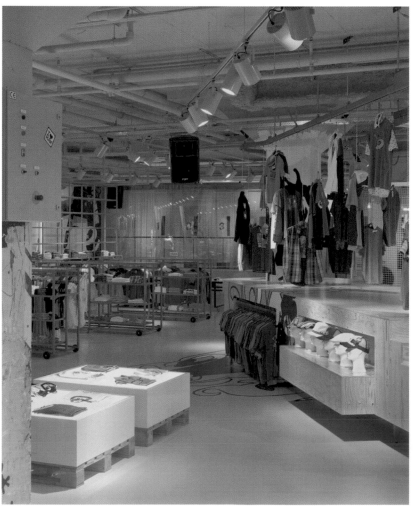

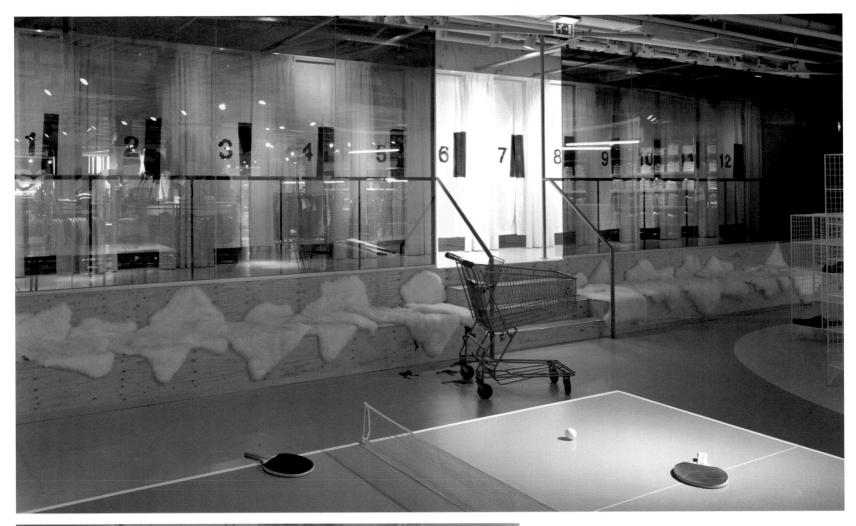

> Certain special items are located behind a curved tennis net, which encloses the space.

> Stash

Architects: Maurice Mentjens Design
Location: Maastrich, Netherlands
Photography: Arjen Schmitz

Stash is a shop that sells modern bags from brands such as Milk, On a Misión, Ortlieb, and Lacoste. In most bag shops the products are displayed on shelves or hangers. Stash designer Maurice Mentjens, however, opted to eliminate any hanger that would obstruct the continuity of the space. In order to achieve this, he designed an ingenious system of magnets that attach to a metal wall, from which buyers can remove bags and then return them, keeping the shop tidy without disrupting the esthetics.

The walls are all painted red to make the designs and colors of the items on display stand out. Steel panels descend from the ceiling in the center of the shop, close to, but not touching, pedestals that serve as display stands. These architectural elements facilitate circulation inside and divide the space in half. The secret of this small shop lies in the mirrors on the walls, which widen the field of vision of the entire space. The cabinet doors and any fixtures that might interfere with the sleek design of this unusual shop have been skillfully integrated by Mentjens into the ubiquitous red surface. The result is a space that delivers all the expected functions of a shop, as well as a bright splash of creative design.

 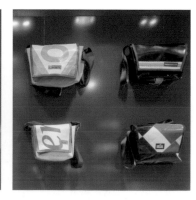

OSTASH

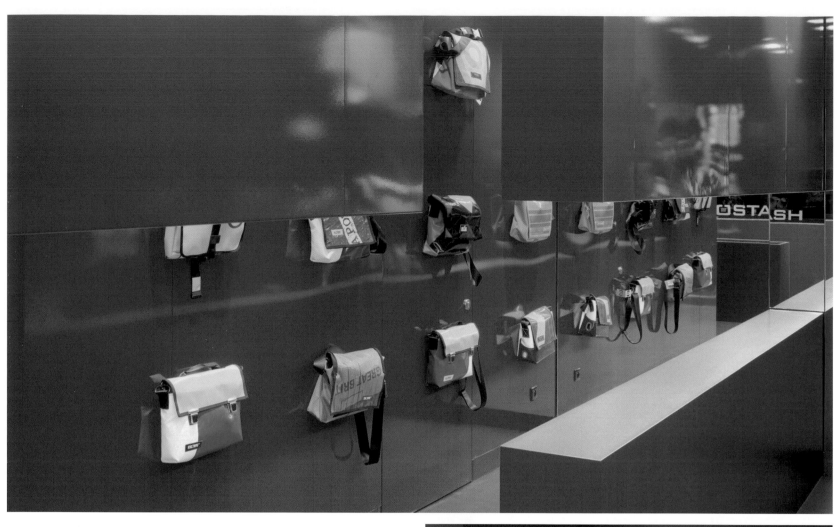

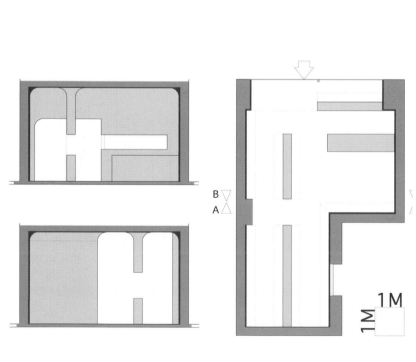

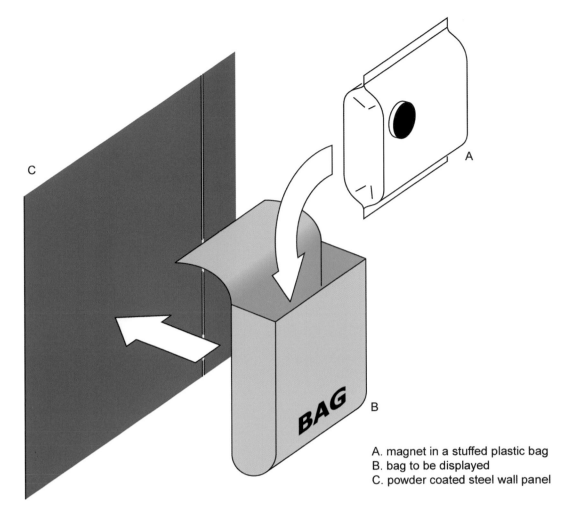

A. magnet in a stuffed plastic bag
B. bag to be displayed
C. powder coated steel wall panel

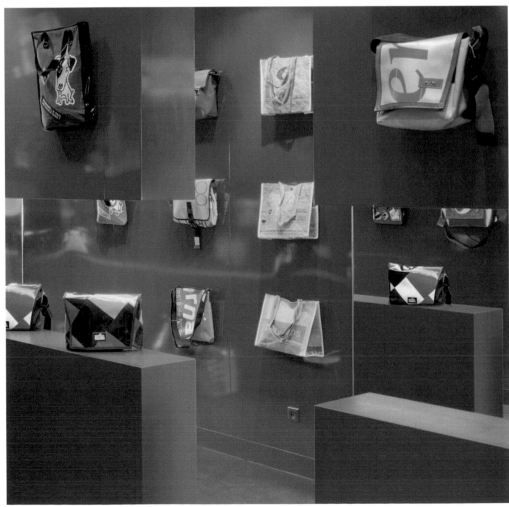

> The display system is based on magnets incorporated into the bags, by which the product can be hung from the metal surface of the walls.

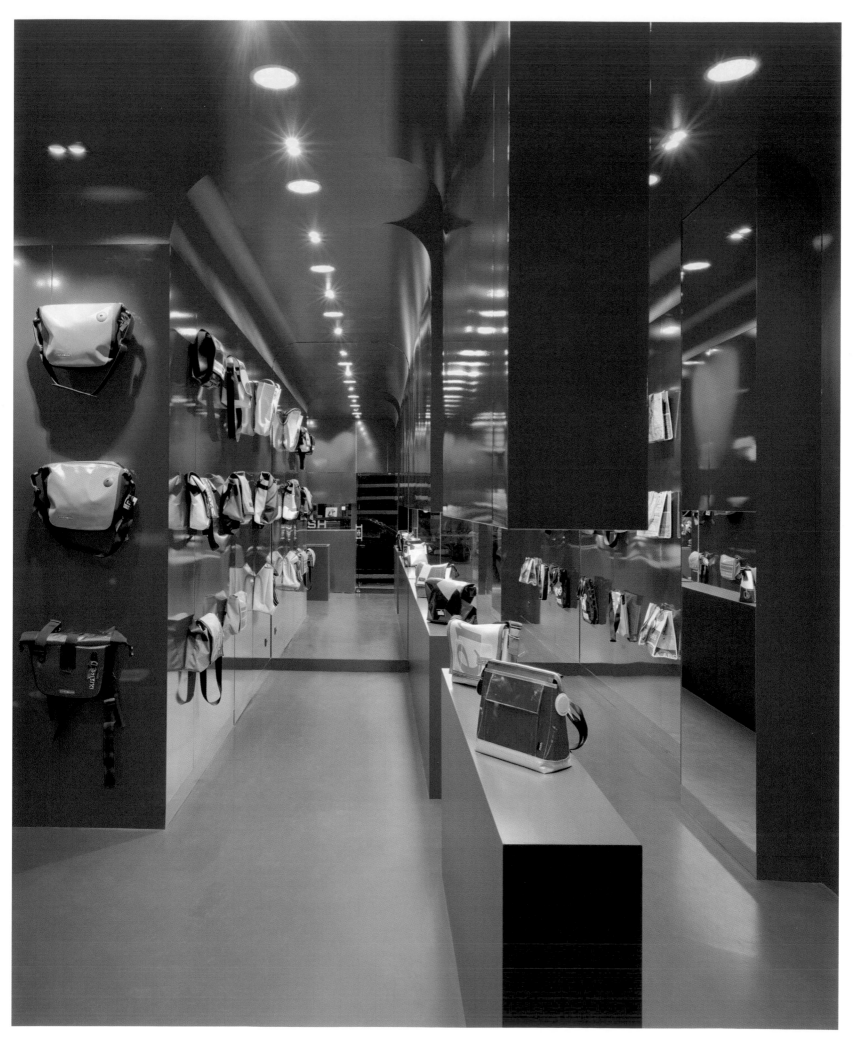

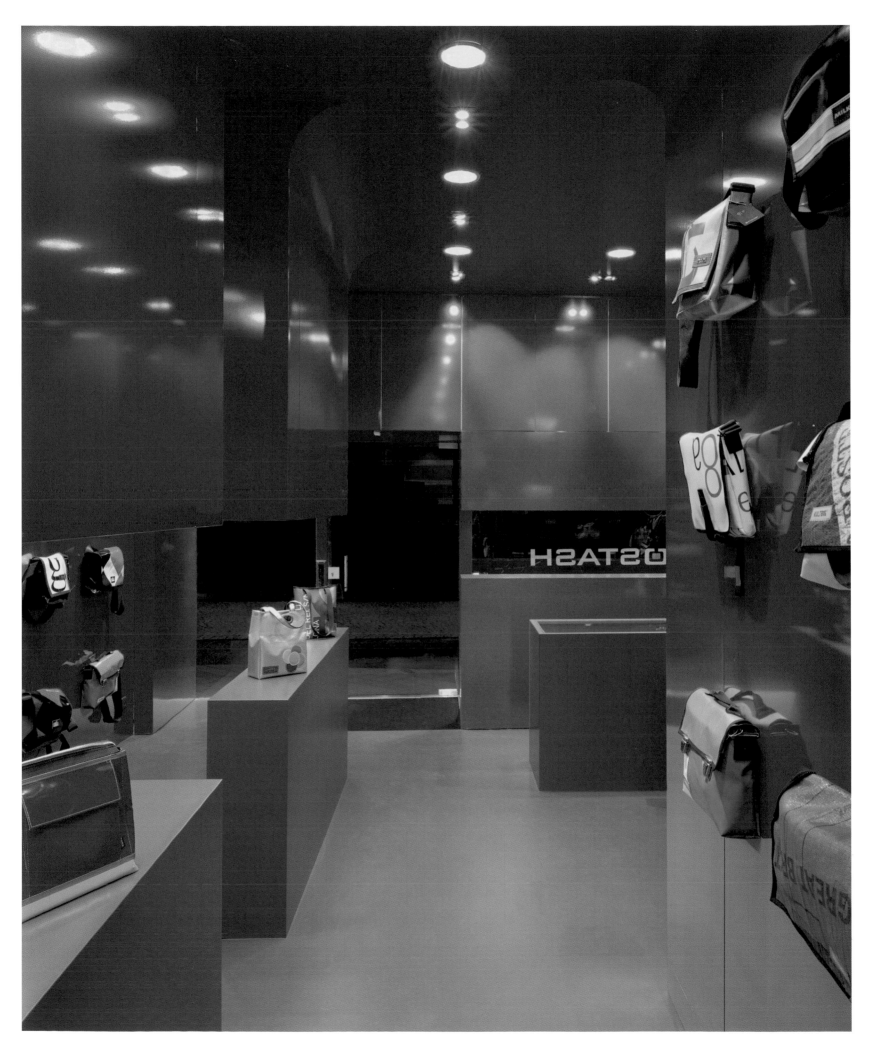

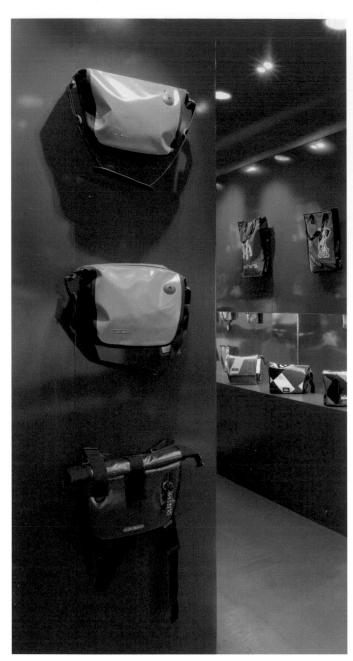

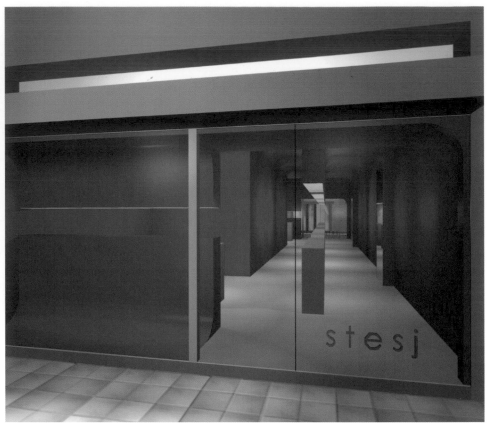

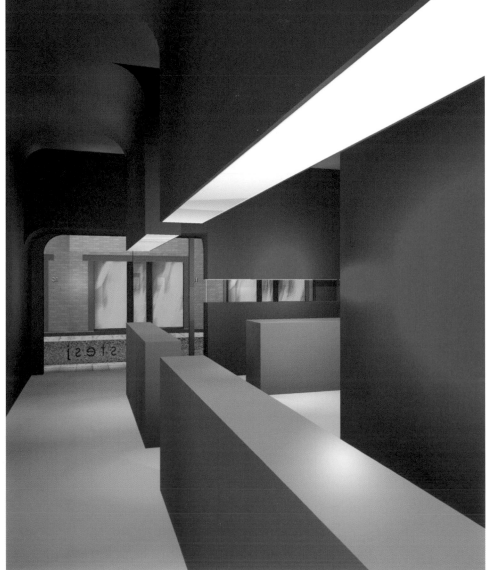

 The panels hanging from the ceiling and the pedestals used to display the products divide the space in two and allow for fluid circulation around the interior.

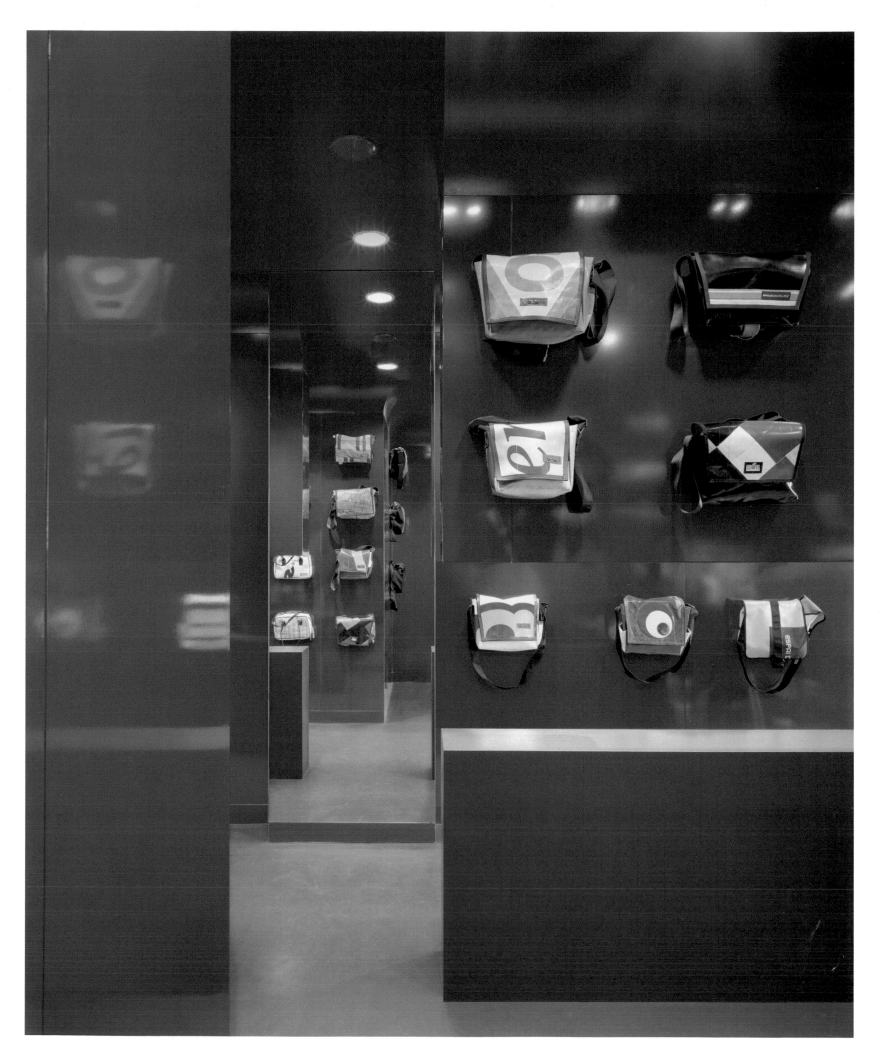

>Little Red Riding Hood Shop

Architects: Corneille Uedingslohmann Architekten

Location: Berlin, Germany

Photography: Joachim Wagner

Since their new main shop in the district of Mitte opened, Little Red Riding Hood (LRRH) has become a compulsory stop in Berlin. Based on a new retail concept, LRRH offers the latest fashions, art, music, magazines, and books in a space that is spread over two floors and arranged as if it were a three-dimensional stage. The ground floor displays the latest ready-to-wear collections, where fashionistas can find new items every three months, as well as works from emerging artists.

Because of the small dimensions of the space, the Corneille Uedingslohmann team of architects designed the most open plan possible, utilizing fiberglass surfaces and transparent textures that extend along the wall to form three levels of display shelving. The occasional bits of color—touches of red—are injected in the area beyond the central sales counter, which is likewise made from white fiberglass.

A multiuse fixture in the middle of the space accommodates visitors who want to sit and read a magazine from the selection for sale or try on the latest style of shoes, which are displayed as part of the same fixture. One side of the shop is punctuated by a wraparound hanger on which collections are displayed and which serves as a chromatic counterpoint to the dominant white theme of the space. The architects chose to leave the track lighting system exposed, and they installed a computer with excellent picture quality near the ceiling to project random images, adding further visual interest to the space.

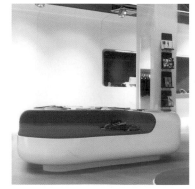 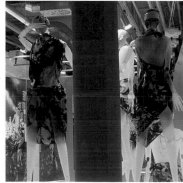

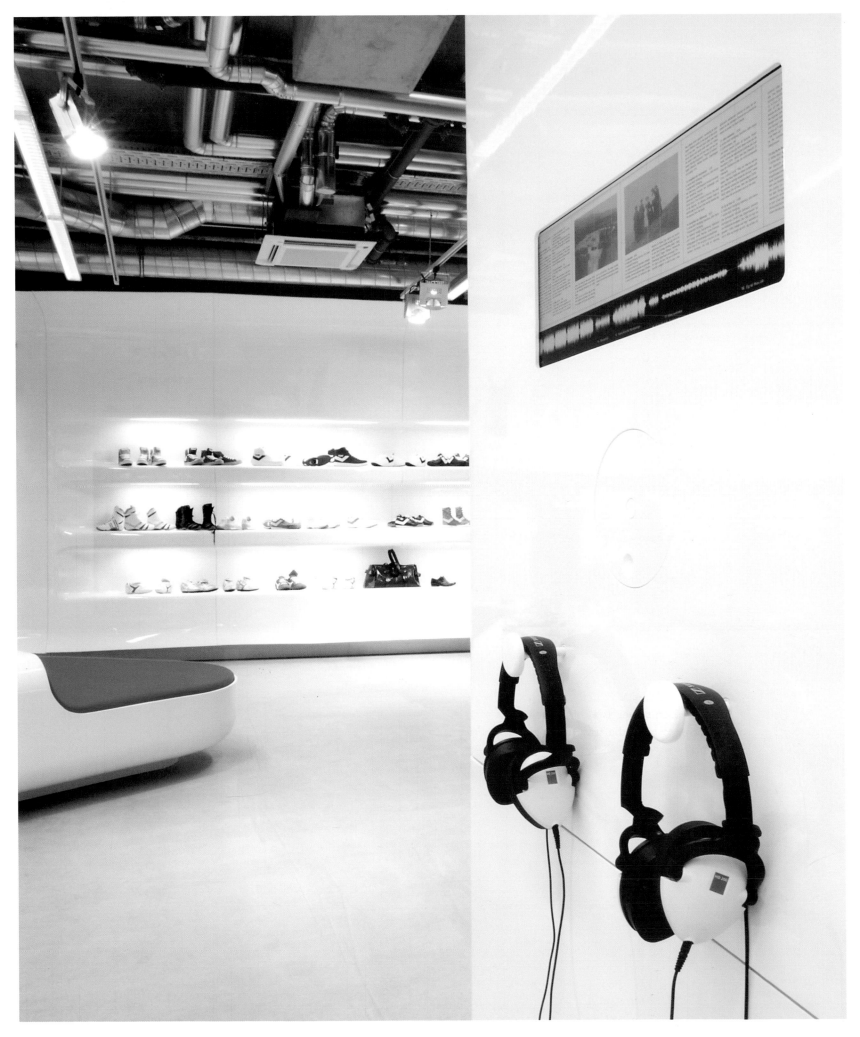

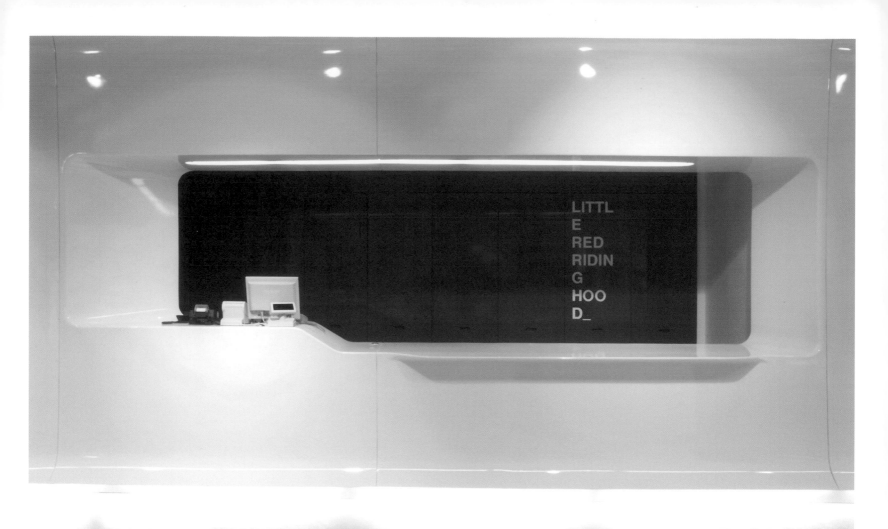

LITTL
E
RED
RIDIN
G
HOO
D_

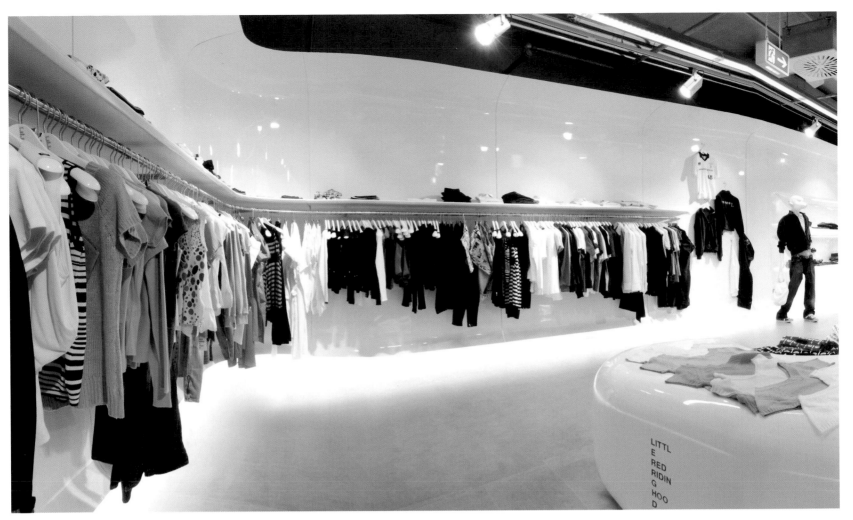

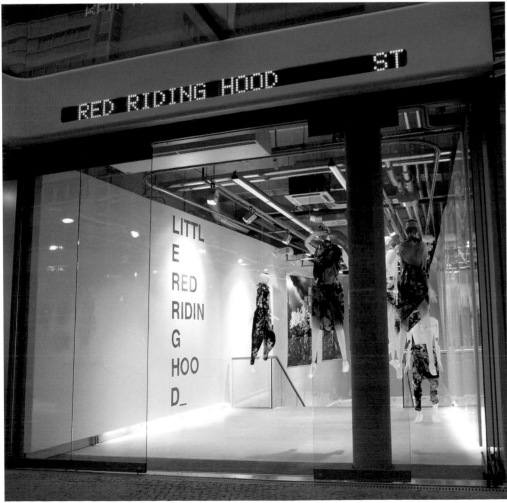

> A hanging fixture in which part of the collection is displayed runs around a corner of LRRH. Following the same trajectory, the upper part was used as shelving to display the rest of the accessories.

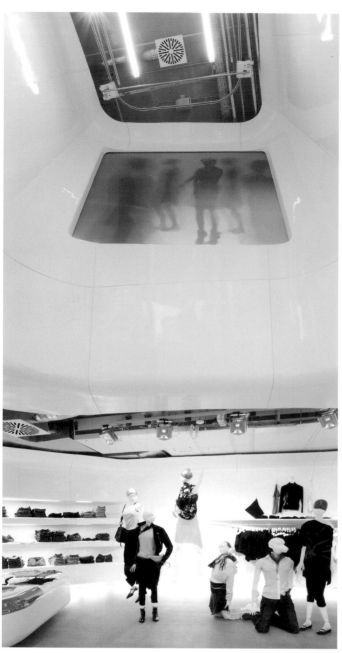

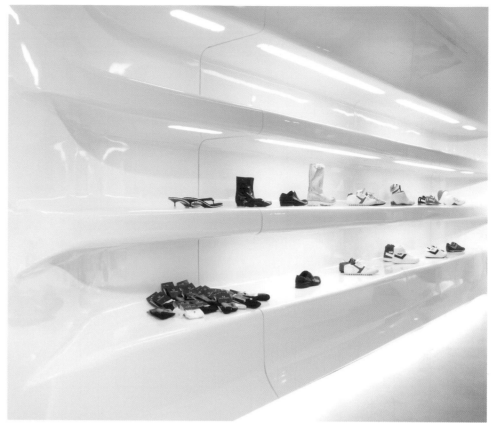

> White dominates the stage here creating an atmosphere of silence and opening up the space. A computer projects random images onto the upper part of the shop.

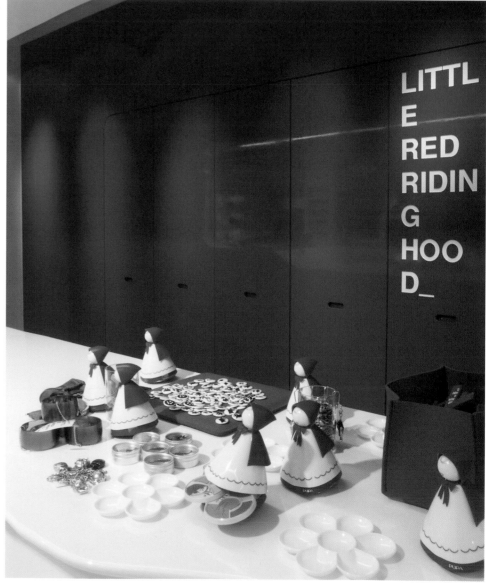

LITTL
E
RED
RIDIN
G
HOO
D_

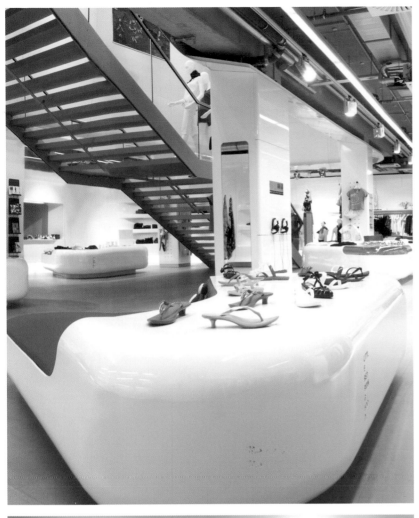

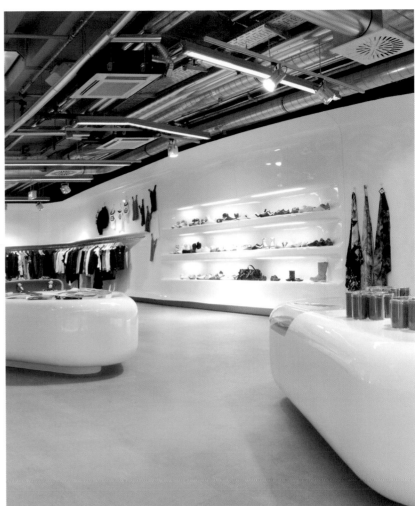

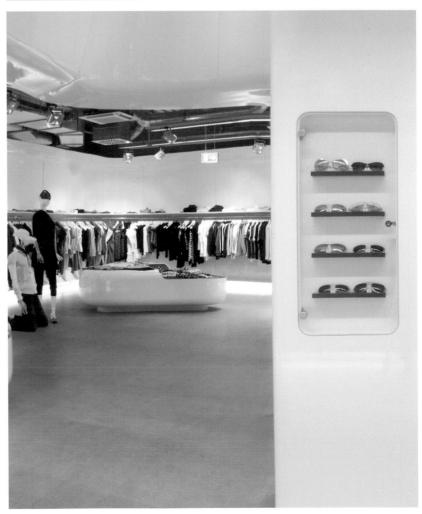

> Griffin

Architects: El Último Grito

Location: London, UK/Paris, France

Photography: Nathalie de Leval, Roberto Feo

El Último Grito was commissioned to design a décor for the brand Griffin and to develop a universal concept that would be valid for the brand's shops in diverse cities. The installations created in London, Tokyo, and Paris capture the attention because of their use of original display systems that present the Griffin collections in a recurring but unusual way.

One of the temporary installations that El Último Grito executed for this brand in Carnaby Street, London, was noteworthy for the unique anatomical display stands created from materials recycled from other shops. The view from outside the shop revealed a completely white backdrop against which a series of inverted body parts dressed in the brand's jeans descend from the ceiling, like an animated extension of the space. The theatrical aspect of the scene is unique. Some of the bodies are back to front, others are joined by a single arm, while the articles displayed on the bodies unify the whole scene.

Another Griffin shop in Portobello Road, London, contains an imitation forest. In the middle of the space, ceiling-height tree trunks shelter a wooden cabin where a portion of the clothing collection is stored. The ceiling is also filled with hangers held by stainless steel tension cables from which exclusive items from the collection can be hung.

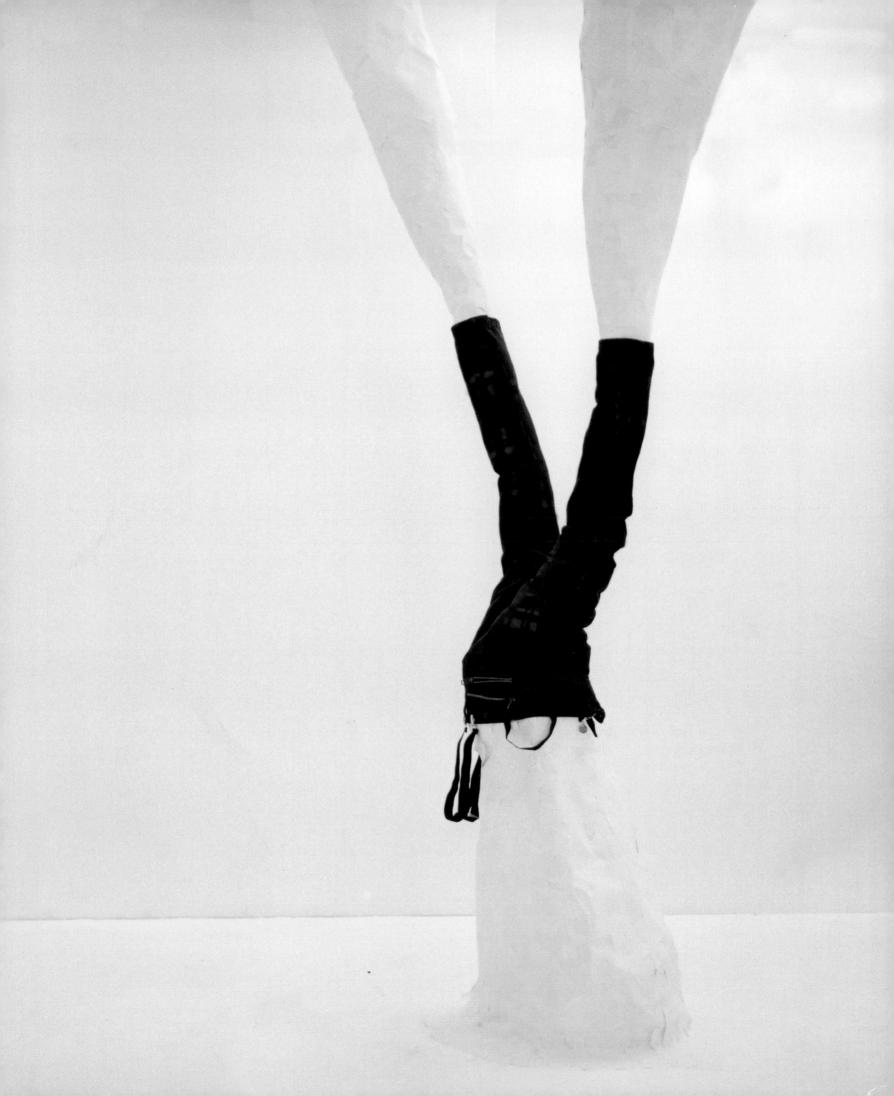

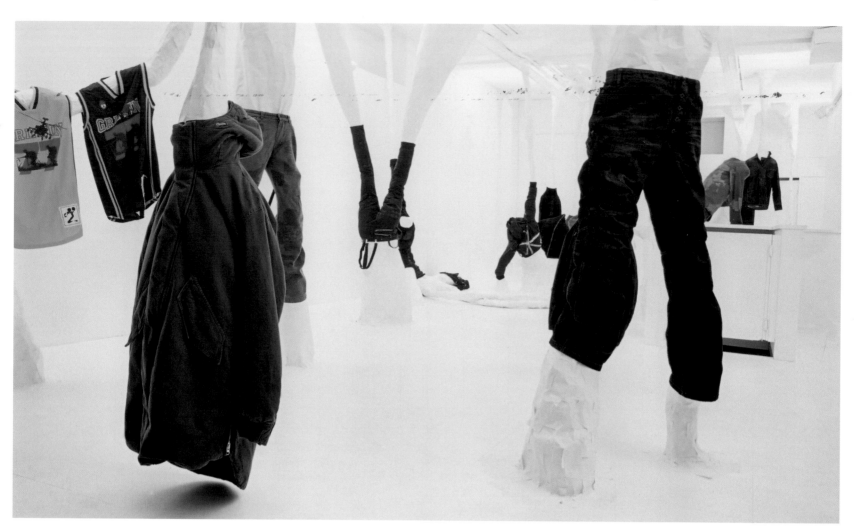

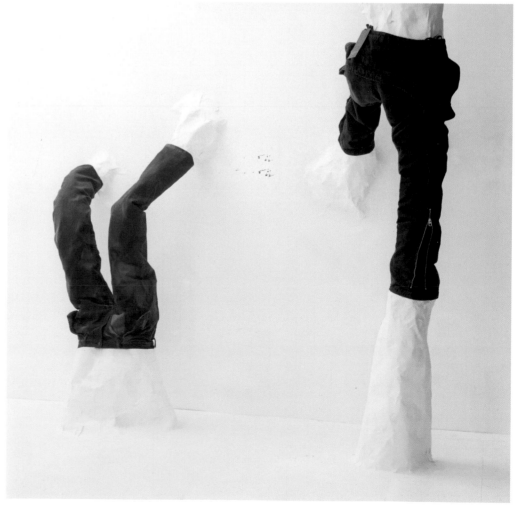

> White anatomical display stands made from materials recycled from other shops display the brand's clothes in an unusual and theatrical way.

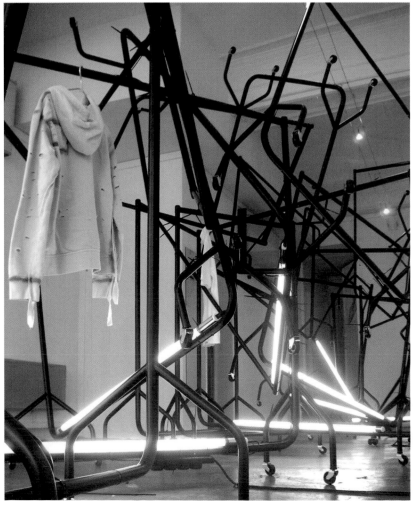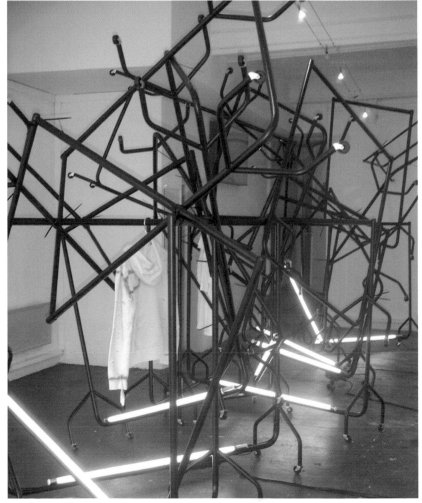

>Killah

Architects: Studio 63

Location: Milan, Italy

Photography: Yael Pincus

Killah attracts attention because of its apparently carefree design. Using striking lines and evincing an almost adolescent attitude, the interior avoids any traditional esthetic formula, existing as a pure and inimitable space.

The Studio 63 team based the different elements of the interior on adolescent experiences, since many of the products on display are targeted at this market. Inviting shoppers to enter Killah, a display of manga comics beckons from the entrance and tempts them to discover the rest of the products. Inside, the geometric theme is dominant. On the central sales counter an arrangement of interrelated photographs welcomes customers. Further inside the store, the same linear design is repeated. On one side, a stainless steel grid extends across the wall to become a changing room. Part of this grid is used as a base for the intense yellow synthetic-cloth shelving, where folded clothing is displayed. A pair of metal bars supports the taut cloth flap that forms each shelf.

More clothes hang from metal bars attached to the walls, making it easy for customers to browse the racks. In the upper section of the shop, a transparent tubular showcase displays still more products. The bathing suit display is an indoor oasis, where bikinis are stretched across fluorescent stands with irregular branching forms.

The lighting scheme for this striking esthetic mix incorporates different levels of intensity, making use of both neon and intense spotlights, and reinforcing the concept of adolescent exuberance that animates this retail space.

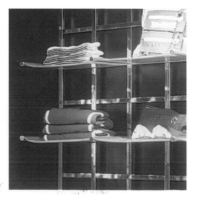

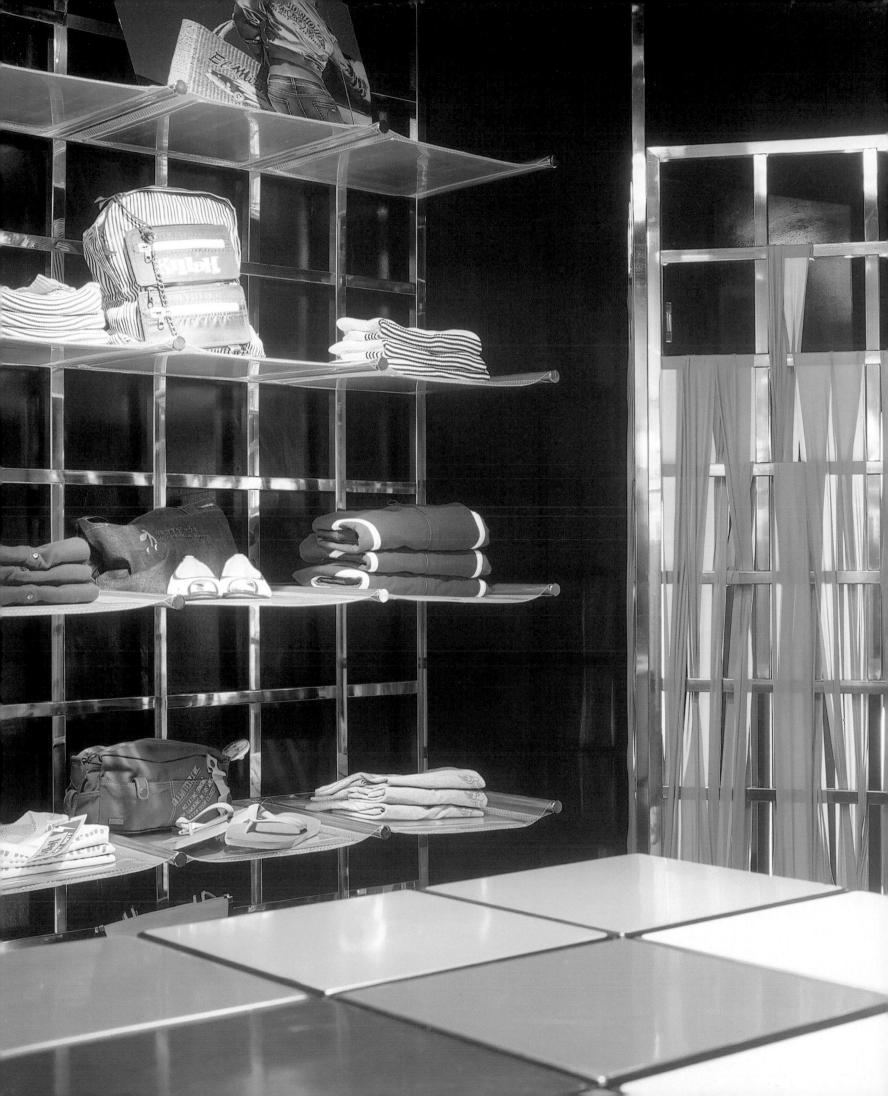

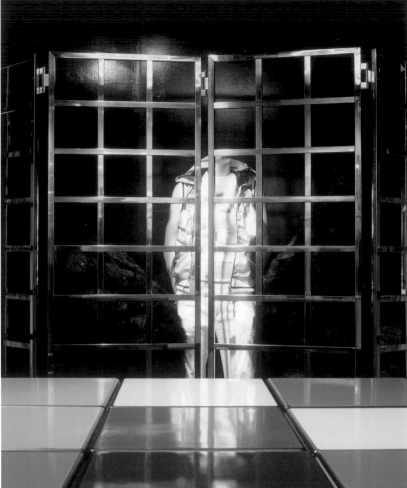

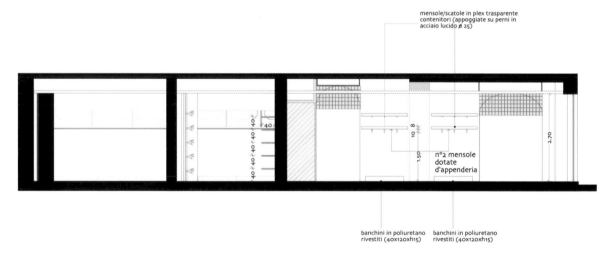

mensole/scatole in plex trasparente
contenitori (appoggiate su perni in
acciaio lucido ø 25)

n°2 mensole
dotate
d'appenderia

banchini in poliuretano
rivestiti (40x120xh15)

banchini in poliuretano
rivestiti (40x120xh15)

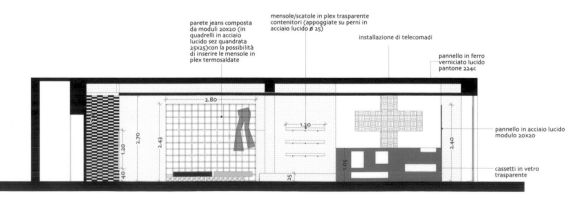

parete jeans composta
da moduli 20x20 (in
quadrelli in acciaio
lucido sez quandrata
25x25)con la possibilità
di inserire le mensole in
plex termosaldate

mensole/scatole in plex trasparente
contenitori (appoggiate su perni in
acciaio lucido ø 25)

installazione di telecomadi

pannello in ferro
verniciato lucido
pantone 224c

pannello in acciaio lucido
modulo 20x20

cassetti in vetro
trasparente

Longitudinal sections

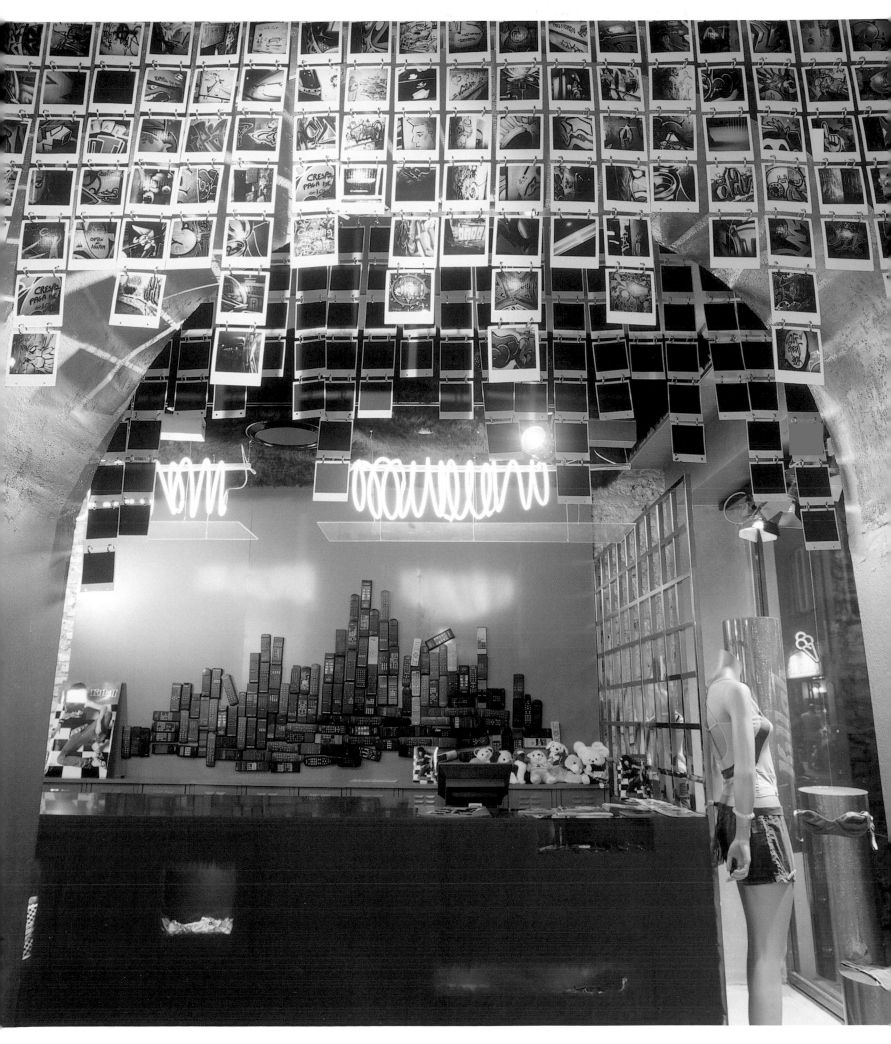

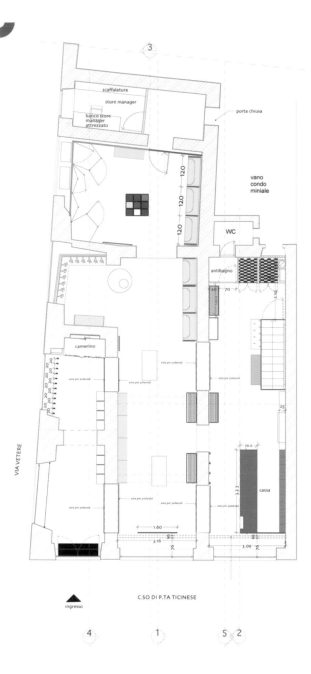

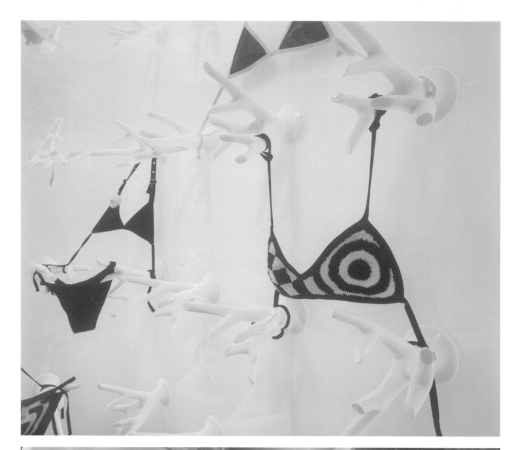

> The swimwear is displayed on irregular fluorescent hangers that pull the clothing taut so customers can easily see the items.

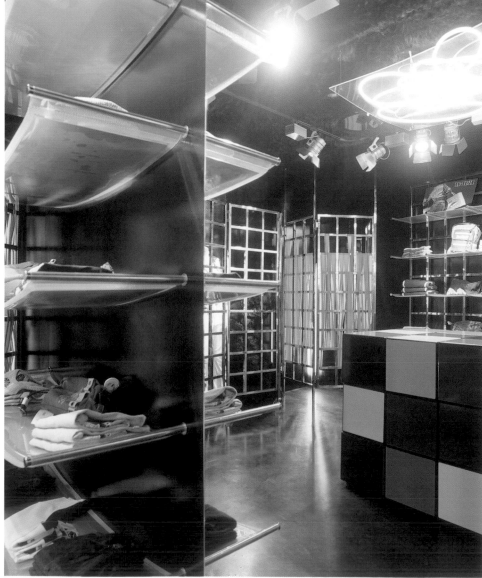

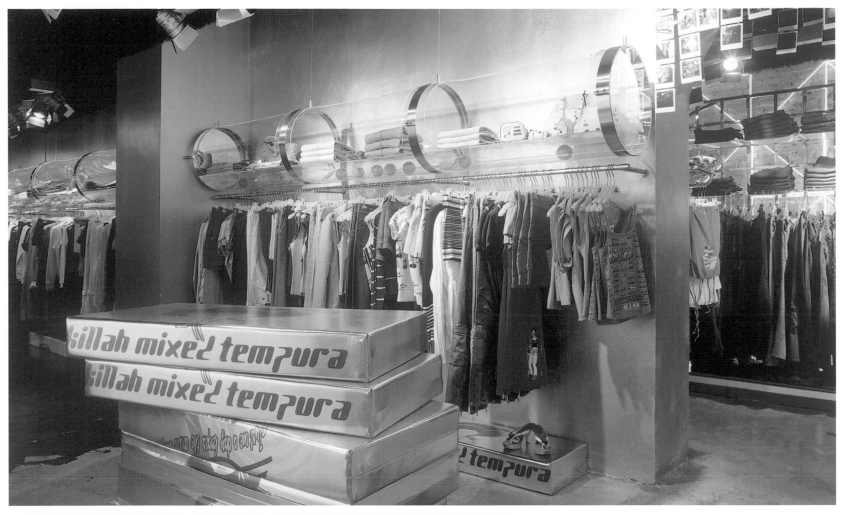

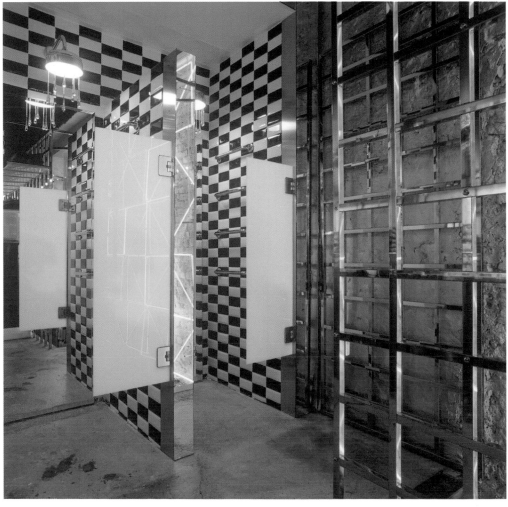

> A transparent tubular showcase, situated above the hangers, displays some of the Killah products as if they were works of art.

>Smart Travelling Store

Architect: Werner Aisslinger/Studio Aisslinger
Location: Berlin, Germany
Photography: Steffen Jaenicke, Nicola Bramigk

Together with the German designer Nicola Bramigk, Werner Aisslinger developed the concept of the Smart Travelling Store and designed all the fittings and display systems for this shop located in Mitte, one of the trendiest areas of Berlin.

The initial idea was to create a shop where people could find books, clothes, food, souvenirs, and other products that have been specially selected from 19 European countries. The result was a three-dimensional tourist guide full of products that are ideal to buy for oneself or as presents. From cookbooks to sleeping masks, Viennese chocolates, and London's Titanic soup, an enormous variety of items can be found in this shop. The space was divided into different zones by theme. The display area for clothes, for example, occupies 23 feet and is one of the central spaces of the shop. The clothes hang from unique light fixtures that divide the space into different display points.

The second zone consists of a 20-foot wall, lit from different sources, where products from various European metropolises are displayed. The display cases—or illuminated aquariums, as Aisslinger calls them—are intergrated into the shelves to showcase products from a particular city. Customers can read the books and magazines in niches specially designed for this purpose. Another appealing feature is the compact disk display, where customers can listen to sounds from different cities around the world.

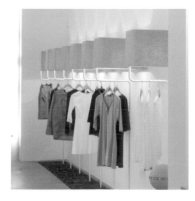

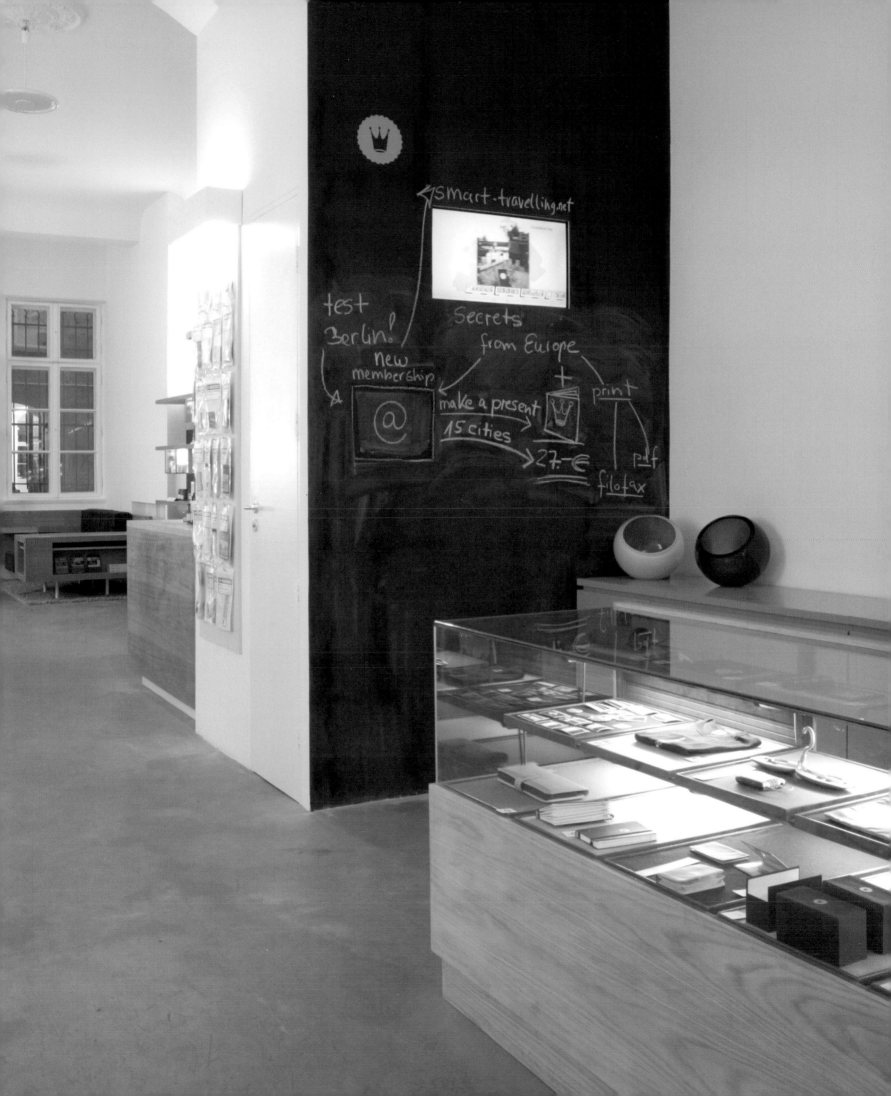

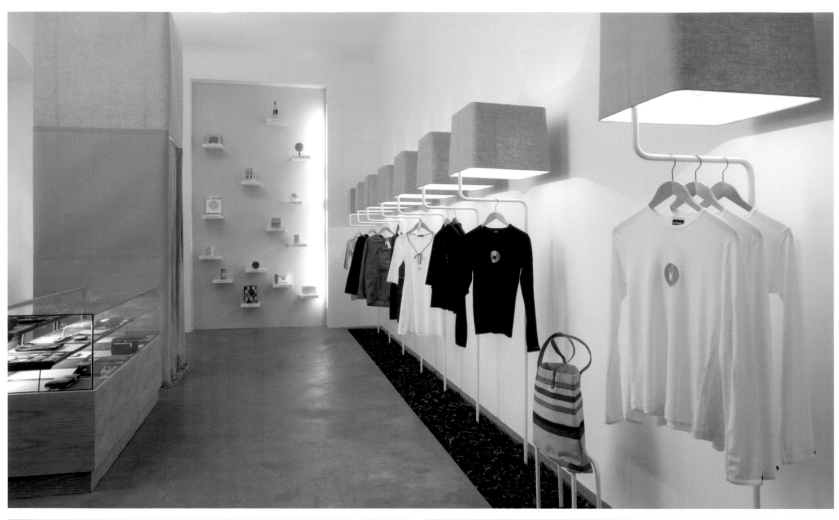

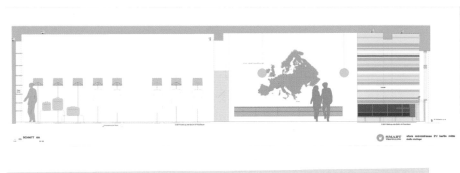

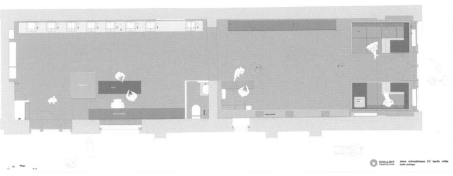

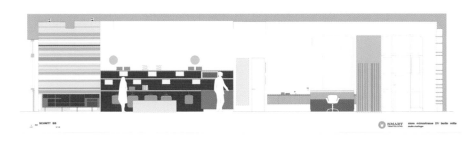

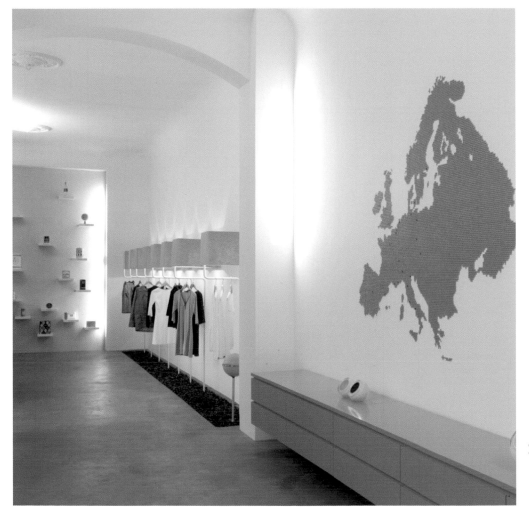

> One of the main zones of the shop, the clothing display area is notable for the unique system whereby the designs hang from pink light fixtures that illuminate the space.

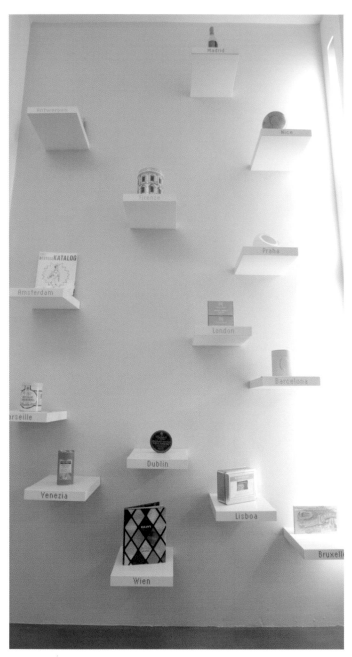

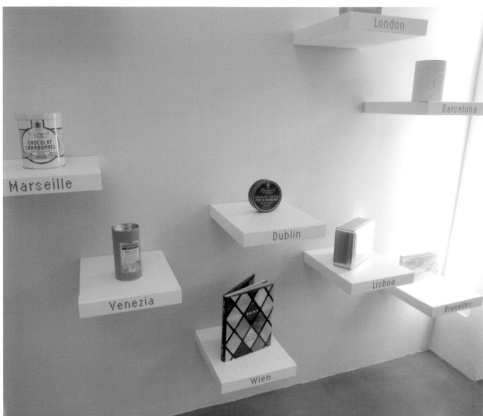

> Another zone in this cosmopiltan shop features a wall of shelves corresponding to various major cities, on which products from the countries in which these cities are located are displayed.

>Blush Dessous

Architects: Krüger Wiewiorra Architekten
Location: Berlin, Germany
Photography: Thorsten Klapsch, Frank Hülsbömer

Fashion designer Claudia Kleinert wanted Blush to be a shop where women could feel good about buying clothes. Blush resides in an old building originally constructed in 1920 in the Mitte district in Berlin. The team of Krüger Wiewiorra Architekten was responsible for creating this space.

Covered in black-and-white wallpaper with old-fashioned motifs, designed by Andrea Pößnicker, the space reflects the provocative style of Kleinert designs. Erotic toys are intermixed with tempting lingerie, hosiery, sleepwear, and special accessories. New merchandise is added each month.

The furnishings and fixtures were designed for maximum practicality. The display modules created by Carsten Wiewiorra showcase the clothing in a seemingly random arrangement and can change size to accommodate additional space as needed. In the middle of the shop, clothing hangs from a bar suspended by ropes attached to the ceiling. This area also features a circular bed where customers can sit and leaf through fashion magazines and other women's publications. The decorative cushions send overt messages such as "Kiss Me" and "Spank Me," conveying the suggestive atmosphere of this unique shop.

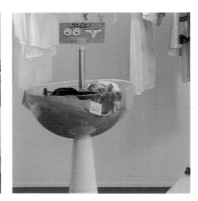

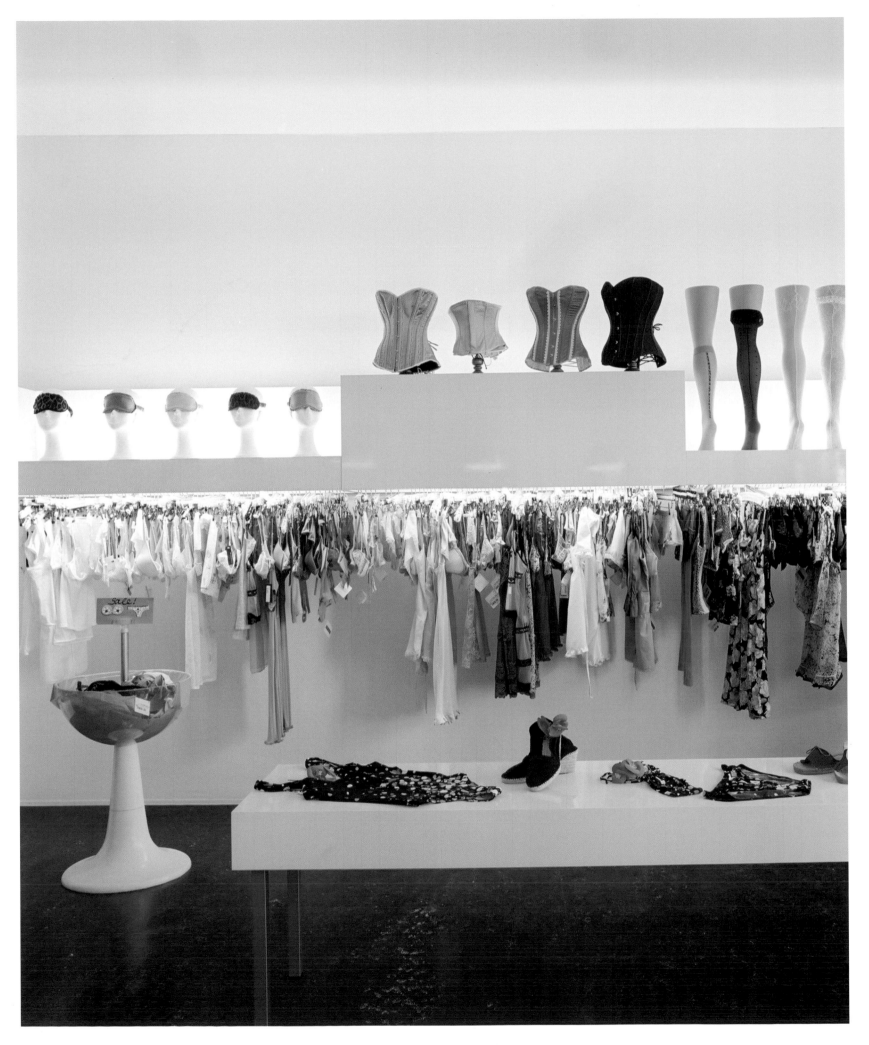

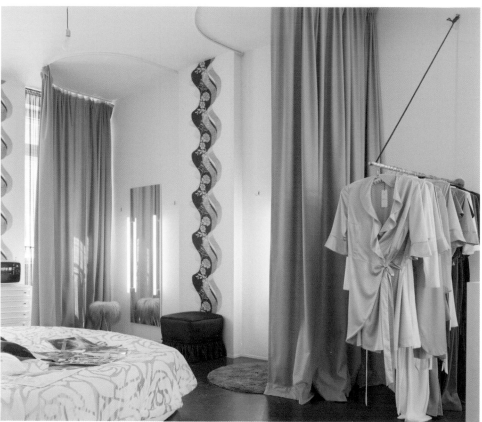

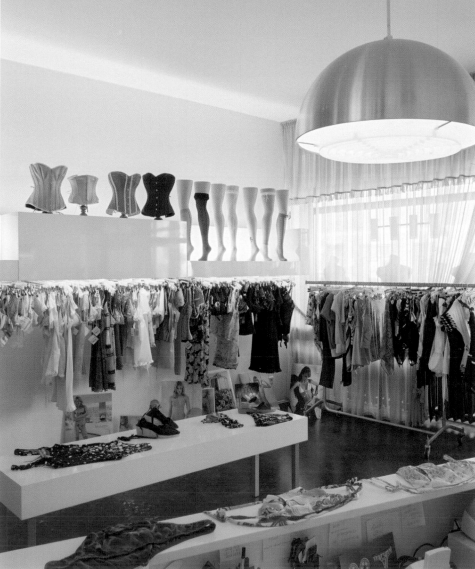

 The wall décor, designed by Andrea Pößnicker and inspired by details from women's lingerie, highlights the items on display in the shop.

Ankleide

Atelier

Verkauf

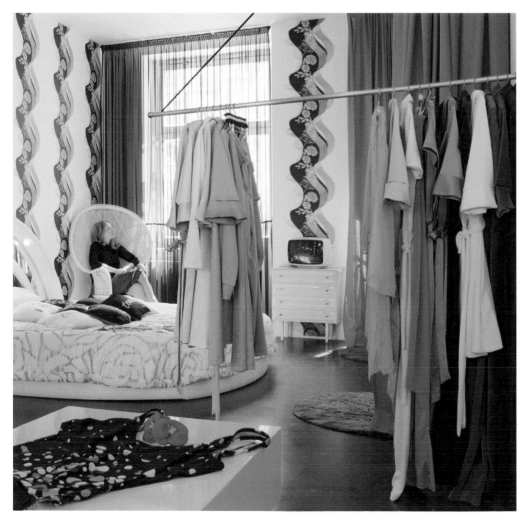

> A portion of the sleepwear collection is displayed on a metal bar that hangs from the ceiling.

>Marni

Architects: Sybarite

Location: Rome, Italy

Photography: Andrea Martiradonna

Once again, Sybarite plays with the senses in the execution of Marni's new space, located near the Via Condotti, in Rome. Following the same concept as the rest of the Italian firm's shops, Sybarite has successfully created a space employing soft contours and malleable textures.

The strength of Sybarite's design is the way the display stands masterfully project into the shop's interior. The sinuous lines make for an organic space that draws inspiration from forms found in nature, reinterpreting them intelligently for this modern shop.

Stainless steel railings follow the curves of the walls, creating shelves and hanging racks that appear to modulate. To emphasize the sense of movement, Sybarite used white marble for the floor, and the central sales counter likewise conveys a fluid and dynamic look and feel. The middle of the space features an eye-catching rack composed of stainless steel arms that open outward to highlight exclusive items, like a tree displaying the season's foliage. At the base, stainless steel "petals" offer accessories as if on a silver tray. The eyeglass collection is shown in cases embedded in one of the walls and designed to echo the shape of the glasses displayed within them.

In a space limited by a narrow footprint, Sybarite has created a shop that melds sleek modernity with organic shapes, where the displays are transformed into moving sculptures.

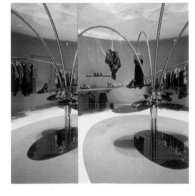
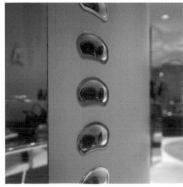
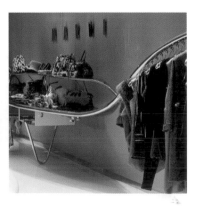

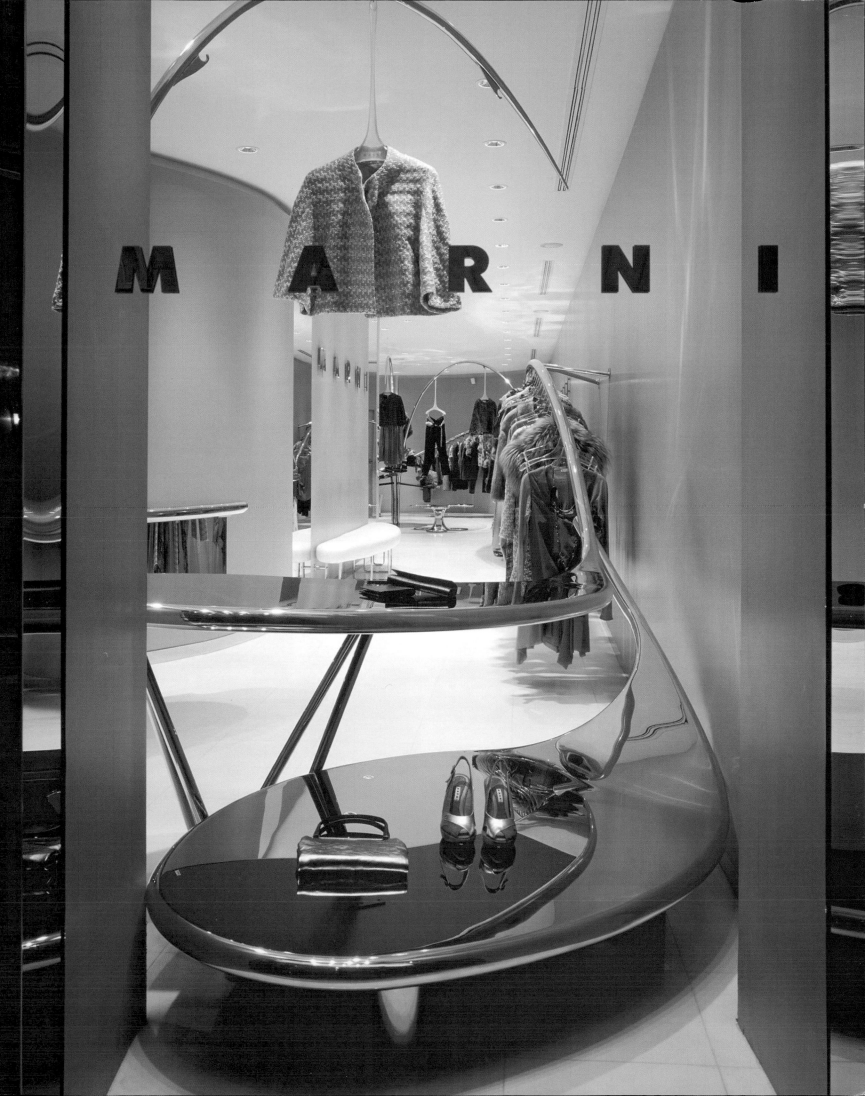

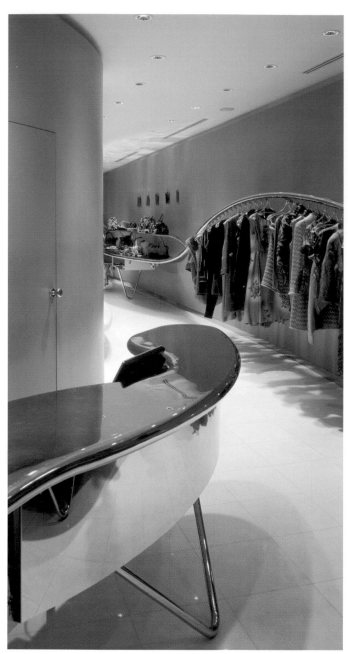

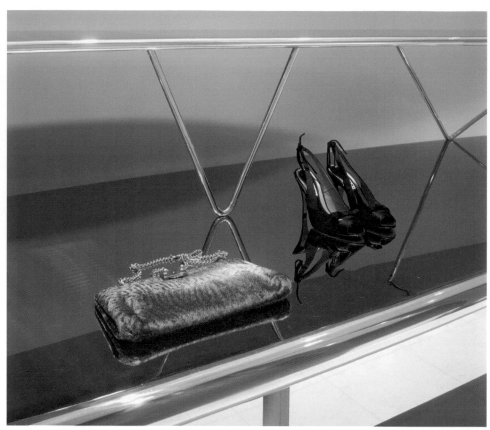

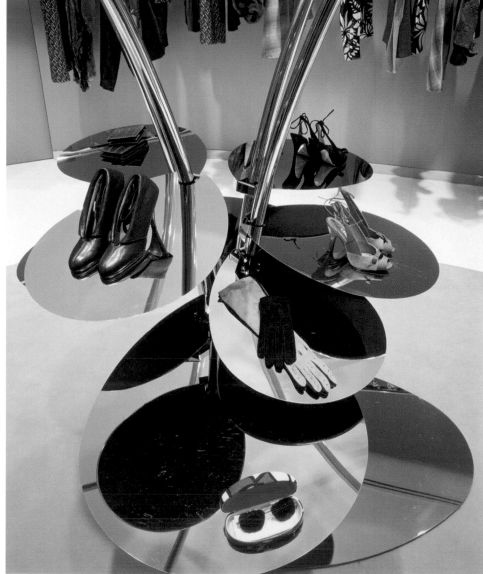

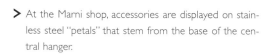

> At the Marni shop, accessories are displayed on stainless steel "petals" that stem from the base of the central hanger.

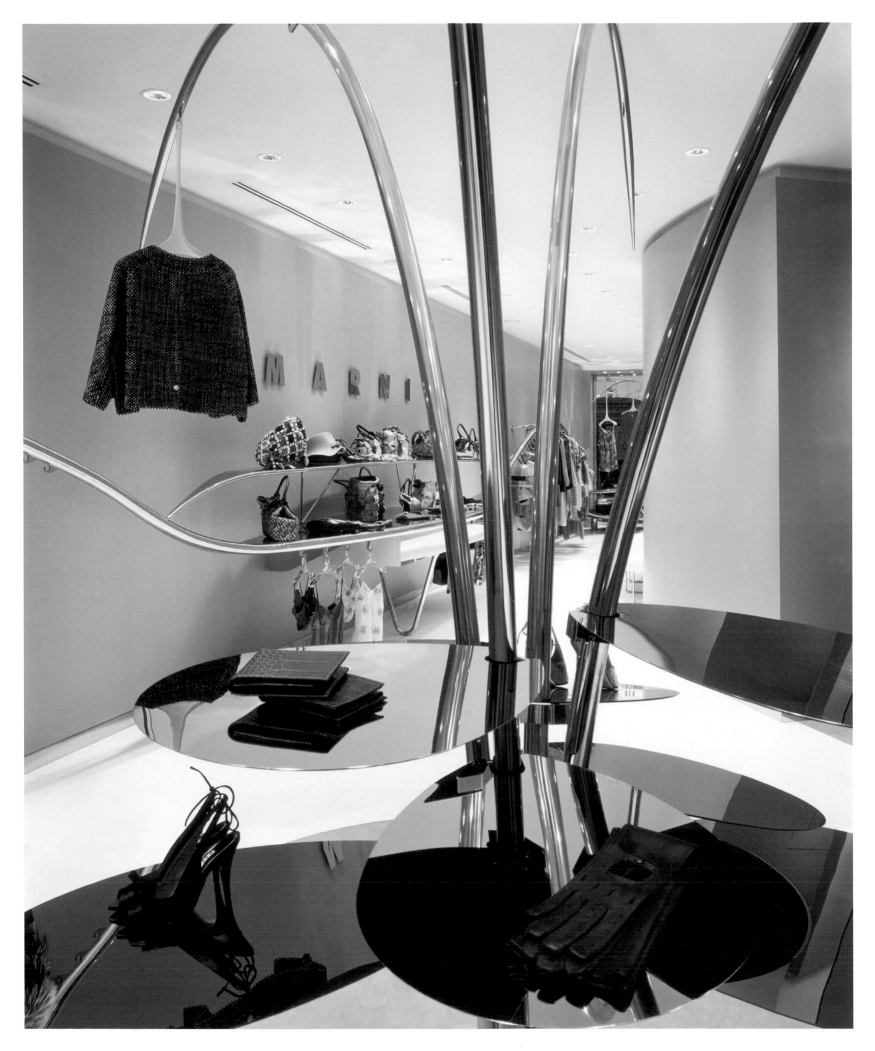

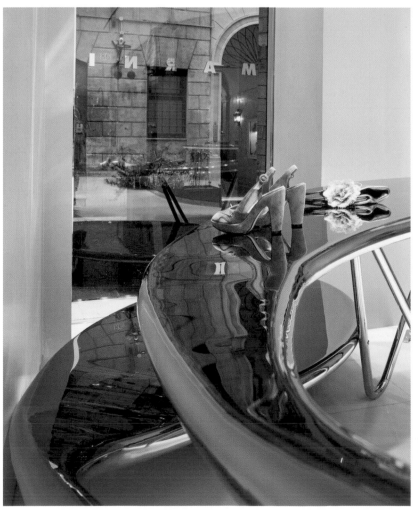

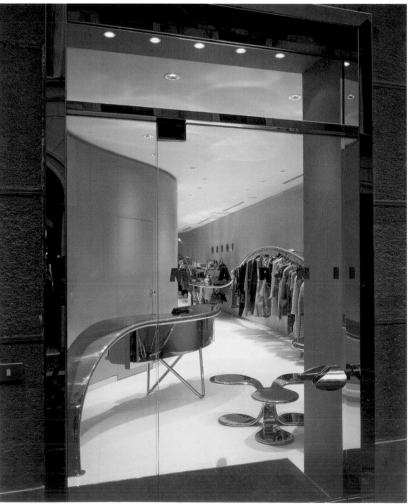

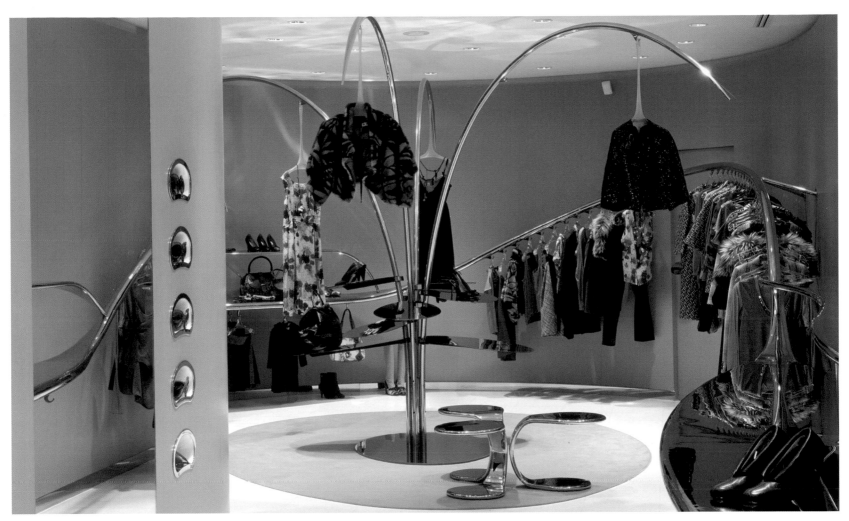

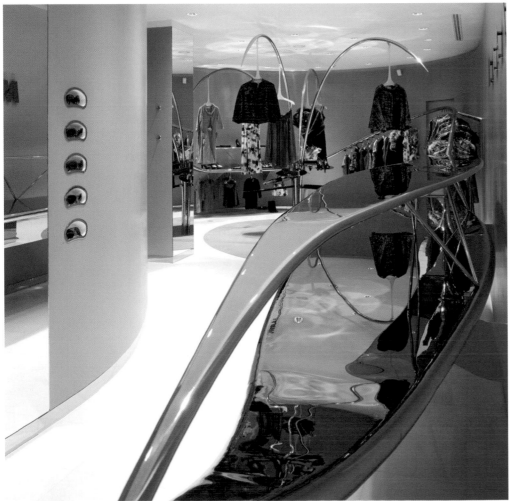

> The winding trajectory of the display stands creates an organic space based on forms from nature. Showcases embedded in one of the walls display eyeglasses from the collection.

>Hussein Chalayan

Architects: Block Architecture
Location: Tokyo, Japan
Photography: Leon Chew

In developing the initial concept for the Hussein Chalayan shop in Tokyo, Block Architecture's main task was to achieve a functional symbiosis between the Turkish-Cypriot cultural references that reflect Chalayan's heritage and the Japanese context of the shop's location.

At the entrance, a ceramic tile ramp in a multicolored herringbone pattern leads customers into the interior of the shop. This motif is repeated on the first floor, where men's clothing is displayed. Customers can relax on traditional Cypriot seating while watching images projected on a screen—much like an open-air cinema—which brings the space to life. The women's clothing area is made to resemble a grove of Cypriot olive trees. The clothing racks are intermixed with real olive trees, creating an idyllic environment reminiscent of Chalayan's origins. The racks themselves are interesting: Lengths of rope suspended between two posts act as hangers—a flexible and unusual system.

The rest of the collection is distributed throughout the shop on various shelves and modules. All of the display modules have wheels to facilitate mobility and contribute to the flexibility of the space. The materials selected for the display units and structural fixtures of the shop intentionally take advantage of the indigenous connotations of Chalayan's background, resulting in an extraordinary setting for the Chalayan collection.

 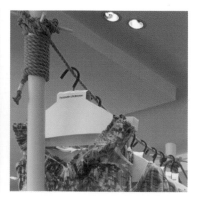

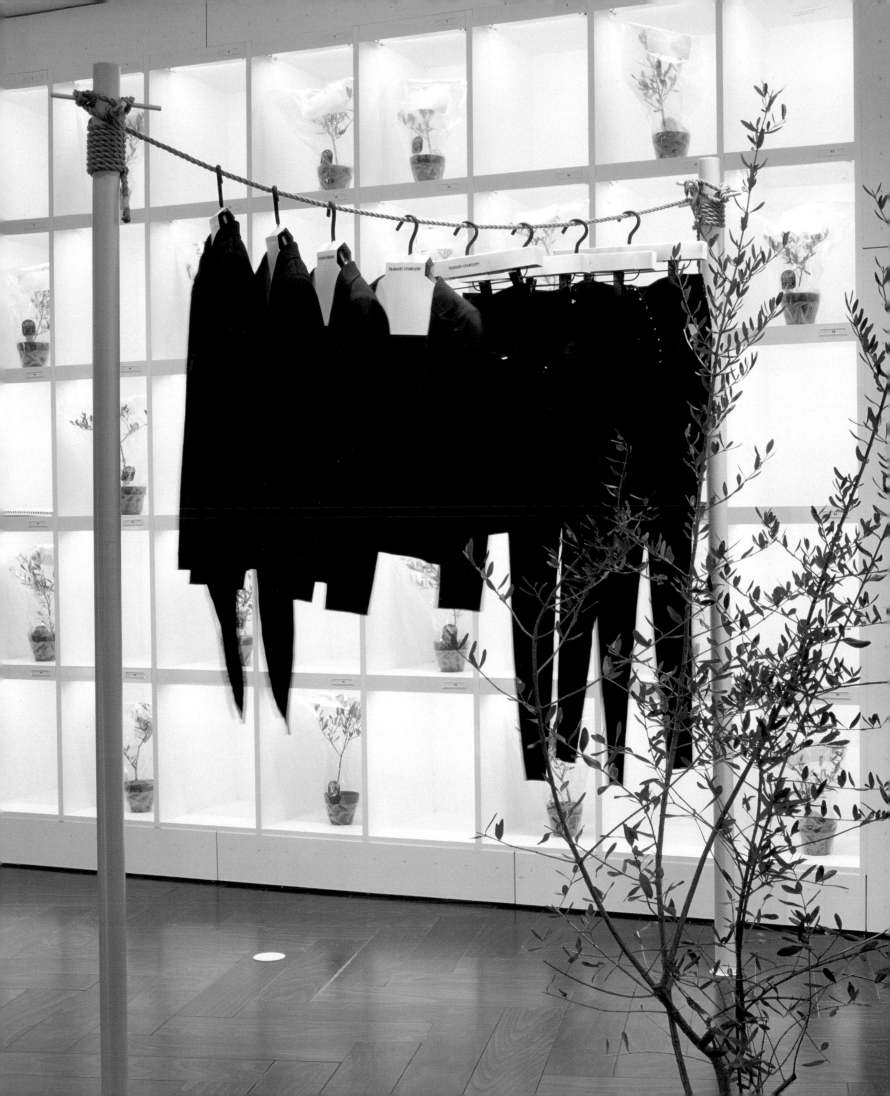

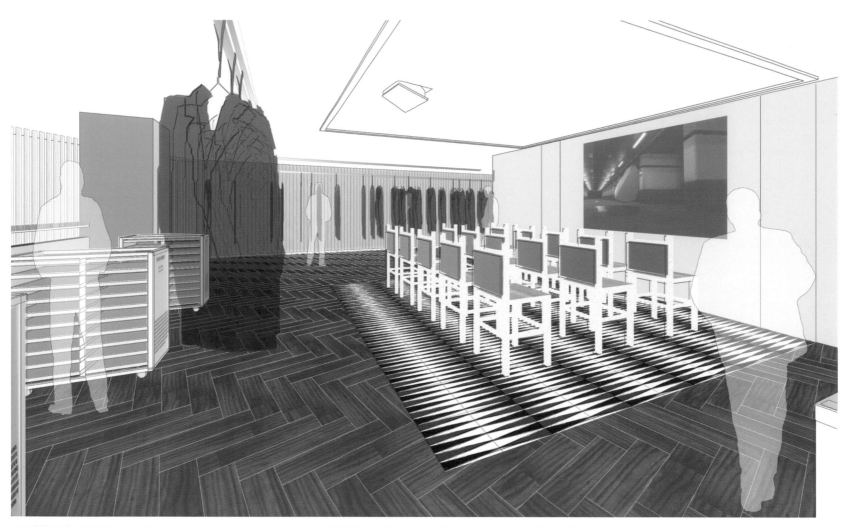

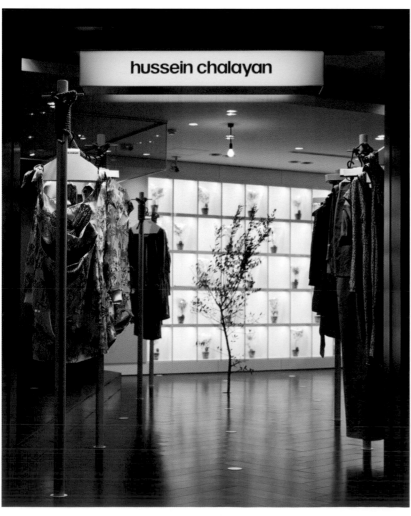

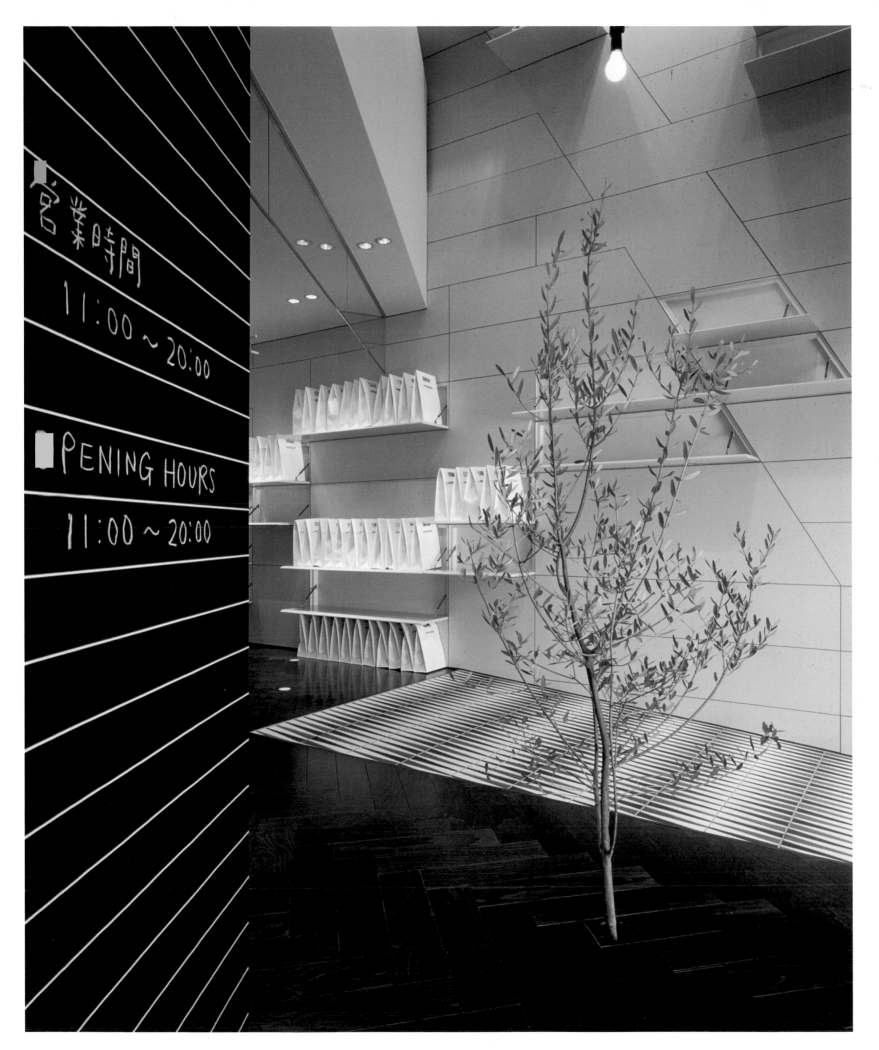

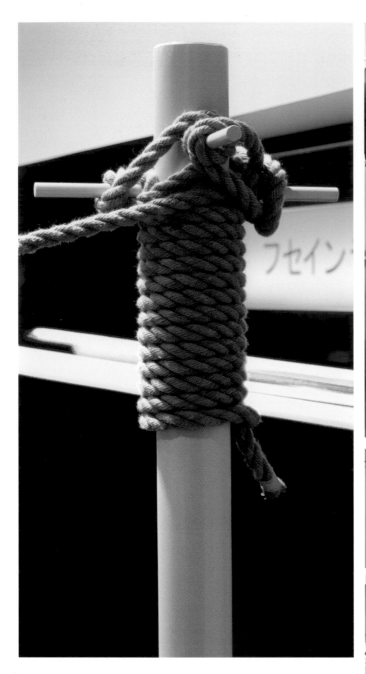

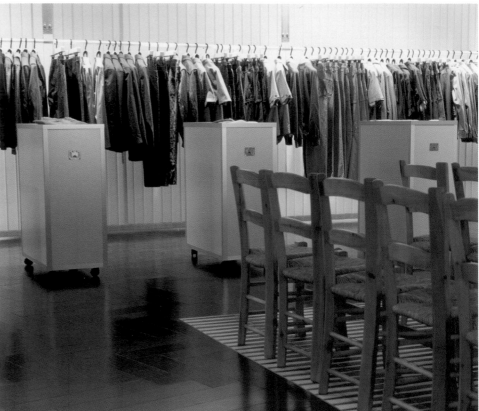

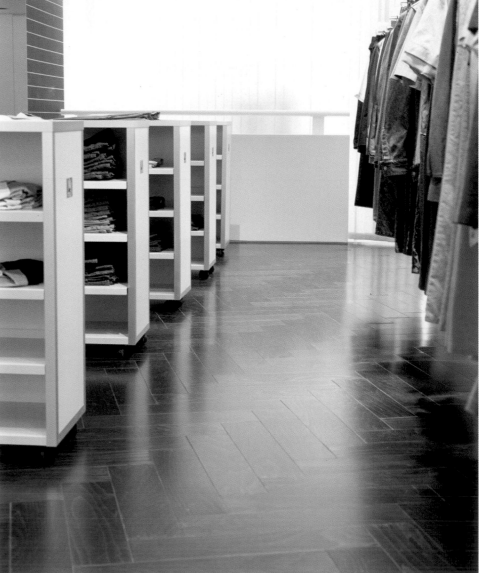

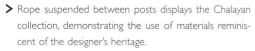 Rope suspended between posts displays the Chalayan collection, demonstrating the use of materials reminiscent of the designer's heritage.

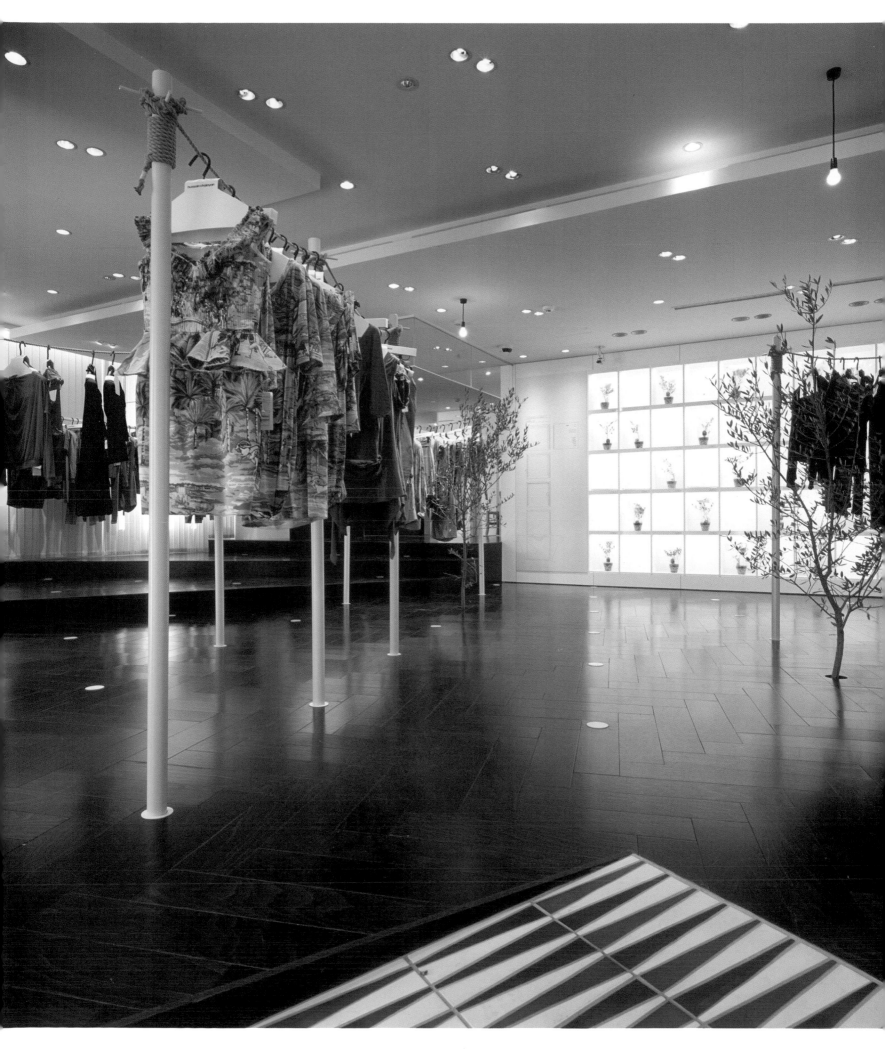

> 14 Once

Architects: Studio 63
Location: Florence, Italy
Photography: Yael Pincus

The Studio 63 team of architects wanted to give this space, located in Florence's historical center, details that reflect the history and tradition of the city. The project is noteworthy for its use of industrial forms and materials reminiscent of times gone by—for example, the clothing display fixtures, which, although different from one another, are all created from the same material: steel.

The irregular wall structure has a roughly circular footprint and is employed in displaying the various items in a dynamic but orderly way. Making use of some of the wall surface, accessories such as bags and shoes hang from glass doorknobs that look like they might have been removed from old doors. Other elements exhibit a geometrical order of rectilinear forms, such as the system of illuminated open and closed cubes, resembling a chessboard, along one of the walls, which are used to showcase jewelry, belts, watches, and caps. A steel-plated tubular structure in one corner displays more valuable items behind glass.

Not everything is displayed in these elaborate systems, however. Part of the collection is hung on racks where customers can easily see and touch the clothes. A white line outlines part of the wall and the floor, defining the display area around these racks. Folded clothing is displayed on shelves recessed into the walls. Shoes are scattered in front of the clothing racks in an informal display.

The overall lighting scheme was resolved by the use of spotlights arranged around the clothing racks. A large chandelier-type fixture descends from the ceiling in the center of the space, adding a historical counterpoint to the scene.

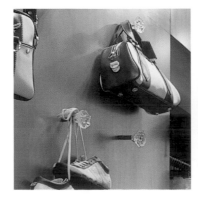

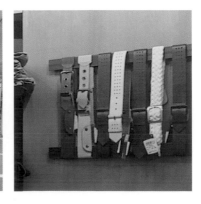

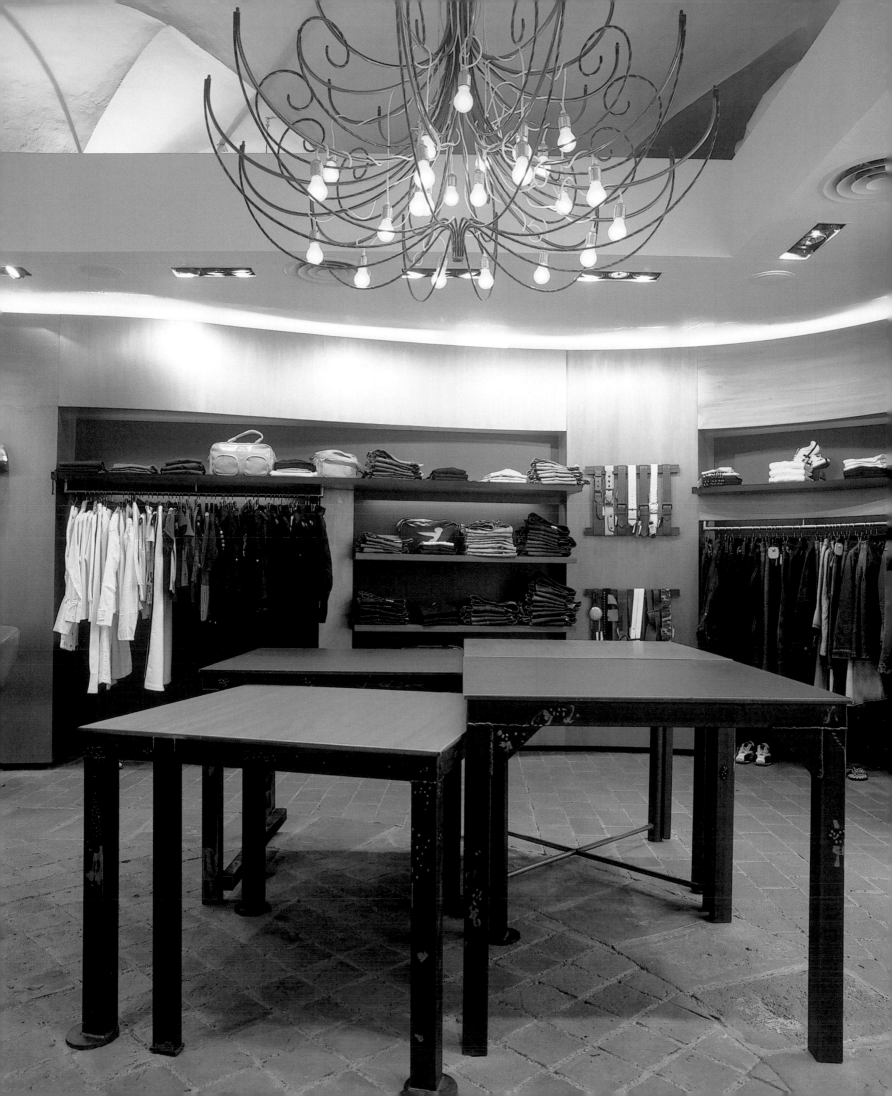

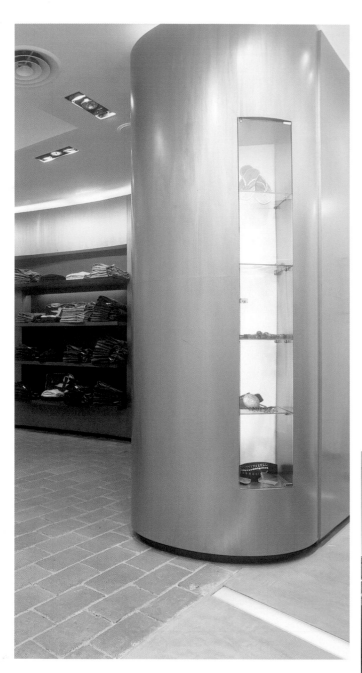

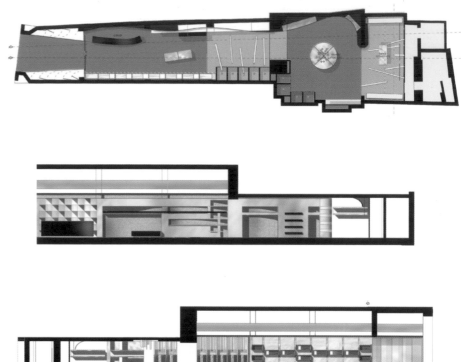

sez DX

 A steel-plated showcase displays the more valuable accessories. Part of the collection is displayed on functional hangers that incorporate shelving where the folded clothes can be found.

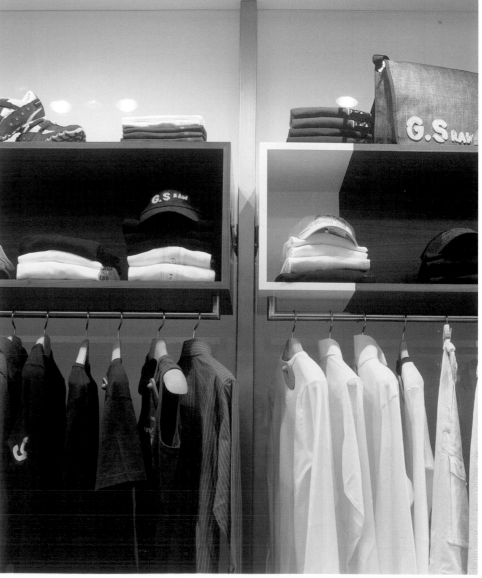

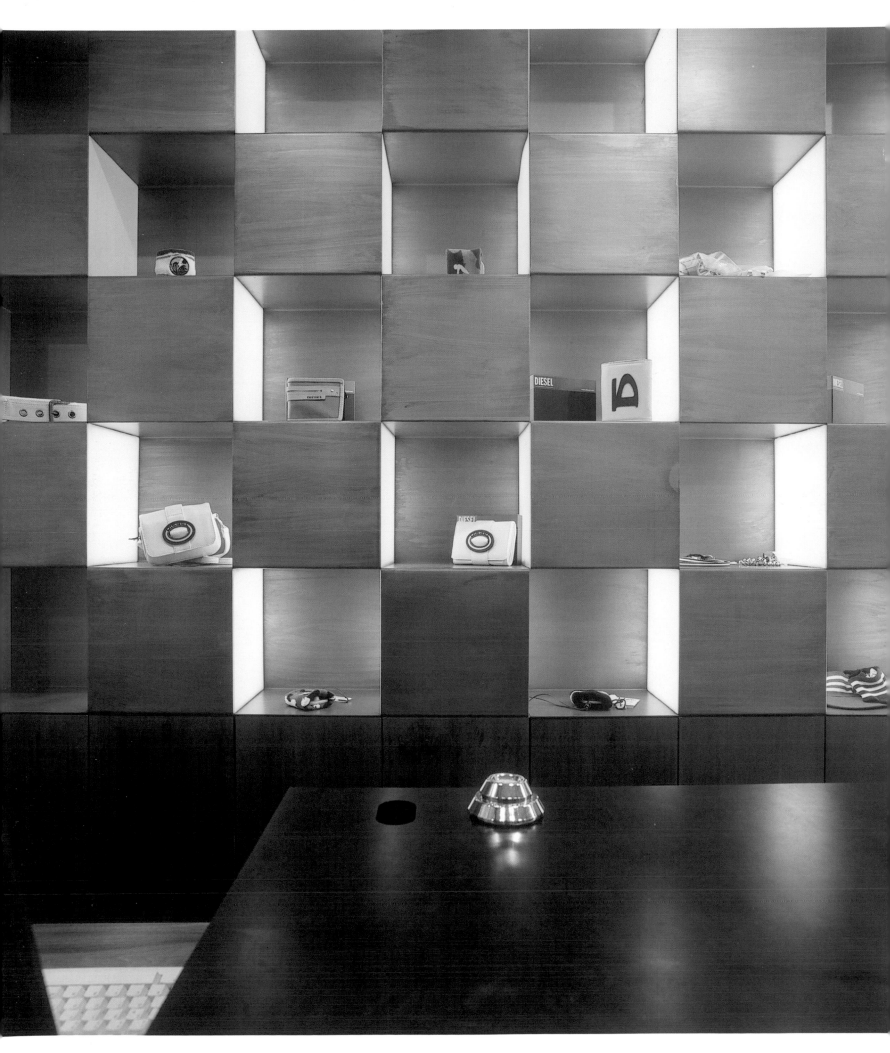

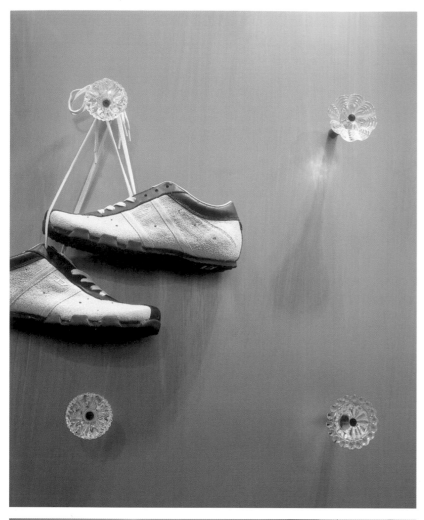

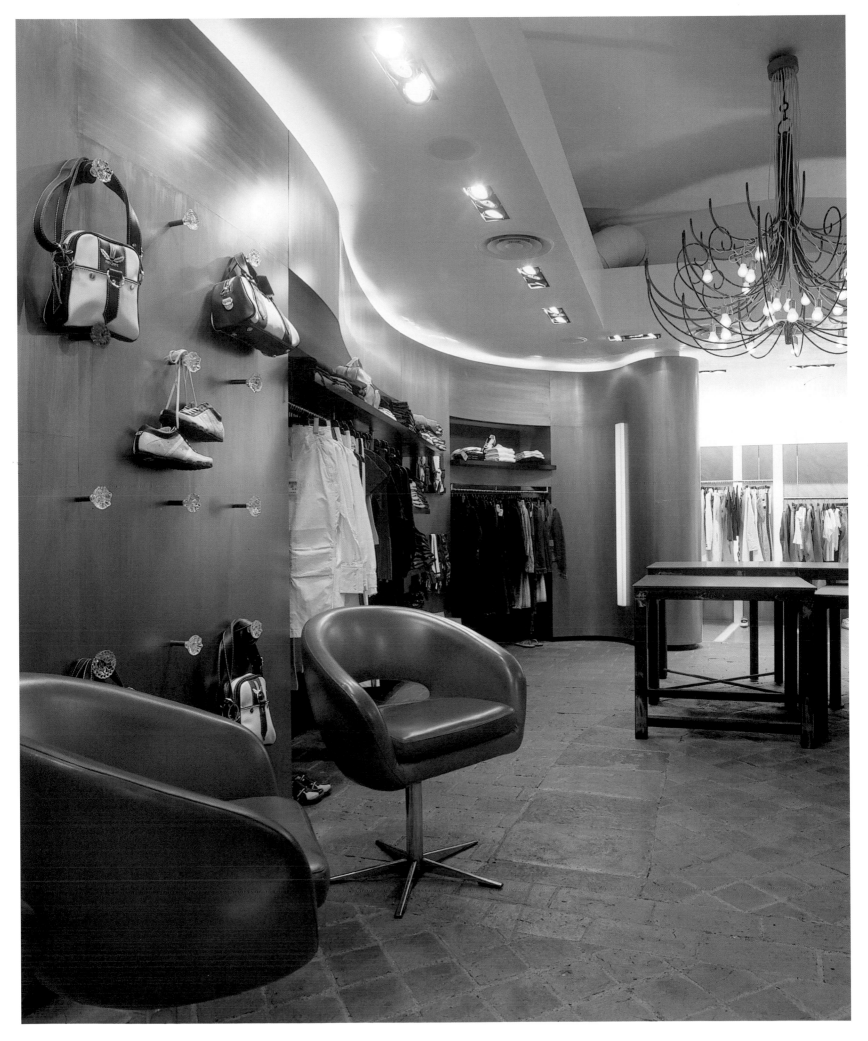

>Muratti Uomo

Architects: Lantavos Projects
Location: Athens, Greece
Photography: Antonis Karis

In the design world, silence is often the sensory equivalent of a physical manifestation. LP Architects, a Greek firm, together with designer Maria Lantavos, employed this premise in designing the interior of the Muratti Uomo shop in Athens, translating it into a completely white space in which both the display fixtures and the items on display convey the same elegant impression.

Modern materials and an attractively futuristic design concept exemplify the magnificent effort of these architects in executing this space. A curved stainless steel tube suspended by metal rods from the ceiling is the form on which the different levels of hanging fixtures are based. This multilevel system underlies the dynamic functionality that is effected globally throughout the shop. The white shelving for displaying products continues this theme. The uncluttered interior space is interrupted only by small, individual display units that can double as seats. The doors to the changing rooms at the rear of the shop provide the sole chromatic counterpoint.

The walls and ceiling are covered in textured white panels that delimit the space while simultaneously allowing for maximum transparency, successfully avoiding a closed-in feel. The lighting scheme likewise plays an important role in this setting; spotlights, grouped in pairs, are strategically positioned above the shelves and display units to maintain a continuous line of light projected directly from ceiling to floor, which provides a greater sensation of clarity and size.

 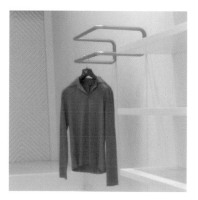

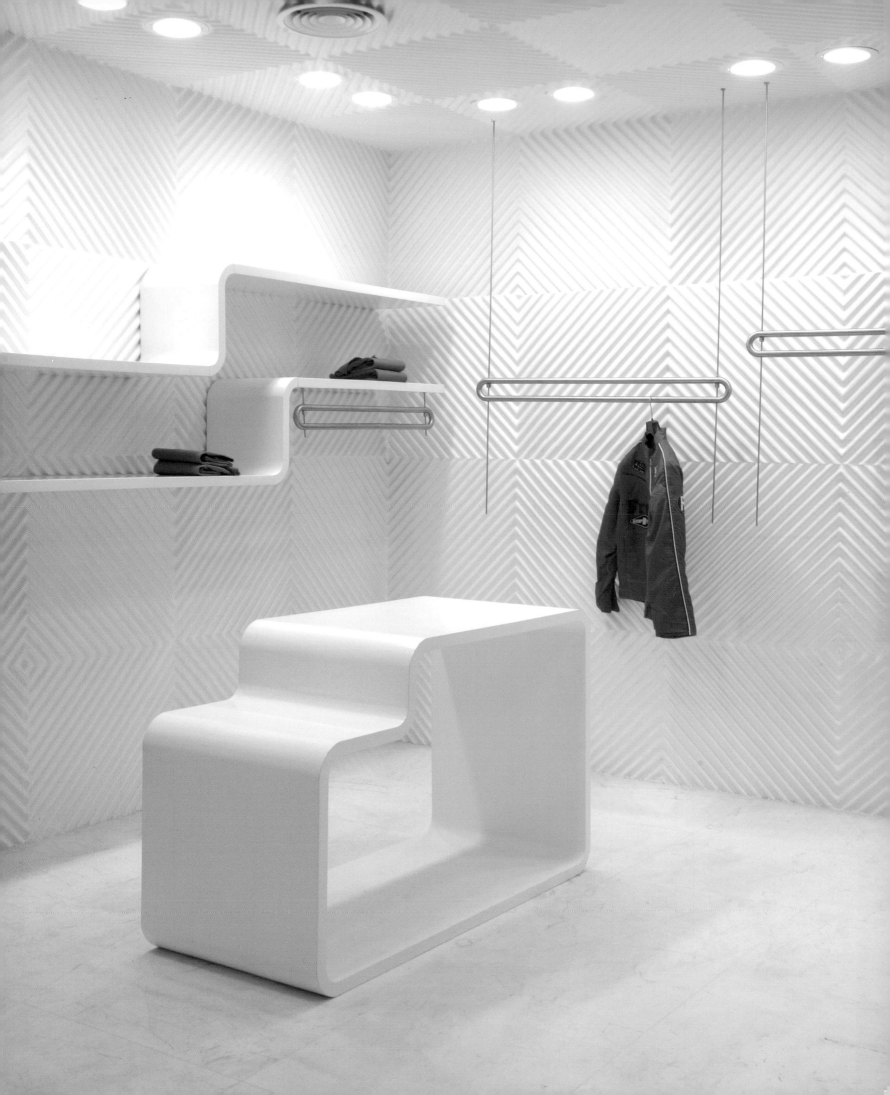

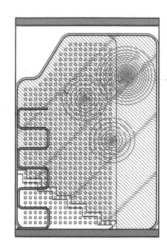

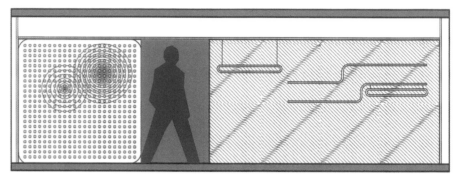

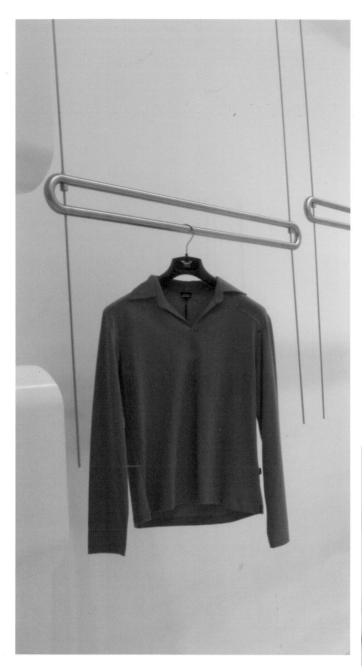

> The hangers, placed at different levels, are formed by a stainless steel tube held by two rods that are fixed to the ceiling.

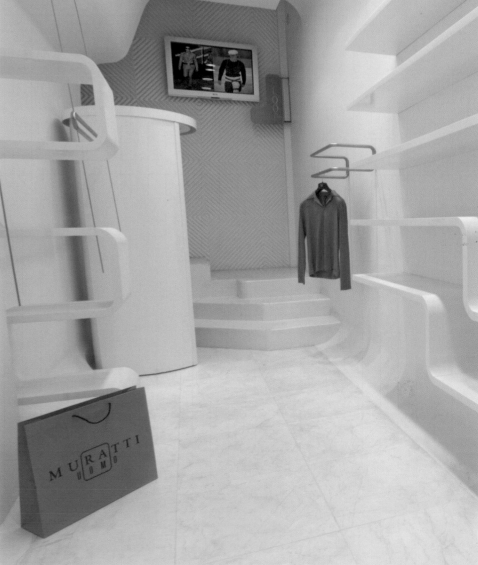

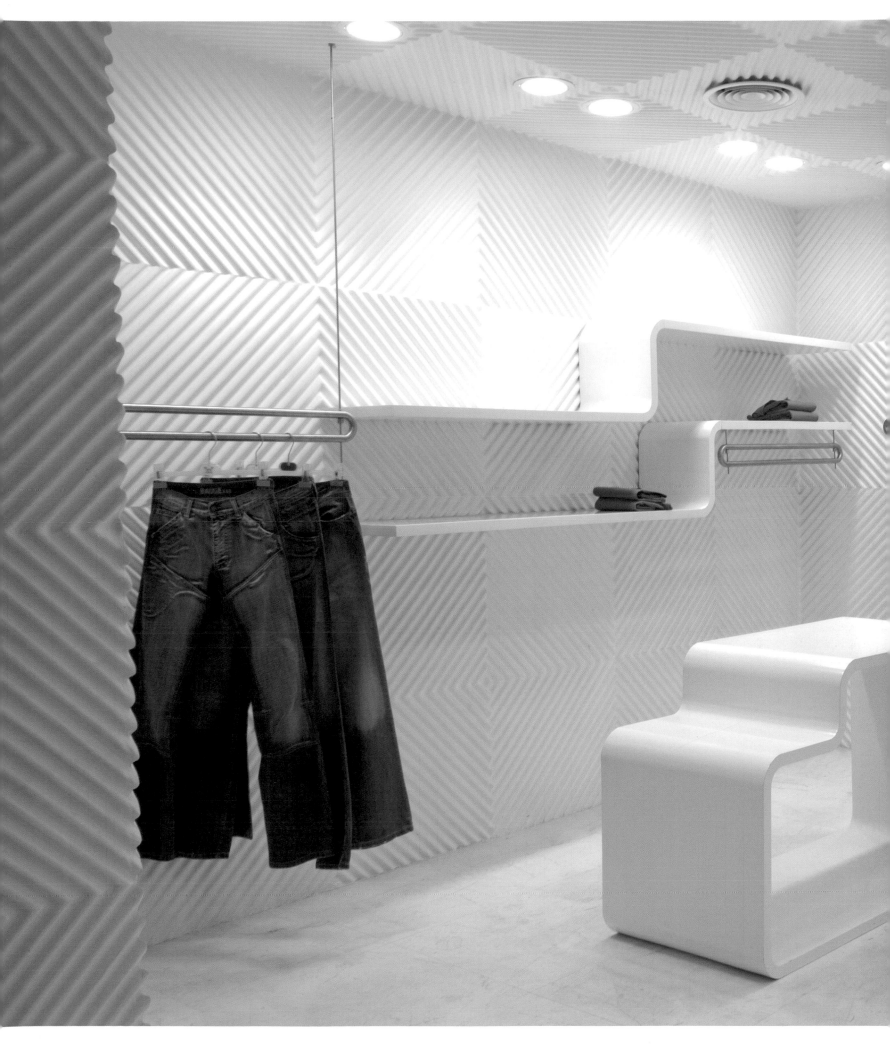

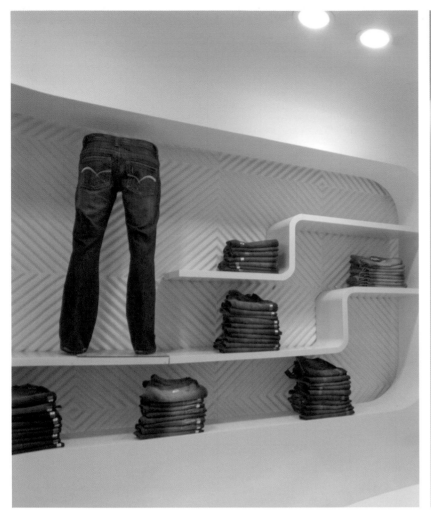

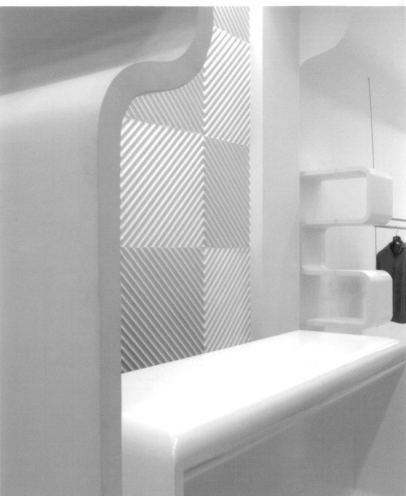

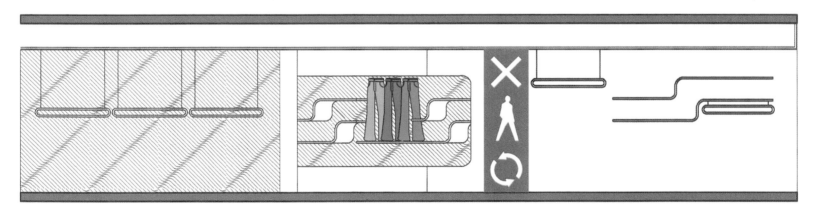

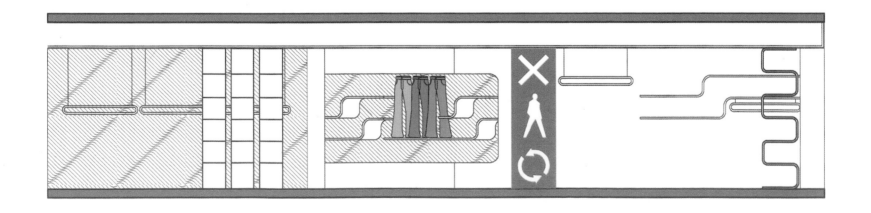

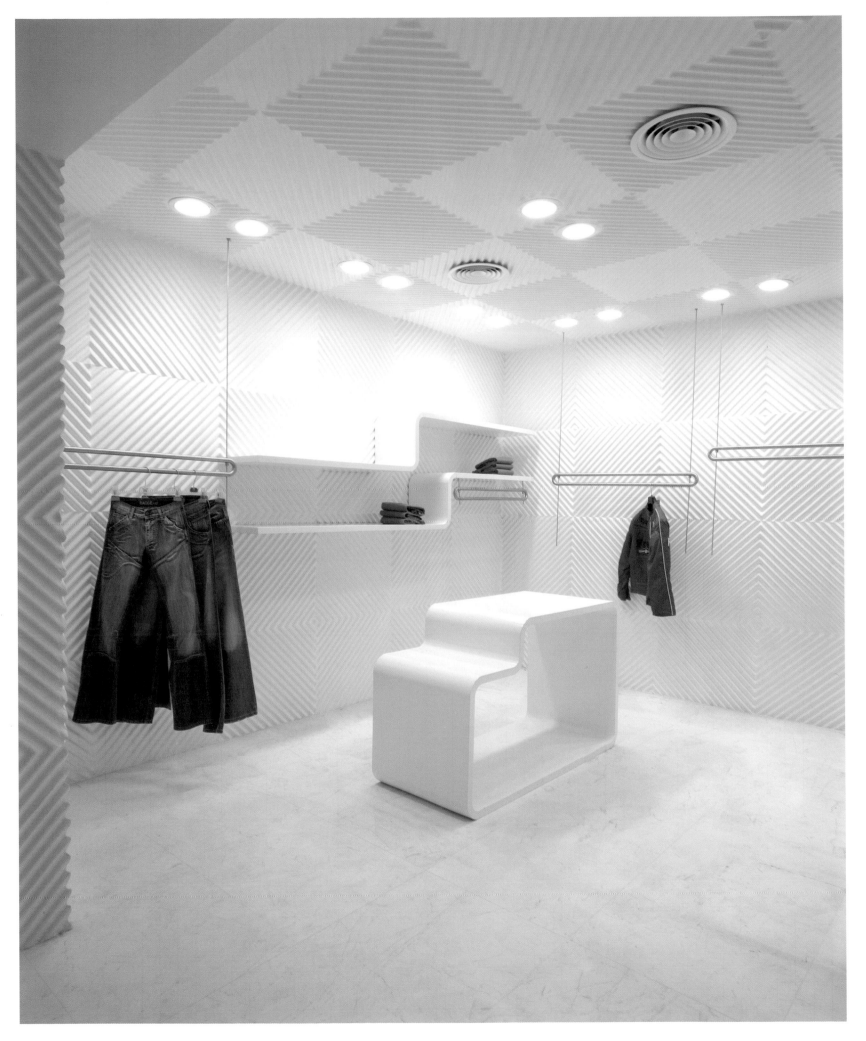

>Lieu Commun

Architects: matali crasset/matali crasset productions
Location: Paris, France
Photography: Patrick Gries

Lieu Commun, in Paris's Marais district, is a shop created by four independent designers—Eric Morand, Laurent Garnier, Matali Crasset, and Ron Orb—as a platform for displaying collections from various designers. The space includes such exclusive elements as a DJ booth designed by Ron Orb and F Communications and a DVD created by Matali Crasset.

One of the main aims of the project was to achieve a common space where the differences in style among the products for sale would not be so apparent. Natural wood, contrasting with the light blue walls and ceiling, was used to create a balanced environment. Lining the walls are display stands made of birch wood, which copy the form of tree branches, making them versatile enough to be used to display clothing, CDs, and a variety of other interesting items. The center of the shop features a similar but freestanding tree form, which is likewise used as a display fixture, allowing customers to more readily see and touch the objects for sale. Structural pillars that might otherwise obstruct the space were painted in the same blue and inlaid with birch panels where they join the ceiling, transmitting a feeling of lightness throughout the shop.

The result of this collaboration is an almost mobile, living, organic space that succeeds in bringing exterior and interior together through an intiuitive design based on recurrent natural forms and materials. The flexible and appealing display system, designed by Matali Crasset, has also been adapted for use in other types of spaces, such as museums and temporary installations.

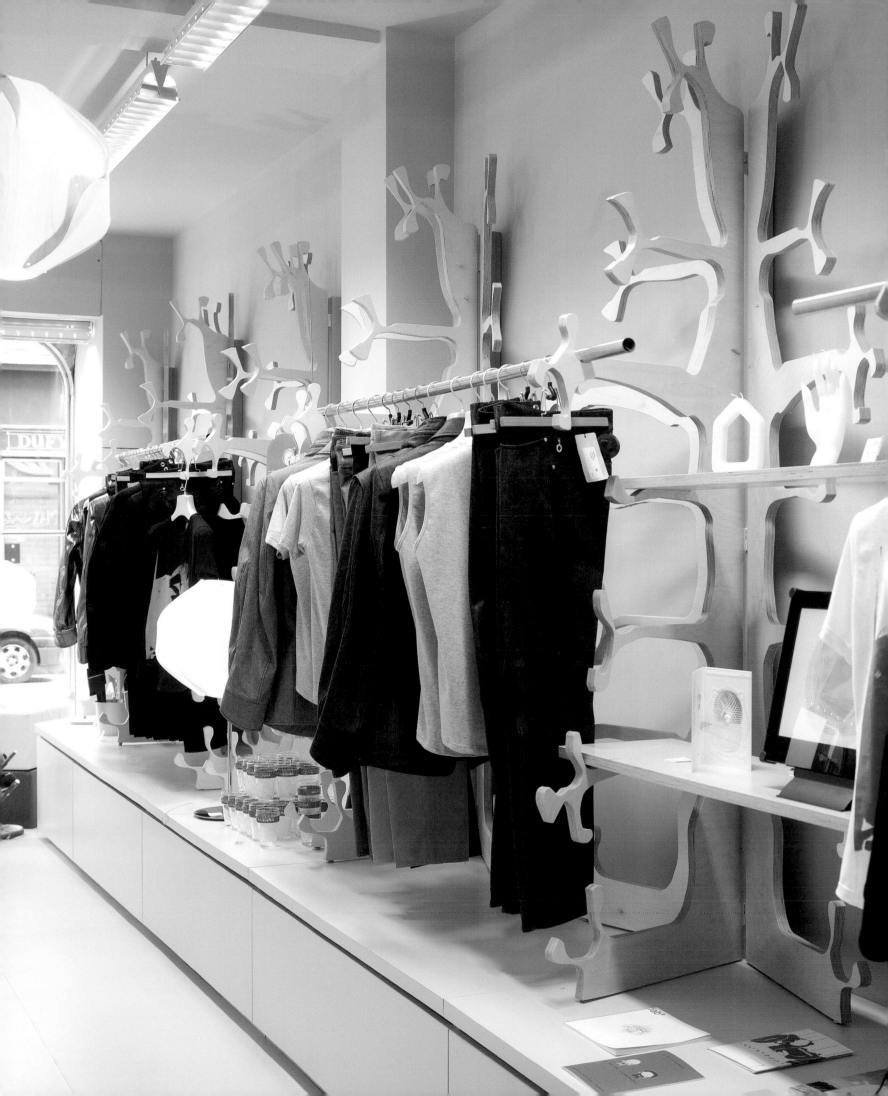

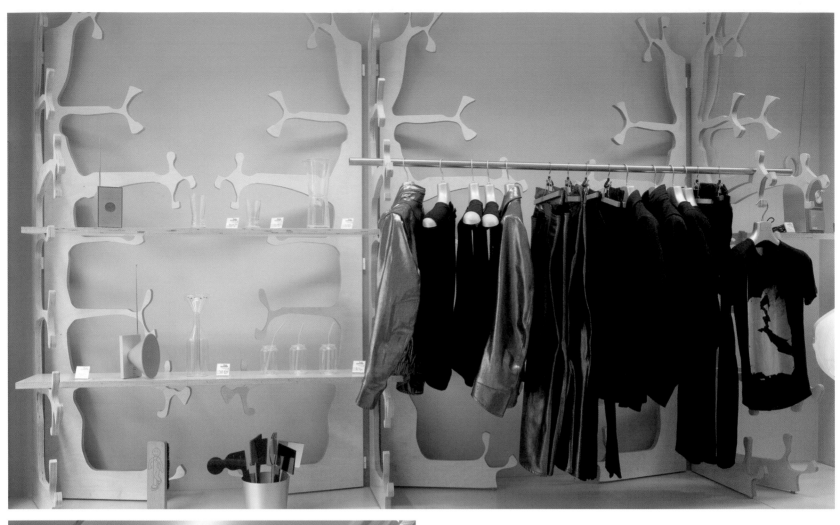

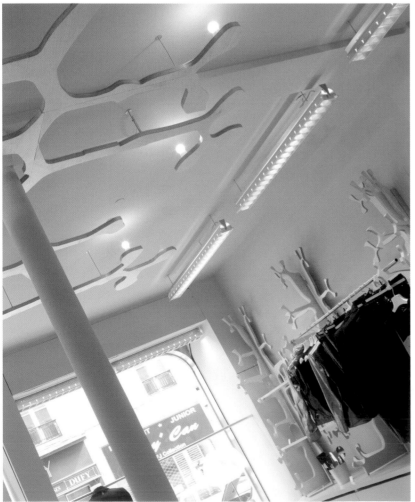

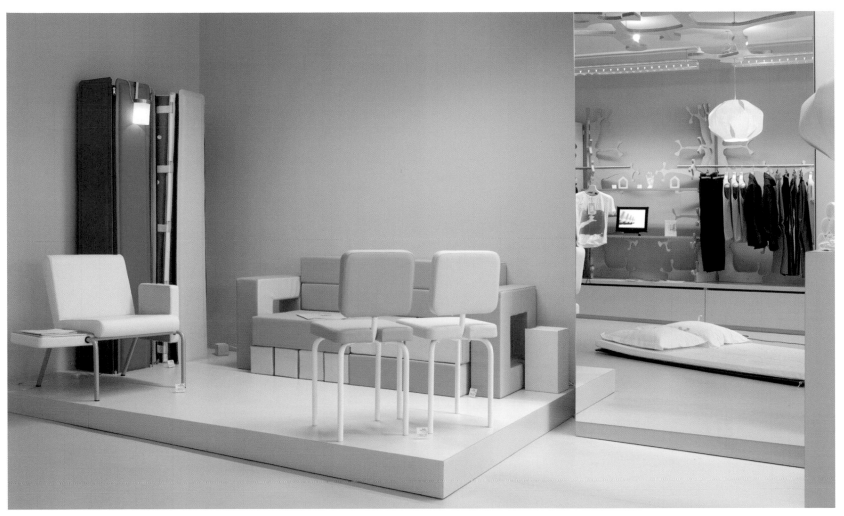

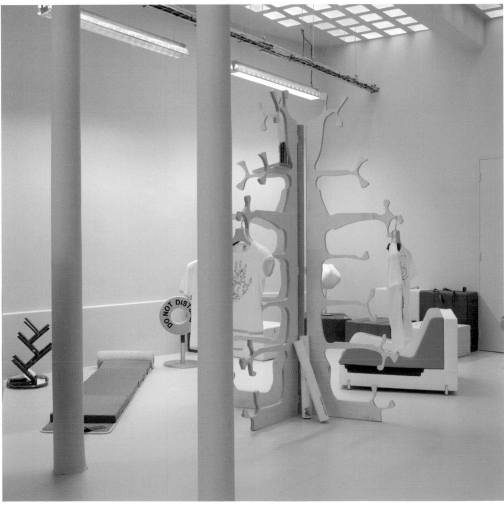

> A birch hanger in the shape of a tree allows shoppers
 to circulate around it, looking at the products that hang
 from its branches.

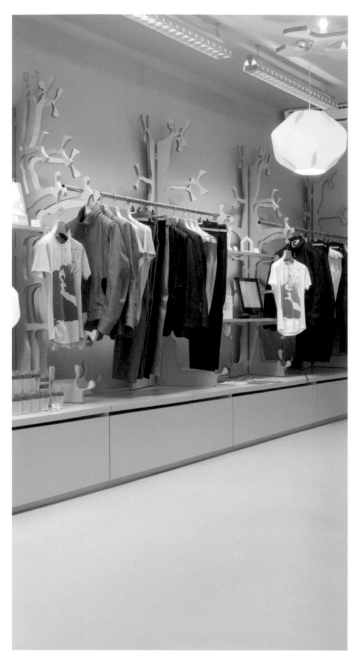

> The display stands, made from birch panels, resemble the branches of a tree and are an attractive way to hang clothing and display items. Drawers at the base allow for storage of extra inventory.

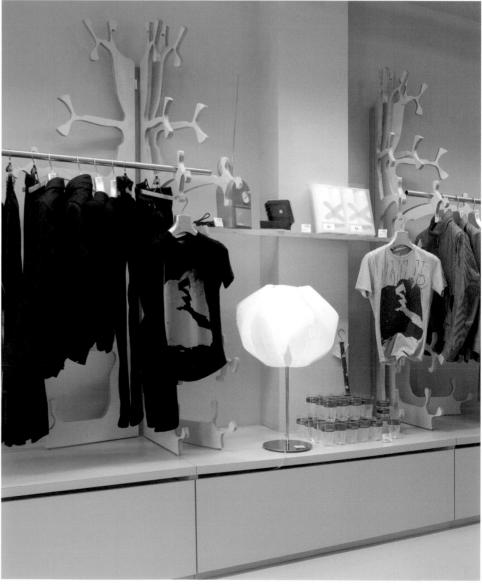

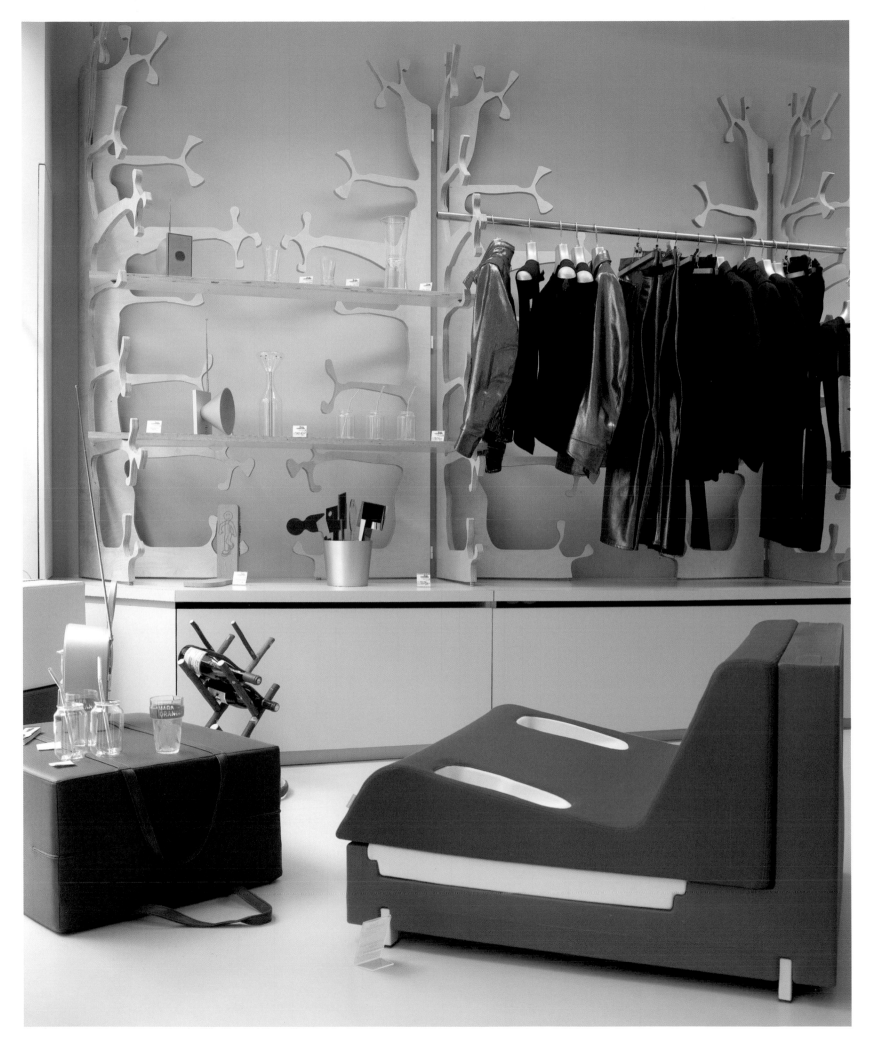

>Y's Store

Architects: Ron Arad Associates

Location: Tokyo, Japan

Photography: Nacasa & Partners Inc.

Japanese designer Yohji Yamamoto commissioned Ron Arad Associates (RAA) to come up with the concept for the new shop in its ready-to-wear line, Y's, located in Tokyo's prestigious Roppongi Hills area.

The shop occupies a space of some 6,000 square feet apportioned by three structural columns that distribute the interior space. RAA decided to disguise these columns, turning them into flexible racks where the collection can be displayed. The system consists of 34 aluminum tubes that are affixed to each column and can rotate 360 degrees, providing for a virtually unlimited number of open and closed display possibilities. Depending on the positions of these tubes, clothing can be either hung or displayed on wide shelving that is reinforced by a transparent plastic surface. Additional display space is provided by the angular shelves positioned at one end of the shop.

The white floor and walls supply the necessary transparency to display the Y's collection with maximum effectiveness. The red of the central sales counter offers the only contrast, and its design picks up the tubular structure of the columnar fixtures. The spiral form generated by these columns takes center stage at night, when the play of light and shadow from different sources animates the interior space. Light entering from the street catches the rotating tubes and makes them look as if they are in motion.

 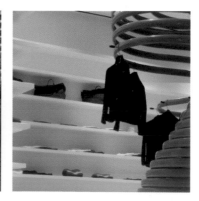

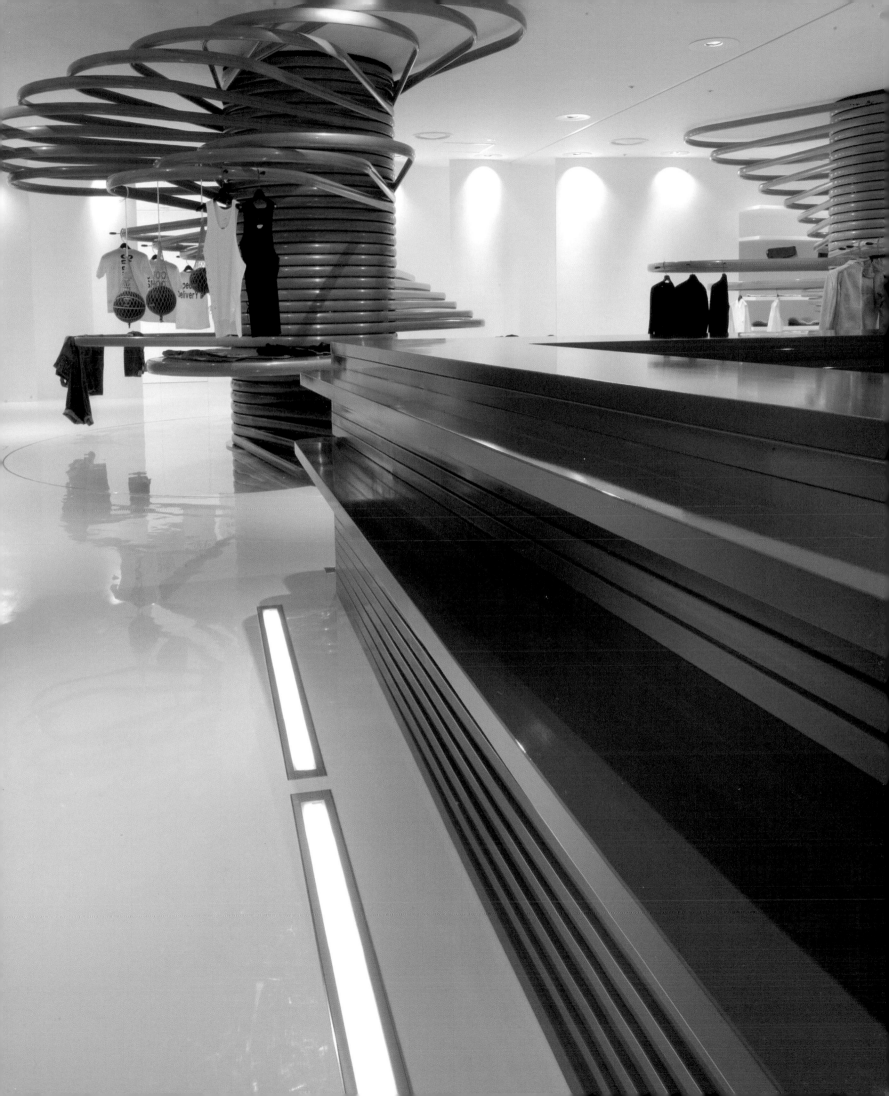

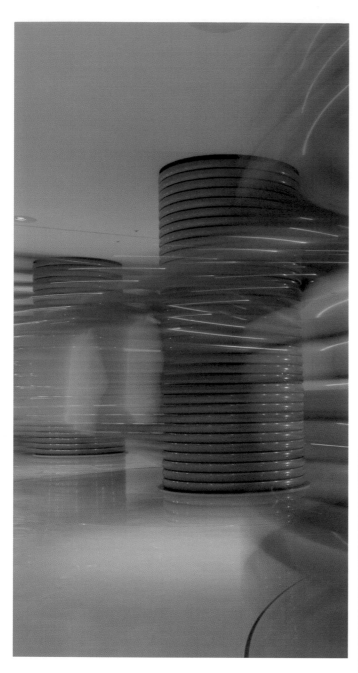

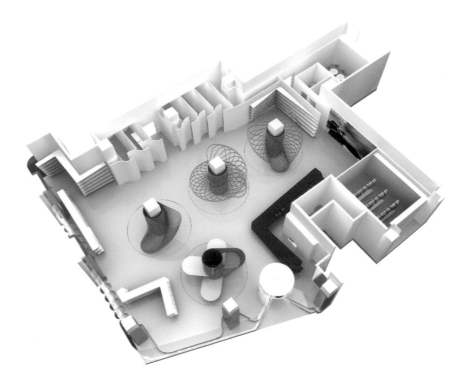

 From the entrance, visitors are greeted by an overall perspective of the structural display stands that exhibit the ready-to-wear line from Yohji Yamamoto.

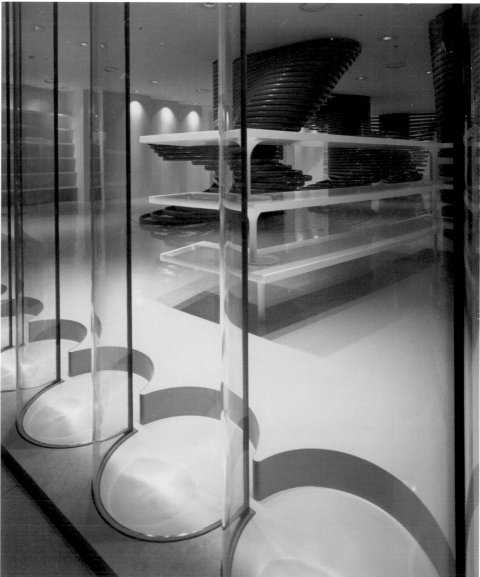

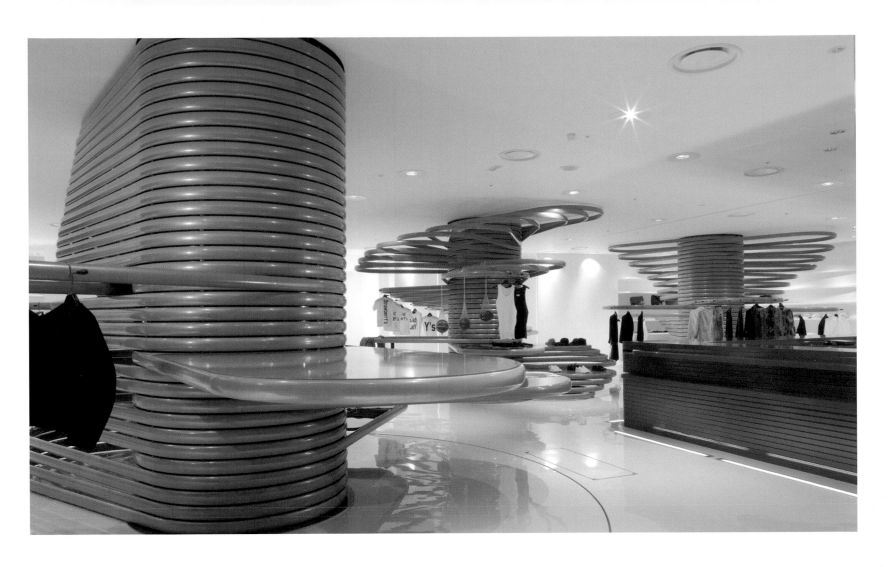

> Rotating platforms created by moving pieces fixed to the structural columns, allow both open and closed plans that can function as display cases.

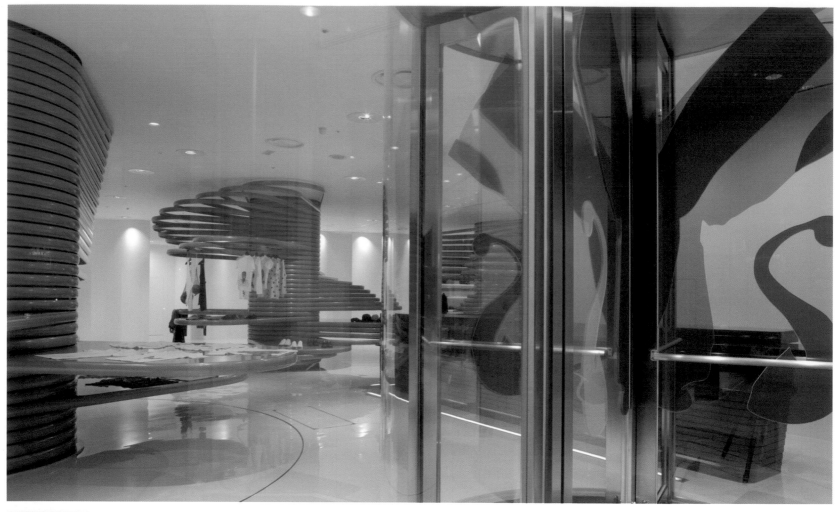

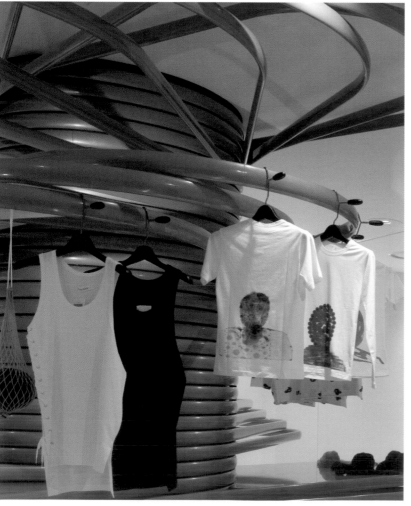

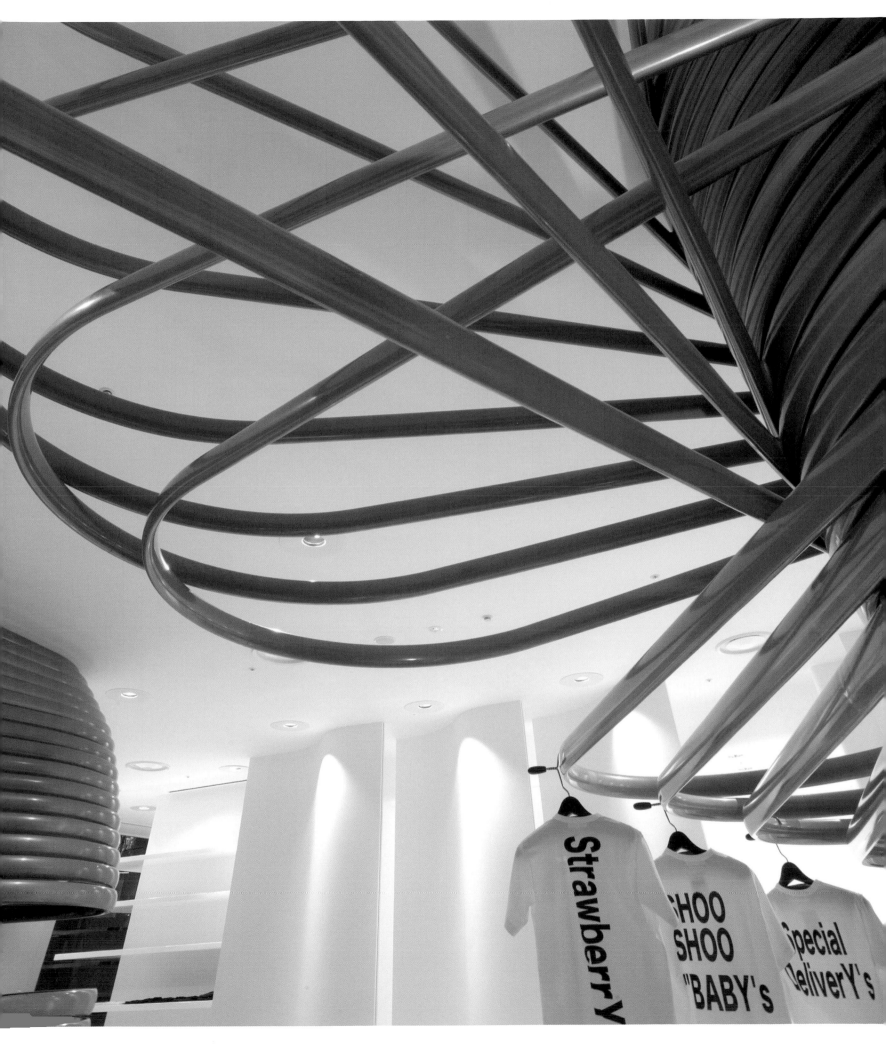

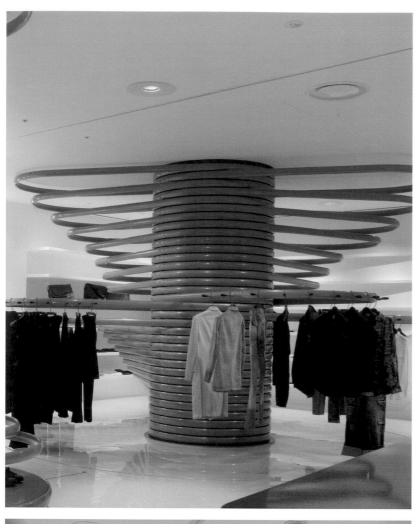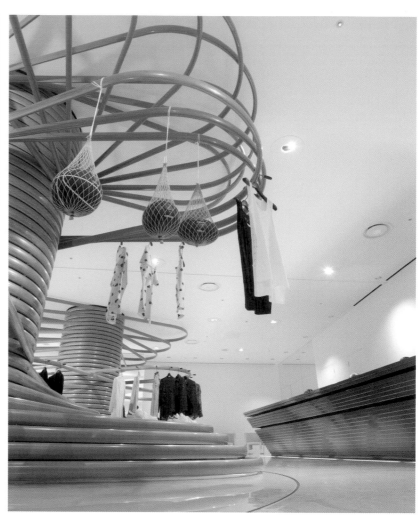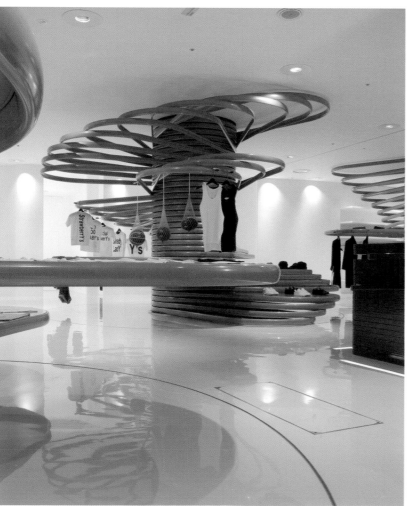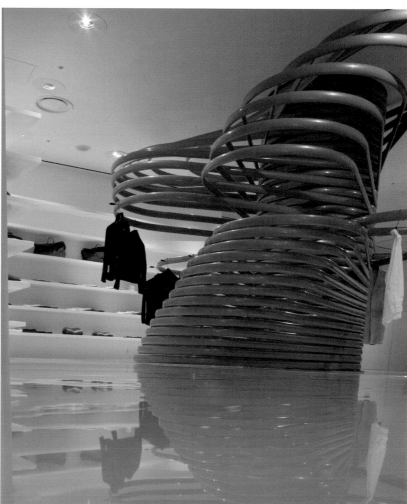

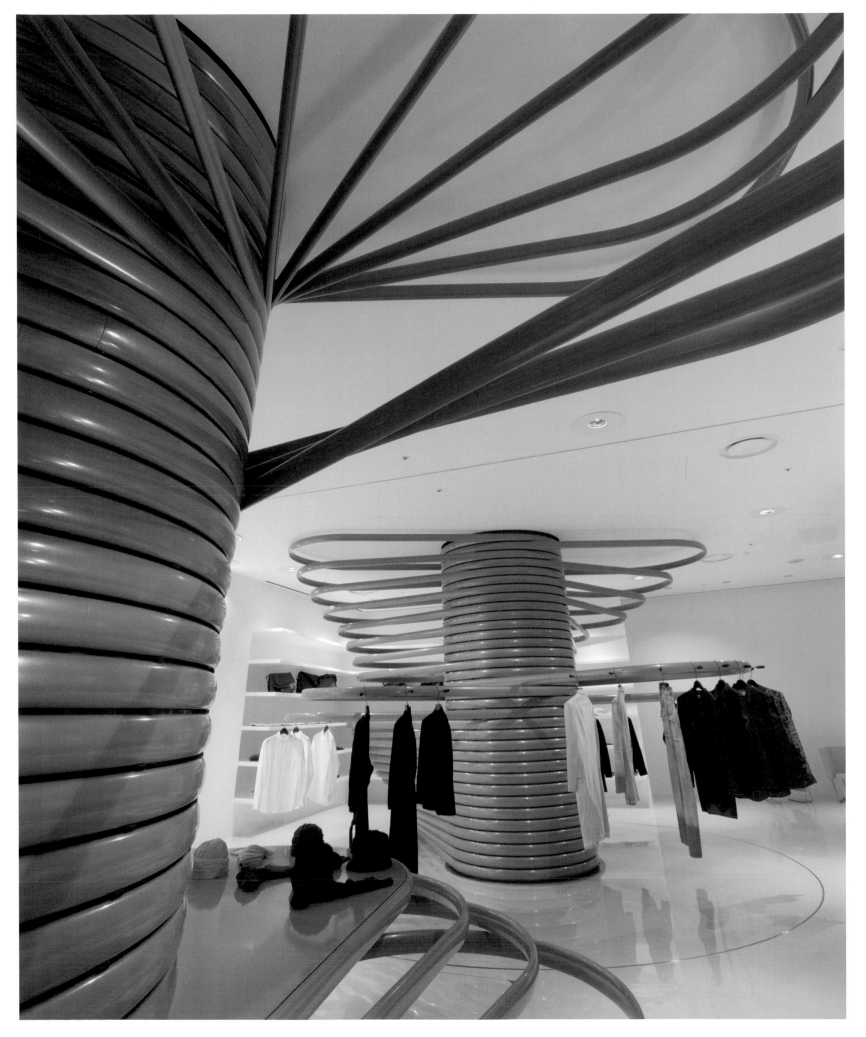

> Display

Displaying products in their purest form without having them lose their intrinsic qualities is not an easy task—even less so when they are displayed in an environment that could change how they are perceived. The examples included in this chapter reveal ways to display products as authentic objects of desire without the display environment interfering with the transparency needed to capture the products' essential value. Shelves, modular systems, sales counters, display stands ... countless practical display possibilities are presented that can generate an environment that encourages the customer to make a purchase.

>United Bamboo

Architects: Acconci Studio
Location: Tokyo, Japan
Photography: Nacasa & Partners Inc.

A simple and concise plan was the starting point for the design of this shop, situated in a two-story building in Tokyo. The challenge was to make this small, 650-square-foot space appear much larger. To do so, the Vito Acconci studio considered it essential to exploit the characteristics of the design materials, using interior surfaces as light sources to generate an almost aerodynamic effect.

White PVC was chosen for the walls and ceiling, which was then backlit by fluorescent lights. A similar effect was integrated into the shelving system, constructed of fabric tautly fastened over a metal framework that follows the curvature of the interior space. Light radiates from the interior of this system, which creates the sensation of being inside a much larger space where white liquid has spilled, on which the display units appear to float.

In the midst of this gently enfolding space stands an L-shaped stainless steel tubular rack system on which to hang clothing for display. This system incorporates an iPod and headphones for customers who wish to listen to music while they shop. An illuminated line along the floor traverses the length of this clothes rack, literally underscoring the pieces on display. A circular lighting arrangement accents the main sales counter, which is also made from PVC. A video screen, which is visible from outside the shop, projects digital art and videos produced by emerging artists.

The ambience Acconci has created for United Bamboo makes this space seem more like an art installation than a retail shop, due largely to the ingenious use of fabric and light to soften the design.

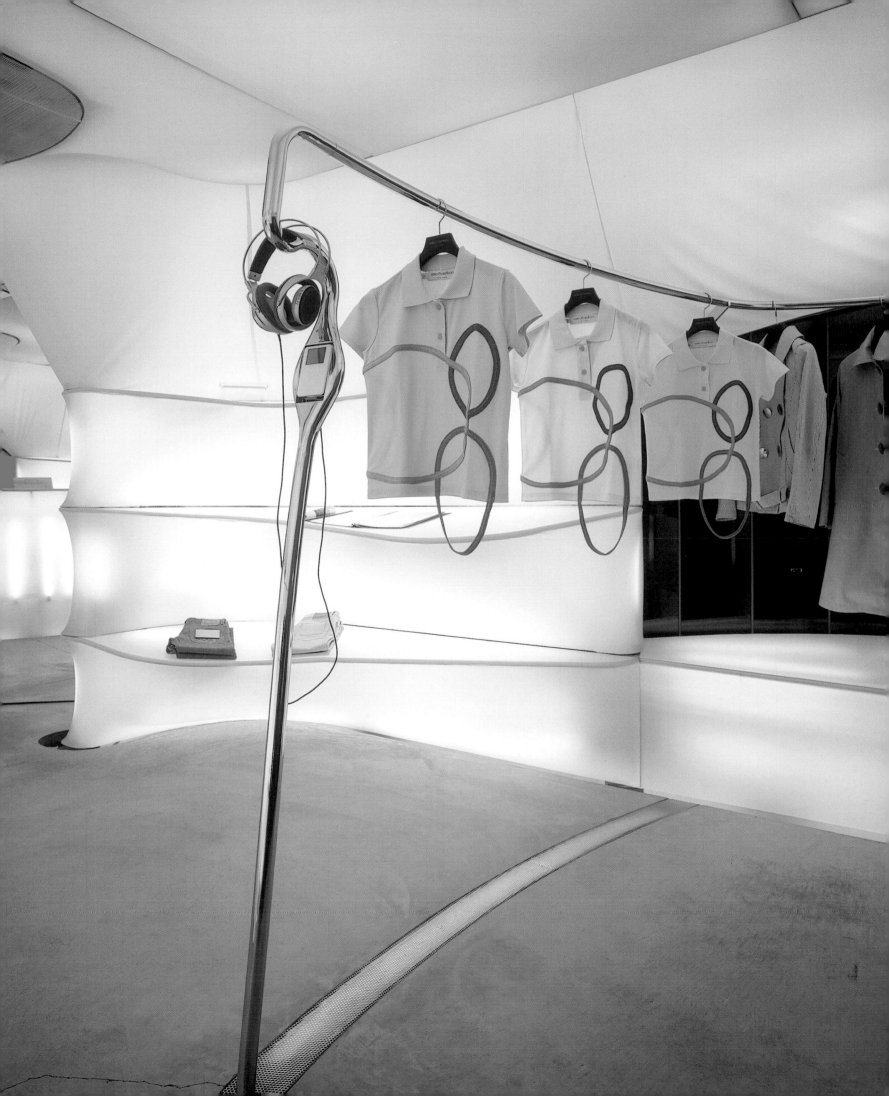

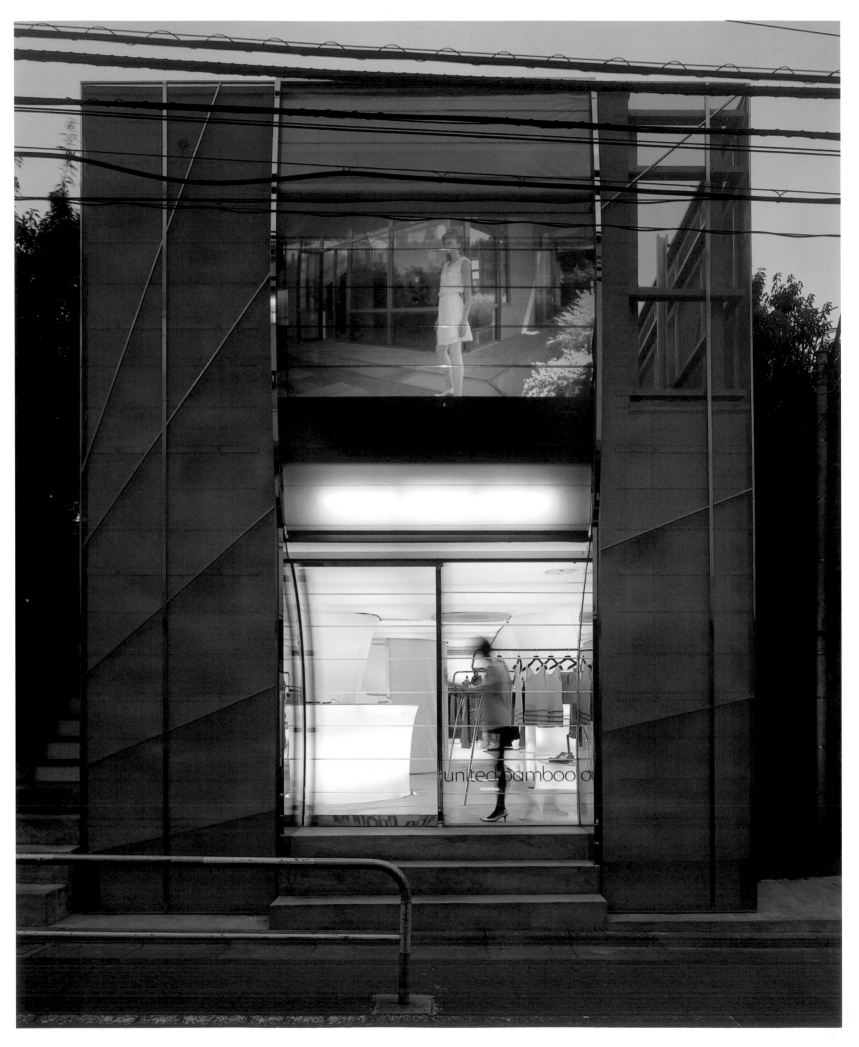

SECTION

1M 5M

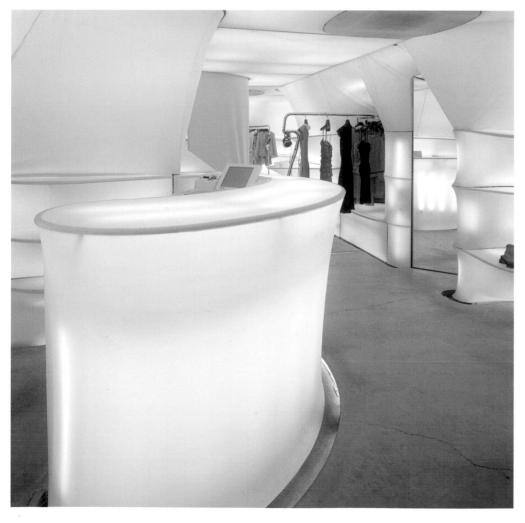

> The PVC central sales counter is completely lit up and
runs up to the shelves, which consist of fabric pulled taut
across a metal framework.

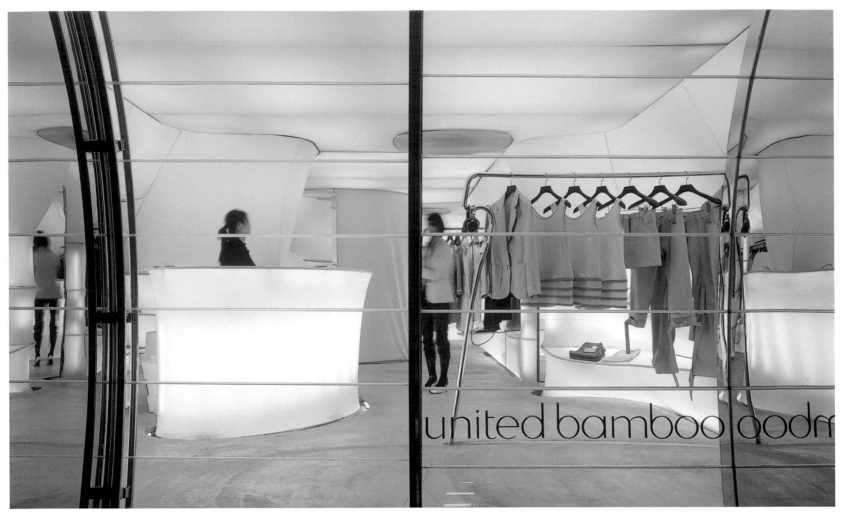

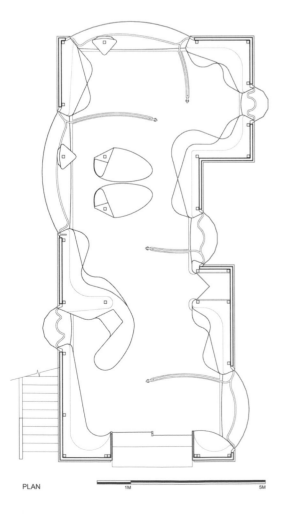

PLAN

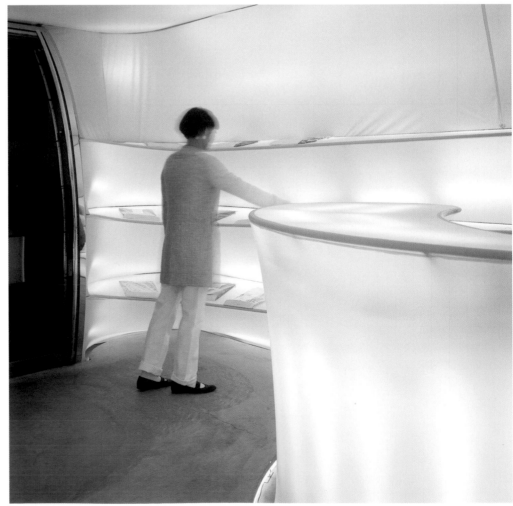

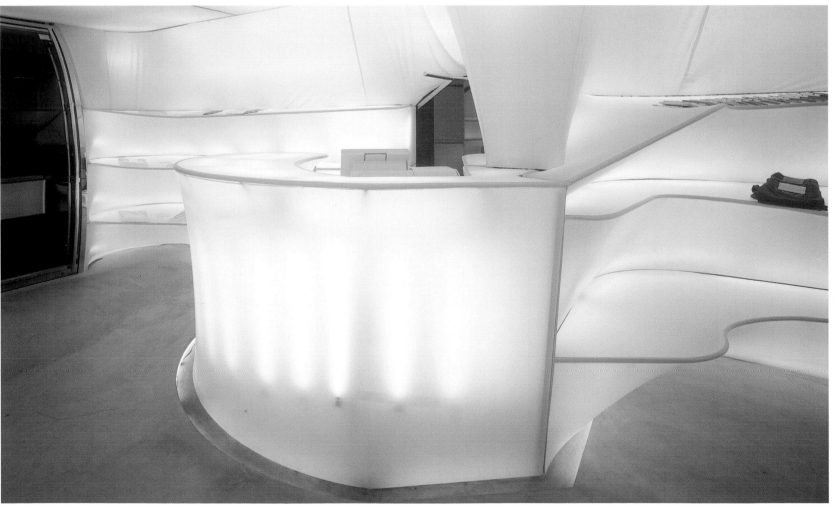

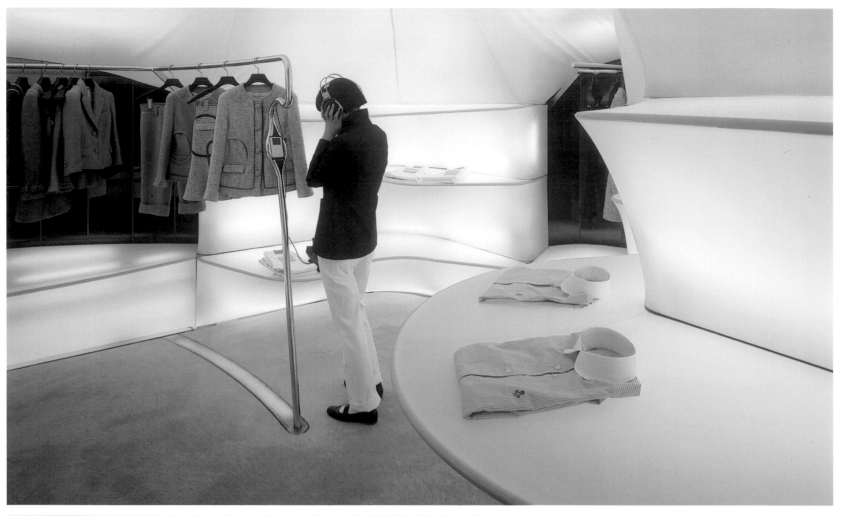

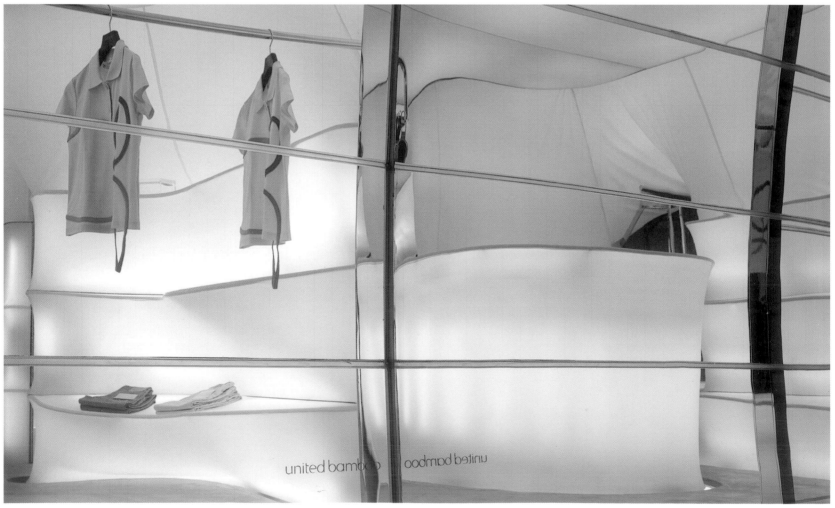

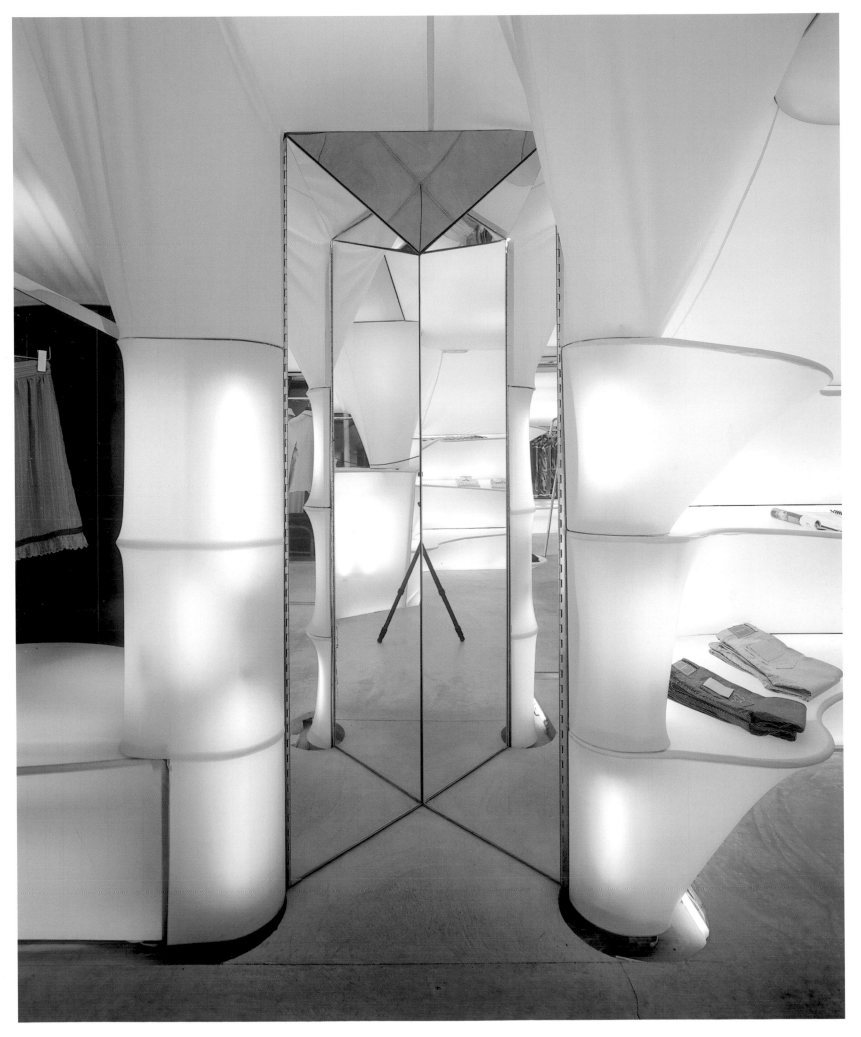

>Cox & Power

Architects: Sybarite

Location: London, UK

Photography: Adrian Myers

The architects from Sybarite took inspiration from the heart of outer space in developing the concept for this London jeweler. The thematic approach involved re-creating the universe in the Cox & Power showroom by installing individualized display areas featuring customized lighting arrangements, like miniature solar systems, located randomly throughout the circular interior space. Each of these systems includes a stainless steel structure for displaying jewels, covered on one side in transparent Perspex and protected by a security lock.

The centerpiece of the shop is composed of a cluster of hand-blown crystal drops suspended from a disc-shaped mirror affixed to the ceiling. These glass drops are reflected in the mirror and thus appear as if they were floating in space. The reflecting glass table directly below them creates the same effect from the other side, highlighting the connection among the different environments within the shop and allowing the light to inundate the central space.

The dark granite of the shop's floor and ceiling provide a strong backdrop for the different areas of light as well as for the display cases of jewels, which are the main attraction. The walls are covered in a soft blue material, which provides for both comfortable and pleasant surroundings and good acoustics. Off the main display space is an area where customers can sit to contemplate the merchandise that is for sale.

The refinement of the materials used, the excellent and imaginative lighting system, and the creative techniques employed in the design of this shop attest to Sybarite's passion for executing unique projects that provide many levels of sensory satisfaction to customers.

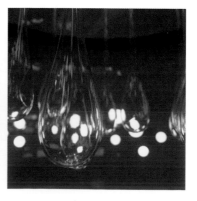

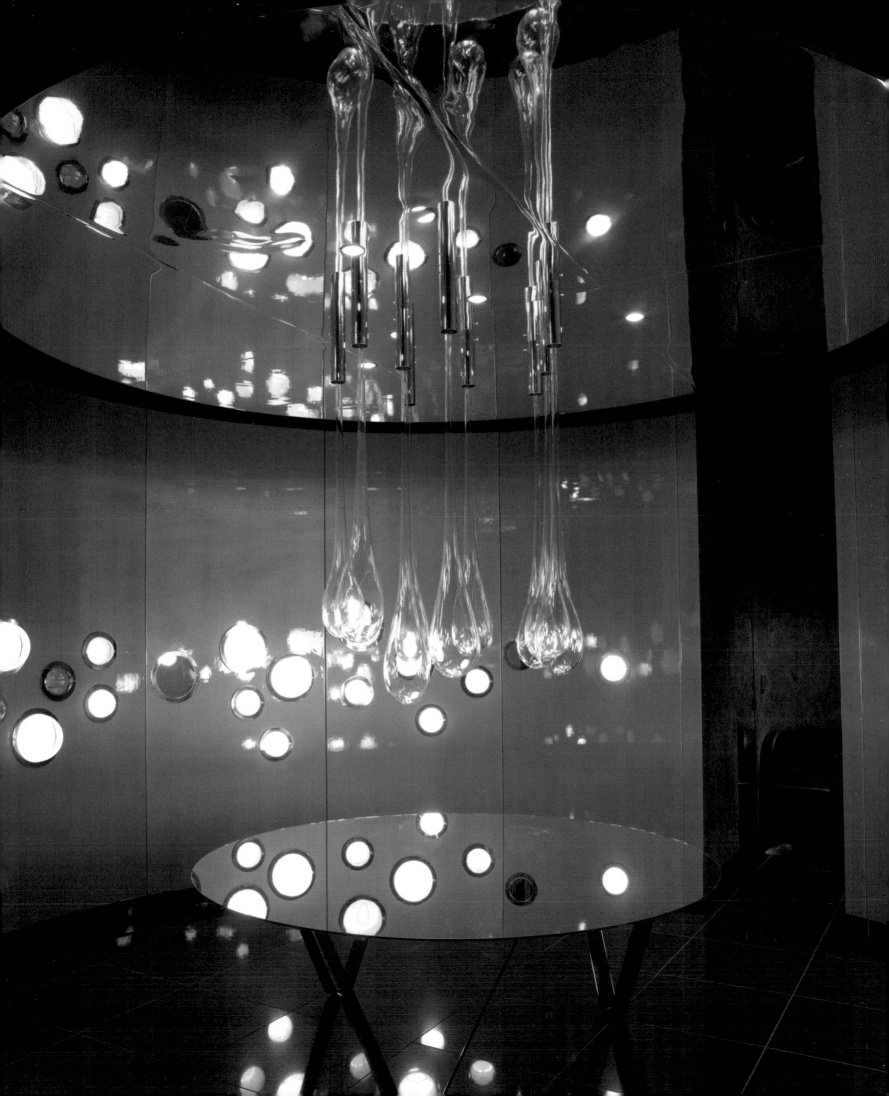

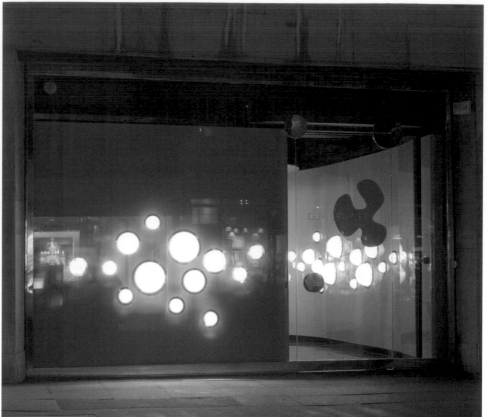

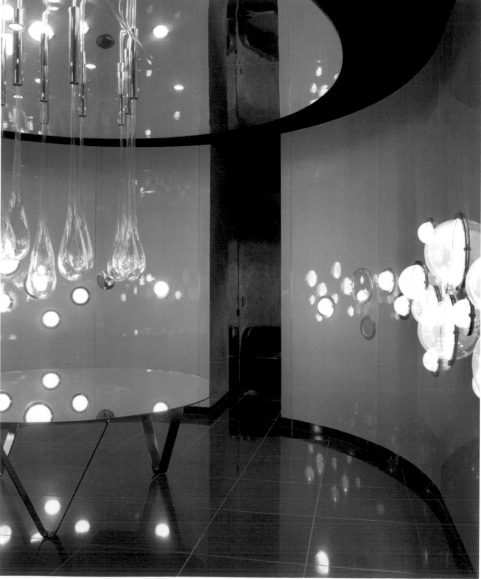

 Each light system includes a custom-designed stainless steel display stand of jewels, with one side covered in transparent Perspex and a security lock.

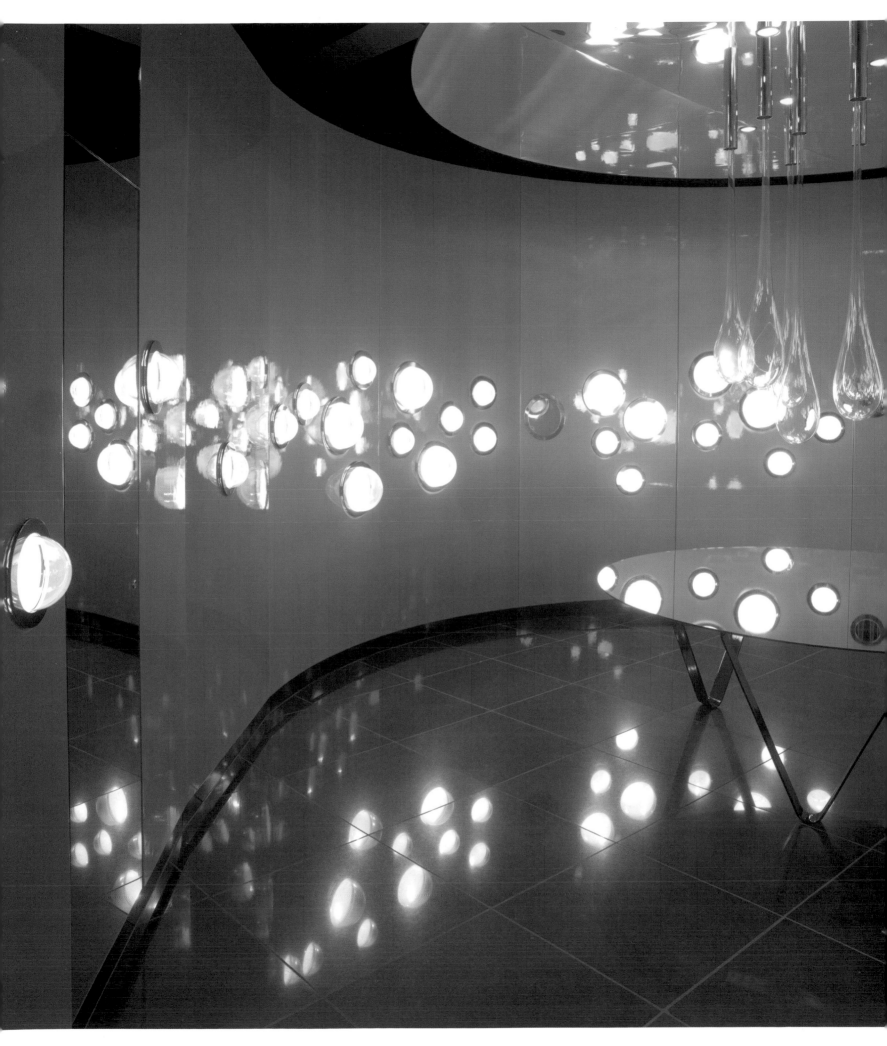

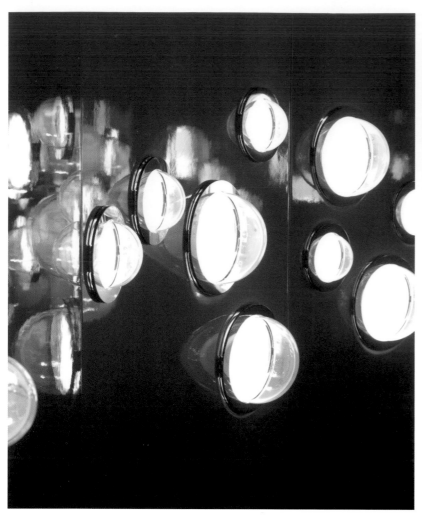

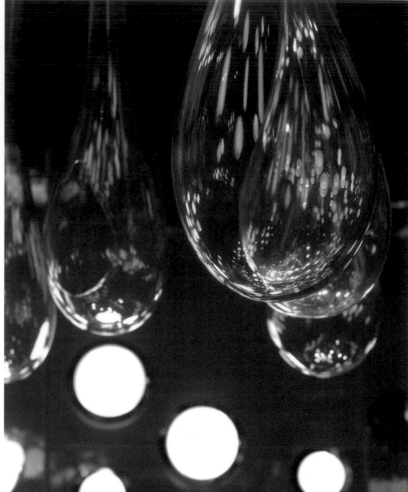

> The cluster of glass drops that hangs from a mirror on the ceiling is reflected in the table in the center of the space. These glass drops were created using a hand-blown glass technique.

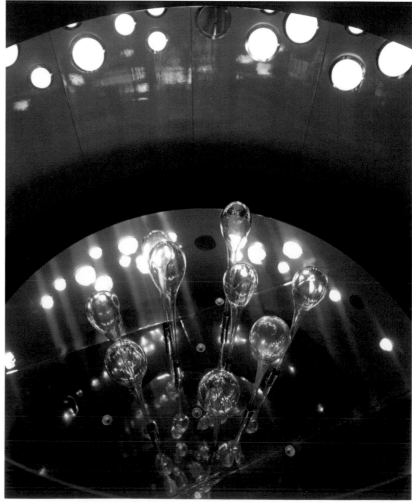

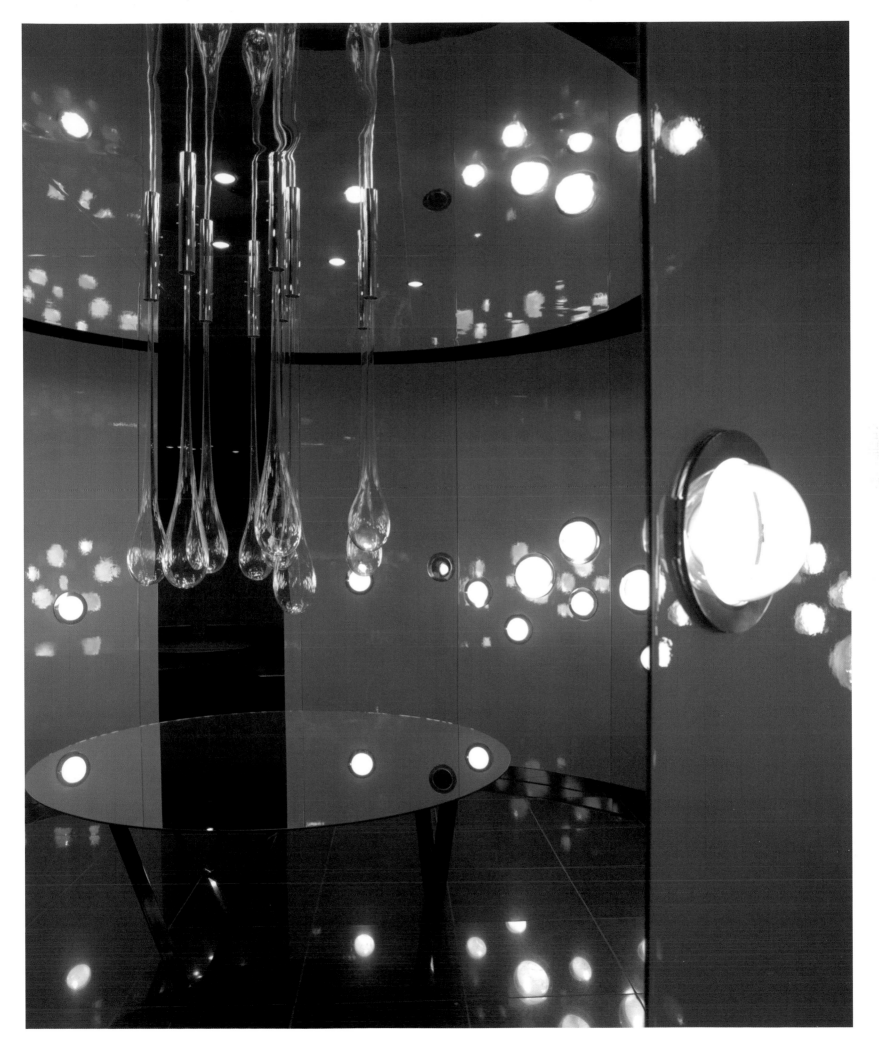

>A1 Lounge

Architects: EOOS

Location: Vienna, Austria

Photography: Paul Prader, Hans Georg Esch, Bruno Klomfar

The EOOS architects based their concept for the Mobilkom shop in Vienna on the continuous changes in the world of high technology. The challenge in this project was to capture the point of interface between the real and the virtual, reflecting the intangible nature of the products offered by Mobilkom. The theme became rematerialization, with EOOS applying multisensory design principles extracted from Mobilkom products in the design of the very space used to display those products.

From the perspective of a visitor about to enter the A1 Lounge, the display screens appear to float off the floor. The ground floor contains independent display islands created from acrylic blocks that integrate RFID (radiofrequency identification) chips that provide access to purchase information for Mobilkom products. The content available from these displays can be changed by the company's central office according to the time of day and type of customer likely to be shopping then (businesspeople in the morning, children in the afternoon).

The "cubes of the future," as defined by the architects, are lined up along a ramp that leads to the upper floor and present holographic display systems of mobile phones that have yet to reach the market. On a wall at the back, a Leon Golub installation, created by Ars Electrónica Center Linz, interacts with visitors. The upper floor also houses a bar, where customers can stop for a drink after browsing the products of the future in this high-tech heaven.

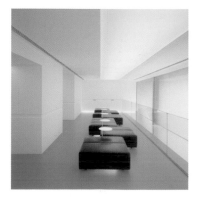

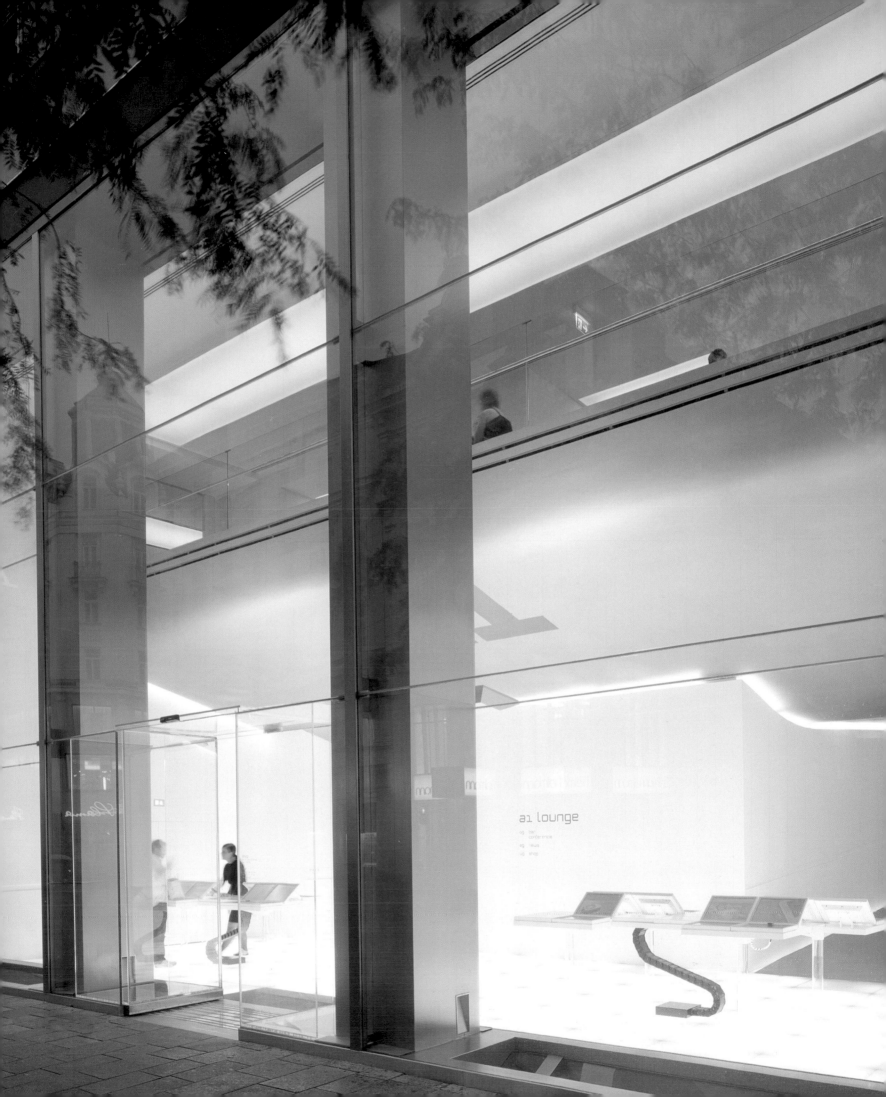

a1 lounge

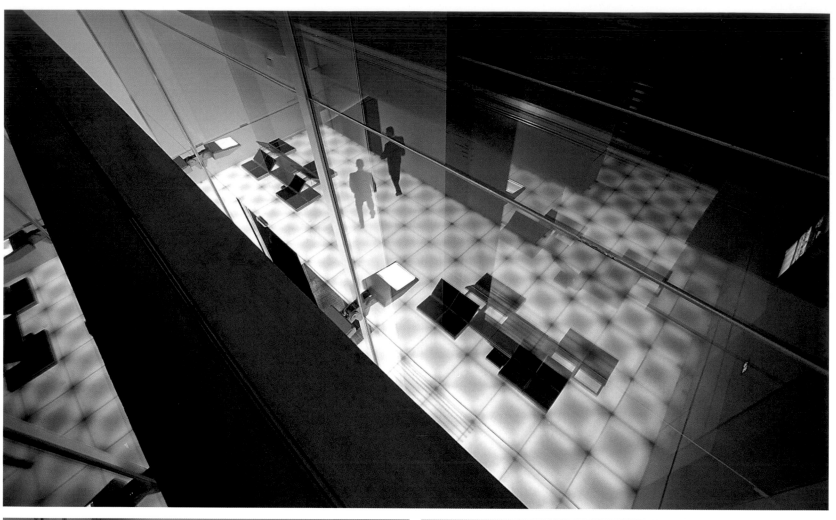

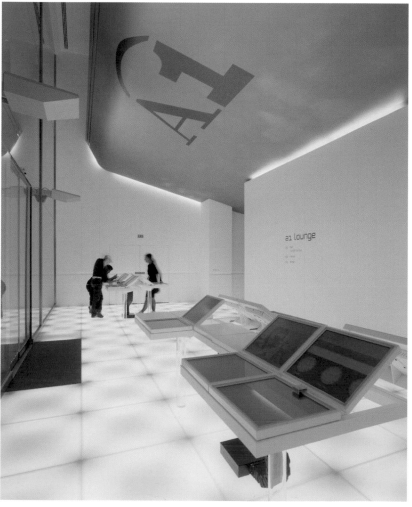

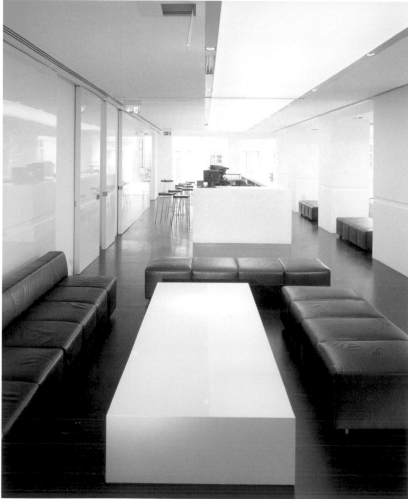

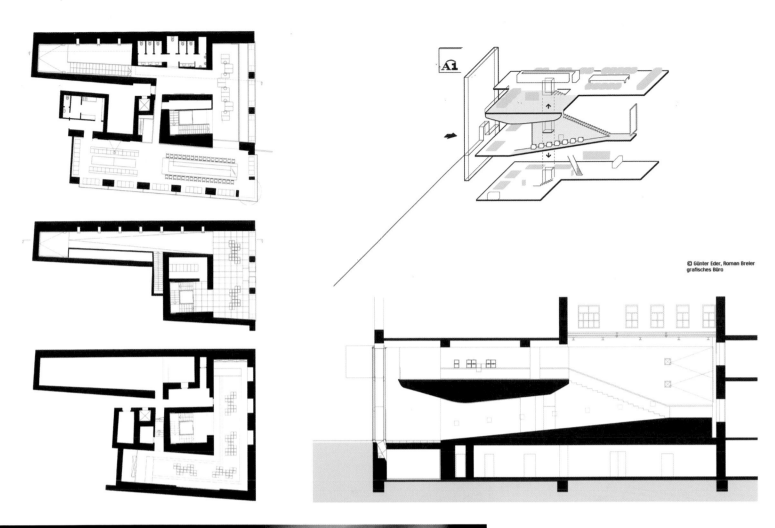

© Günter Eder, Roman Breier
grafisches Büro

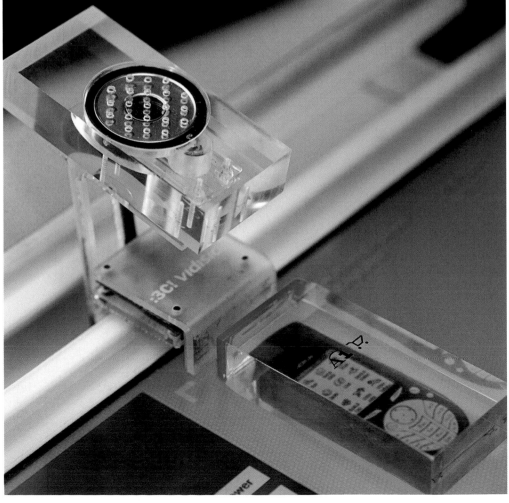

> This shop allows visitors to discover high-tech products
that have yet to come on the market.

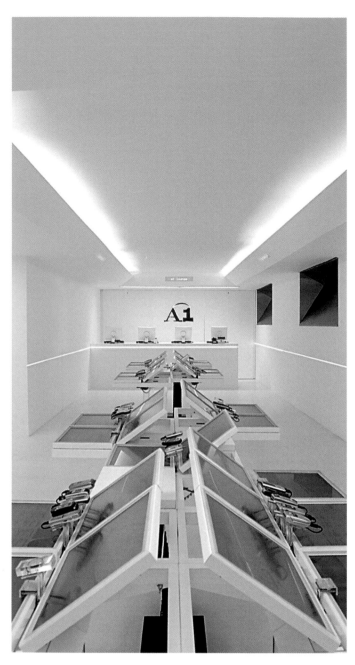

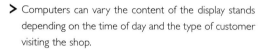

> Computers can vary the content of the display stands depending on the time of day and the type of customer visiting the shop.

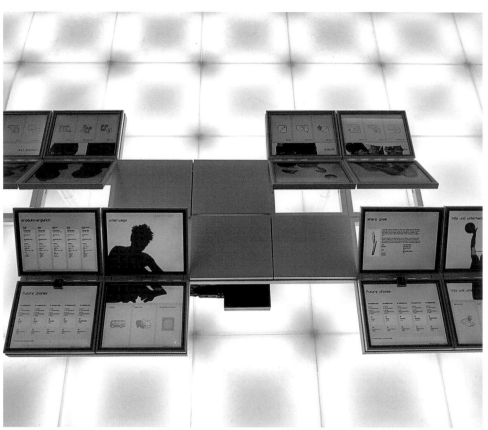

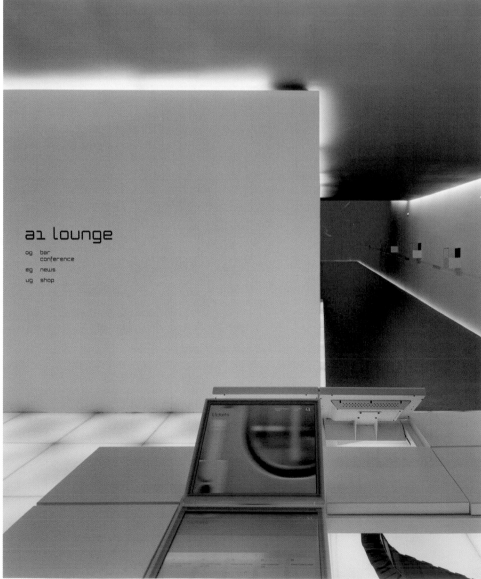

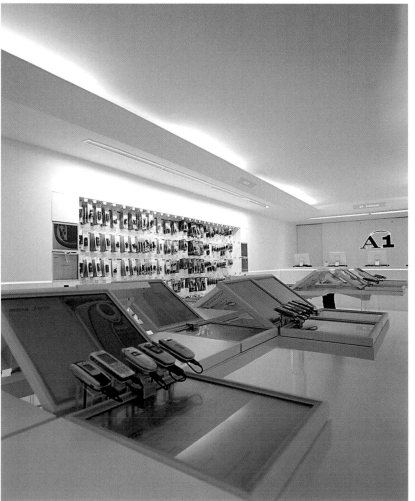

bar
conference

>Can Publishing Bookstore

Architects: Arkizon Mimarlik

Location: Istanbul, Turkey

Photography: Ali Bekman

The Can Publishing Bookstore is located in the Beyoglu district in Istanbul, an area similar to New York's Soho neighborhood for its shops, art galleries, and museums, such as the UFO Museum.

In the midst of these appealing surroundings, the bookshop created by the Arkizon team speaks a new language. From outside, the directness and plainspoken functionality of the façade attracts shoppers. Inside, fixtures were designed and installed in such a way that they would not obstruct the view of the books, which are displayed vertically on red shelving. These shelves are arranged in six undulating rows throughout the shop and streamline the space, creating a sensation of movement and solving the problems of rigidity and lack of expression that often characterize bookstores. The shelves, each about 2-1/2 inches thick, are built on a steel structure and are supported by stainless steel columns, which are barely visible. The lowest shelf stands about 20 inches from the floor for ease of browsing.

The space required a lot of light, to facilitate browsing and the handling of the books on display. The floor and walls are completely white, providing a neutral backdrop that showcases the books themselves. The vertical lines formed by the red shelving guides shoppers through the interior of the shop to the stairway to the upper floor. In the precision of the architectural language they've employed here, Arkizon has created a dynamic space where the shop itself both competes with and complements the product on display.

 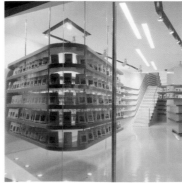 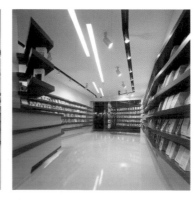

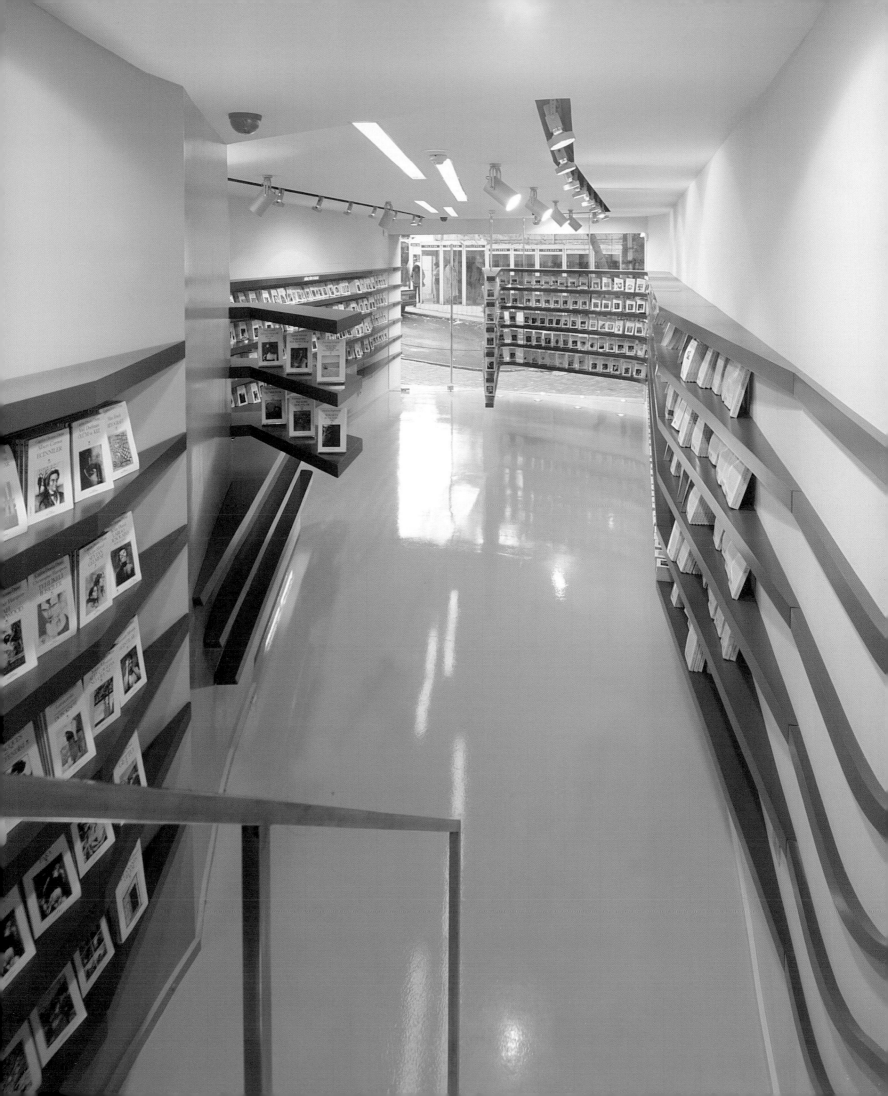

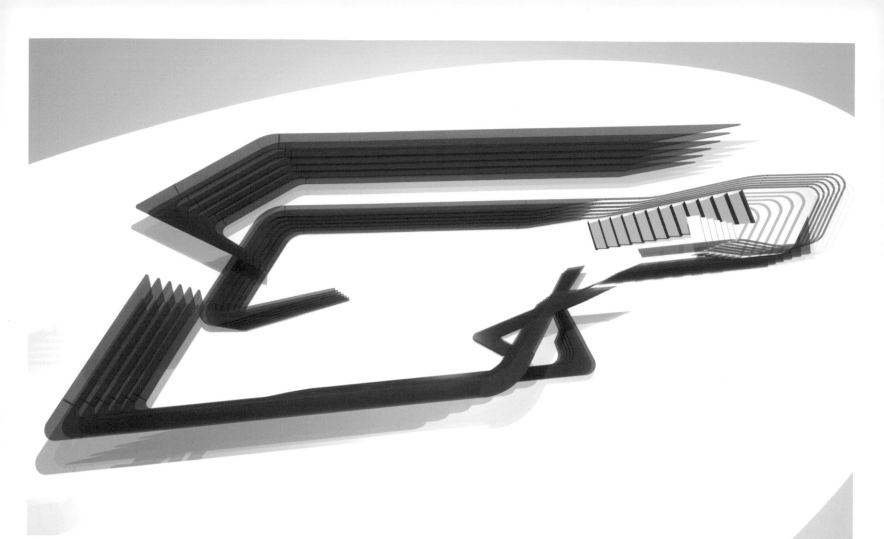

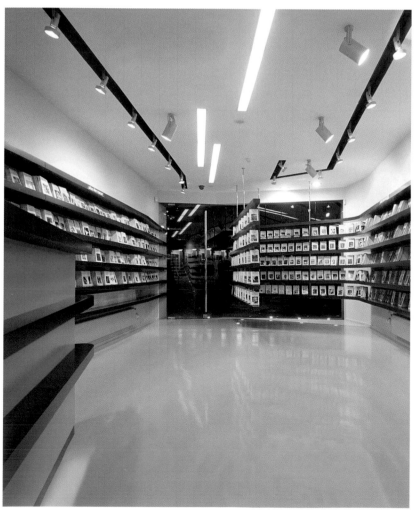

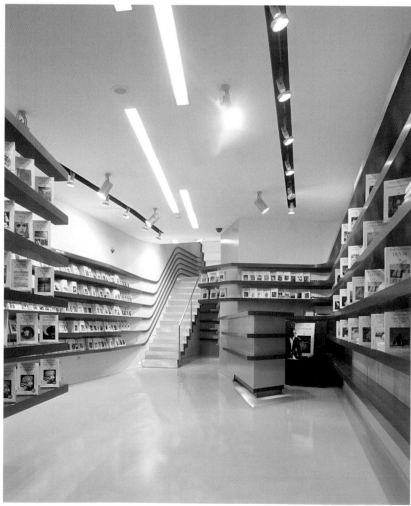

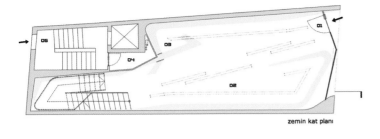

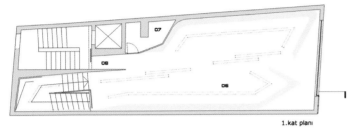

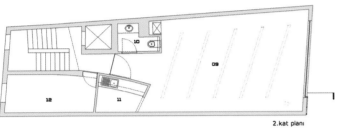

zemin kat planı

1.kat planı

2.kat planı

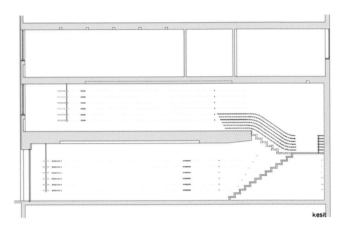

kesit

01 kitapevi girişi
02 kitap sergileme
03 kasa
04 depo
05 söyleşi salonu girişi
06 kitap sergileme
07 depo
08 personel girişi
09 söyleşi salonu
10 w.c.
11 mutfak
12 yönetici odası

0 5m

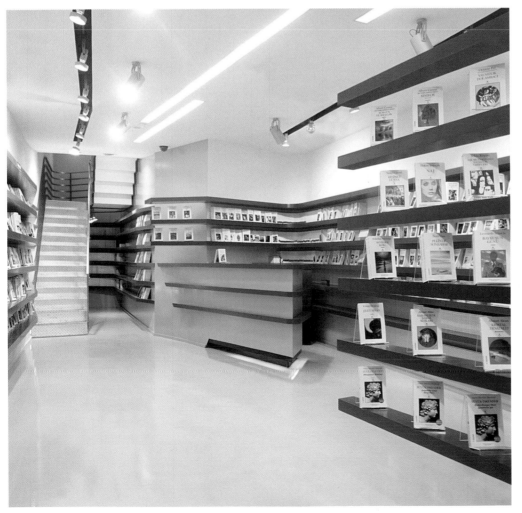

> The books are displayed vertically on six rows of red steel shelves, which extend to the stairs that lead to the upper floor.

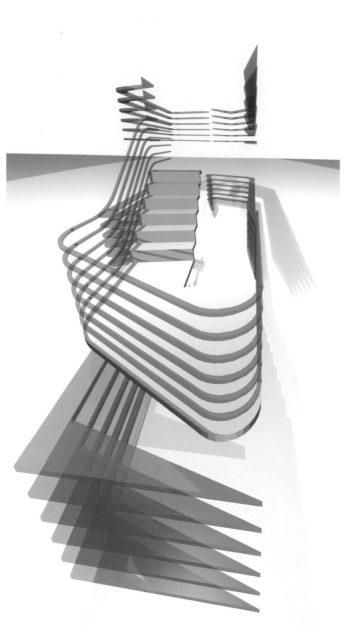

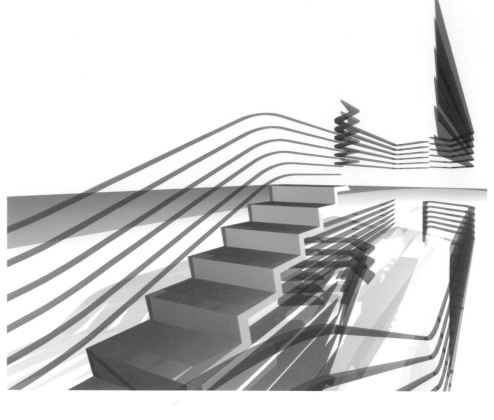

> The space achieves continuity as a result of the six rows of shelves that mark the way to the stairs and to the repetition of the scene on the upper floor.

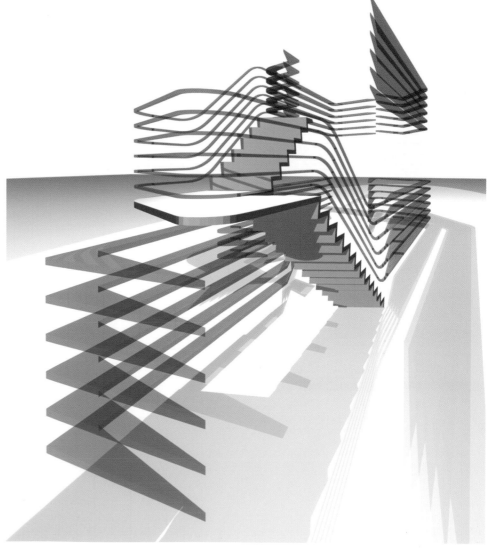

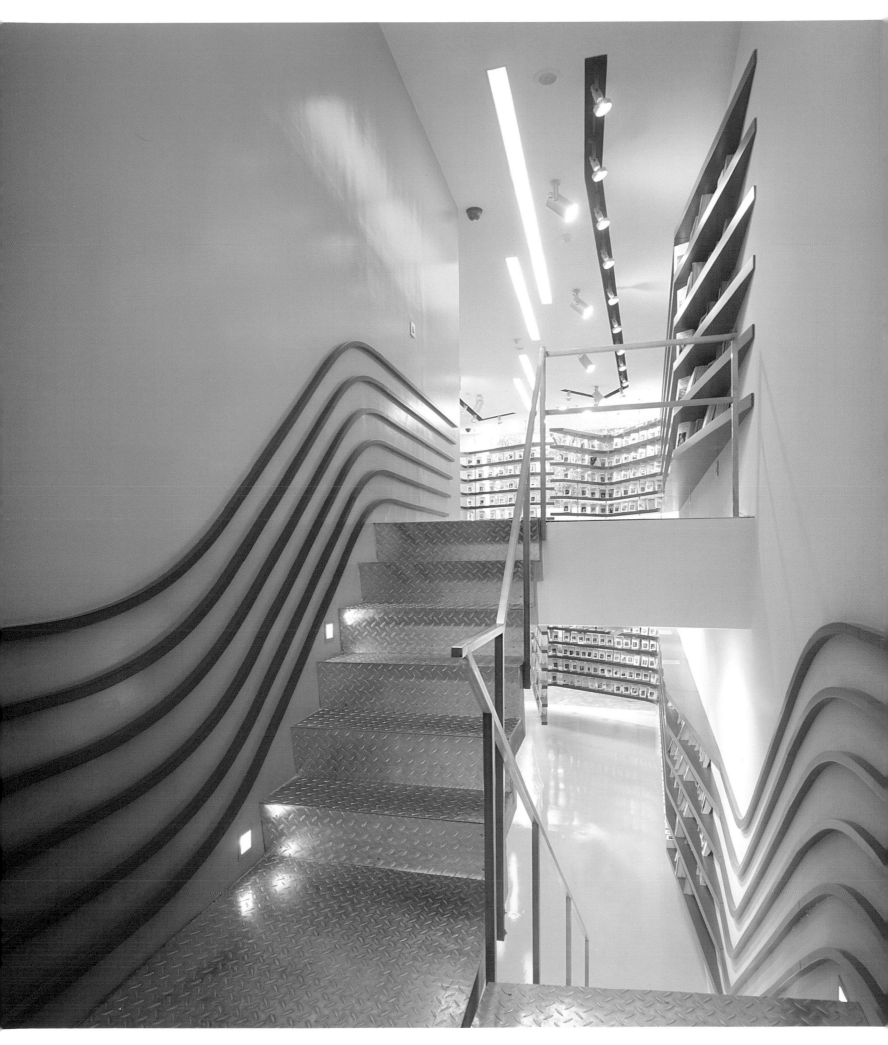

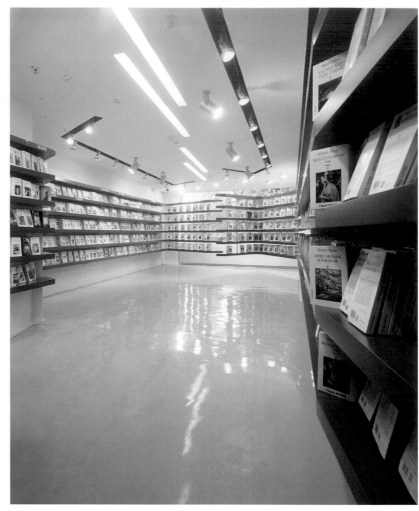
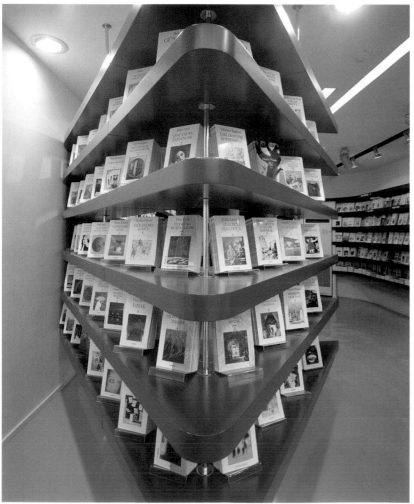
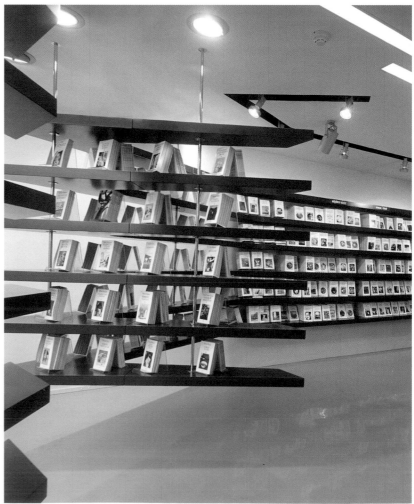

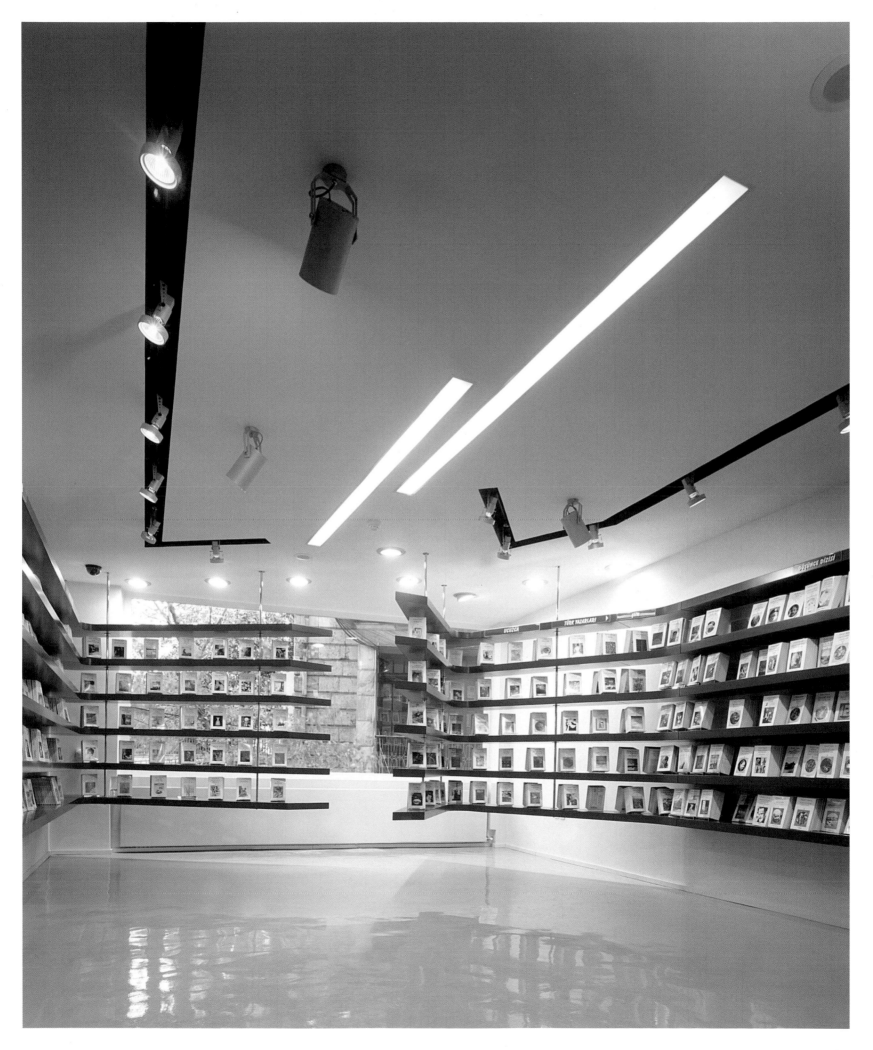

>FAO Schwarz

Architects: Rockwell Architecture, Planning and Design
Location: New York, New York, USA
Photography: Frederick Charles

Like the proverbial kids in a candy store, Rockwell Architects applied their imaginations to the renovation of New York City's FAO Schwarz shop, already a toy mecca for both children and adults.

Although the end result may be reminiscent of a children's game, there was an obvious complexity to the project. The first step was to open the existing space upward to create more expansive exterior views and facilitate more fluid circulation on the main floor. This space, which resembles a giant aquarium set down in the middle of Fifth Avenue, has been transformed into a perpetual light-and-motion machine.

The entrance hall brings to mind the legendary commercial spaces of this great city, while the remainder of the store functions like an authentic toy theater, where children can see, touch, and play with the products on display in fantasy-steeped surroundings that seem almost magical. Sales points consist of display units, tables, and shelves featuring toys of all types and sizes, which seem to come alive under the avid gaze of customers. Some of the larger toys are showcased in transparent, cubical tree houses that also display smaller toys at the base, making these units genuine altars of fun.

In addition to these innovative displays, FAO offers a soda fountain serving refreshments, a flight simulator, and an enormous piano, as seen in the movie *Big*, which can be played by treading on the keys. This renovated store is a true entertainment paradise.

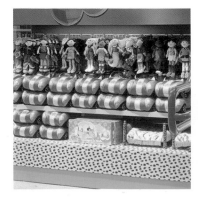

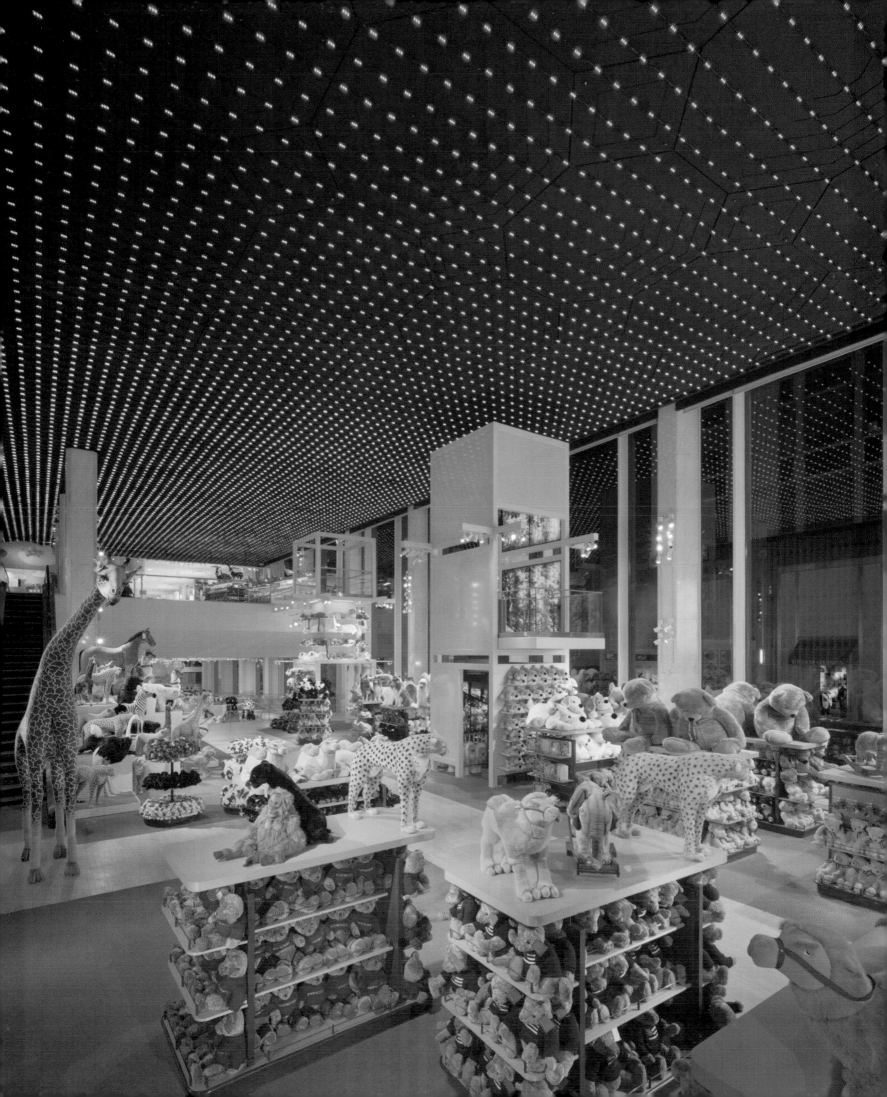

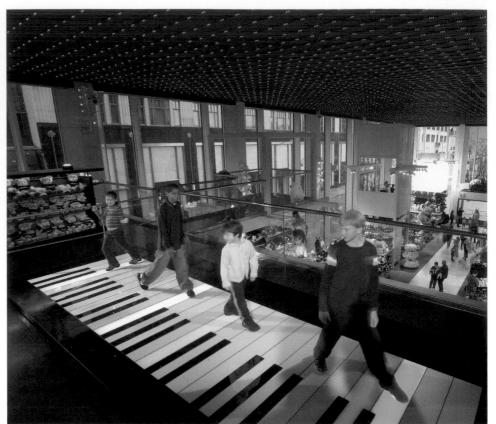

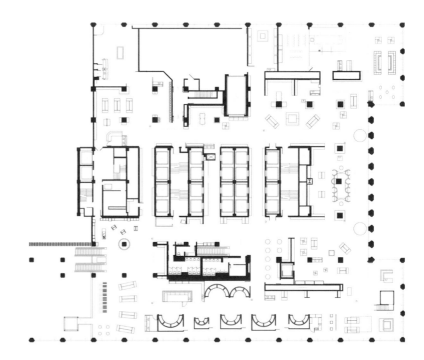

> Large, open structures are used to display toys as if they were almost inaccessible items. Children can entertain themselves with a giant piano that is played by treading on its keys.

0 10 20 40 80

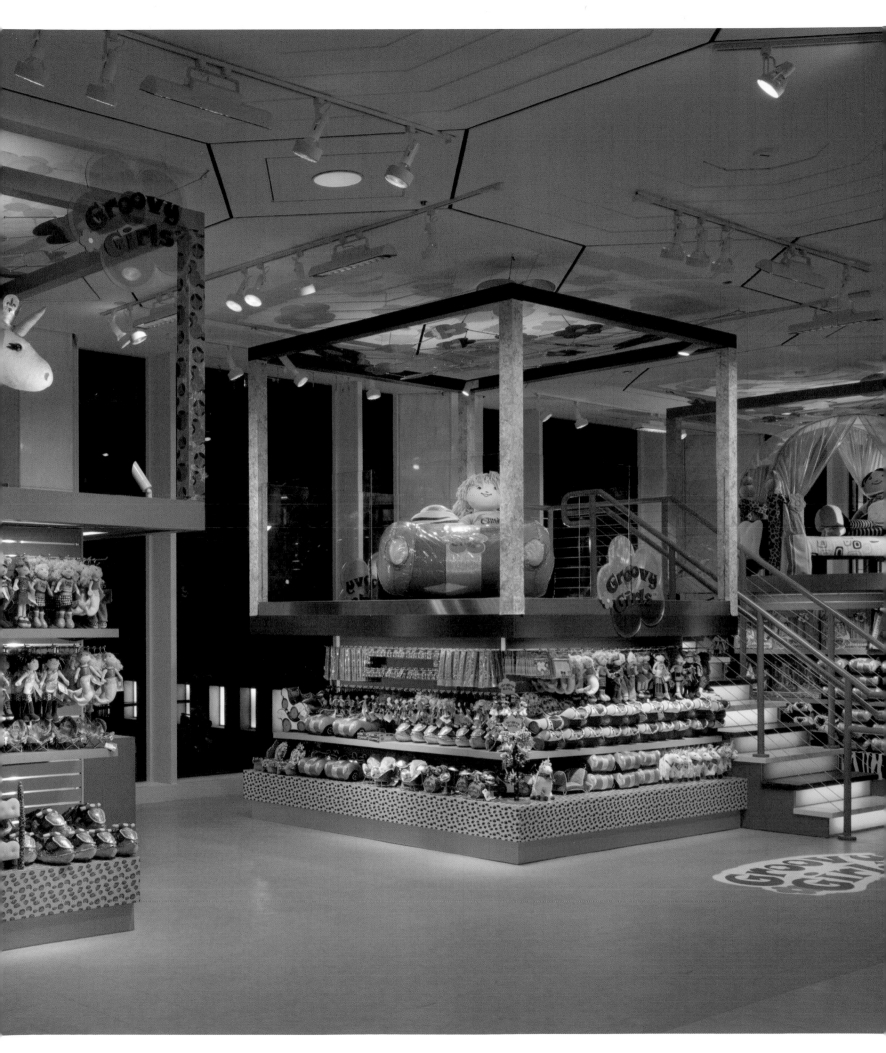

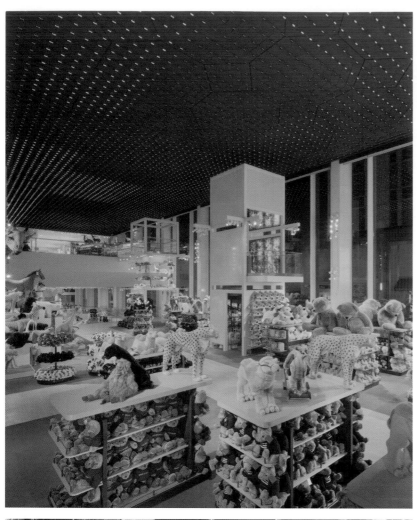

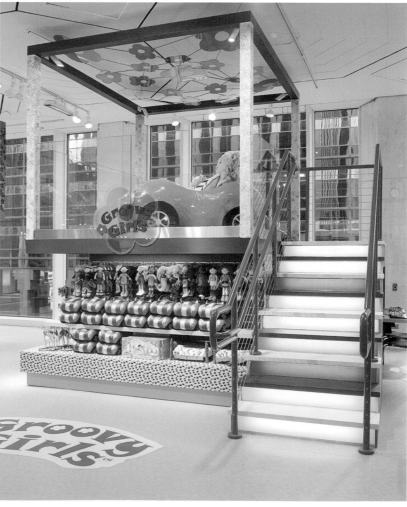

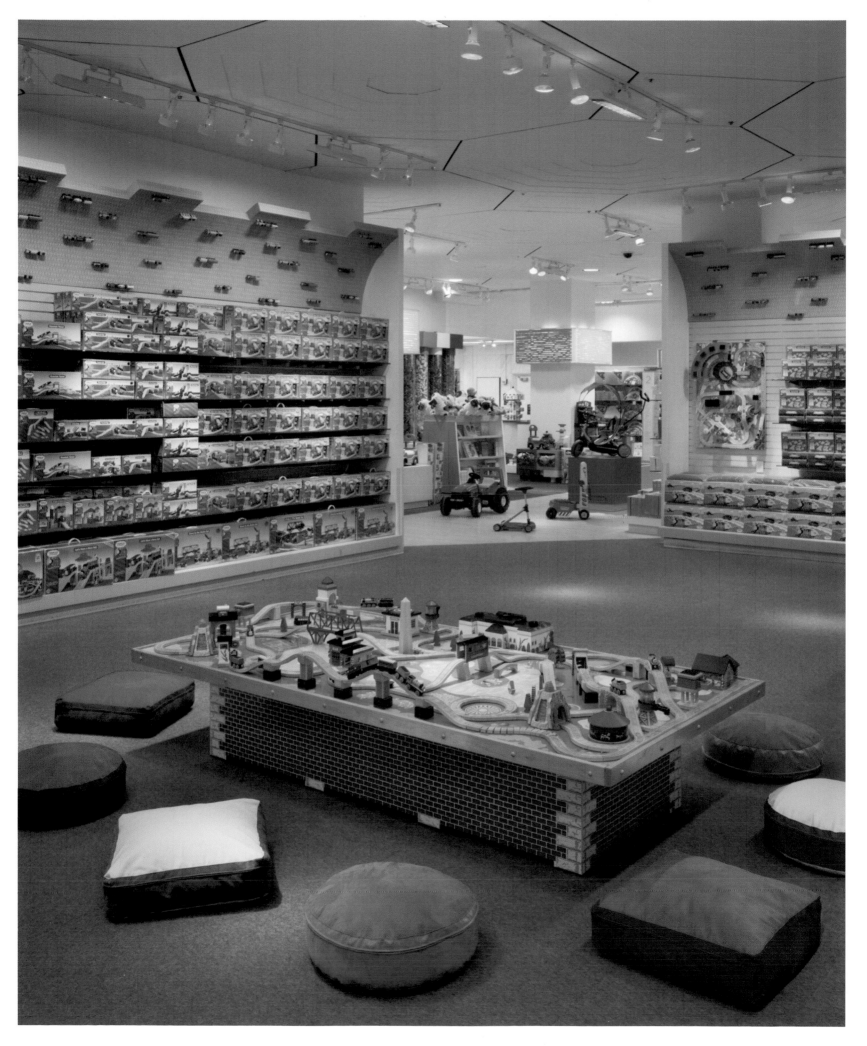

>Bizarre

Architects: Randy Brown Architects
Location: Omaha, Nebraska, USA
Photography: Farshid Assasi

Randy Brown Architects based their design for Bizarre, a women's shop, on three fundamental concepts: experimentation with new forms to maximize space; the creation of continuity between display elements and the surrounding structure, and the creation of a fluid space in which to display products as if they were works of art.

The team was commissioned to develop a space that would facilitate the organization of products by function and category. The solution, arrived at by experimenting with folded paper, was to employ independent white modules as display units arranged in succession within the open-plan interior of the shop. To make them appear as if they are floating on air, items for sale are grouped by function on transparent acrylic shelves built into these display units. The continuous pattern of white-and-transparent fixtures reflects light onto the merchandise, enhancing its appeal. Glass shelving that extends across one end of the shop completes the setup.

From the entrance, visitors see a striking geometrical arrangement accented by the light reflecting from the strategic use of glass.

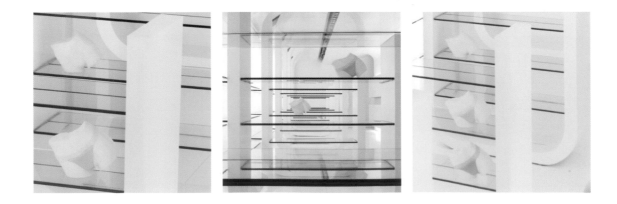

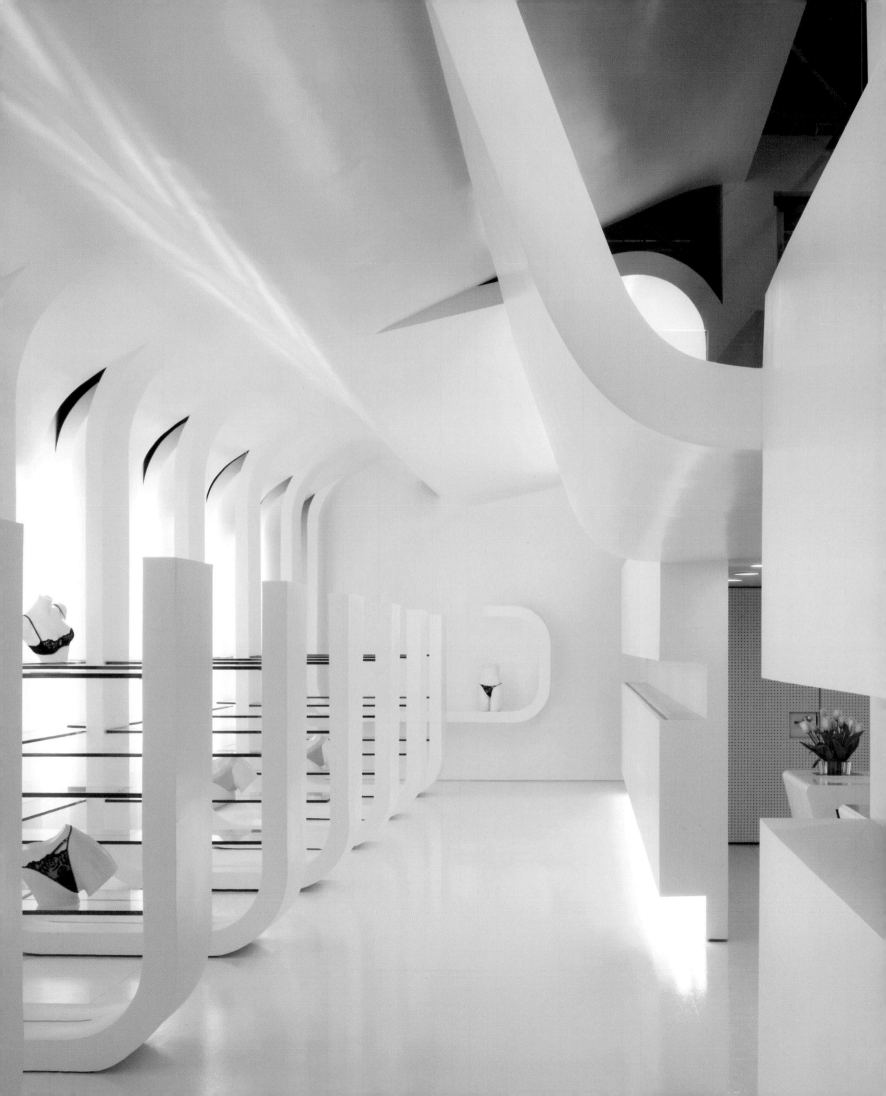

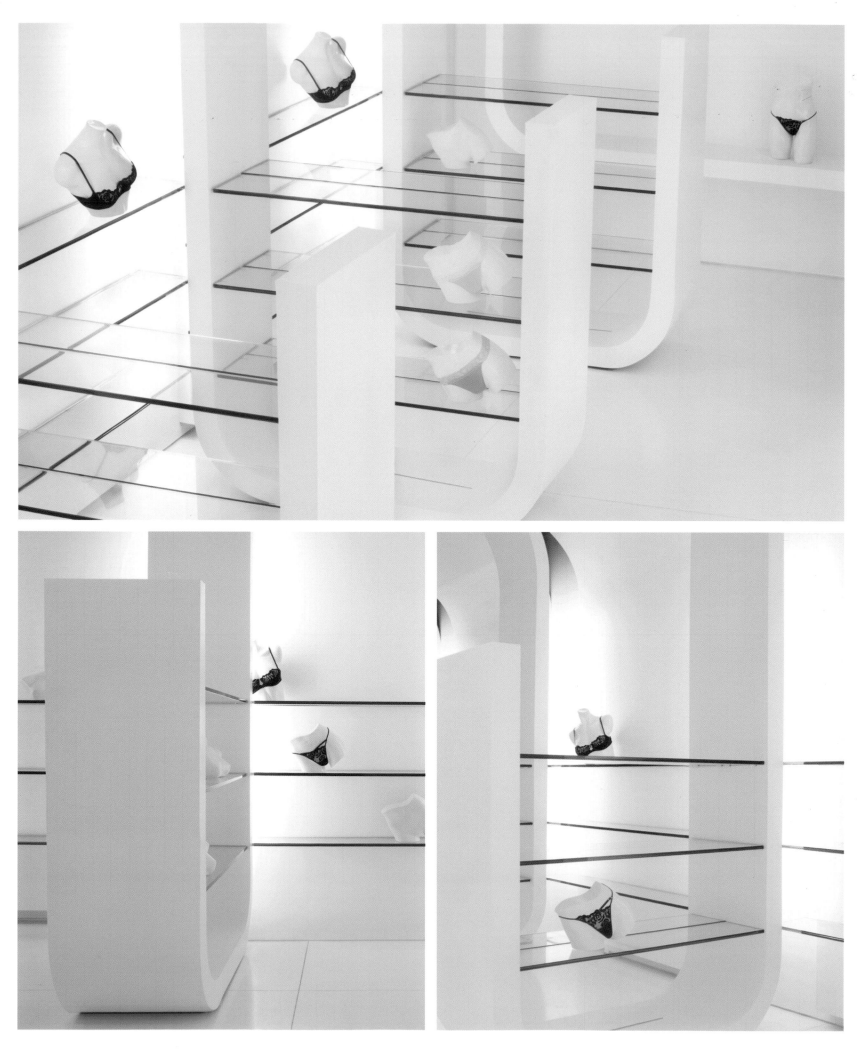

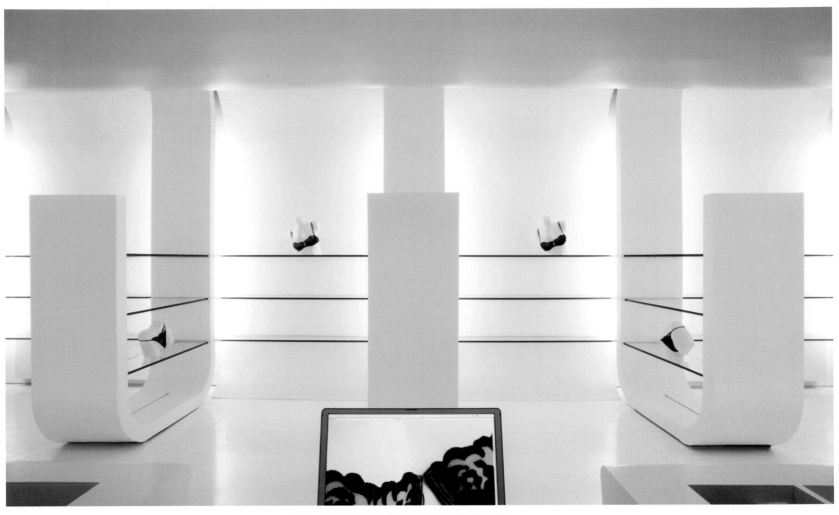

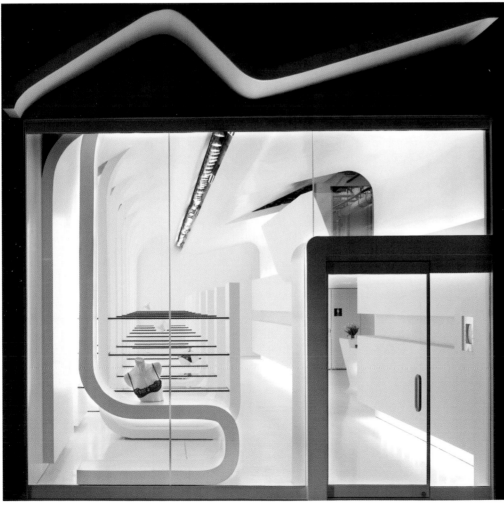

> The U-shaped modules are distributed successively throughout the space and organize the products according to their function and category.

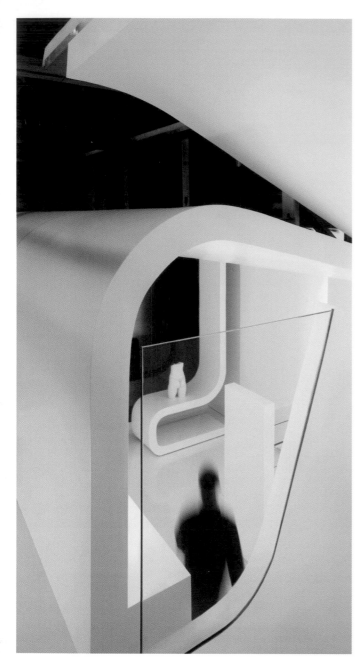

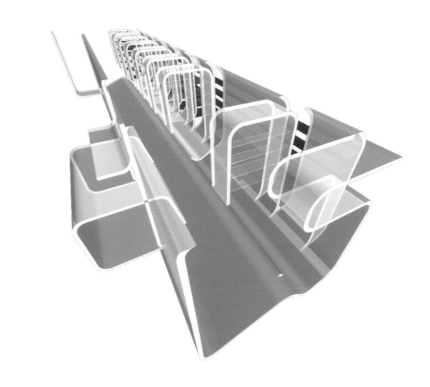

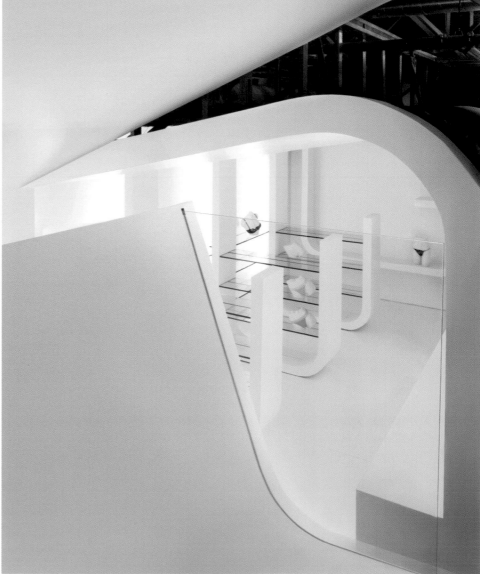

 The intersection of glass surfaces with white structures results in an interior suitable for displaying the products that reflects the ideal amount of light for enhancing the character of each item.

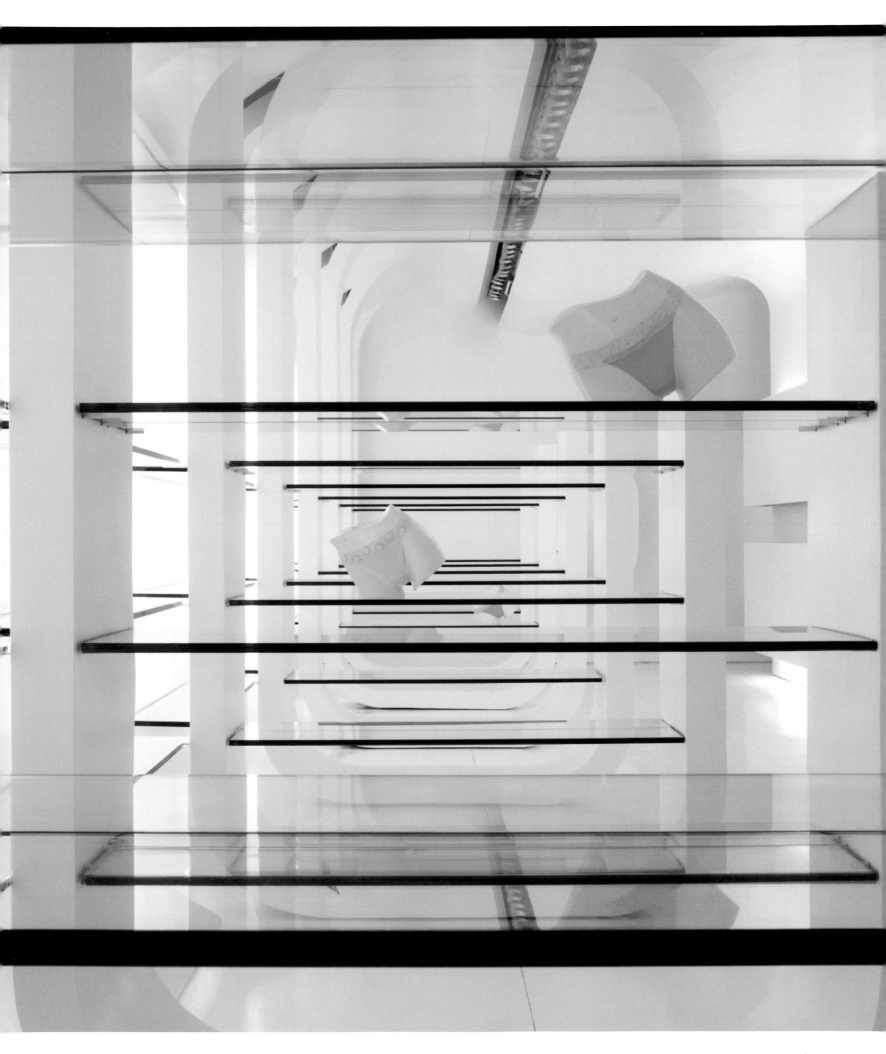

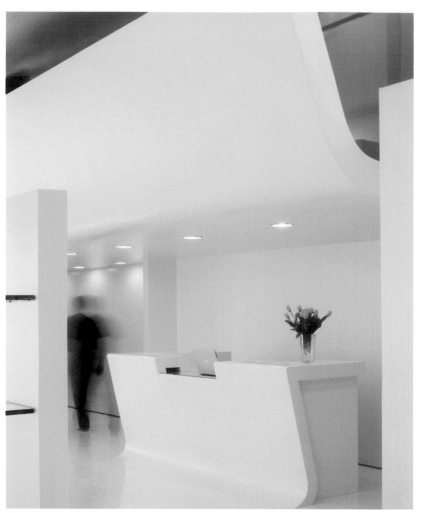

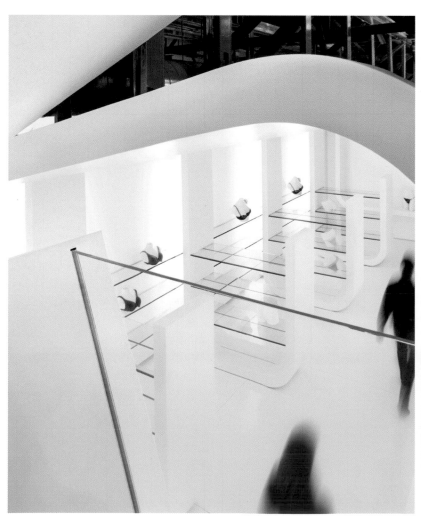

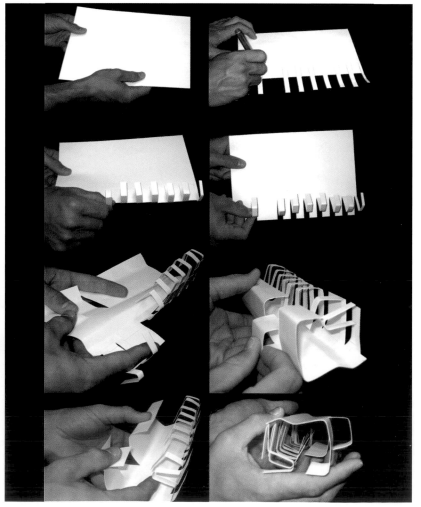

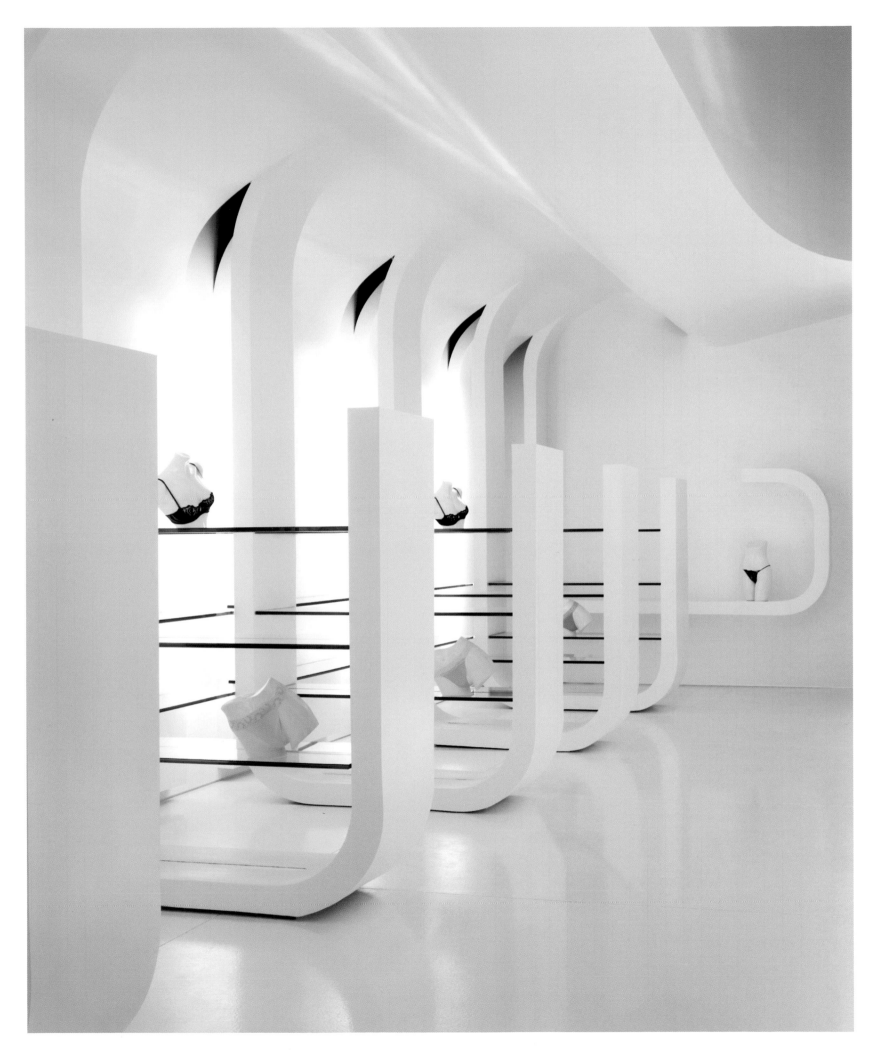

>WATX Shop

Architect: Martí Guixé

Location: Barcelona, Spain

Photography: imagekontainer.com

Martí Guixé created the concept of the WATX shops, a franchise system for selling various brands of watches under the same roof as well as under the umbrella brand name WATX, which would function as a logo of choice for consumers.

The basic idea behind the WATX system is to concentrate the product displays in different "shops in a box," as Guixé refers to the box-shaped display spaces with variable micro-décors. The linear and intersecting display cases make for a seemingly haphazard presentation of the vertical levels and the brands, but actually makes it easier for customers to examine the products and get information about them. This approach to product display renders the surrounding shop décor irrelevant—the space itself is merely a generic wrapping with functional lighting.

In designing these shops, Guixé aimed to create the image of sophisticated factory outlets with one main function: to invite customers into the shops to touch, try on, and buy the products on display. The interior of this shop is decorated with murals that stimulate reflection, a device Guixé employed to good effect in previous projects. Sales points are denoted by large asterisk shapes formed by WATX labels. At the front of each shop is a written description of the various types of watch (atomic, biological, etc.)—a graphic way to inform customers of the history of this accessory, transforming the shop into a veritable temple of time.

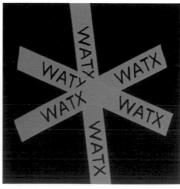
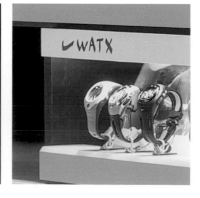

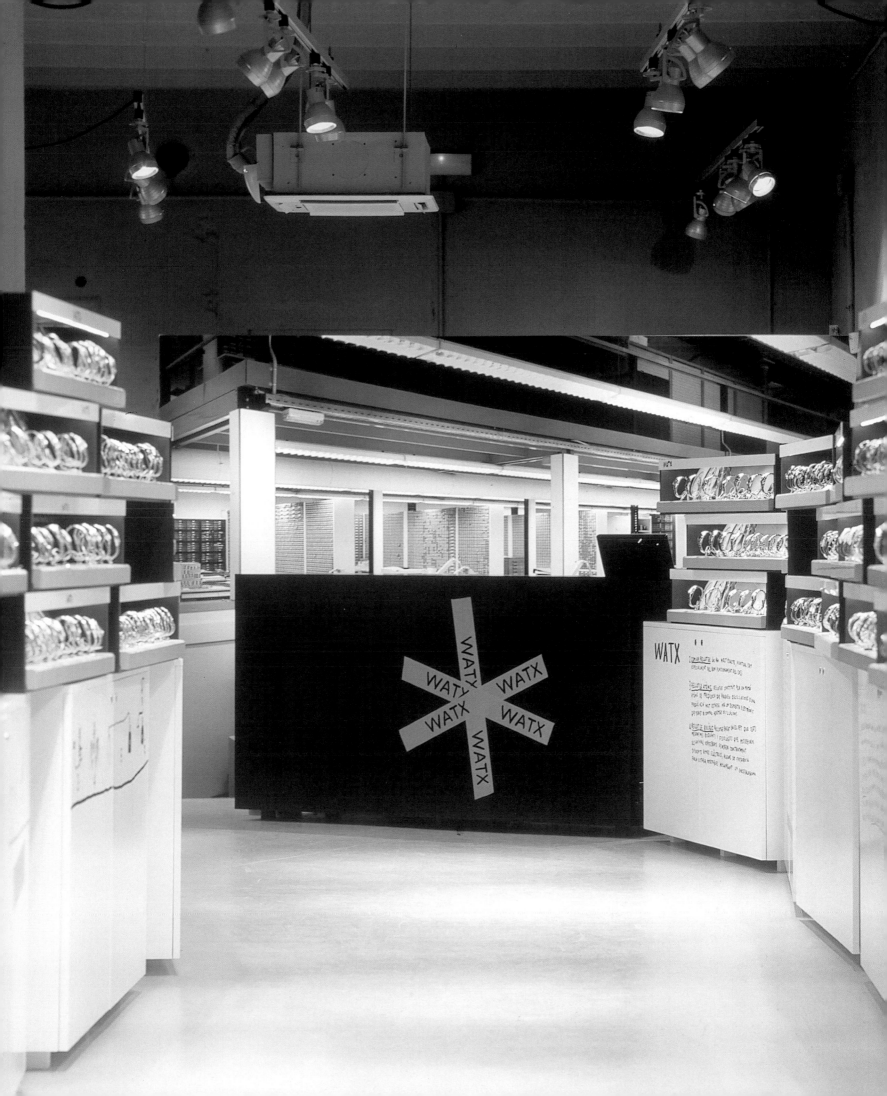

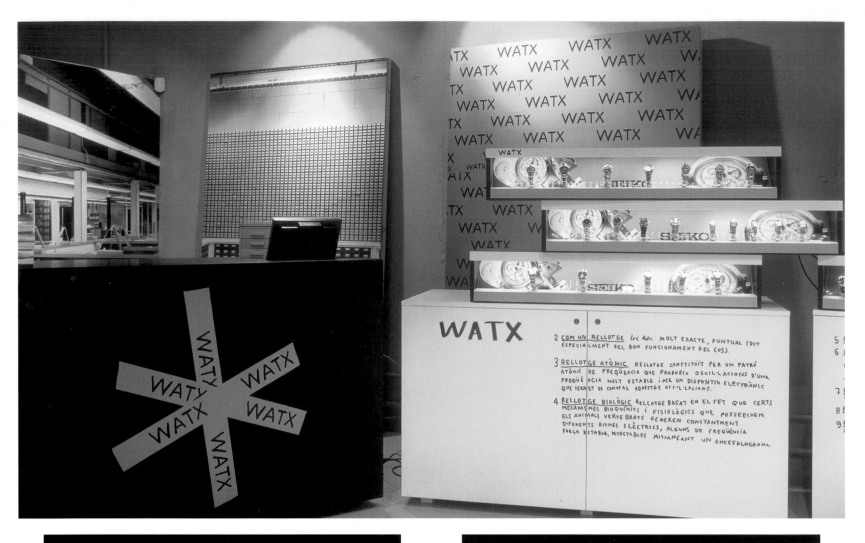

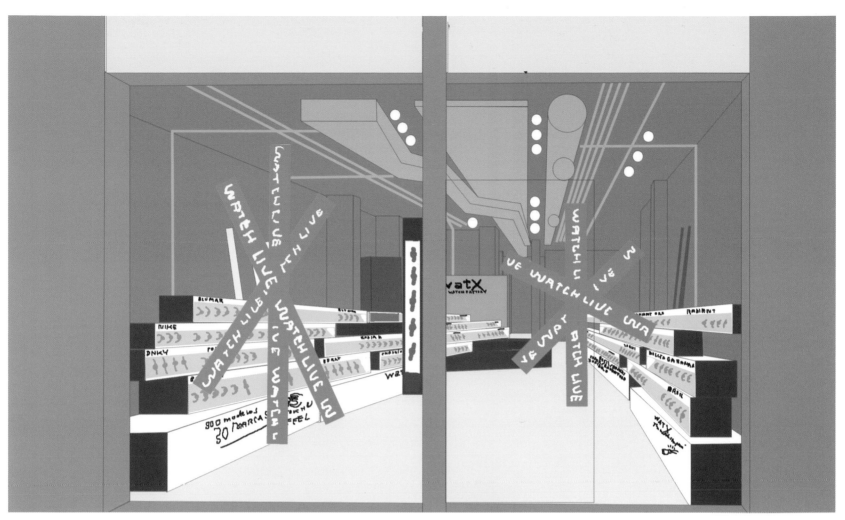

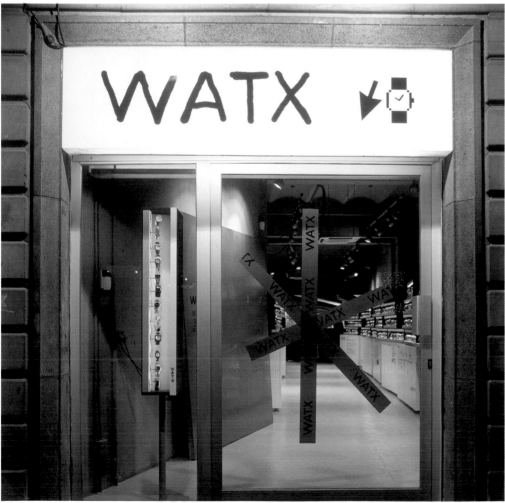

> The linear and crossed positions of the displays of different brands and styles of watches present a seemingly haphazard arrangement but facilitate viewing and getting information about the products by customers.

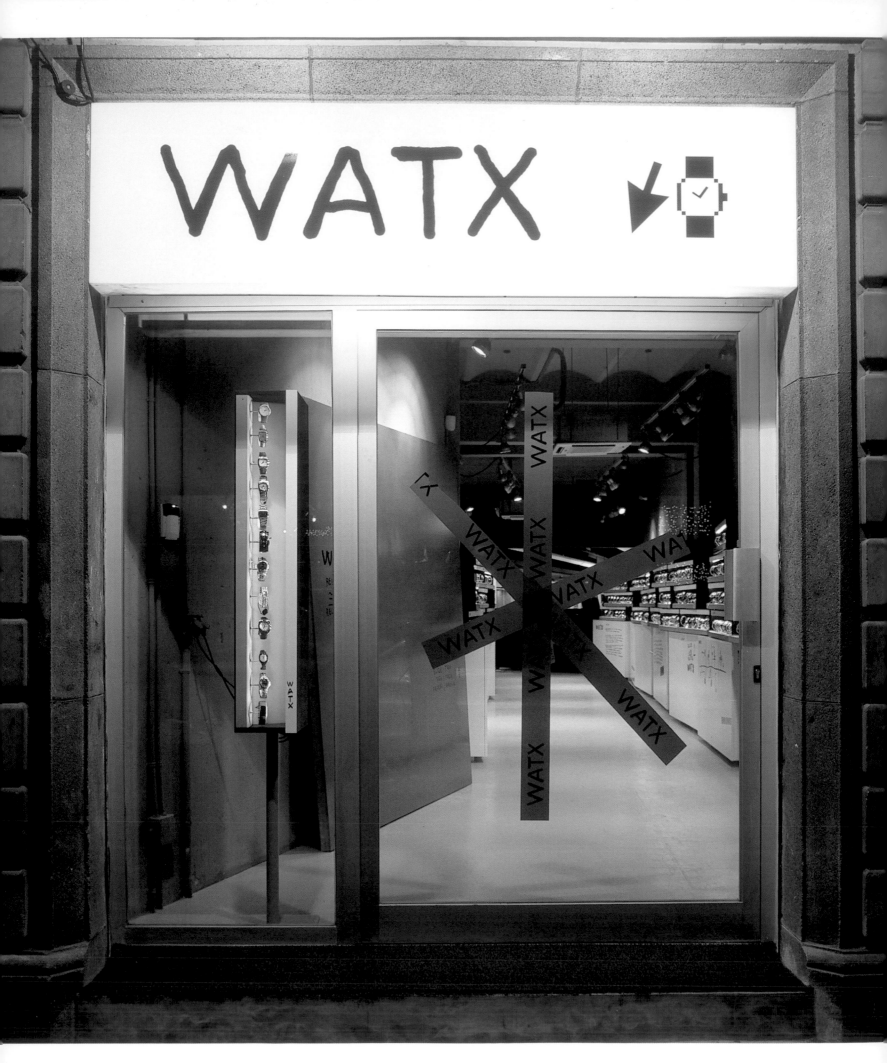

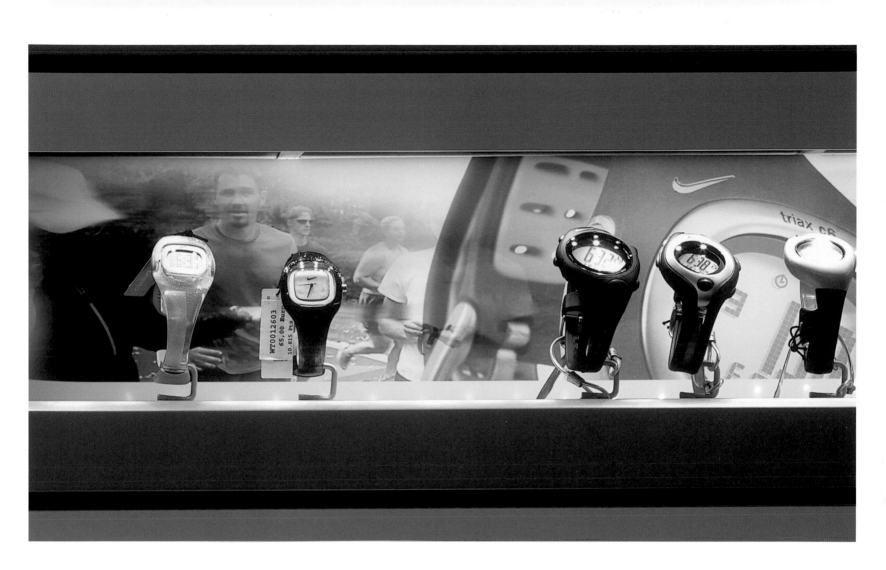

WATX

ELIGE
TOCA
PRUEBA

WWW.WATXSHOP.COM

MAS DE
360
RELOJES

20
MARCAS

> The watches are displayed in the "shop in a box" and are protected by a security system. The focal lighting of the display case enhances the product within.

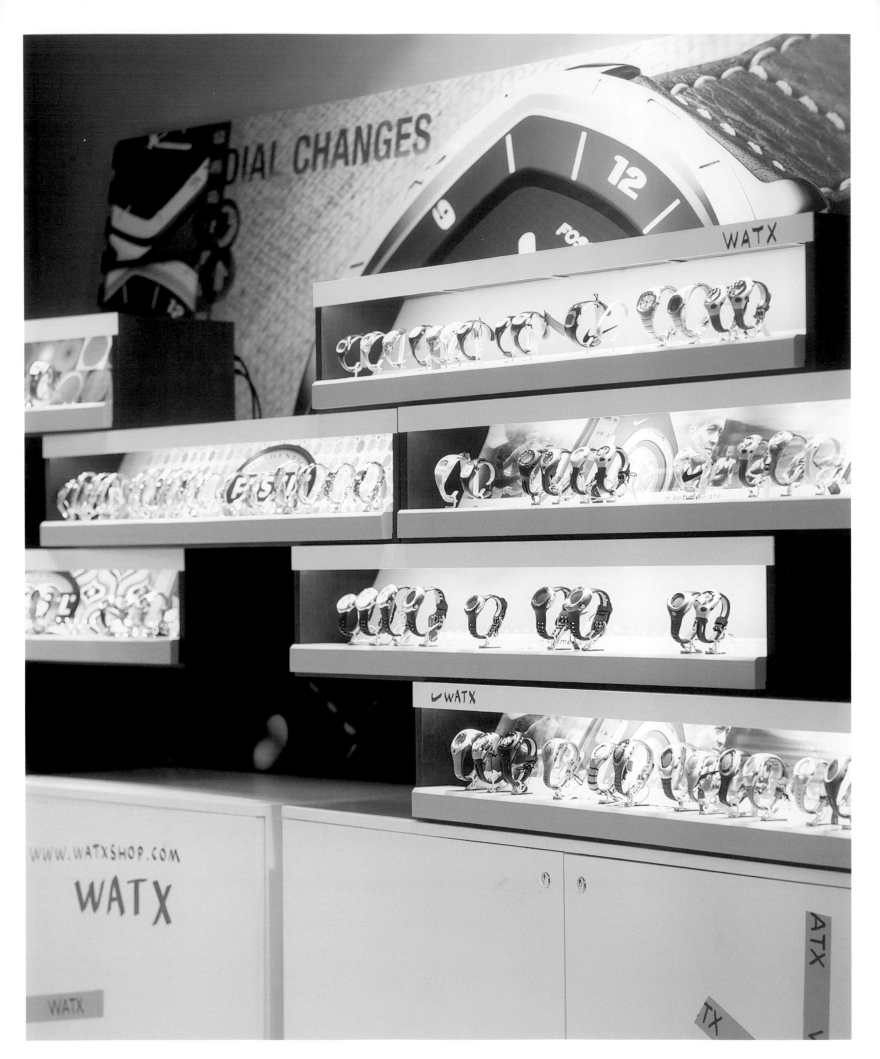

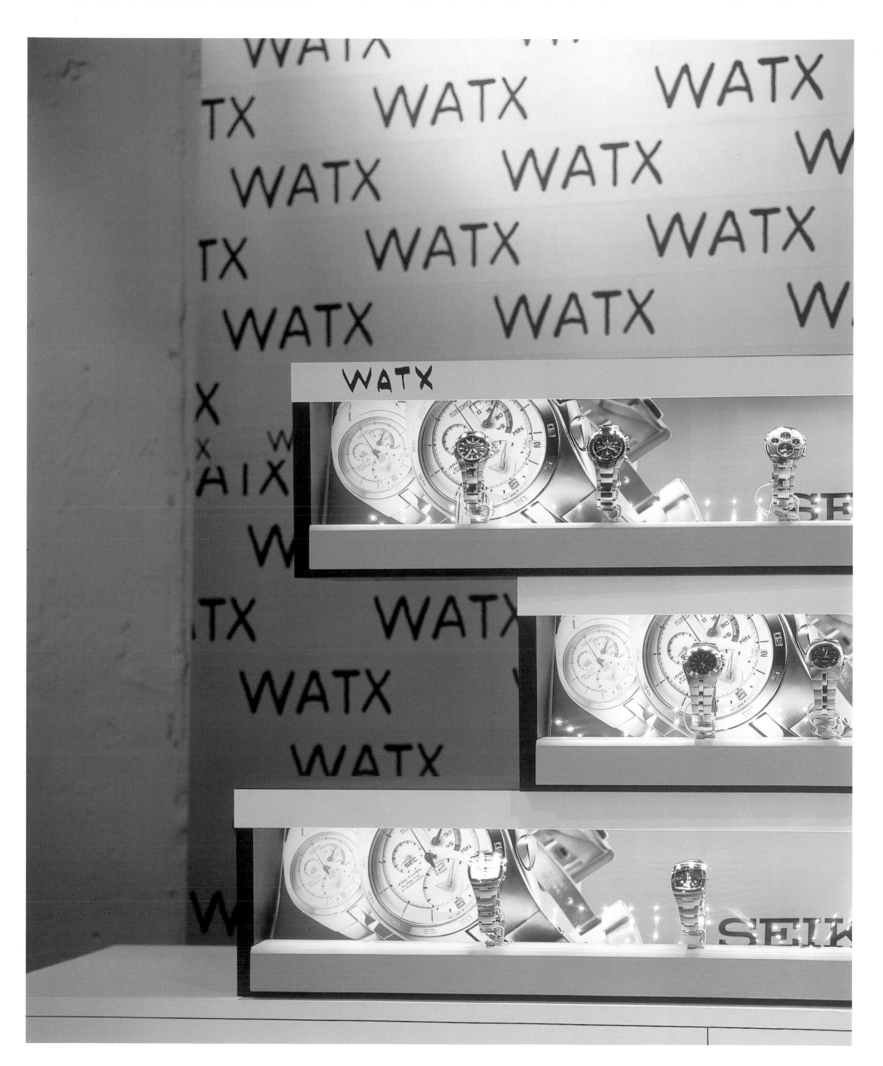

>Pierre Hermé

Architects: Wonderwall

Location: Tokyo, Japan

Photography: Nacasa & Partners Inc.

The prestigious Pierre Hermé Paris entrusted the Wonderwall team, and specifically designer Masamichi Katayama, with the commission to design the first of its cake shops in Tokyo. Katayama specializes in creating elegant spaces with a healthy dose of ingenuity, making him one of the most acclaimed designers on the international scene.

For Pierre Hermé, Katayama opted for a luxurious and sophisticated ambience, distancing the space from the traditional concept of a mere shop. The open and spacious interior was achieved through the use of transparent materials like glass and cold textures like marble. The white marble floor, glass display cases, and sweeping stairway with stainless steel banisters carry out this effect in grand style. As with most of Katayama's works, the furnishings and accessories were exclusively designed for this project.

Customers entering the shop are treated to the tempting sight of delicious chocolates presented on glass display stands as if they were precious jewels. The display cases themselves are a clever innovation, shaped like tables, with glass showcases forming the upper part, equipped with cooling systems to maintain the chocolate in optimum conditions, and stainless steel legs. The second floor features the Bar Chocolate, which continues the image of luxury and ostentation. The temptation for customers is irresistible.

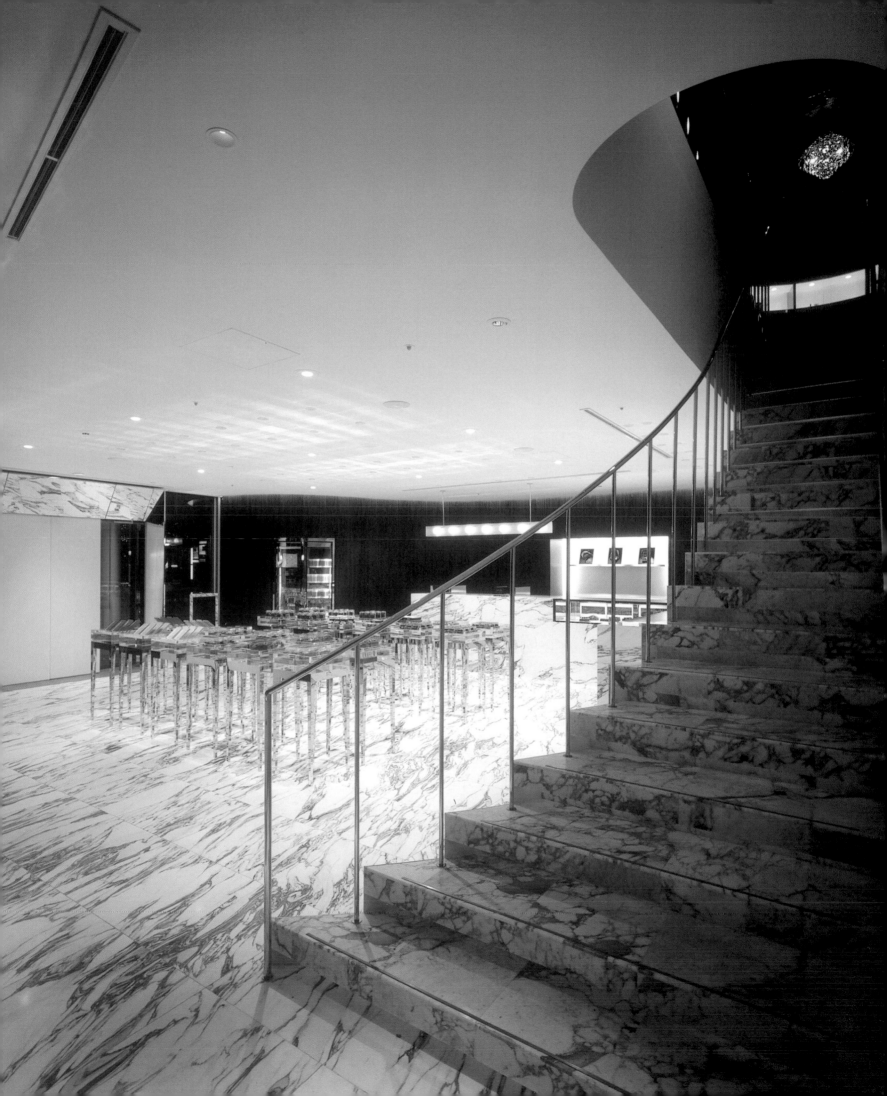

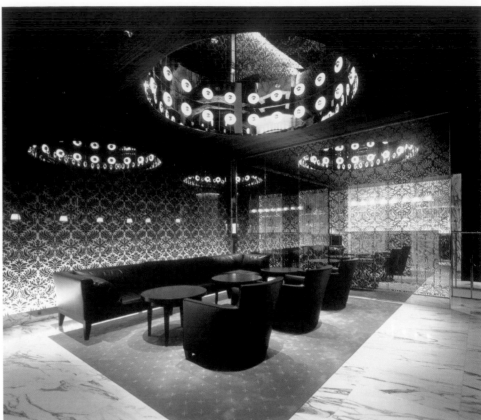

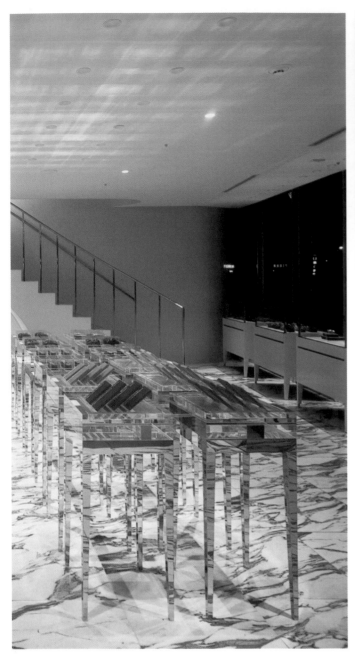

> The display stands, which have a stainless steel base and an air-conditioned glass showcase, present the chocolates in an exquisite way.

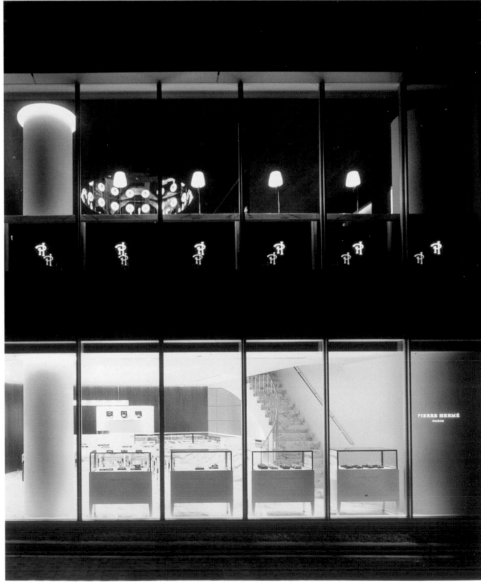

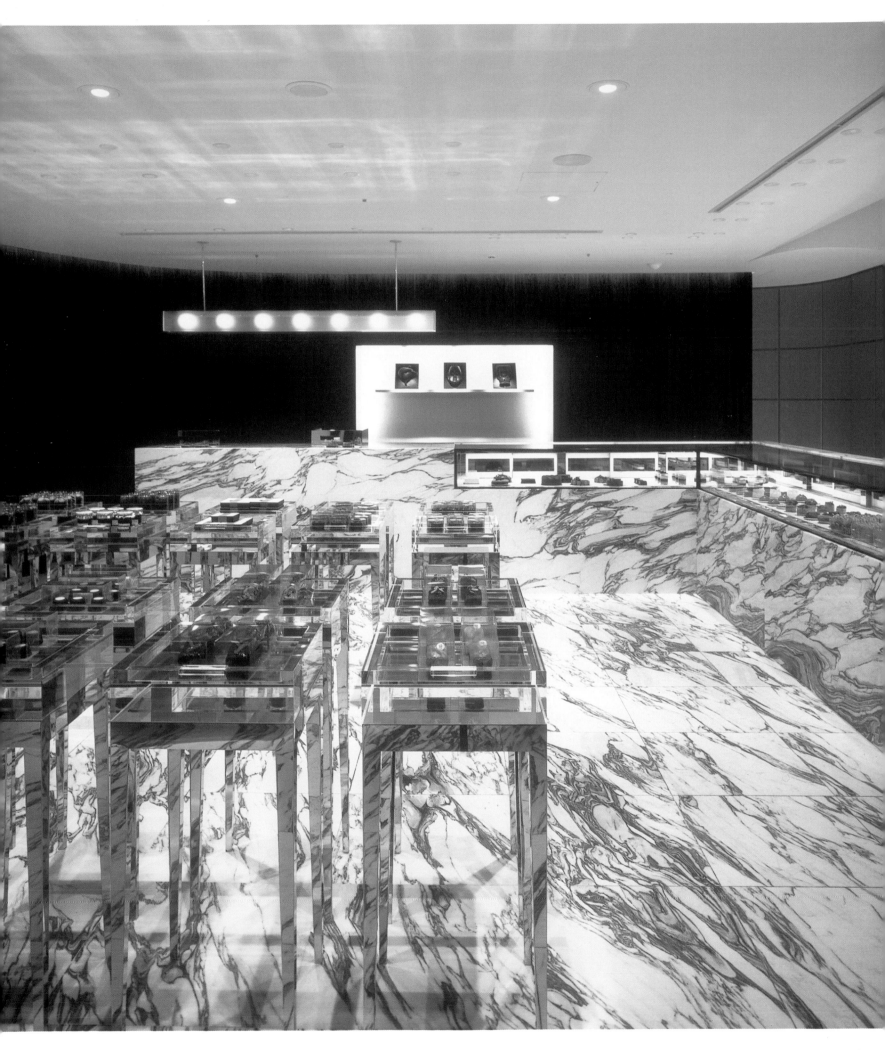

>Genaro

Architect: Jordi Torres/Torres & Torres

Location: Barcelona, Spain

Photography: Rafael Vargas

Genaro is a select fish shop located in the Boqueria market, midway between a jeweler and a workshop, in Barcelona. Designer Jordi Torres was tasked with creating a space that combines the functions of a shop during the day and those of a restaurant at night.

From the outside, the glass-fronted space appears to be one big shop window, through which the stainless steel display fixtures are visible, lending an industrial air to the premises—like that of a research laboratory. The fish selections are displayed on circular trays framed in laminated glass hand-painted an apple-green color. These display mounts highlight the silvery sheen of the fish and the intense red of the other seafood being offered.

The fixtures were custom-designed with the goal that they be both functional and flexible. It is essential in a shop like this that the product be cleaned, washed, prepared, packaged, and stored or displayed in optimum hygienic conditions. Stainless steel step arrangements of different heights have been specially designed to accommodate these activities. Beneath them is a small storage space, which is used for bags, boxes, and product for shipping. Above the central fixture, which is also used to store boxes, hangs a steel and polycarbonate screen of fluorescent light. Another steel fixture, raised on wheels and including three prominent painted-glass trays, hides the cage that protects the service elevator that leads to the refrigerators. It performs a double function by serving as a bar on which evening diners can set their glasses of *cava* while they sample the oysters.

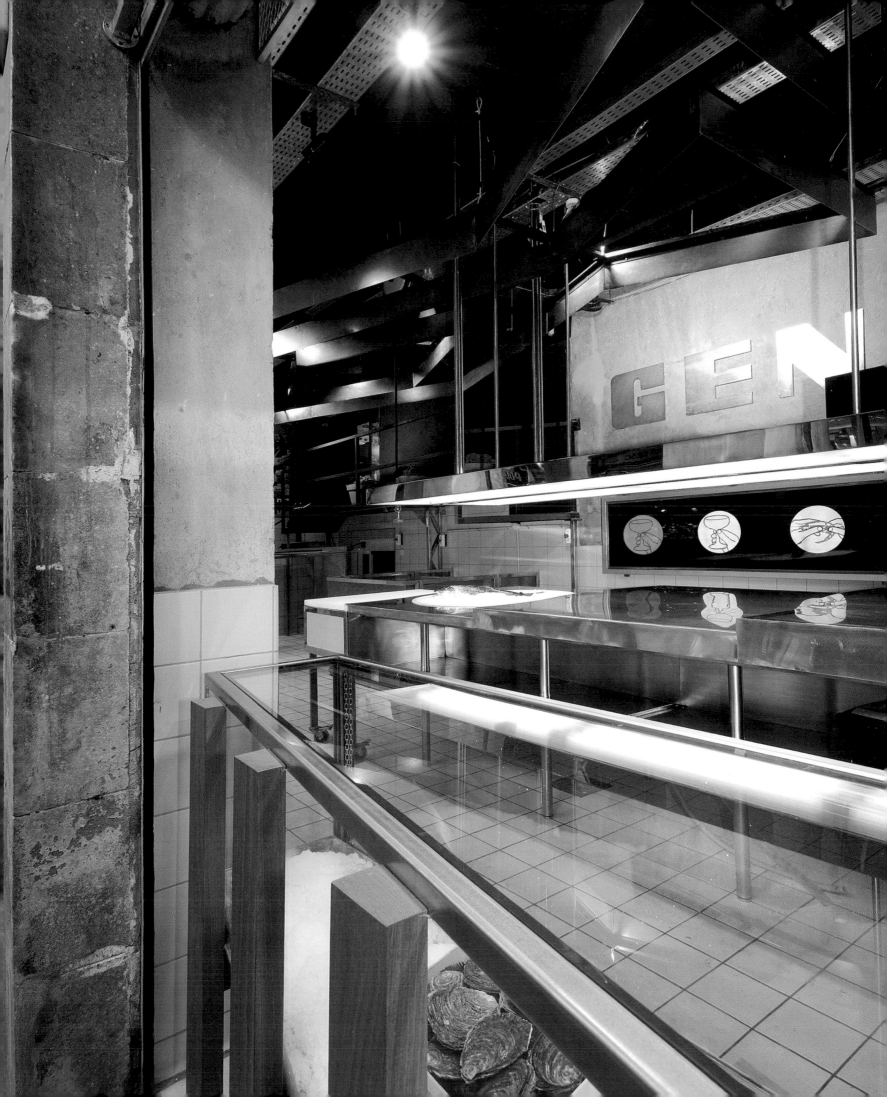

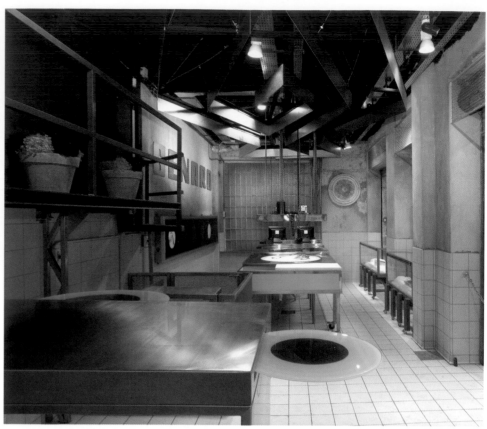

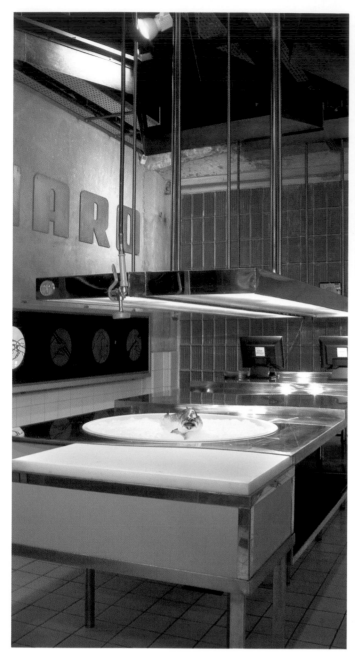

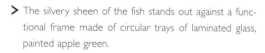 The silvery sheen of the fish stands out against a functional frame made of circular trays of laminated glass, painted apple green.

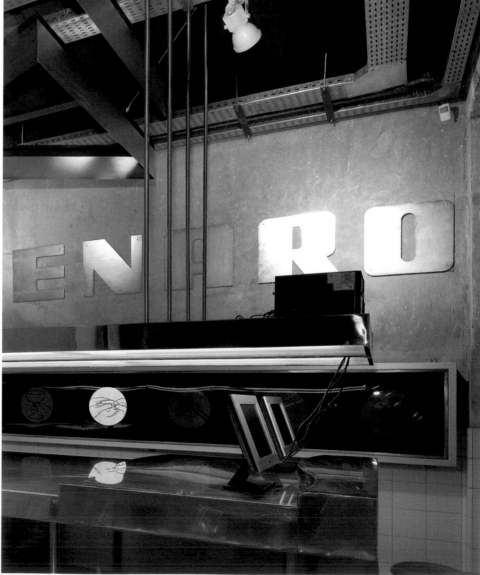

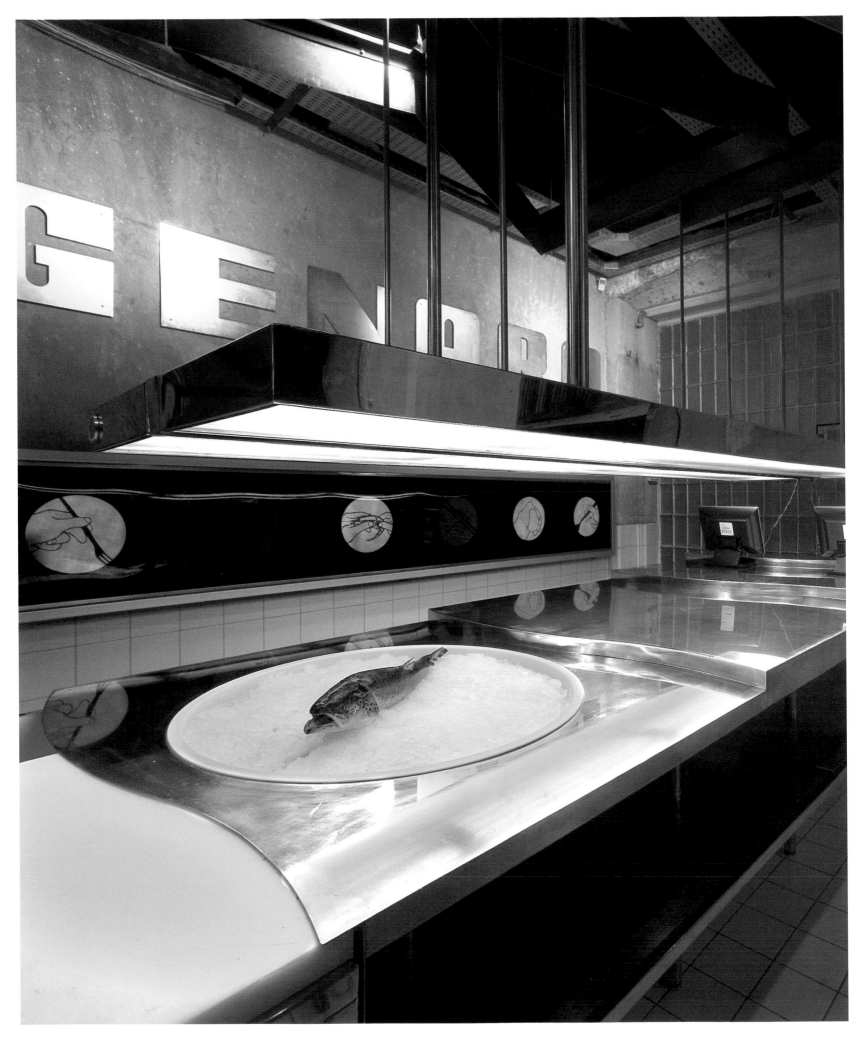

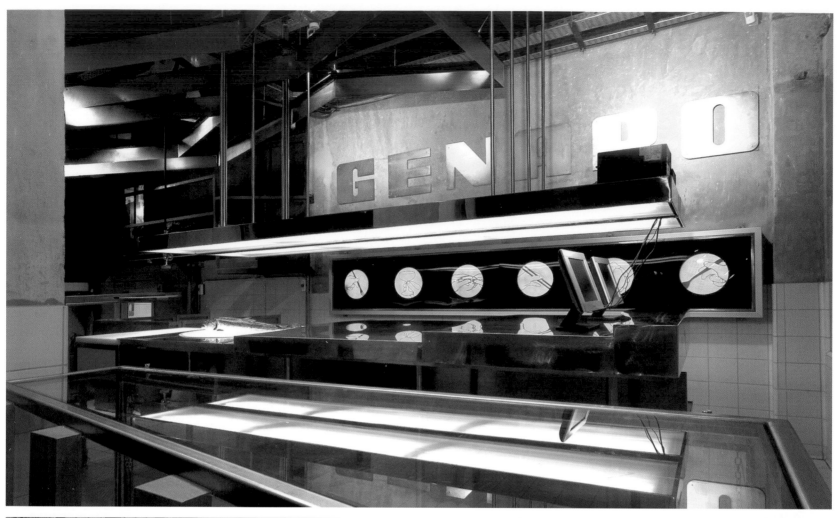

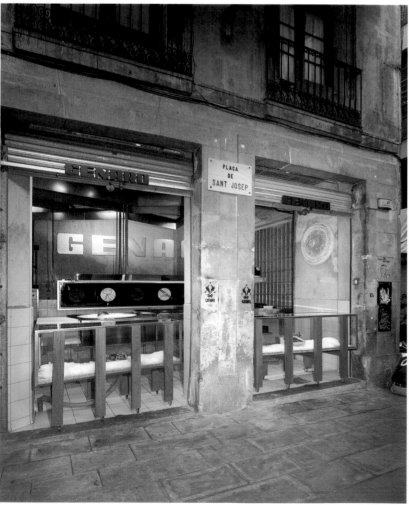

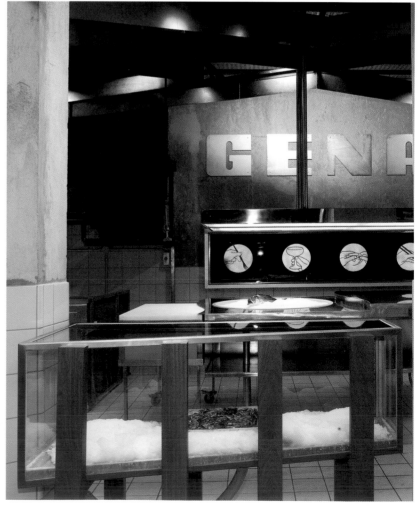

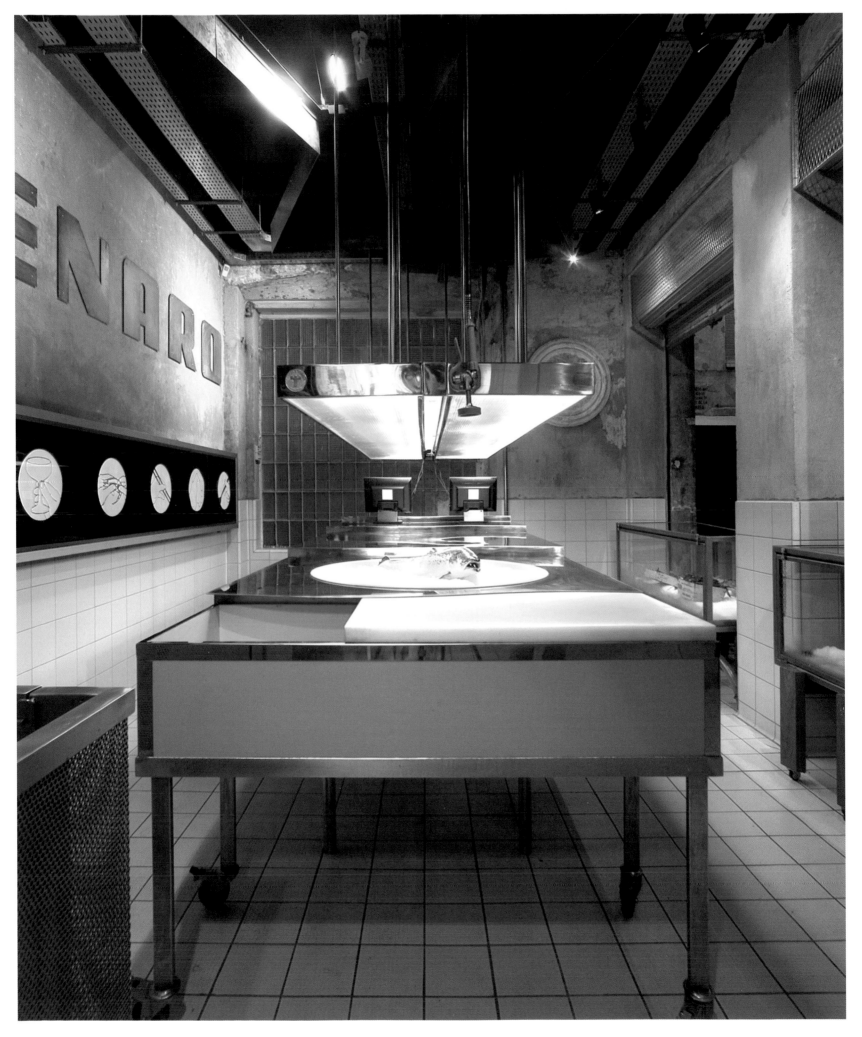

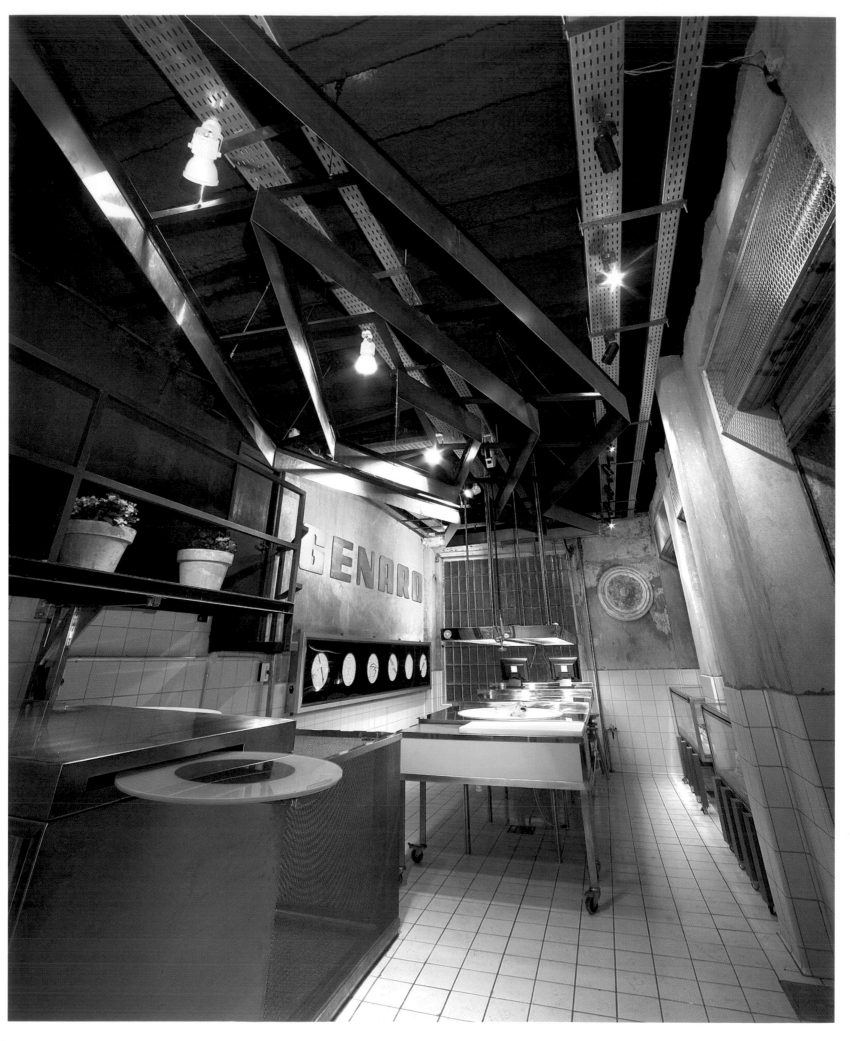

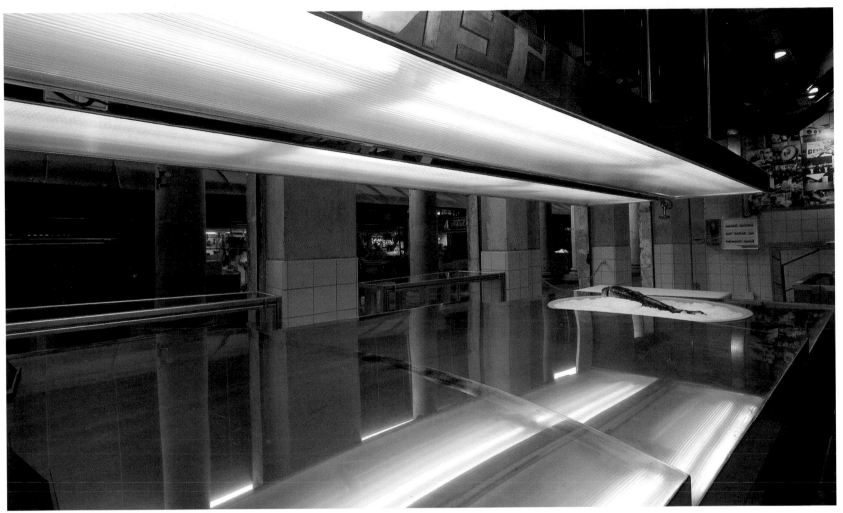

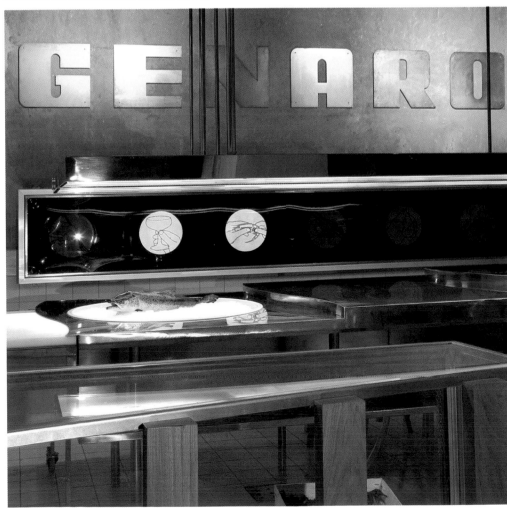

> A fixture with wheels and three prominent trays doubles as a bar where diners who frequent the establishment in the evenings can set their glasses.

>Passeig 40

Architect: Agustí Costa
Location: Berga, Spain
Photography: David Cardelús

The requirements for the design of Passeig 40, a cake shop, were that the space had to be converted into a showroom and that it had to incorporate refrigerated sales counters, tasting tables for six people, and an on-premises bakery for making the products. The result is a shop that plays with textures, is expressive and dedicated to innovation, and provides the requisite functionality.

The shop features the diverse shapes, colors, and textures of the merchandise within a geometric esthetic. The space itself was designed as a neutral backdrop, and the fixtures were kept simple and basic. The display platforms appear to be suspended in midair and the showcases are made completely of glass to avoid any interference with the products on display and to capture the interest of customers. A 36-foot-long alcove that serves as both a display stand and a continuous light source extends between the main sales counter and the bakery.

From outside, Passeig 40 presents itself as a modern and functional space in which the cakes themselves command the attention.

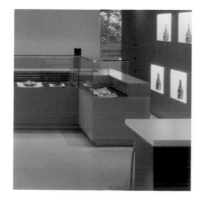 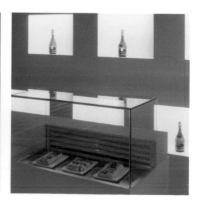

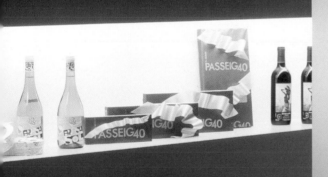

PASSEIG40

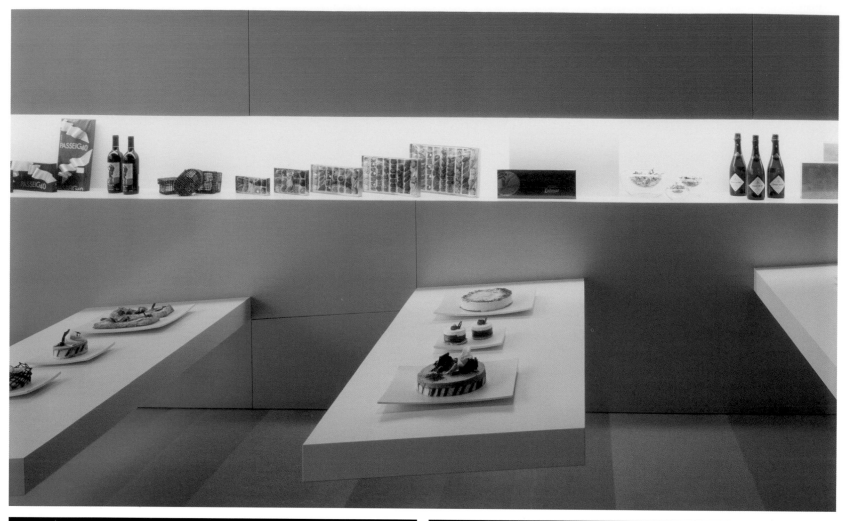

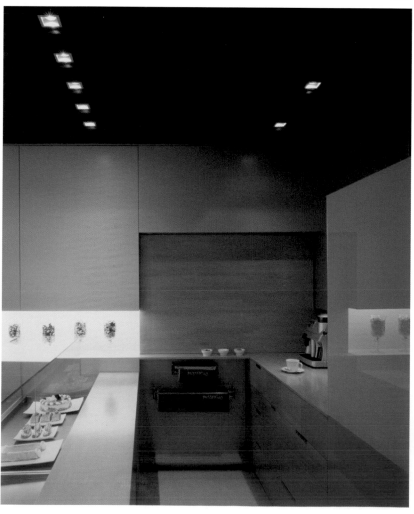

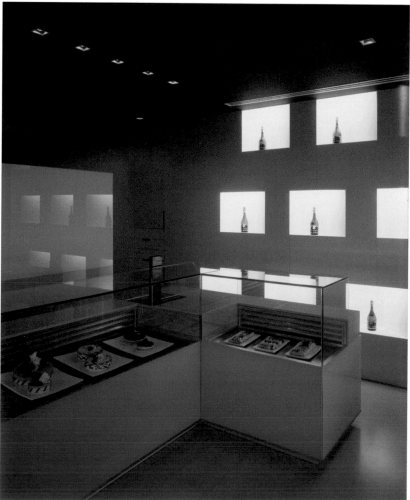

SECCIÓ L-1

SECCIÓ L-2

SECCIÓ L-3

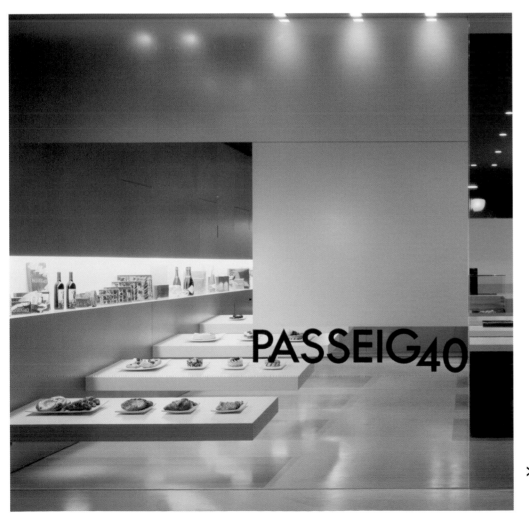

> From the outside, it is apparent how the neutrality of the materials and the simplicity of the forms enhance the texture and color of the product on display.

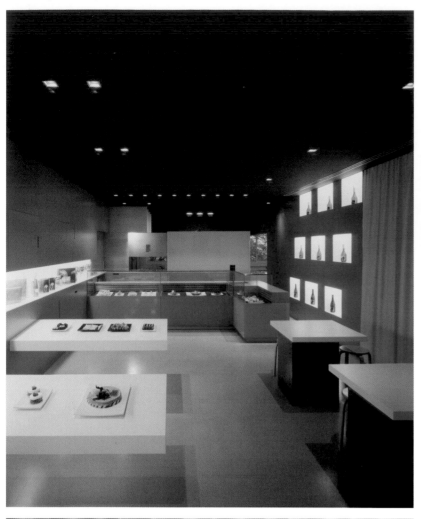
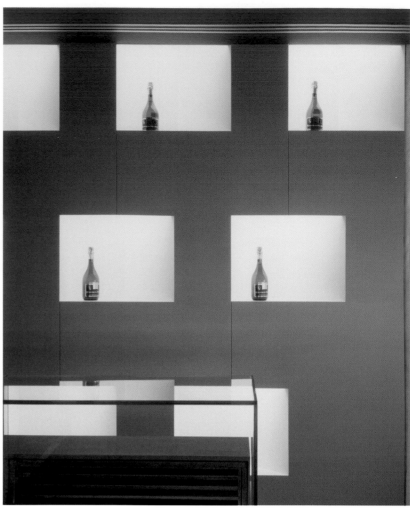
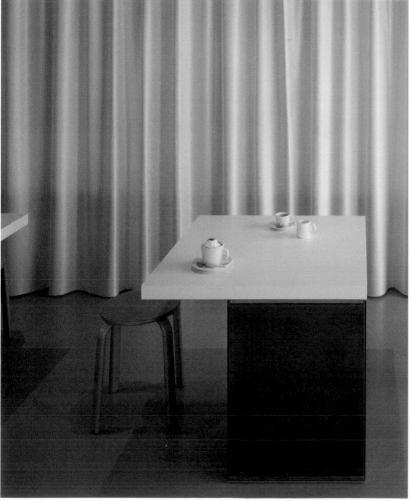
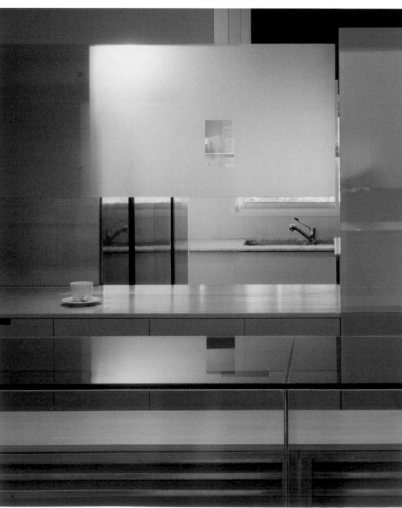

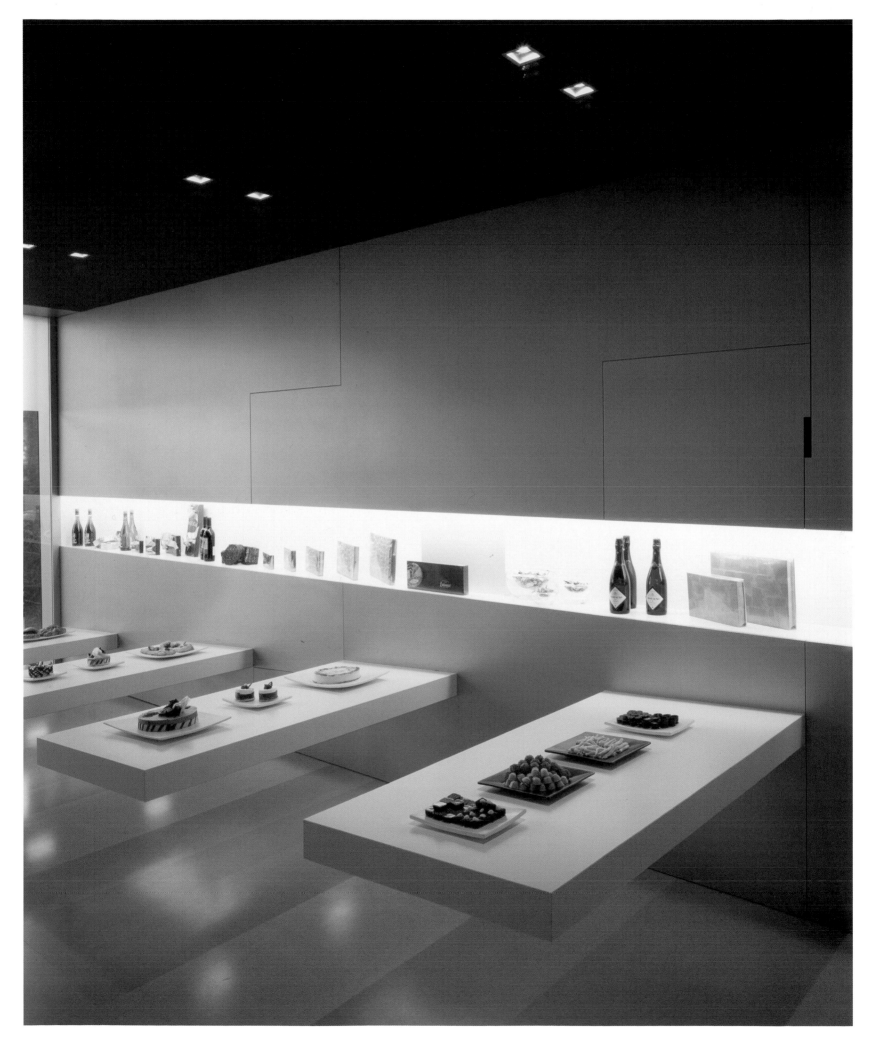

>Fornarina

Architects: Giorgio Borruso Design
Location: Las Vegas, Nevada, USA
Photography: Benny Chan

The objective of architect Giorgio Borruso in conceptualizing the space that would become Fornarina in Las Vegas's Mandalay Bay was to create an oasis within this spectacular but chaotic environment. Employing a system of organic shapes as display fixtures, Borruso came up with a sort of dreamscape that invites visitors in to discover what sort of products are offered in such a magical environment.

The use of organic forms is extended to structural elements that configure the space. The walls appear to undulate, lending a dynamic quality to the interior. The lighting system that descends from the ceiling consists of spotlights grouped together like tentacles. A portion of the collection on display is suspended from a flexible system composed of fluid materials that show off the merchandise to great effect. Accessories are displayed within pearlescent and chrome fiberglass rings. Mannequins wear some of the fashions, while others are featured at sales counters.

The result is a fusion of the visual and the tactile—the collection captured in the rhodamine red spotlight, drawing customers from the world outside into the magical world inside Fornarina.

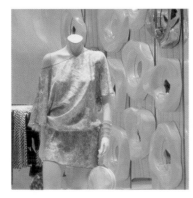 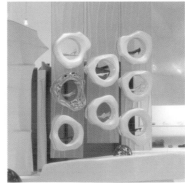 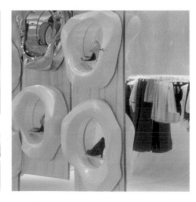

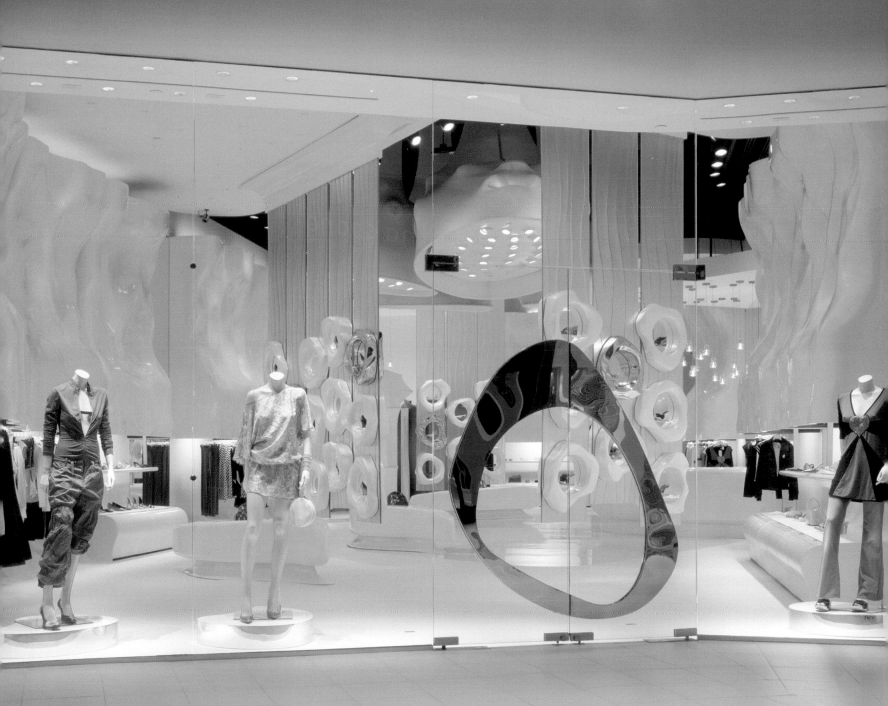

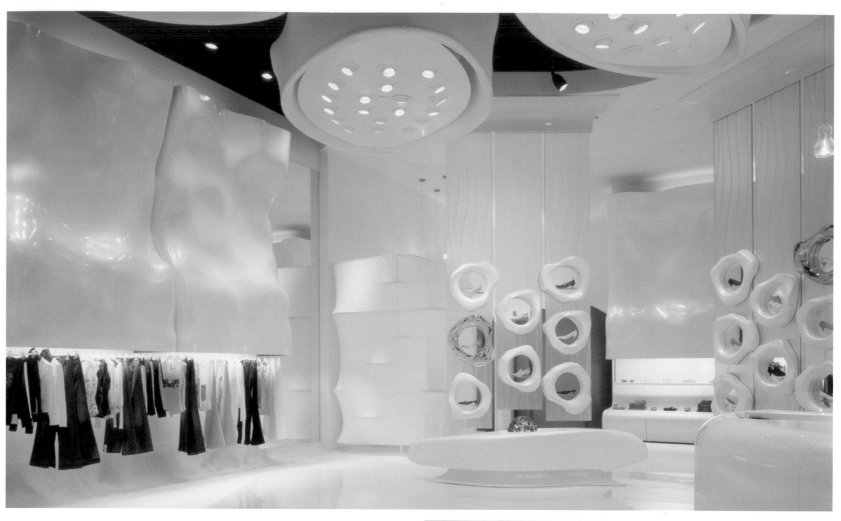

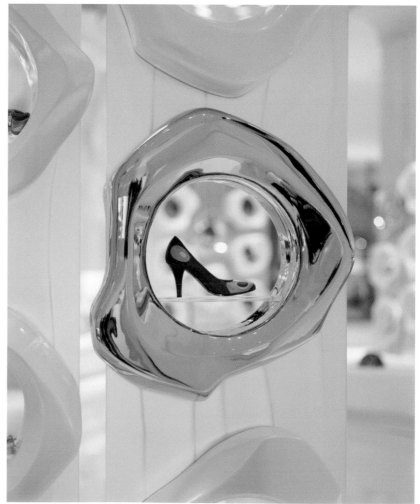

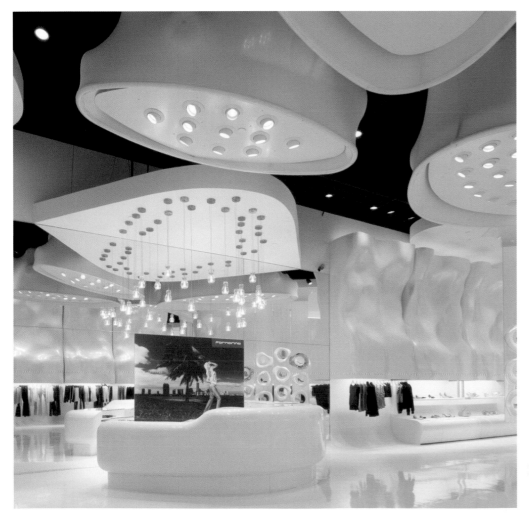

> Spotlights embedded in the tentacles enhance the sales space. The tentacles pulse with an infusion of rhodamine red light.

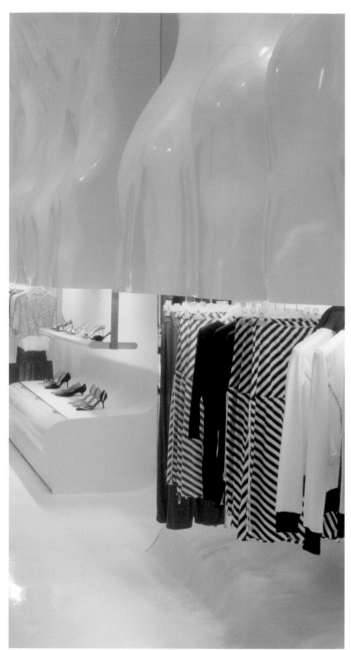

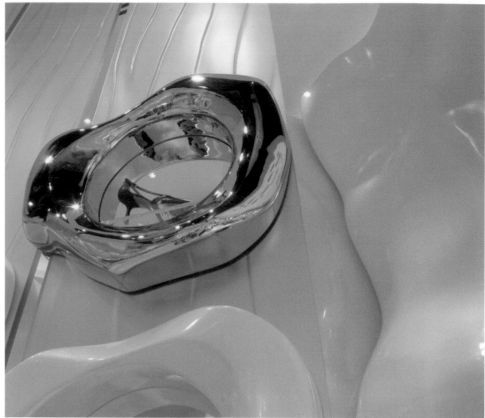

> Products are displayed in unusual ring-shaped fixtures, made from fiberglass in pearlescent and chrome, which echo the organic form of the space.

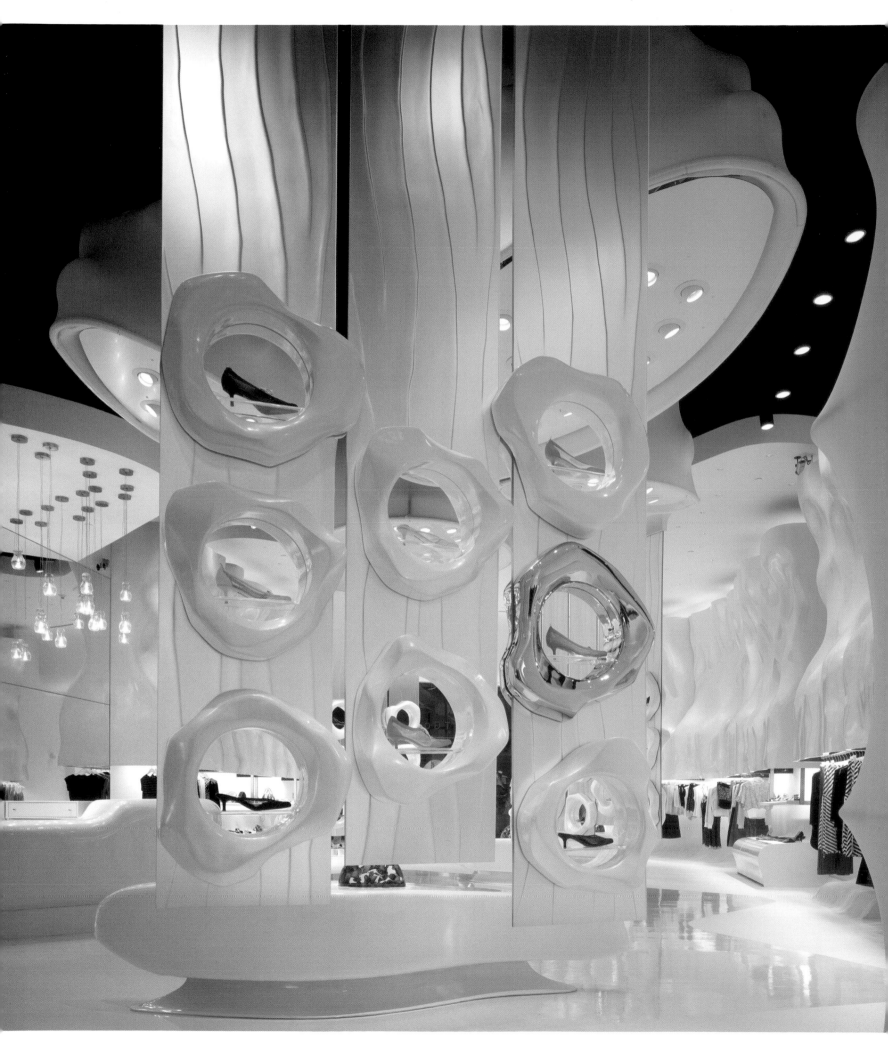

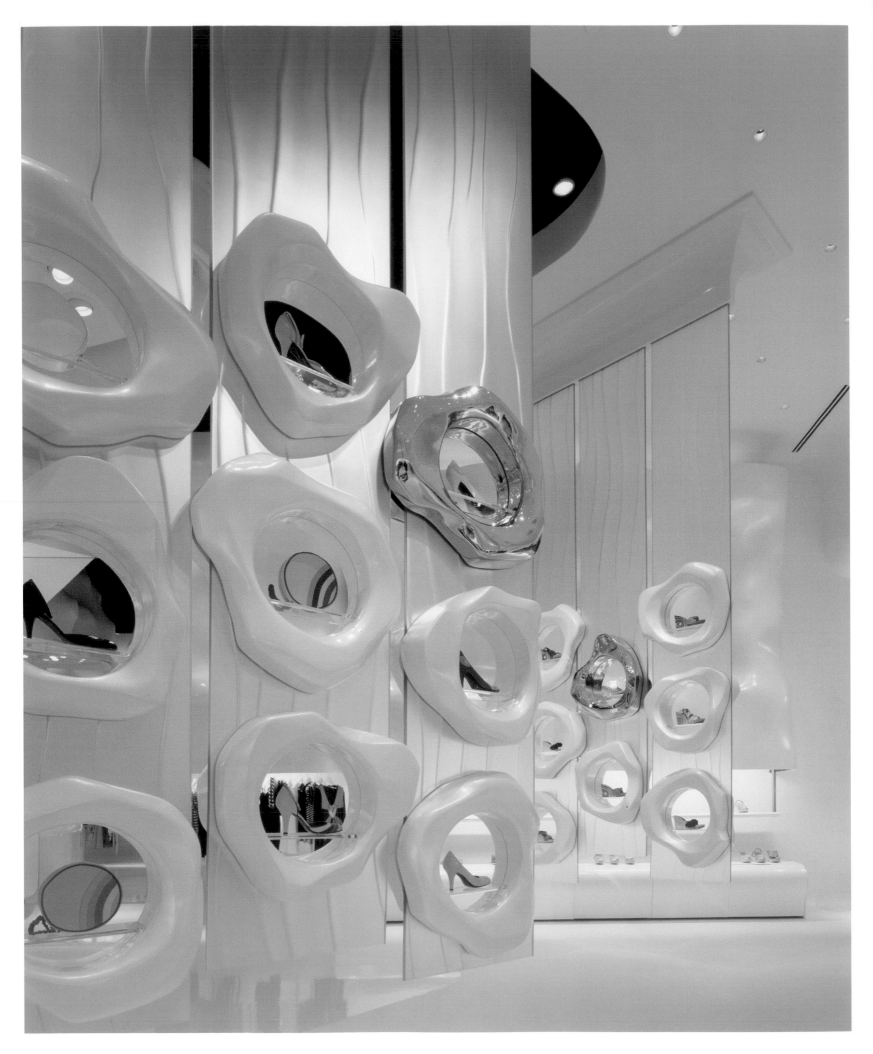

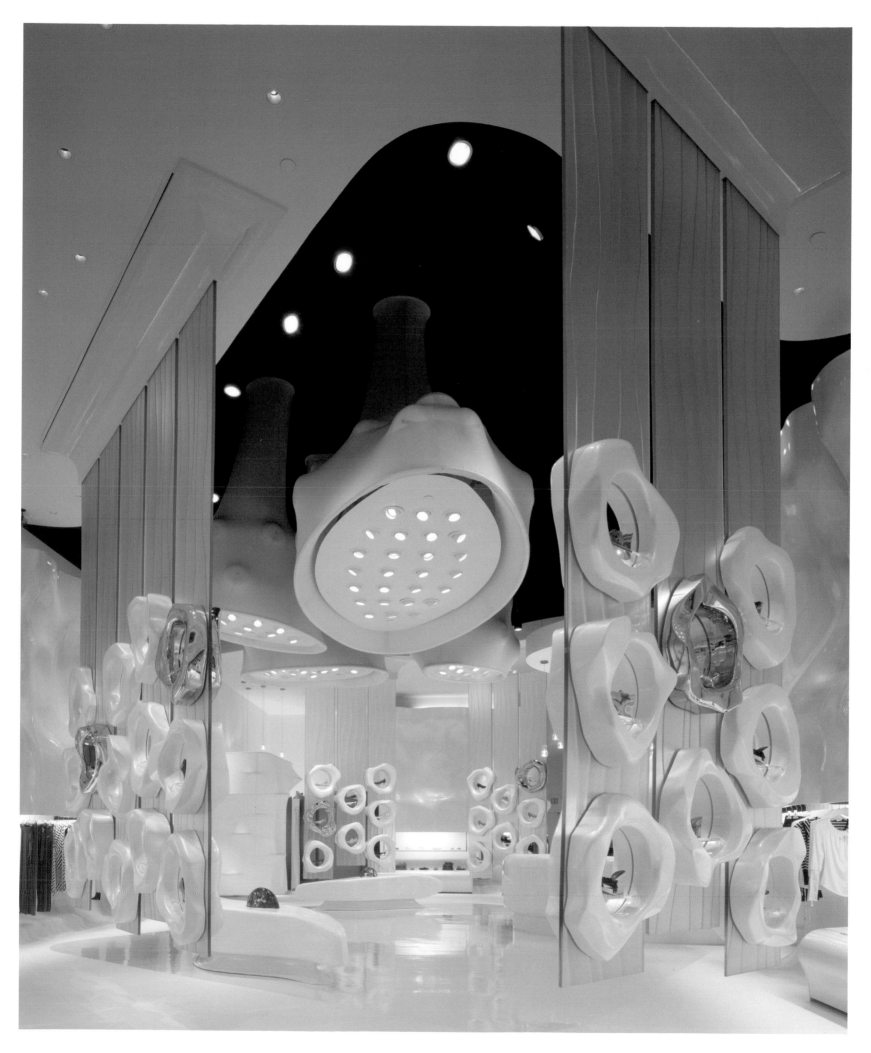

> Tag Heuer

Architects: Curiosity

Location: Shibuya-ku, Japan

Photography: Nacasa & Partners Inc.

French designer Gwenael Nicolas and Japanese designer Reiko Miyamoto head Curiosity, a Japanese design studio that works mostly on the international scene. The team mixes graphic design, product design, and interior design to produce their unique blend of refined and concise interiors. Among their most acclaimed work are the shops of Issey Miyake, Nintendo, Pioneer, and Tag Heuer.

The design for the Tag Heuer showroom is intended to transmit the silence of the passage of time. Opting for sophistication and a somber tone, the designers employed cold materials and blunt forms to create the appropriate environment in which to display Tag Heuer products. The result is a display space that surrenders itself to the products it features, emphasizing their beauty and enhancing their preeminence.

In the center of the space a transparent glass column with barely perceptible edges encloses a glass showcase in which watches are displayed. A light source strategically located on this column delimits its height. Transparent cubes serve as independent display cases that rotate on their axes, enabling their position to be changed and contributing to the dynamics of the space. Glass cases are also embedded into the structure of the overall space, extending along one wall.

Eschewing excess, Curiosity achieves an elegant simplicity that serves the product well through restrained use of form, materials, and color.

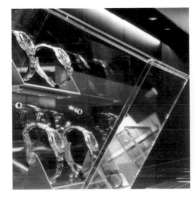
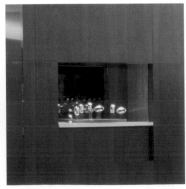
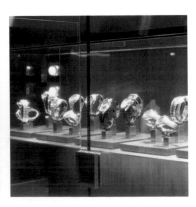

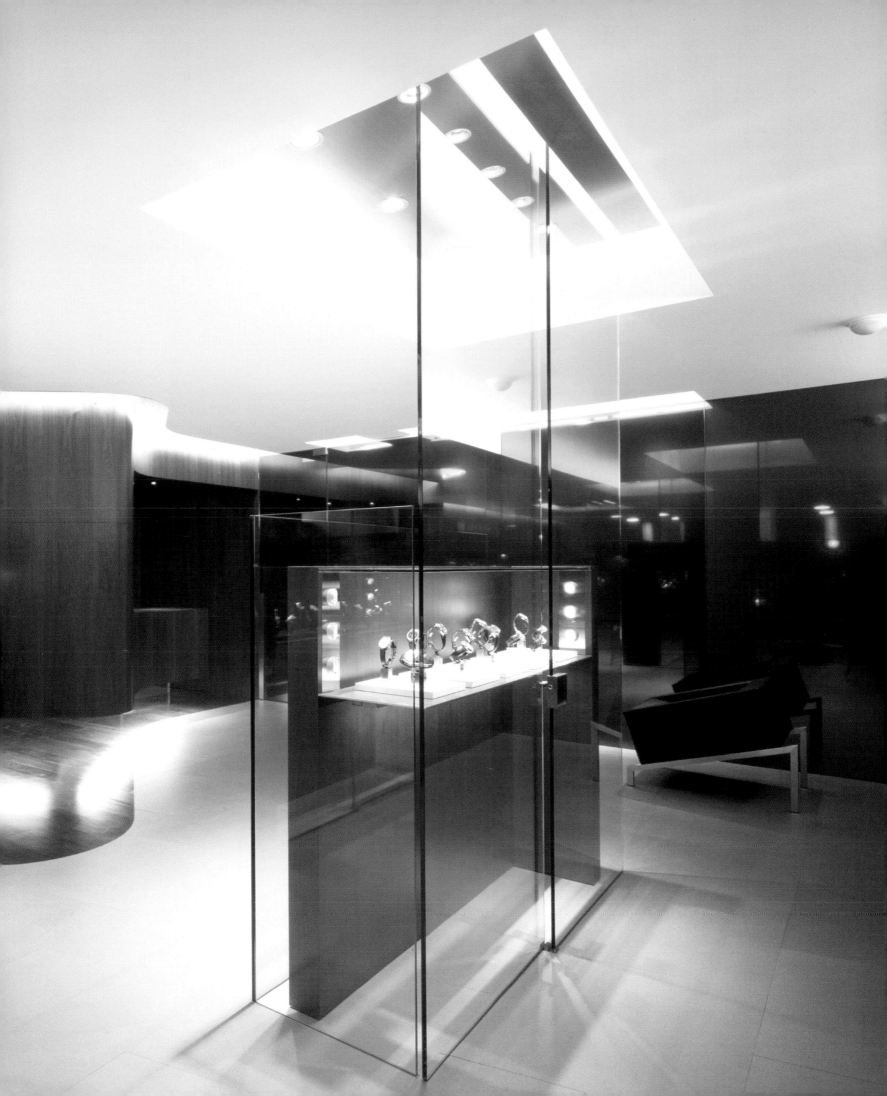

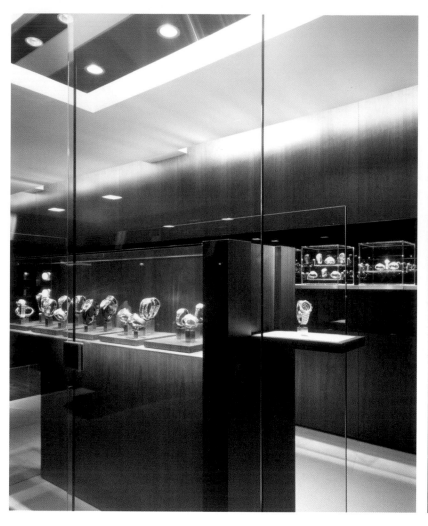
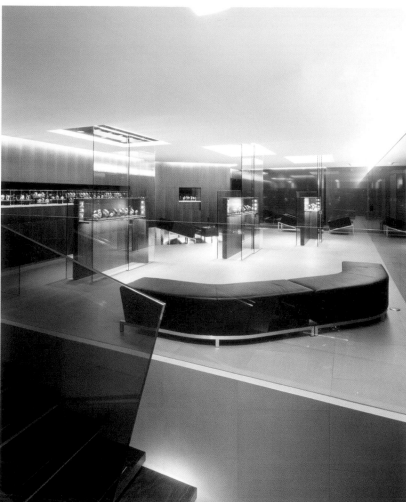

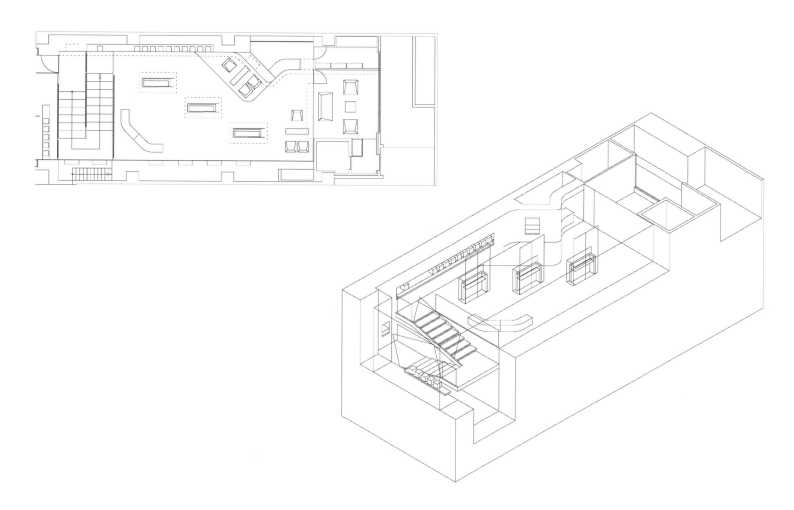

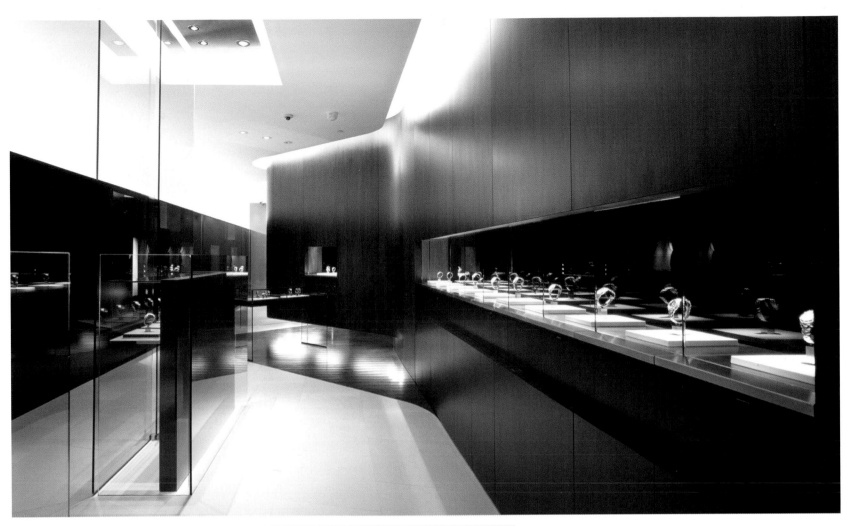

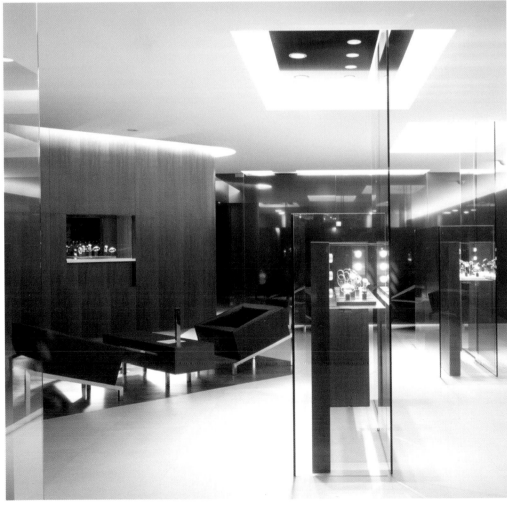

> An almost imperceptible glass column, located in the center of the space, houses a showcase where part of the Tag Heuer watch collection is displayed.

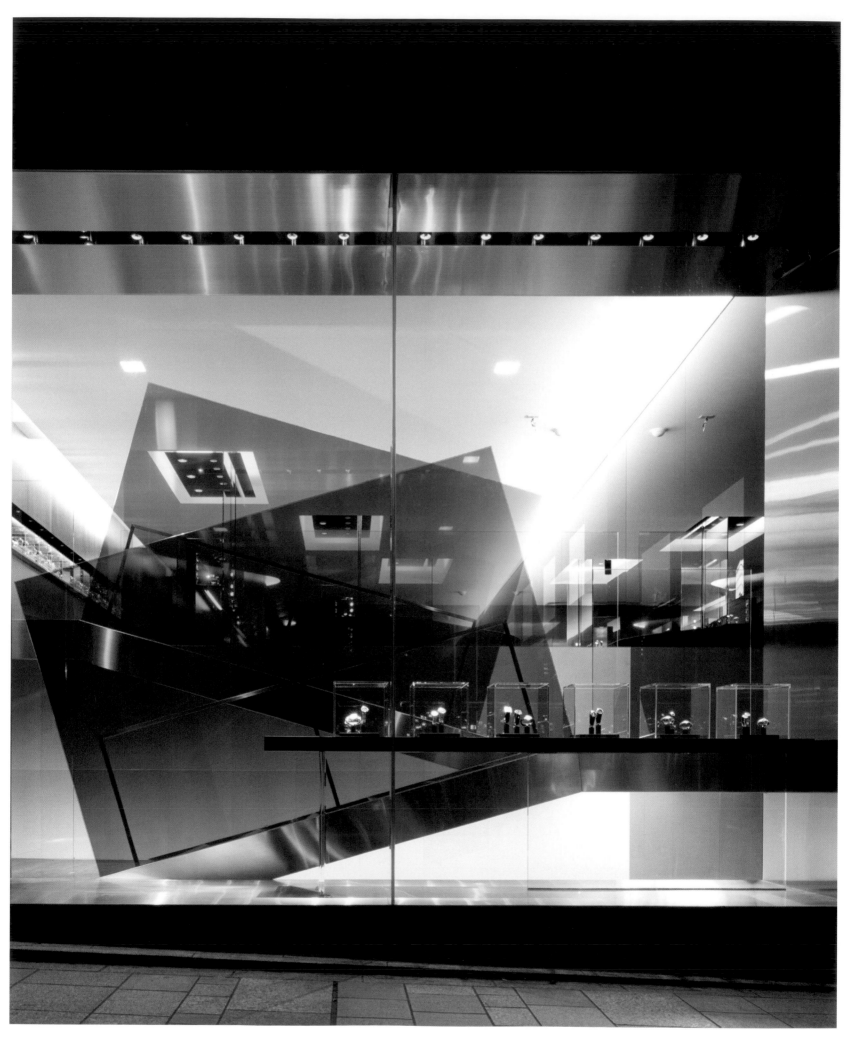

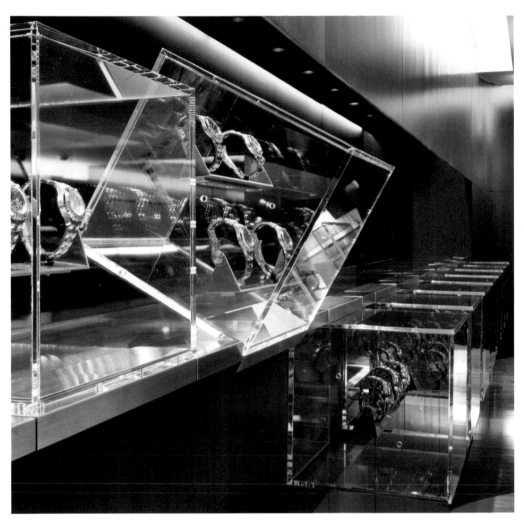

> A flexible system based on transparent cubes that rotate on their axes makes it possible to change the arrangements of the items on display.

>Bomboneria Leonidas

Architects: Elia Felices Interiorismo
Location: Barcelona, Spain
Photography: Rafael Vargas

The chocolate culture of Leonidas, a Belgian brand of praline created in 1910, has spread around the world thanks to its 2,000 purchase points on five continents. This shop, located in the Eixample district Barcelona, is an excellent example of how to display the product, transforming it into an object of desire. The display venue, the packaging, and the product itself are all factors for which design plays an important role in achieving competitive advantage in the marketplace.

The pralines, including white, milk, and dark chocolates with liqueur, marzipan, butter cream, fruit, and other fillings, are imported weekly from Belgium and must be maintained under specific conditions in refrigerated cases for only a limited time. Hence, the inventory is constantly turned over and the shop does not need a lot of storage area, which frees up space for display. The main sales counter is visible from the shop's entrance, but there is also an area reserved for tasting.

In the past, the wrapping for a box of chocolate was as important as the design of the packaging is today, so the shop's décor is based on a wrapping paper concept and this floral motif is painted on the walls. The packaging for some of the chocolates sold in the shop consists of special boxes called *ballotins*, which at Leonidas take the form of a gold ingot.

Chocolate can be as much a pleasure as a vice, and the act of purchasing it can become a ritual that extends that pleasure. As designer Elia Felices explains, "The aim was to make the purchase itself something to enjoy, like that of a spectator who interacts with his surroundings."

 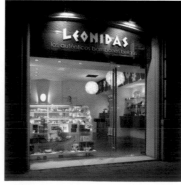

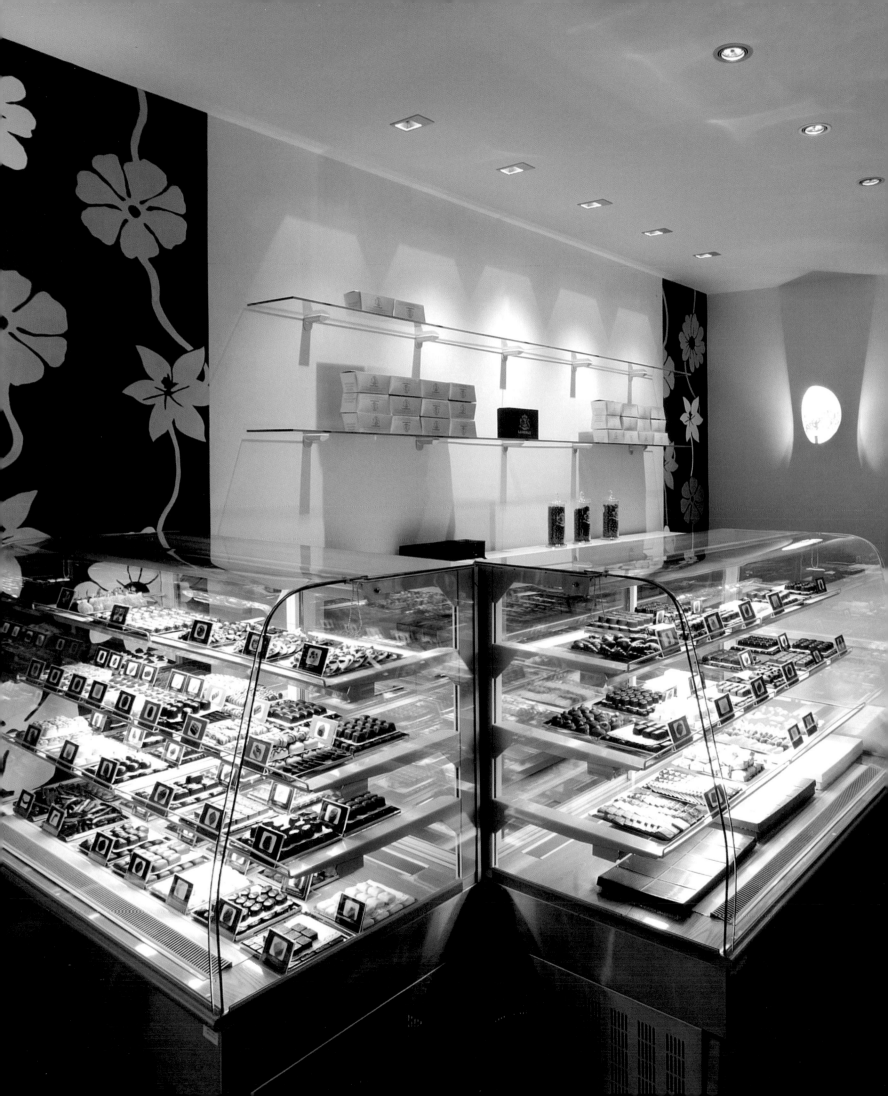

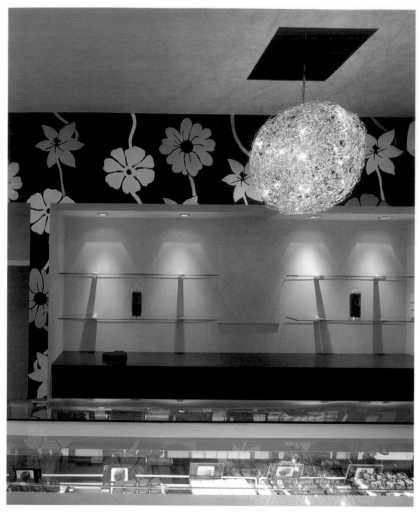

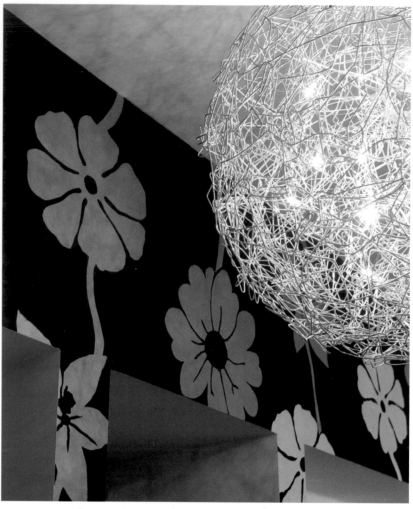

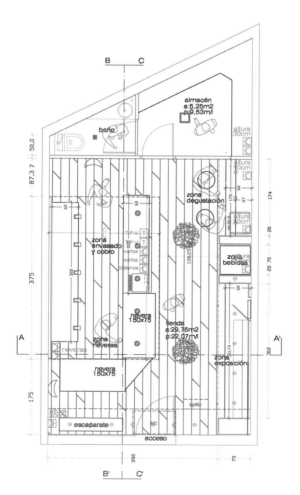

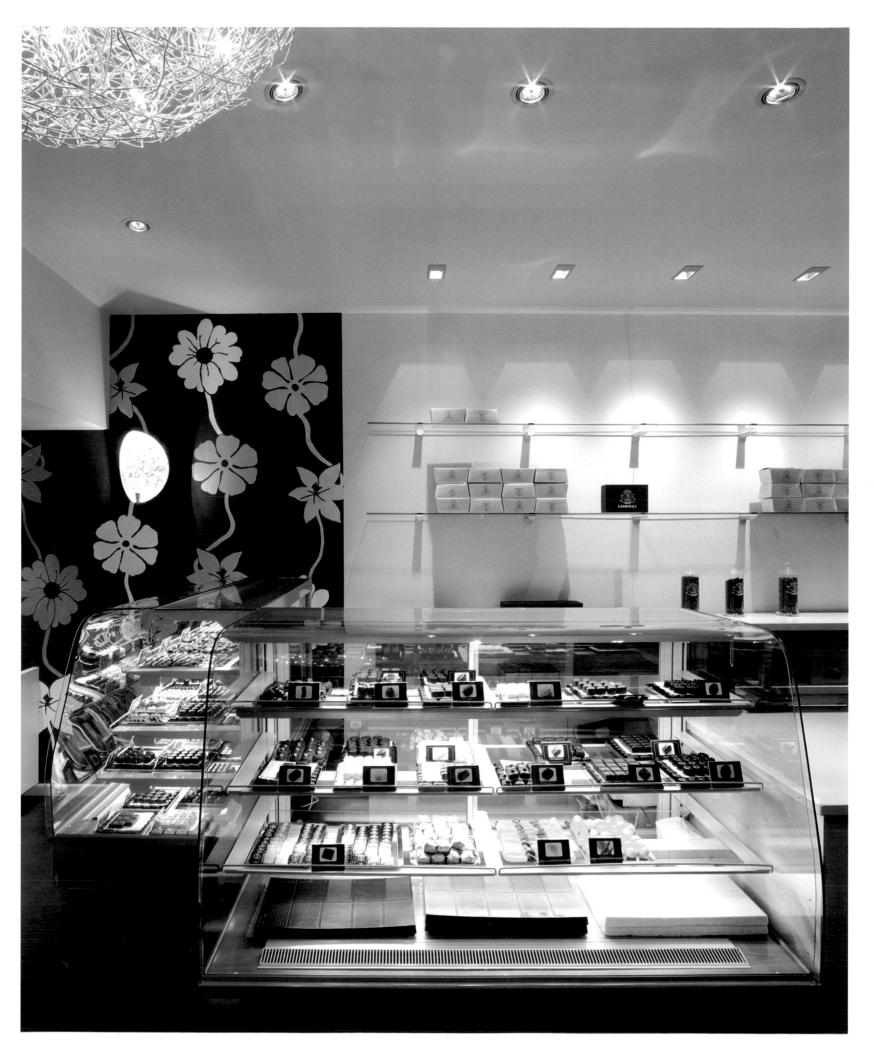

>Camper FoodBALL

Architect: Martí Guixé

Location: Barcelona, Spain

Photography: imagekontainer.com

Although from its name it might not appear as such, FoodBALL, a creation of the shoe company Camper, is a food shop, a bar, a fast-food restaurant, and potentially a compulsory meeting place for those who pass through the Raval district in Barcelona.

The space is divided into three parts: the entrance, containing the main sales counter and into which you can bring your bicycle; the kitchen; and the dining area, which was designed to resemble stadium bleachers on which people can sit and chat as though they were in the stands at a sporting event. The walls feature drawings done by the designer, Martí Guixé and represent the idealization of the rural world, with axonometric figures that resemble those in video games. These pictures convey information to customers concerning nutrition and prices of food on the menu.

Martí Guixé designed FoodBALL with the intention of promoting roadside food and creating a different way of eating. The physical space was conceived on ecological principles and built using bioconstruction concepts, utilizing nonpolluting materials and consuming green electricity. Like the space itself, the food is unusual. The main attraction is balls of rice mixed with various organic ingredients that are all made by hand and contain no additives or preservatives. The rice balls, both sweet and savory and appropriate for eating at any time of day, are displayed according to flavor and texture at the main sales counter, which takes the form of a glass box. FoodBALL also serves other macrobiotic dishes, including salads, rice, and vegetables, as well as purified tap water and fruit juices.

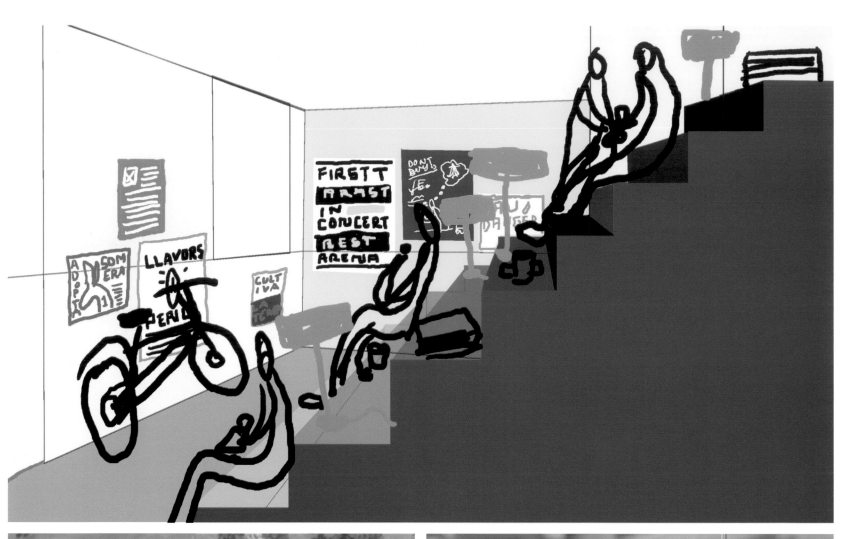

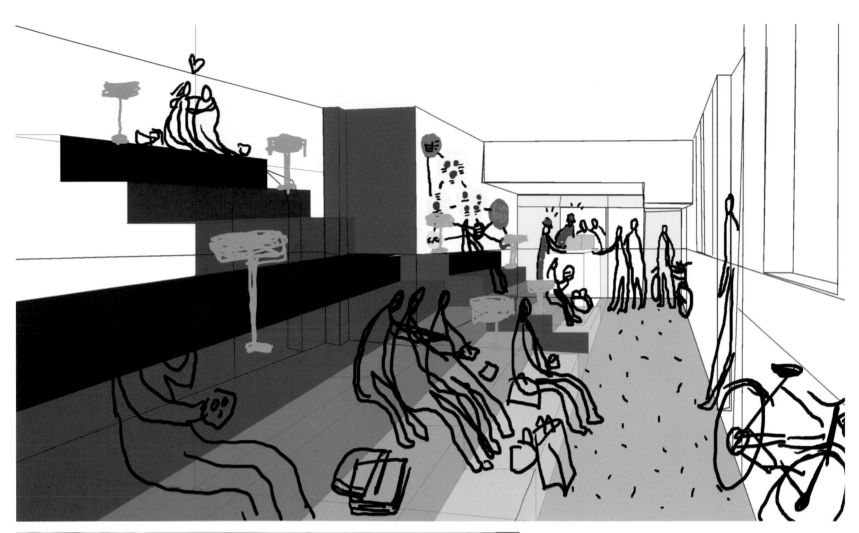

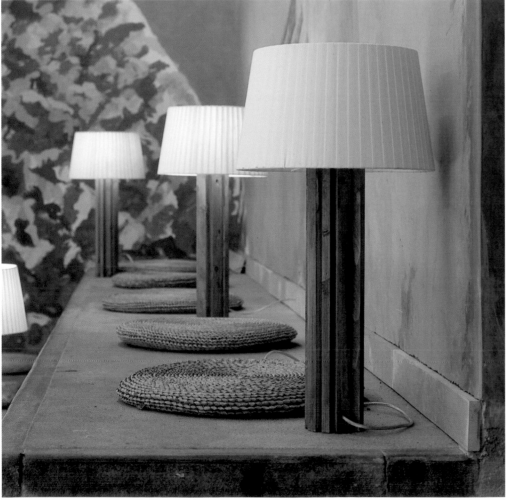

> FoodBALL offers customers the option of eating while sitting on the stadium-style bleachers inside. The place was built on the principles of bioconstrucion, uses non-polluting materials, and consumes green electricity.

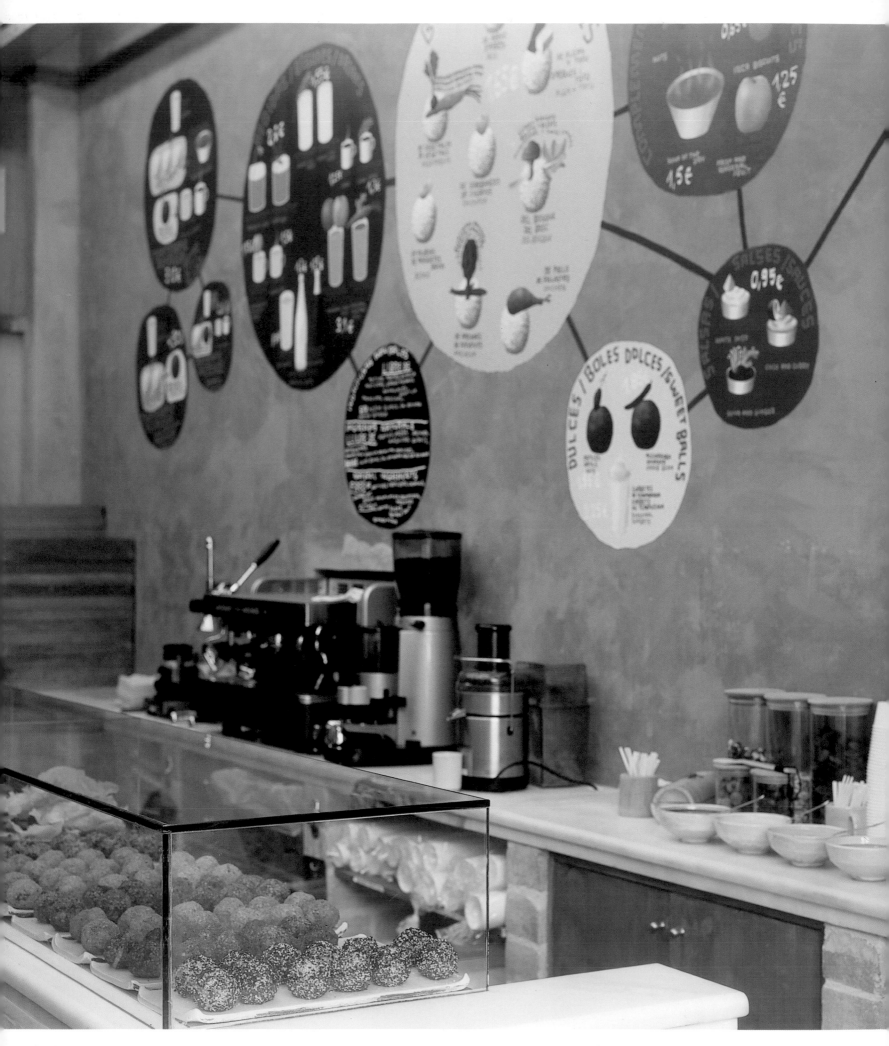

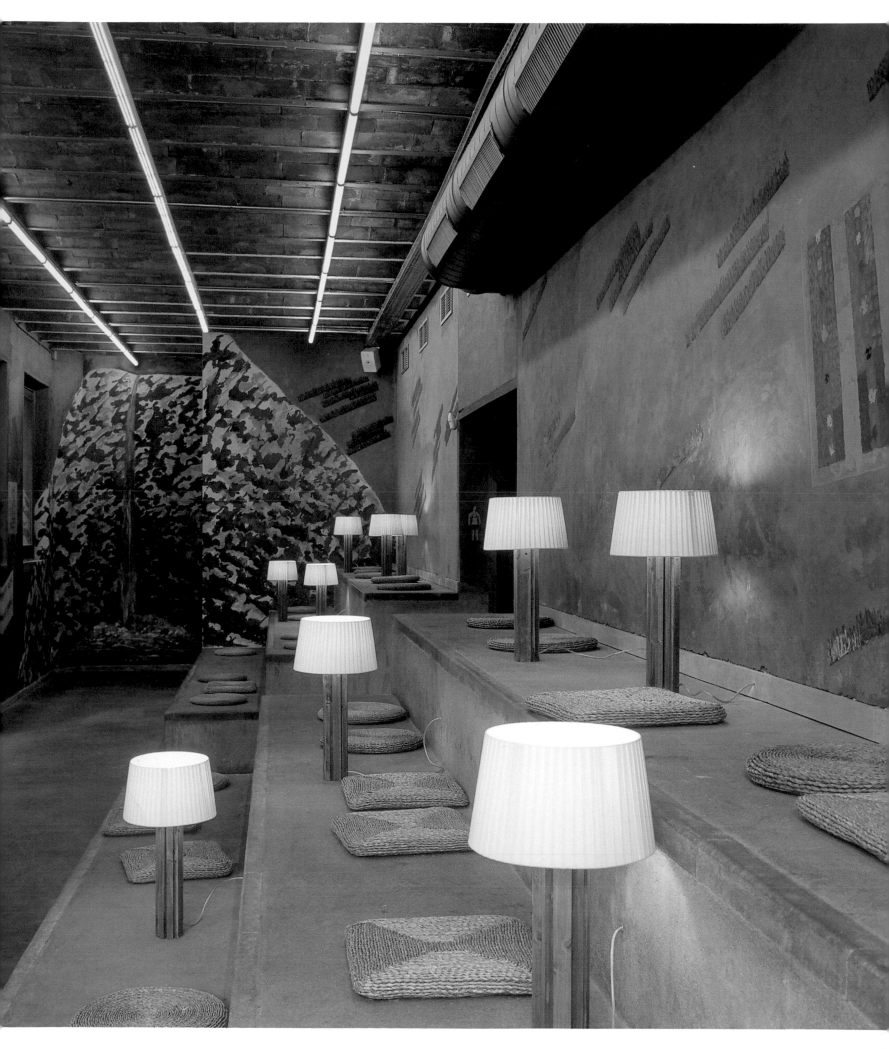

> Transport and Store

This chapter explores different display possibilities available through immediate commercial solutions based on systems of easy transport and storage: wheels that aid mobility, multiple drawers to store the products that are not on sale, shelves that can modulate their capacity, and even systems that simplify retrieval of the product. This is a selection of the best display fixtures in commercial spaces that facilitate purchases by customers while displaying products conveniently and easily.

> Stéphane Marais

Architects: Sergio Calatroni Art Room
Location: Paris, France
Photography: Sergio Calatroni Art Room

For Stéphane Marais it is all about emotions, and makeup is his secret weapon for achieving unexpected and intense esthetic effects. Marais teamed up with Italian designer Sergio Calatroni to create an ideal atmosphere in which to sell his cosmetics.

The first of these spaces, located next to the shop Colette, in the rue Saint Honoré in Paris, was conceived as a workshop where clients could explore the world of color and cosmetics. Marais imagined an unconventional space in which people could move around freely and become involved in the process of selecting colors to enhance their appearance. To execute his idea, he commissioned Calatroni to design a series of fixtures that would display the products with animation and color.

Calatroni came up with 12 unique modular units, each of which features its own particular line of Marais products. These units are built from various materials, including Corian, transparent Perspex, aluminum, oxidized metal, and Cuban wood, which were selected to reflect the lively but nonetheless elegant overall esthetic of the space. Each module is equipped with wheels to allow it to be moved easily.

The synergy between Marais and Calatroni is evident in the unique presentation of the products as they are displayed. In keeping with Marais' belief that "colors speak the language of the heart," the products are featured in glass cases that take inspiration from diverse sources including nature, urban settings, art, architecture, and graphic drawings and icons. For now, Marais' cosmetic line is sold only at this Parisian outlet; however, other European cities such as Milan, London, and Berlin are next in line.

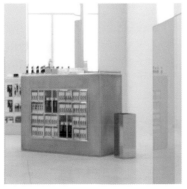

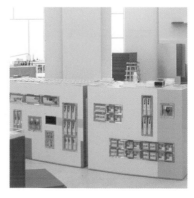

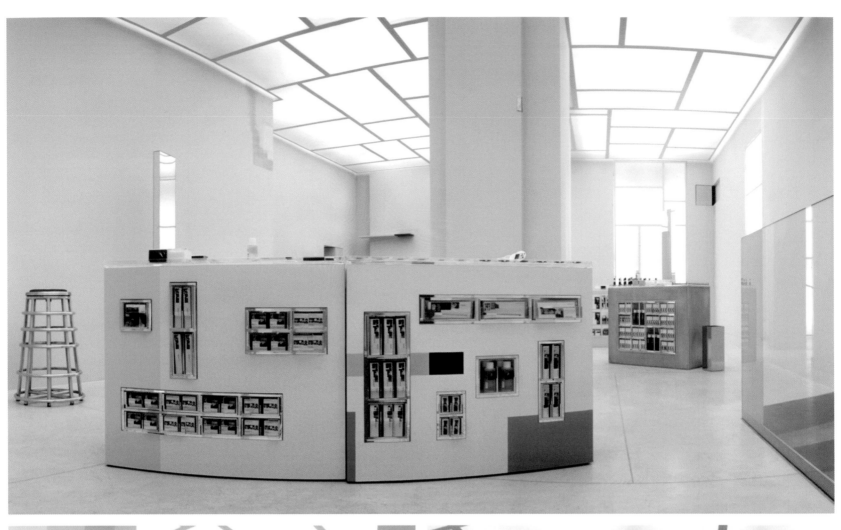

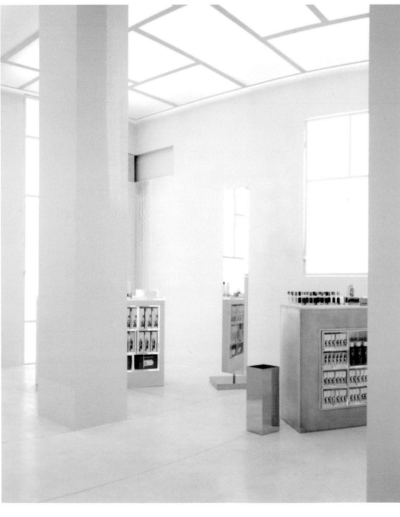

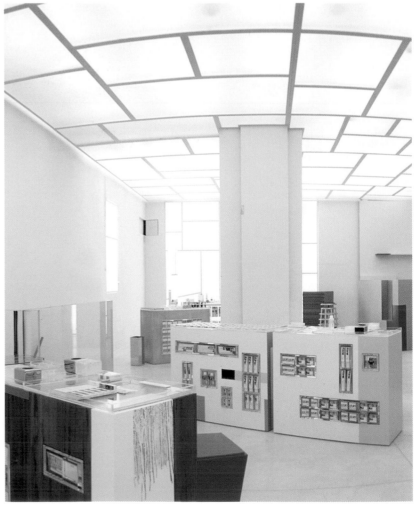

> The modular display units were designed to be as practical as possible, and they are different from other, traditional display systems.

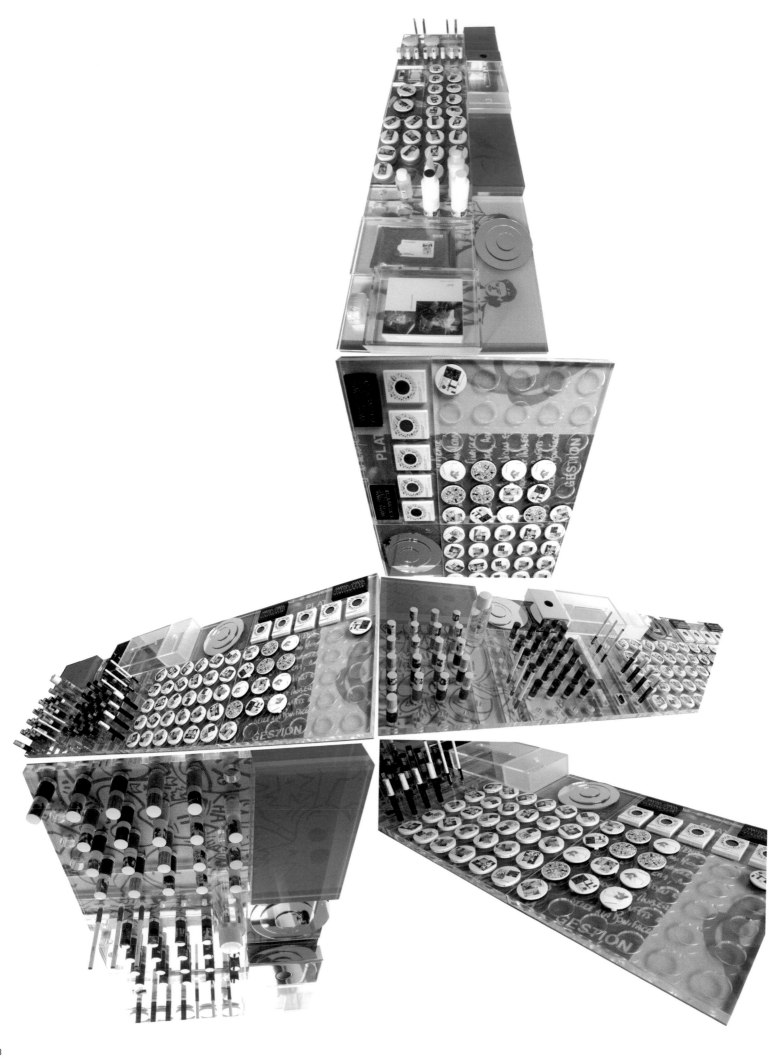

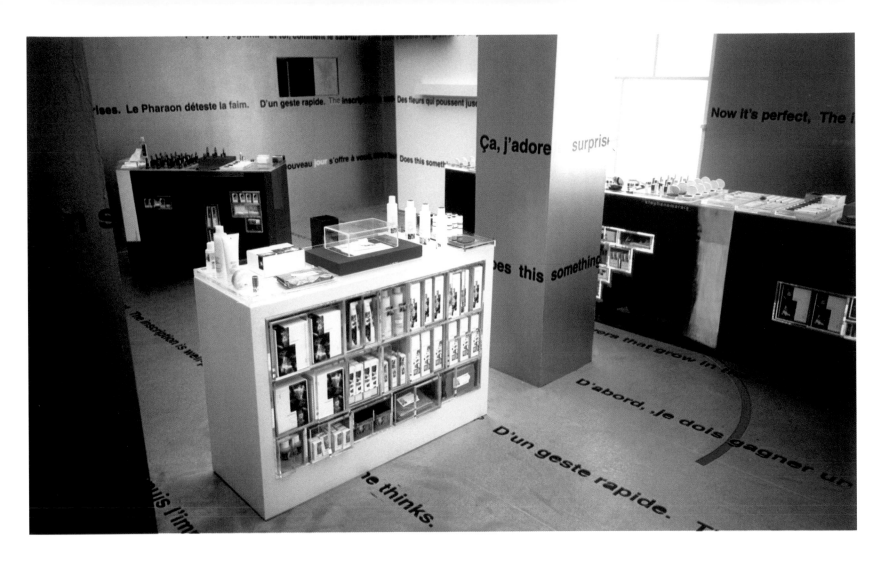

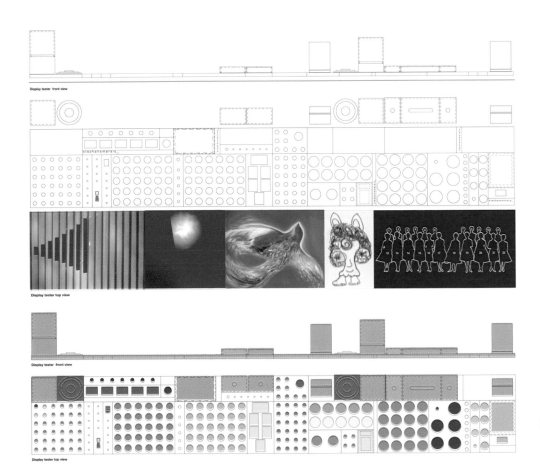

Display tester front view

Display tester top view

Display tester front view

Display tester top view

> Like the packaging of the cosmetics, the purchase points
are based on the concept of color that, according to
Marais, speaks the language of the heart.

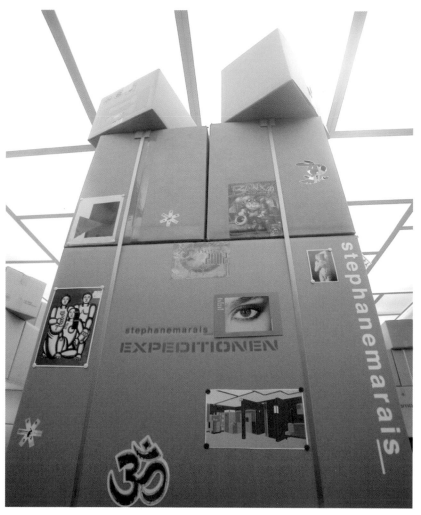

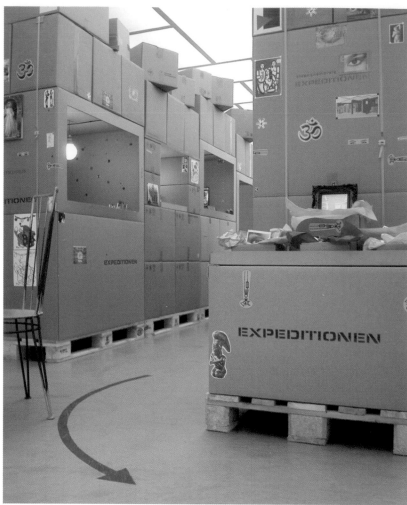

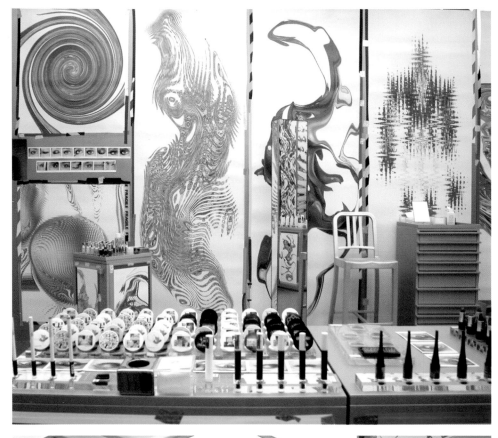

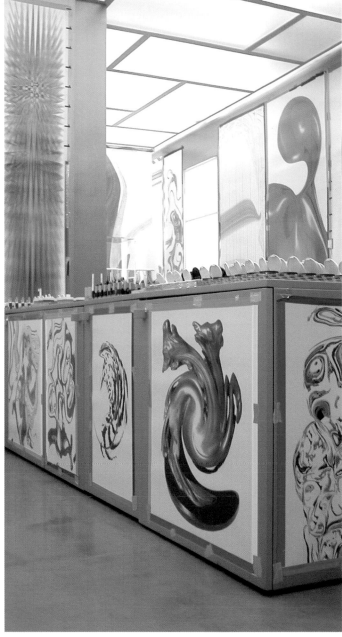

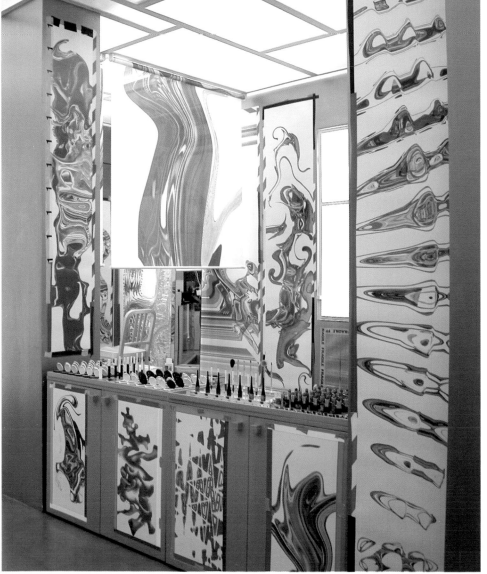

> The explosion of colors comes together at this sales point inspired by abstract graphic icons and natural forms. On the sales counter, the cosmetics are organized according to their function and color.

>Rodenstock Gallery

Architects: Shuhei Endo Architect Institute
Location: Tokyo, Japan
Photography: Nacasa & Partners Inc.

German eyeglass brand Rodenstock commissioned Japanese architect Shuhei Endo to design the first of their shops in Japan. Located in Tokyo's Ginza district, an upmarket shopping area, Rodenstock sees itself as a new generation of optician for which the display of products is perfectly integrated into the structure of the space in which they are featured. Thus, the designer's approach to this project was to adhere to the principles of simplicity and maintain respect for the product on display.

The space was based on a circular plan and is notable for its expanse of white walls against which circular panels of various sizes are arranged. These panels were intentionally designed by Endo to incorporate functionality and lend flexibility to the showroom: They serve as shelves for displaying the eyeglasses, incorporating a small mirror, and they also rotate, making it easy for customers to access the displayed eyewear.

The quality of the materials used for the display fixtures and the neutral color of the walls enhance the impact of the lighting system on the merchandise, showing it off to best advantage. The bright green of the carpeting, which brings to mind an interior golf course, provides an intense contrast to the rest of the setting. A small area at the rear of the shop, designed in warmer tones, is reserved for buyers to sit and relax while they try on glasses.

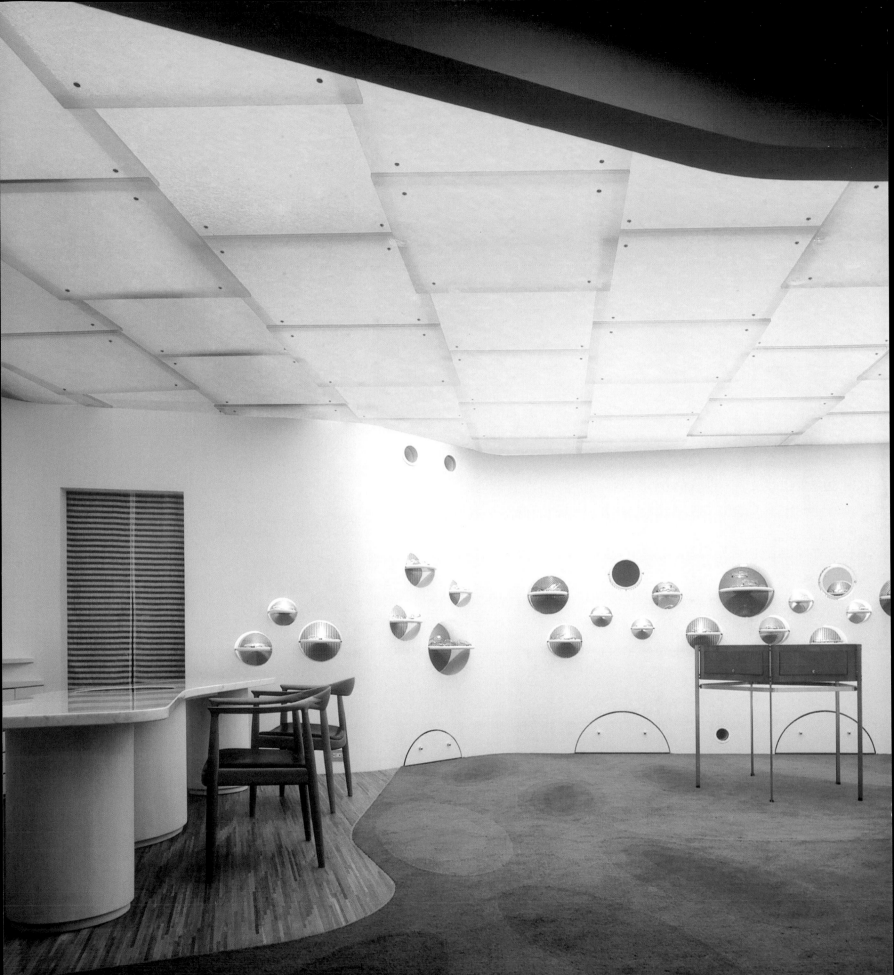

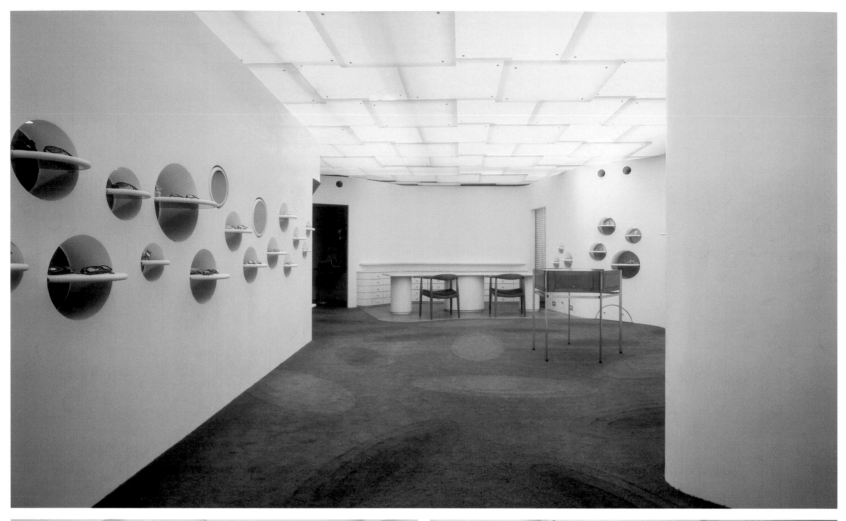

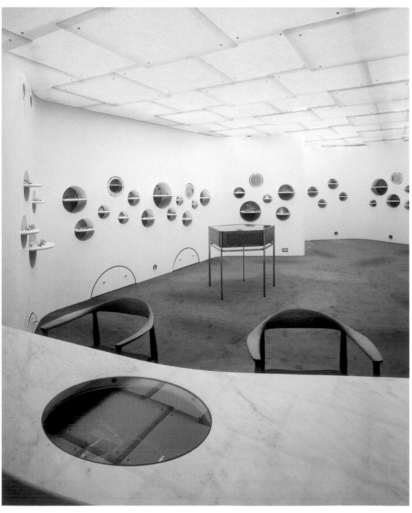

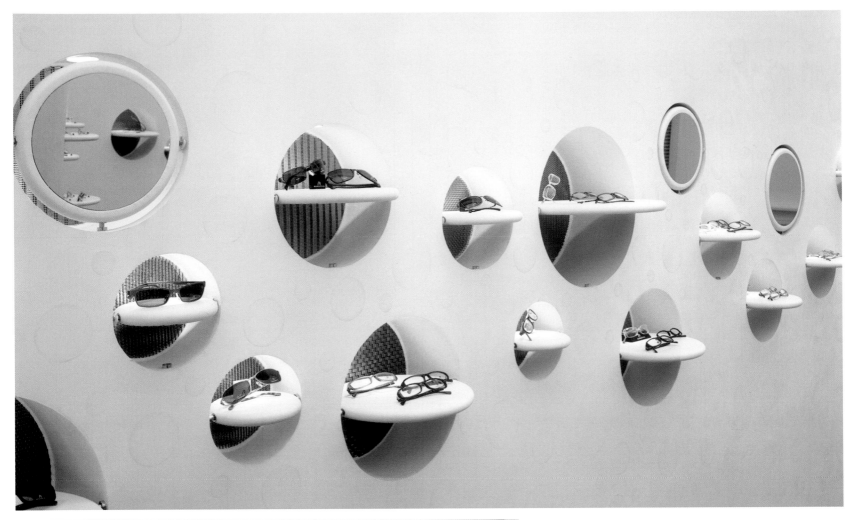

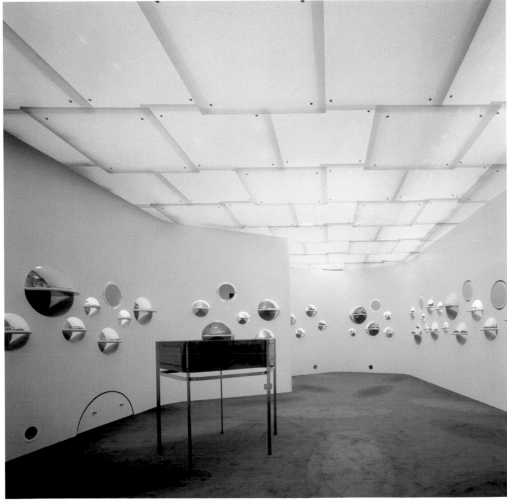

> The flexible display system has a double use: the fixtures serve as shelves to display the glasses and also incorporate a small mirror. The ceiling is covered in overlapping lighting panels.

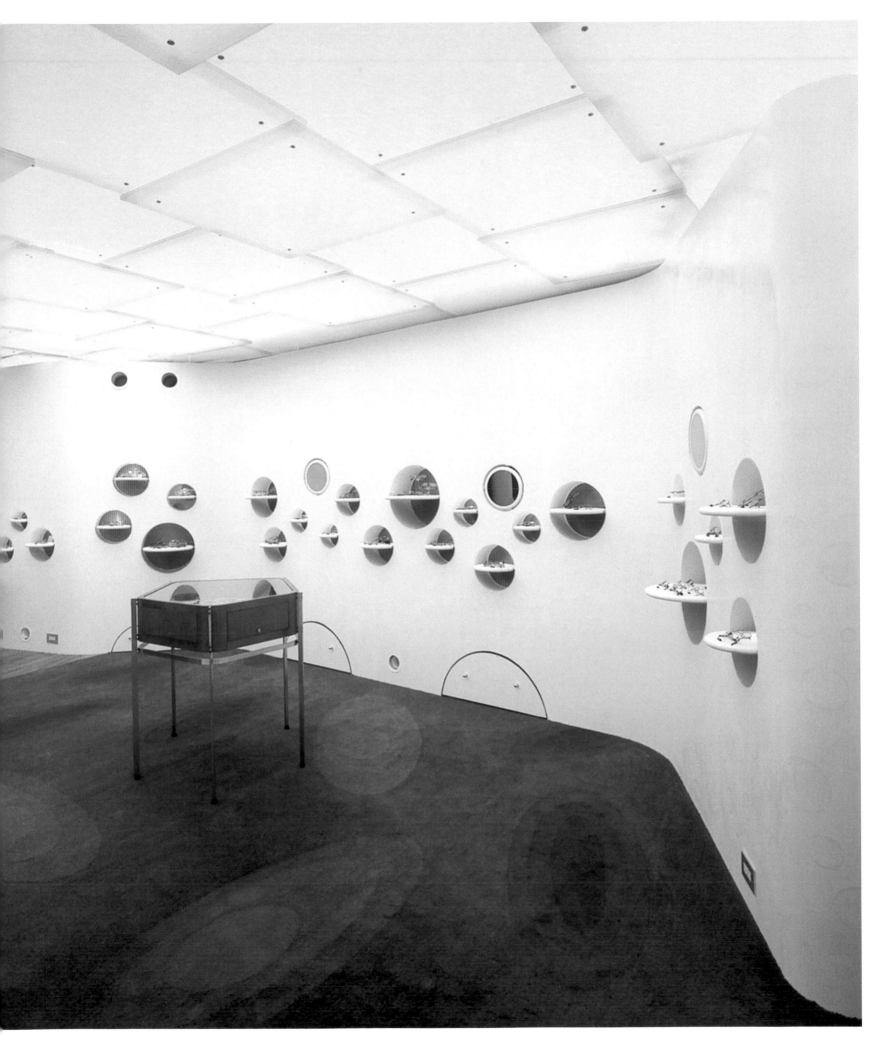

>Template in Claska

Architects: Torafu Architects
Location: Tokyo, Japan
Photography: Daici Ano

Claska, a nine-bedroom hotel that inhabits a 1960s-era building in Tokyo, has become a very popular place thanks to the uniqueness of its rooms. Because of the reduced dimensions of the rooms, which measure only about 195 square feet, Torafu Architects came up with a thoroughly innovative storage concept consisting of a customized hollow structure with outlines cut into it in the shapes of the items it contains— for example, a hair dryer, a suitcase, a lamp, a coat, shoes, an alarm clock, and even a doghouse for AIBO, the adorable Sony robot dog.

MDF mahogany was chosen for this multifunctional storage stystem. The outlines of the objects in each storage unit were cut into it with great precision using a laser that is also used in the Porsche factory. When you enter one of these rooms, you see the outline of a jacket, for example, and know exactly where to hang yours. There is even a system for hanging jewelry. At one end of each room, a foldaway table is integrated into the wall and can be pulled down to create a small study area. Even the television is worked into this system without taking up unnecessary space.

This concept represents a refreshing perspective on the design of a new generation of hotels that transform the overnight stay into a unique and unforgettable experience.

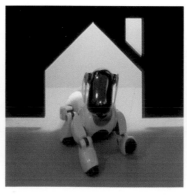

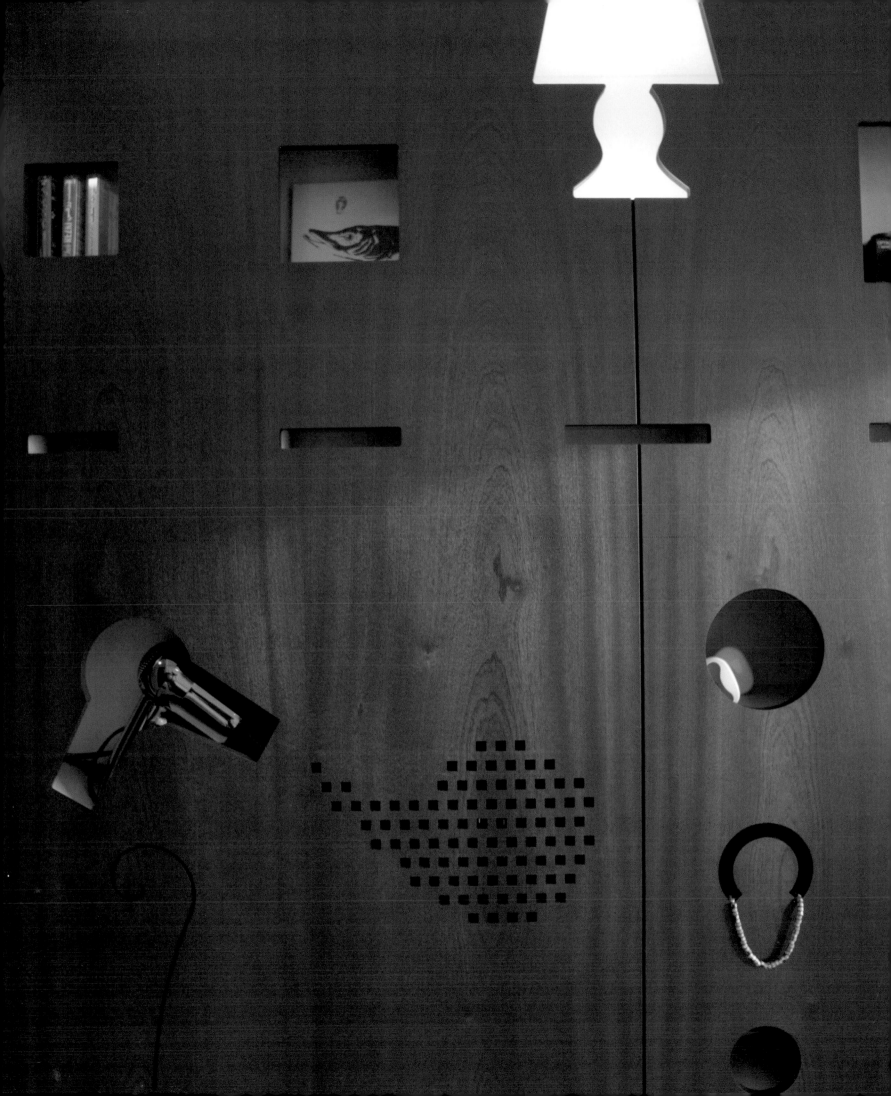

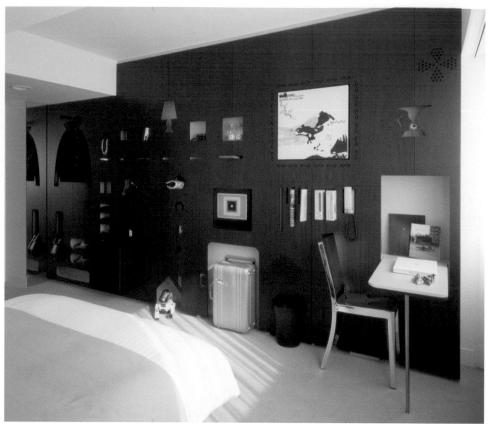

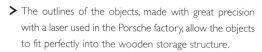 The outlines of the objects, made with great precision with a laser used in the Porsche factory, allow the objects to fit perfectly into the wooden storage structure.

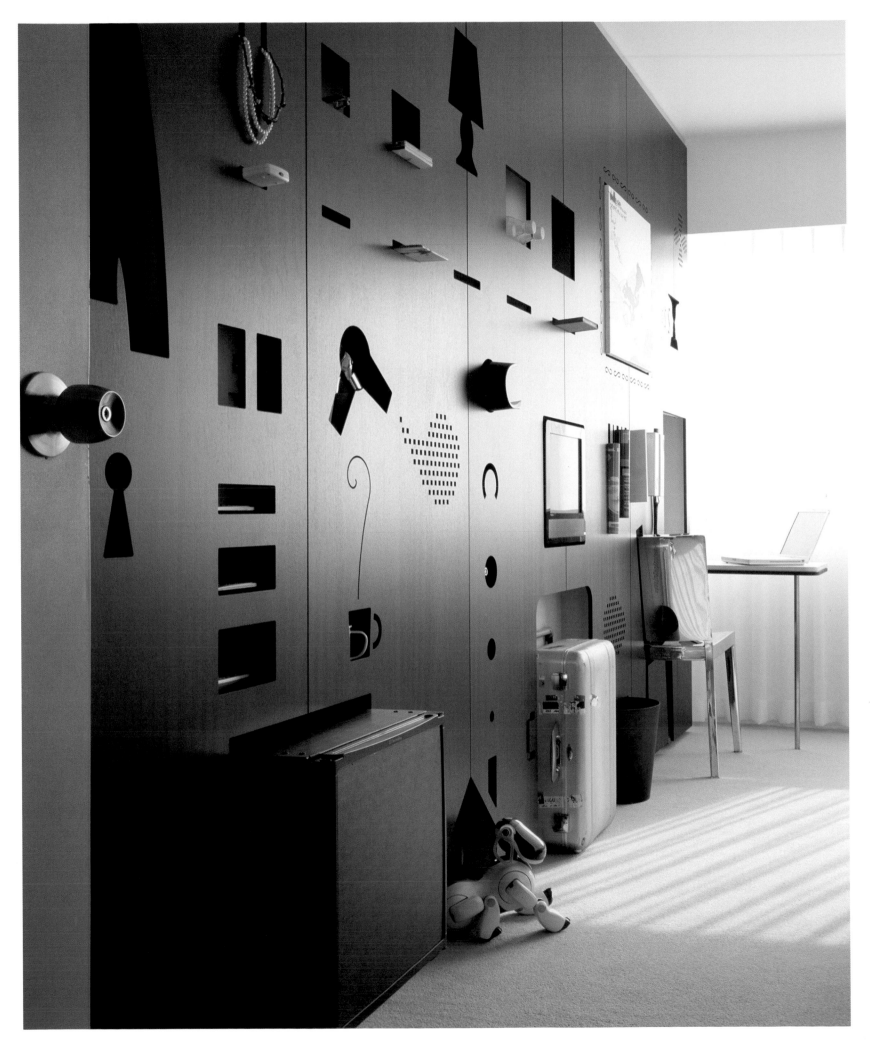

>Me, Issey Miyake

Architects: Curiosity
Location: Tokyo, Japan
Photography: Yasuaki Yoshinaga

Me, the new brand from Japanese designer Issey Miyake, sells mainly single-size T-shirts. Although the shirts are cut narrow, they contain a stretch material, making the size universal. This new concept is based on the globalization of sizes and allows everyone to own an Issey Miyake T-shirt.

The 215-square-foot space in which these T-shirts are sold is likewise based on a new concept: self-service, which redefines the buying process as a direct interaction between the buyer and the product. The T-shirts are packaged in plastic tubes, which have been specially designed to display the shirts by color and texture. These tubes, dubbed by the designers as "PETs," resemble a mineral water bottle, opening from one end and displaying the brand logo on the front. They are arranged inside a transparent display system from which customers can select a tube containing the shirt of the desired color and style. When a tube is extracted from the display, another one automatically appears to take its place. No additional packaging is necessary; customers serve themselves, then take the T-shirt tubes home to be recycled after the purchase.

The novelty and ingenuity of this self-service display system attracts the attention of potential buyers, rendering them unable to resist the temptation of selecting a tube for themselves.

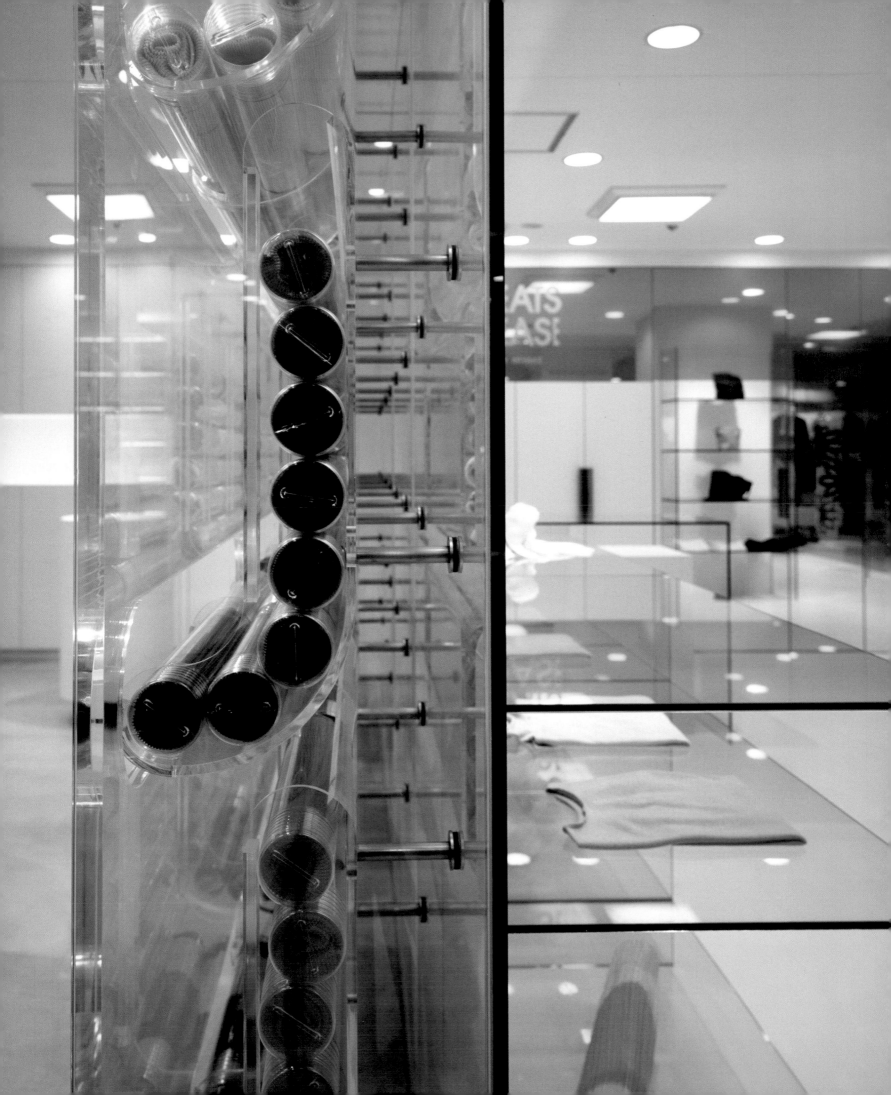

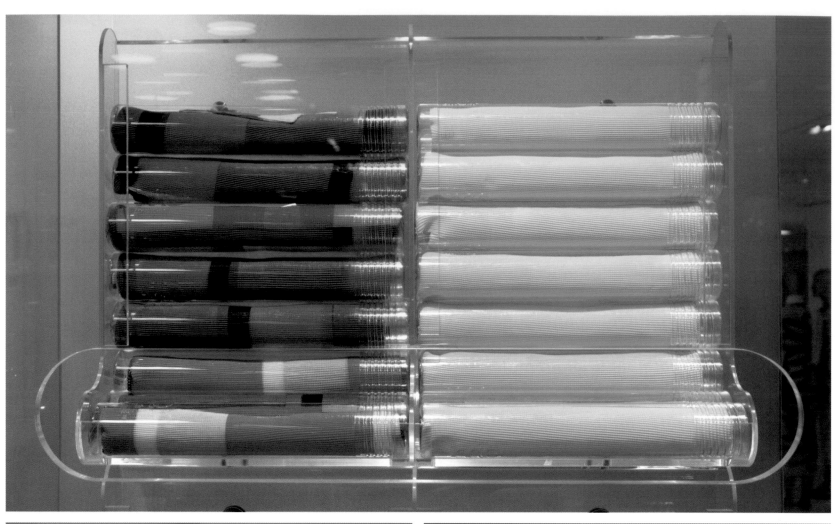

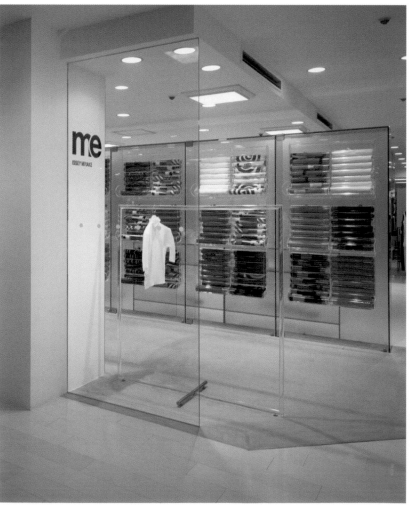

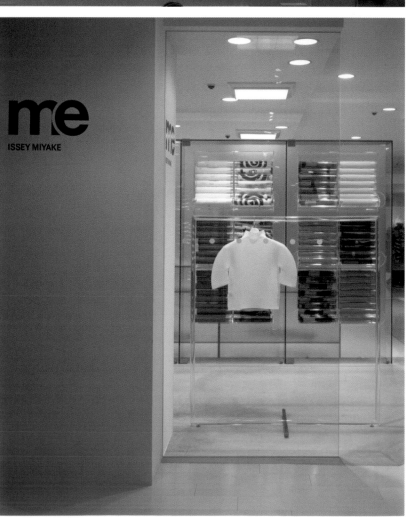

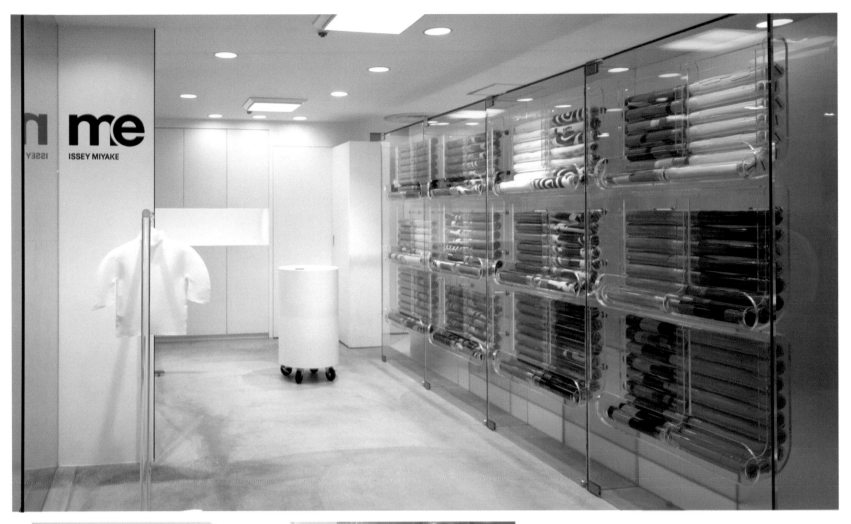

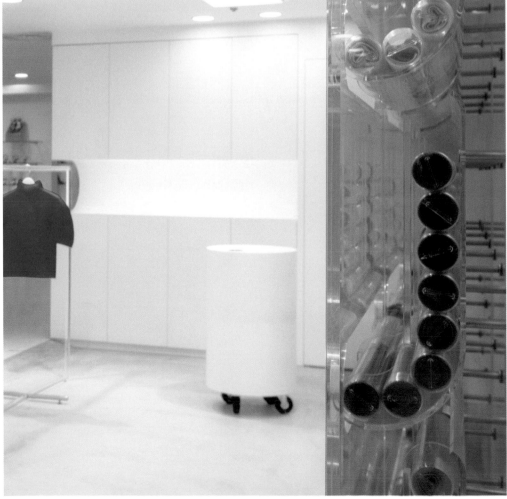

> The display case, designed by Curiosity, is based on a transparent system that contains plastic tubes (PETs) that buyers themselves can extract and recycle after the purchase.

>LA Philharmonic Store

Architects: Belzberg Architects
Location: Los Angeles, California, USA
Photography: Tom Bonner Photography

The LA Philharmonic Store, inside the Los Angeles Walt Disney Concert Hall, sells products related to music and various merchandise connected to the orchestra. In developing the sales concept for the interior of this shop, Belzberg Architects aimed at creating a versatile and open space integrated with the surrounding architecture of the concert hall.

The focal point of the shop is the shelving system, which is an essential element in the conception of this space and determines the layout. Each shelving unit consists of a framework of steel bars extending to the lights recessed into the ceiling. Multiple horizontal wooden shelves are stacked across these bars and are shaped such that CDs and other merchandise can be displayed at various heights in the stacks. The stacks of shelves can be raised or lowered in different combinations to allow for a variety of display formats, depending on the desired use. The wooden base can be used to display more CDs and books, and it also incorporates drawers where extra inventory can be stored.

Steel V-shaped beams preside over the space itself. The shop contains additional display points, including box containers and hanging racks, that showcase other types of merchandise from the Los Angeles Philharmonic.

 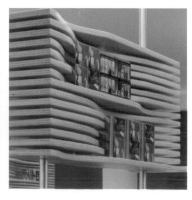

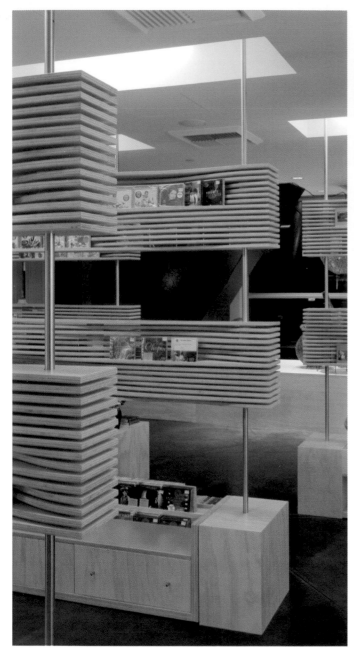

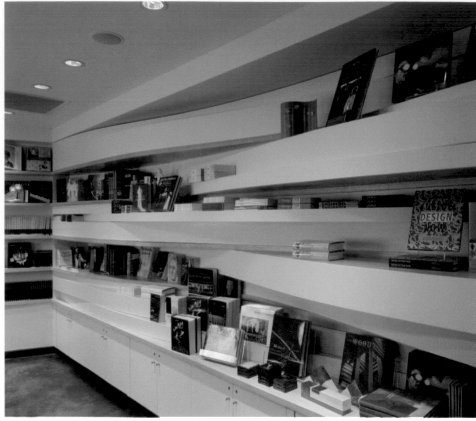

> The shelves are formed from steel bars that support wooden strips, piled one on top of another, which can be moved depending on their intended use.

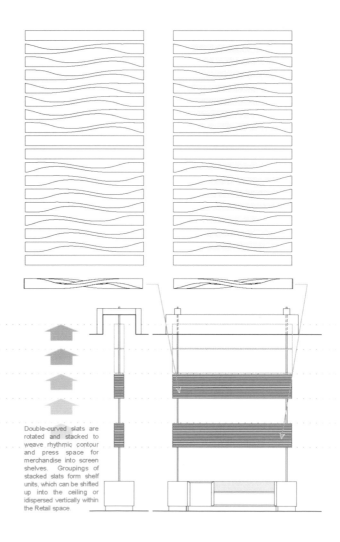

Double-curved slats are rotated and stacked to weave rhythmic contour and press space for merchandise into screen shelves. Groupings of stacked slats form shelf units, which can be shifted up into the ceiling or idispersed vertically within the Retail space.

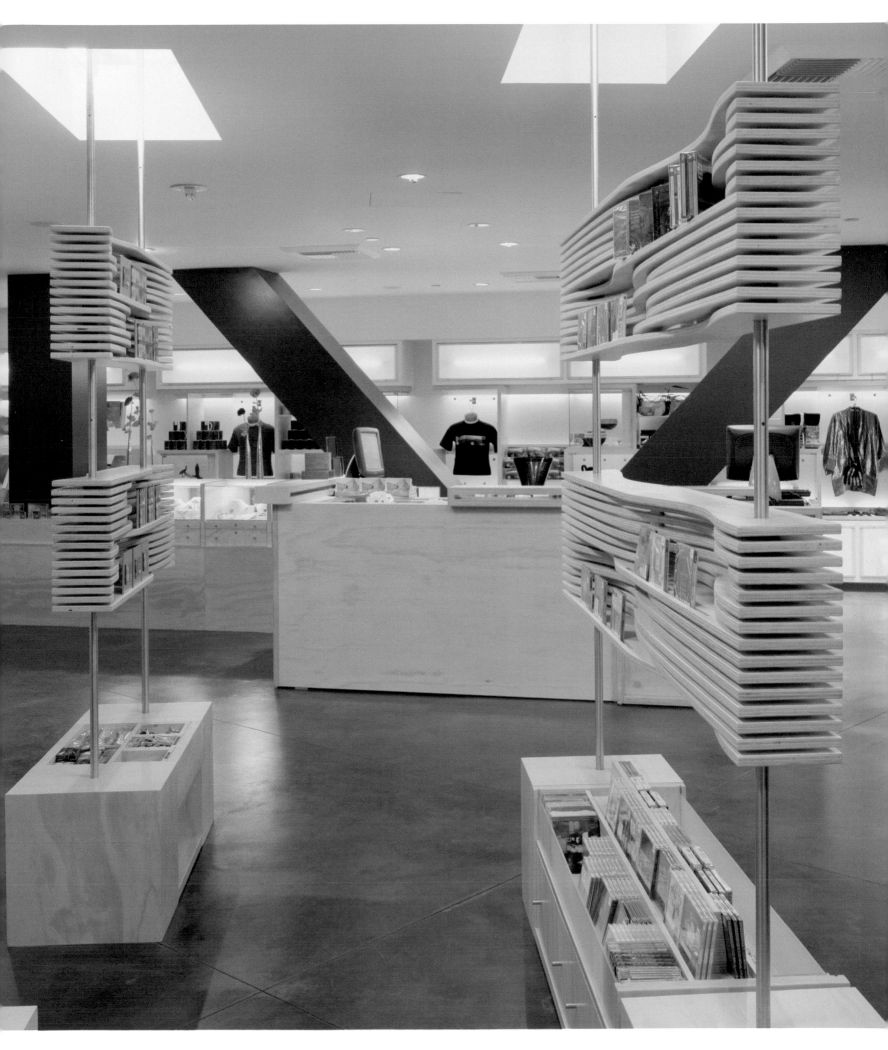

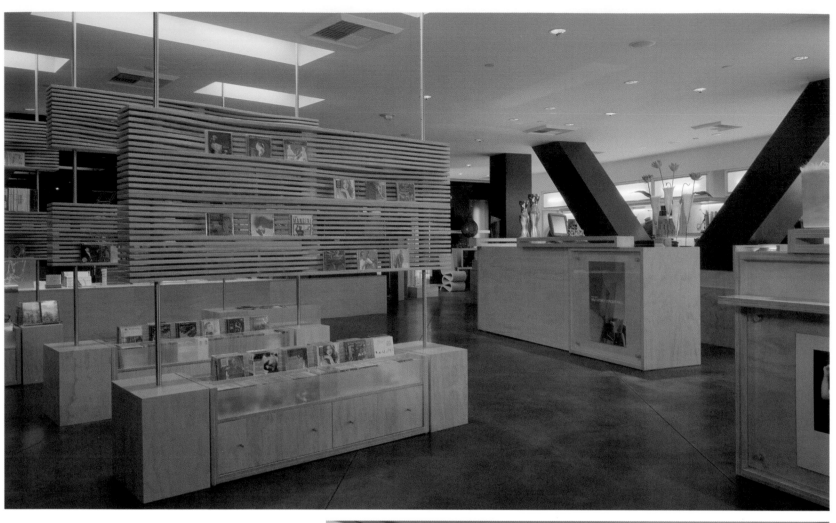

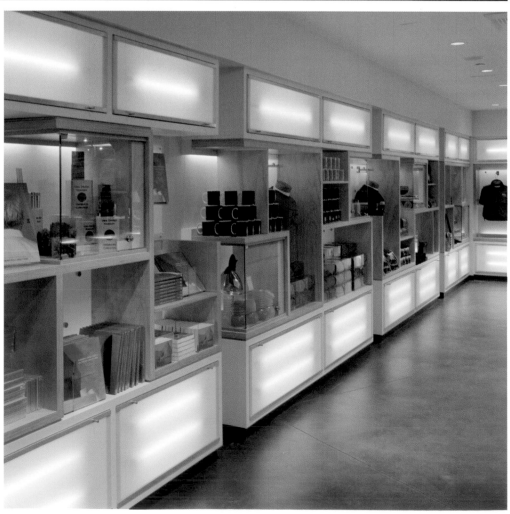

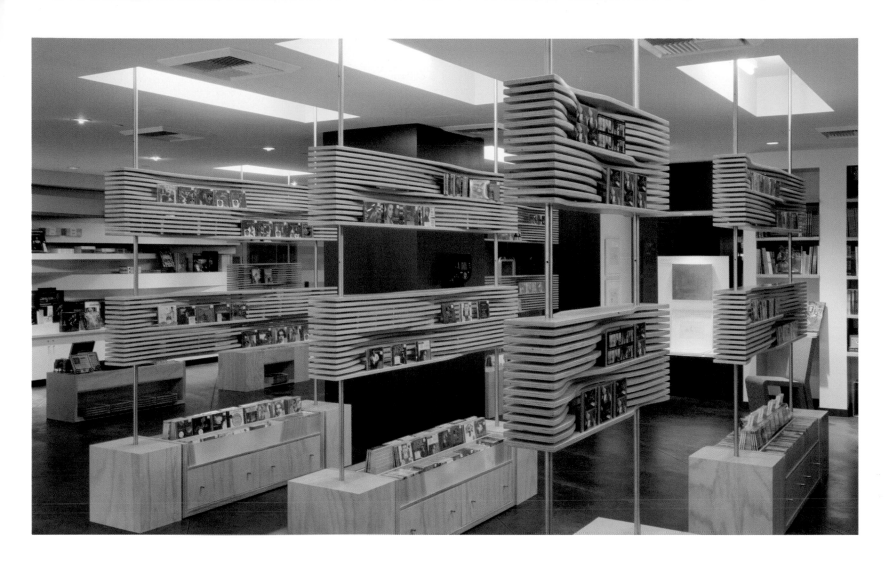

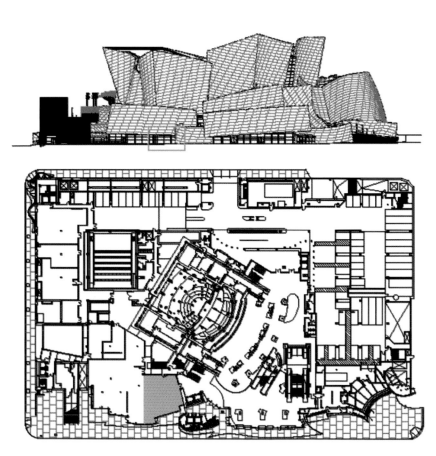

> The base of the wooden structure can be used to display compact discs and books and contains drawers where products that are not on display can be stored.

>The Paul Frank Store

Architects: Giorgio Borruso Design
Location: Los Angeles, California, USA
Photography: Benny Chan

Giorgio Borruso's team based their concept for the Paul Frank store located in South Coast Plaza near Los Angeles on the brand's philosophy. The result is a space that captures the carefree, almost ironic, style of the brand, in which the display mode is matched to the texture and color of the product being shown.

The store was divided into two halves: the right-hand side expressing the lighthearted aspect of the brand, and the left-hand side reflecting a more formal, geometric and controlled aspect. On the right side, one wall bears the message: "Paul, this is your wall. Make a mess! Have all your fun here." This wall was intended to be a point of interaction with true Paul Frank fans, who will also find the store appealing for its bold combination of colors—orange, white, blue, and black. Curved display modules of varying sizes and shapes generate a dynamic in this area, in contrast to the more precise half of the shop.

The display fixtures were designed to showcase the merchandise for sale but without sacrificing the sense of surprise. The depth of the walls, for instance, was exploited by embedding storage and display units in them. Shelving pulls out to reveal storage drawers and sliding cabinets move about allowing customers to experiment with color combinations and to reveal the hidden display units. The overall effect is fresh and youthful—like the Paul Frank philosophy.

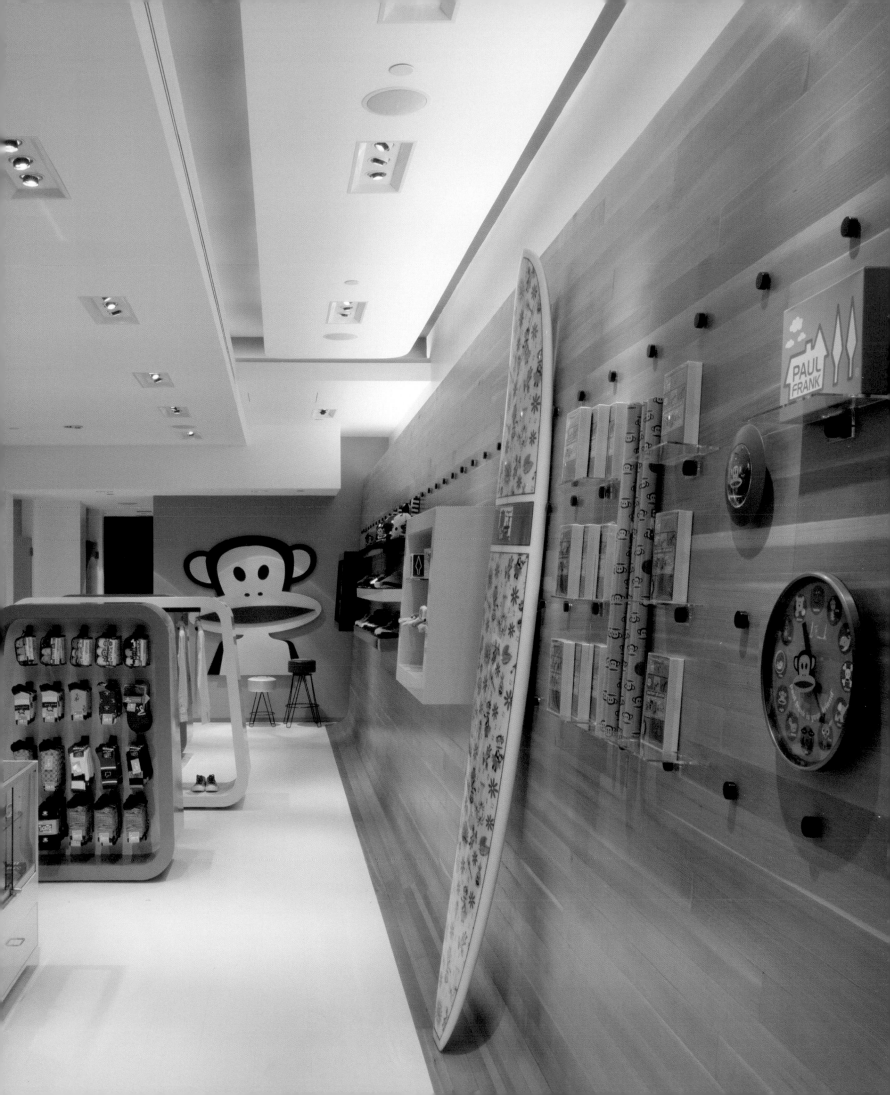

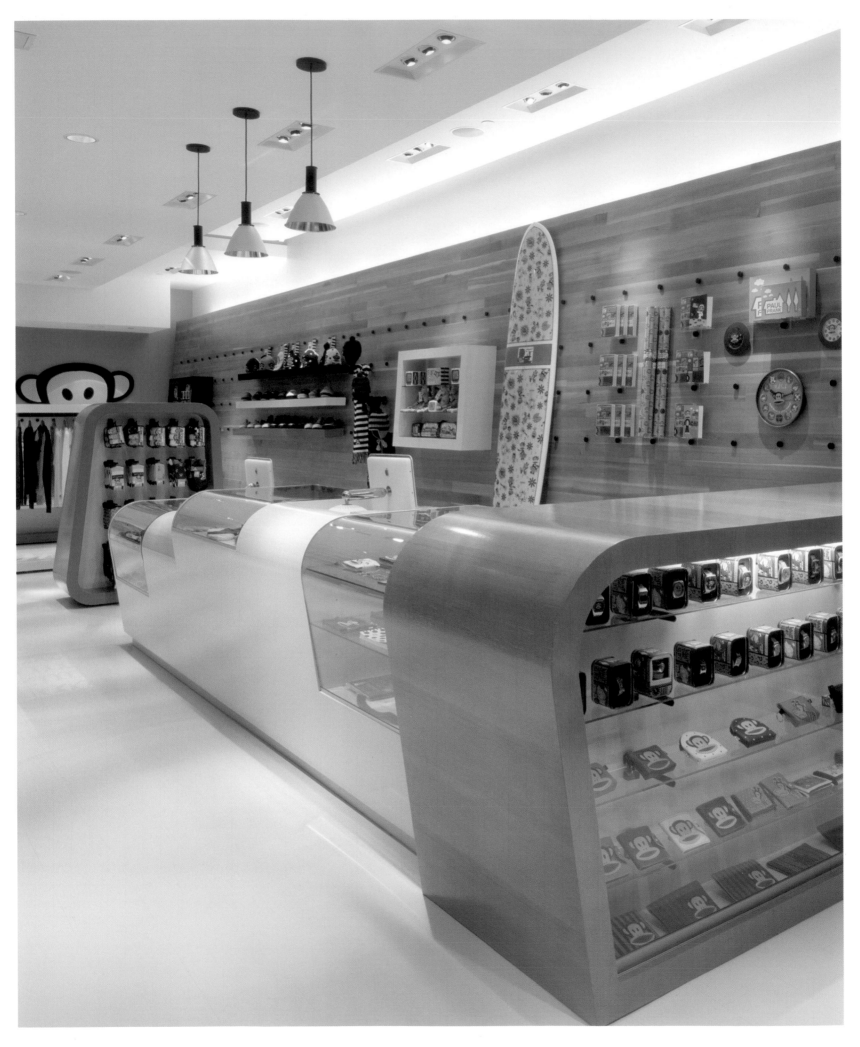

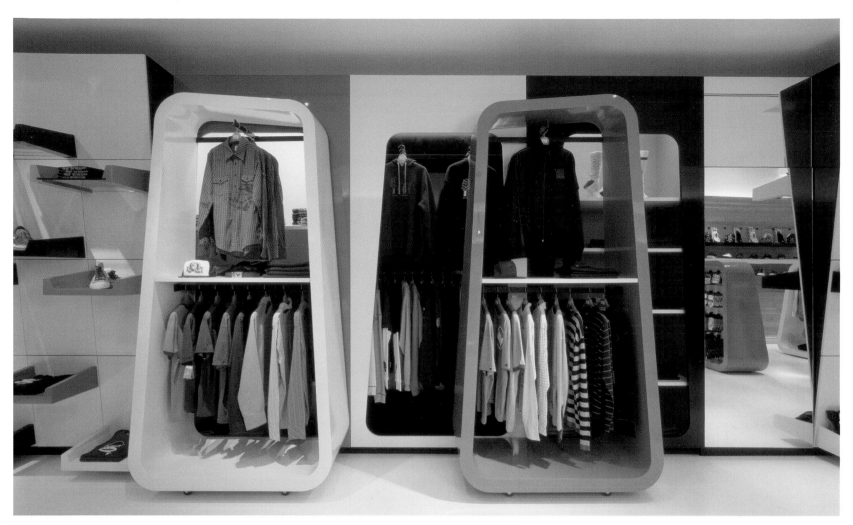

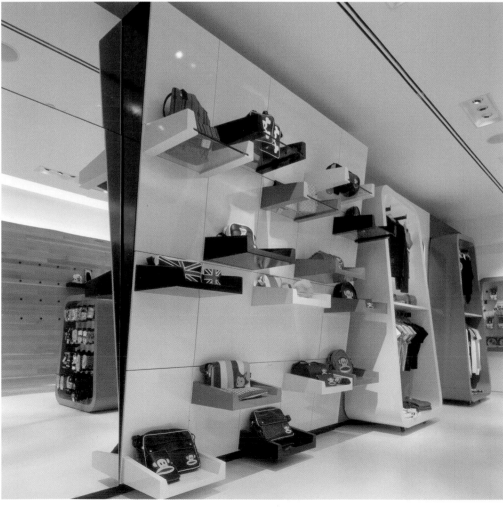

> Extending from one of the walls is a series of individual shelves in striking colors with transparent surfaces on which the merchandise sits.

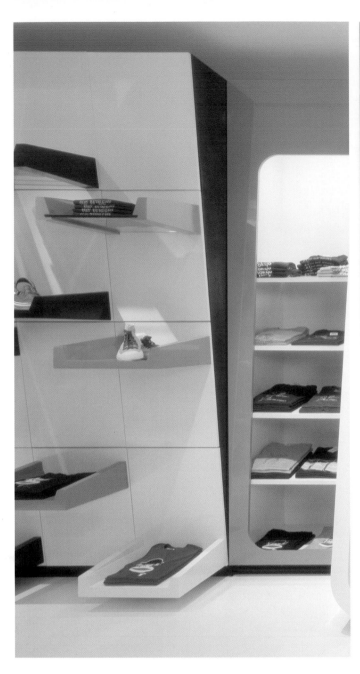

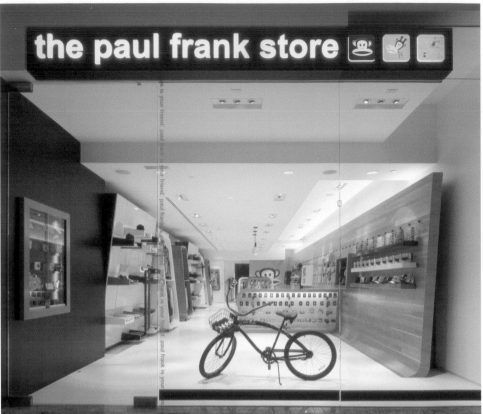

 The sales counter, comes out from the canted wall like
a wave crashing, also reflecting the rounded forms that
can be seen in the shop's display fixtures.

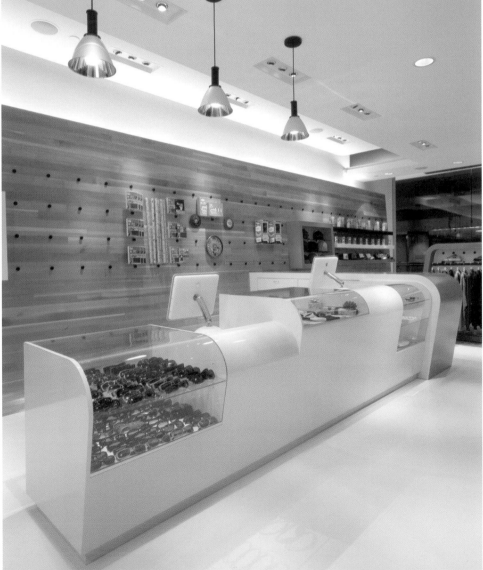

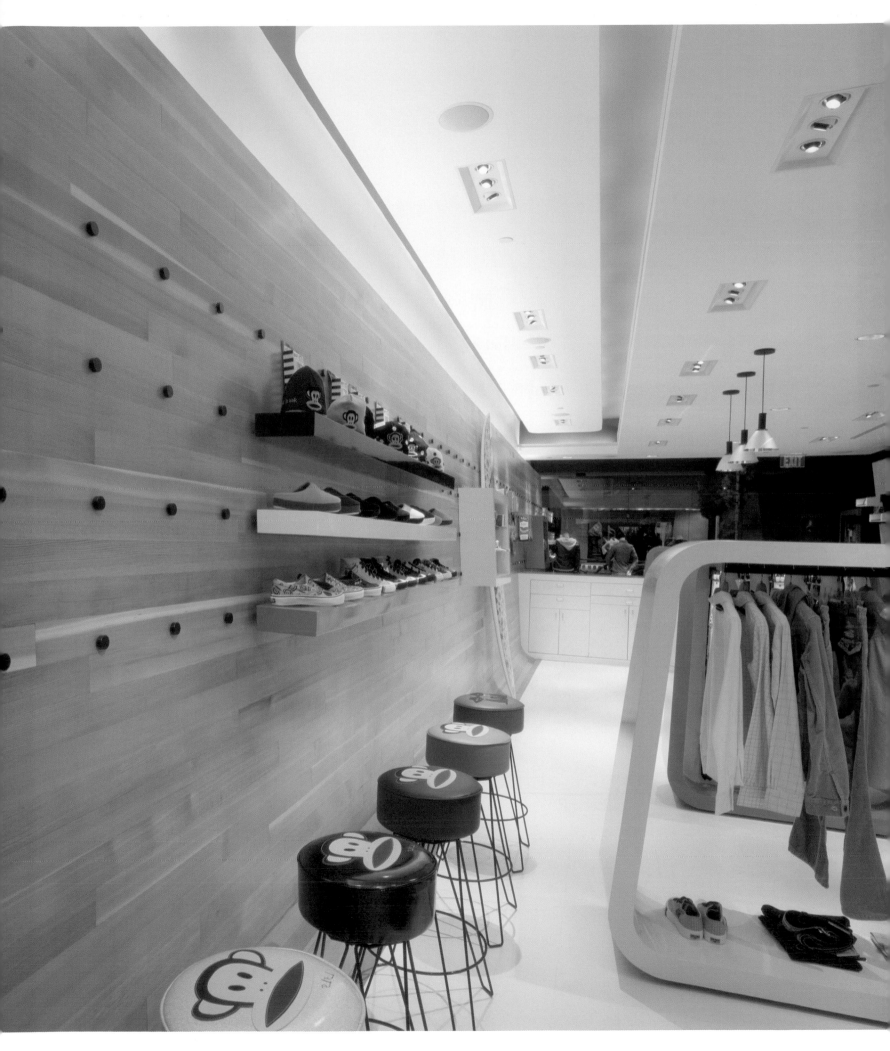

>Pharmacy "Zum Löwen von Aspern"

Architects: Artec Architekten
Location: Aspern, Austria
Photography: Margherita Spiluttini

The problem posed to Artec Architekten in designing this space was how to display pharmaceutical products in an innovative way. The solution they arrived at exploits the spaciousness and height of the shop and uses an unconventional material—concrete—to reinterpret the concept.

The white sales counters are located to one side, where customers can consult the pharmacy staff prior to making their selections. Behind these counters is a system of drawers where additional pharmaceutical inventory can be stored.

Shelving units descend from the concrete ceiling without reaching the floor. They are arranged according to type of product to make it easy for customers to find what they need. A linear lighting system traces the length of the shelving and likewise descends from the ceiling like another architectural element.

The arrangement of the shelving units helps to break up the space, while maintaining a sufficiently open plan to facilitate circulation. The walls are also covered in cement, creating a utilitarian backdrop that gives prominence to the display units.

 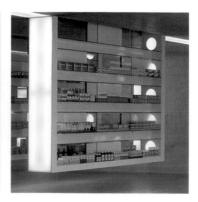

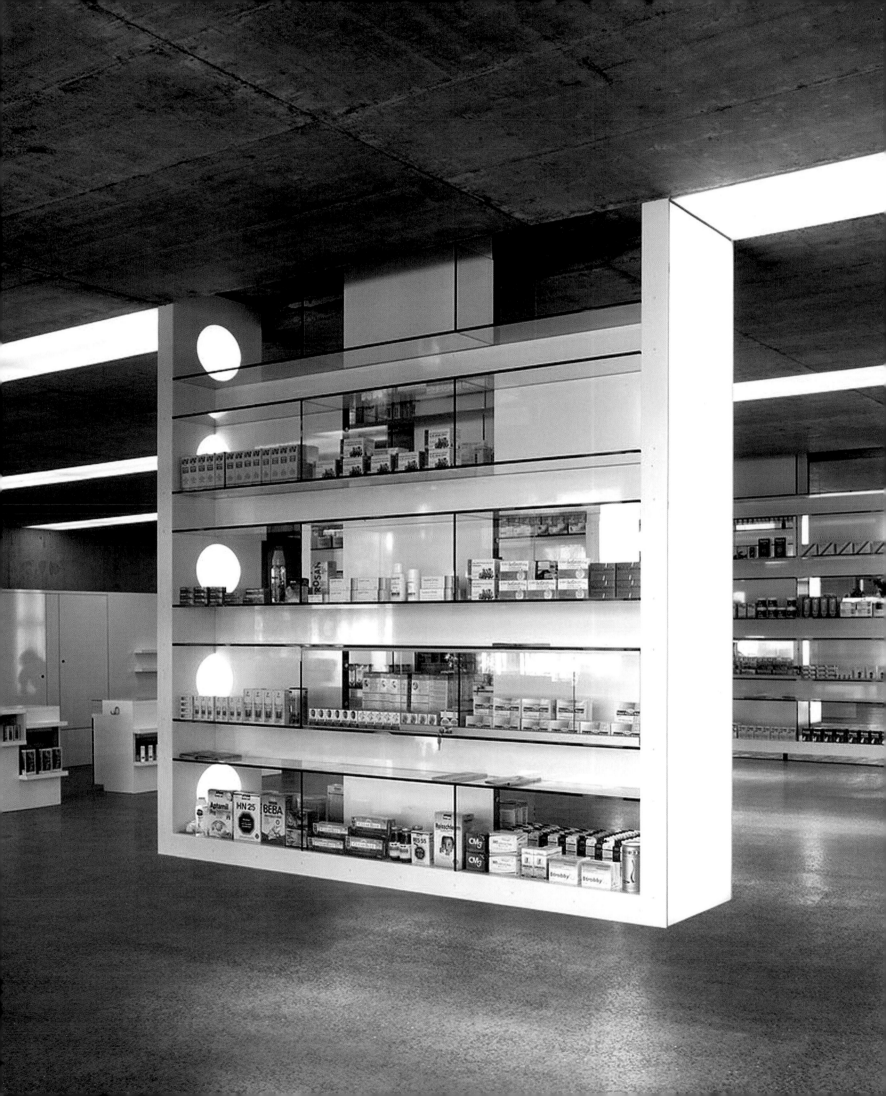

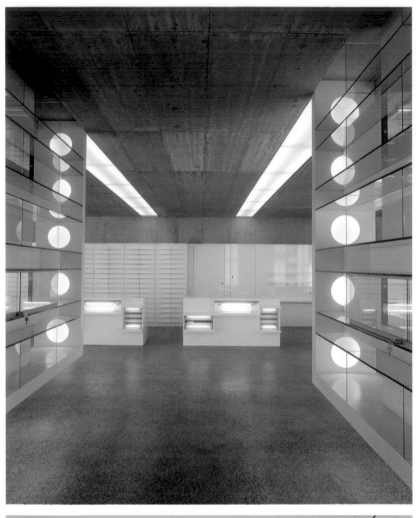

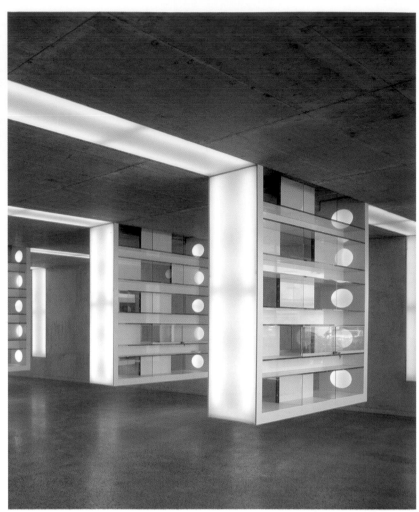

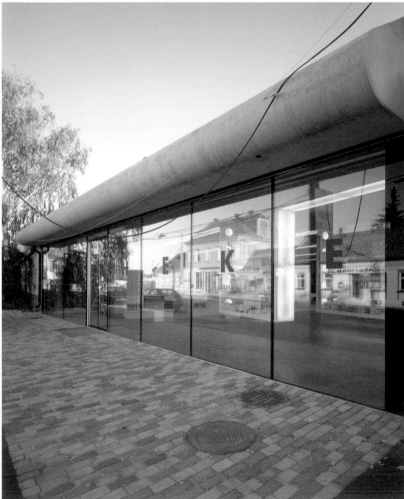

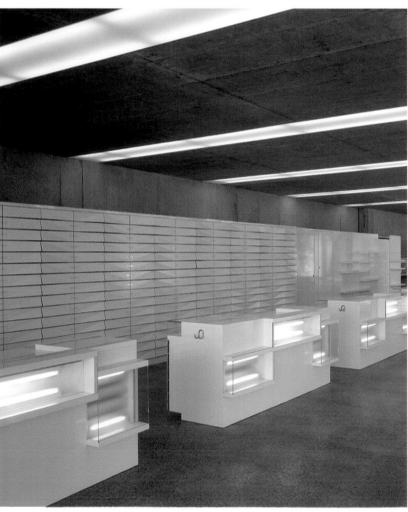

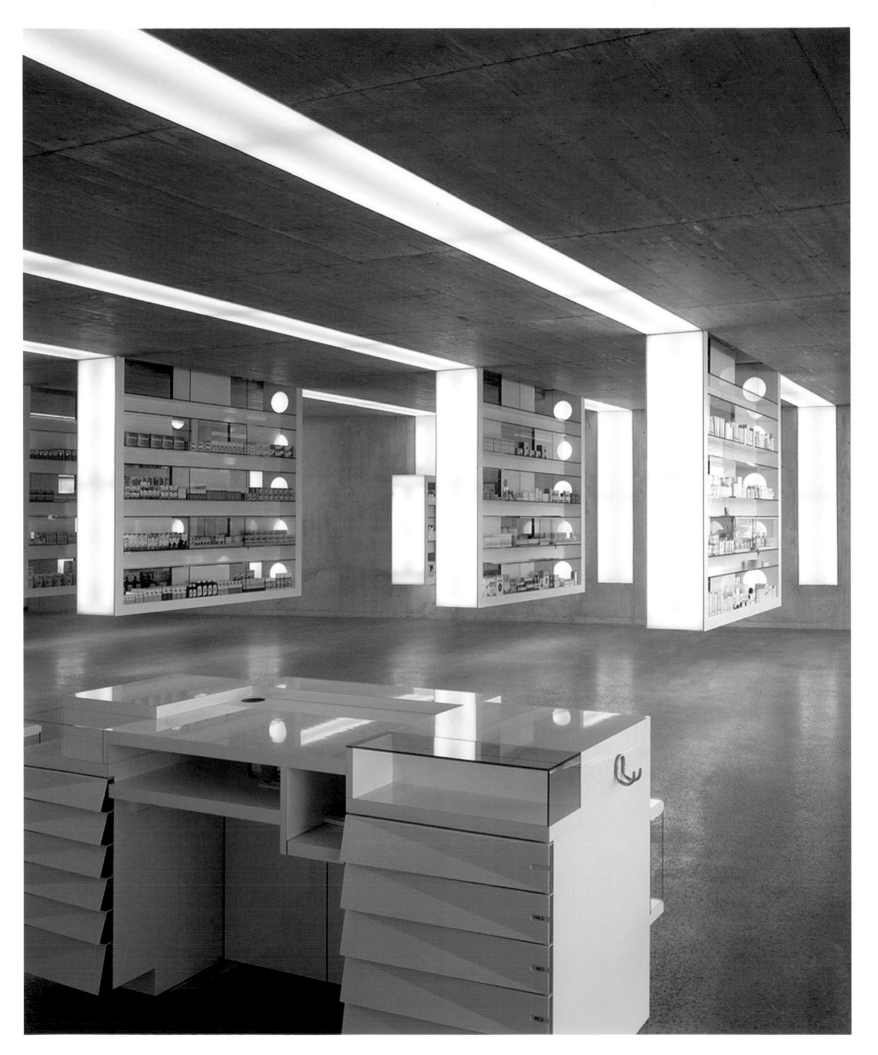

> Aleste Flowpack

Architect: Francesc Rifé

Location: Barcelona, Spain

Photography: Eugeni Pons

The Aleste Flowpack shop in Barcelona employs a completely innovative concept in product display, storage, and delivery, based on mobility.

The architect designed the space for open access, without doors. Sales are made at the sales counter, a boxy structure in the trademark color of pistachio green, located in the main part of the store. Behind this is the display area, which employs a mobile system of tubes, or flowpacks, that permits merchandise that has been sold to be easily replaced. The display area accommodates clothing that needs to be hung as well as items such as blankets, shoes, and cushions. Adjacent to this is the dressing room, where green opaque glass fixtures filter light into the space.

The heart of the operation is the storage area, located behind the dressing room. This is where the flowpack chain starts. The tubular structure holds a series of mobile metal boxes lengthwise, and these act as a containing shelf for the flowpacks. The highest of the boxes reaches about 13 feet and is accessed by one of two sets of steps. When an item is removed from the display area for purchase, it is immediately replaced by a flowpack from this storage area.

This unique concept functions as a perfectly meshed system for delivering the product to the customer as efficiently as possible.

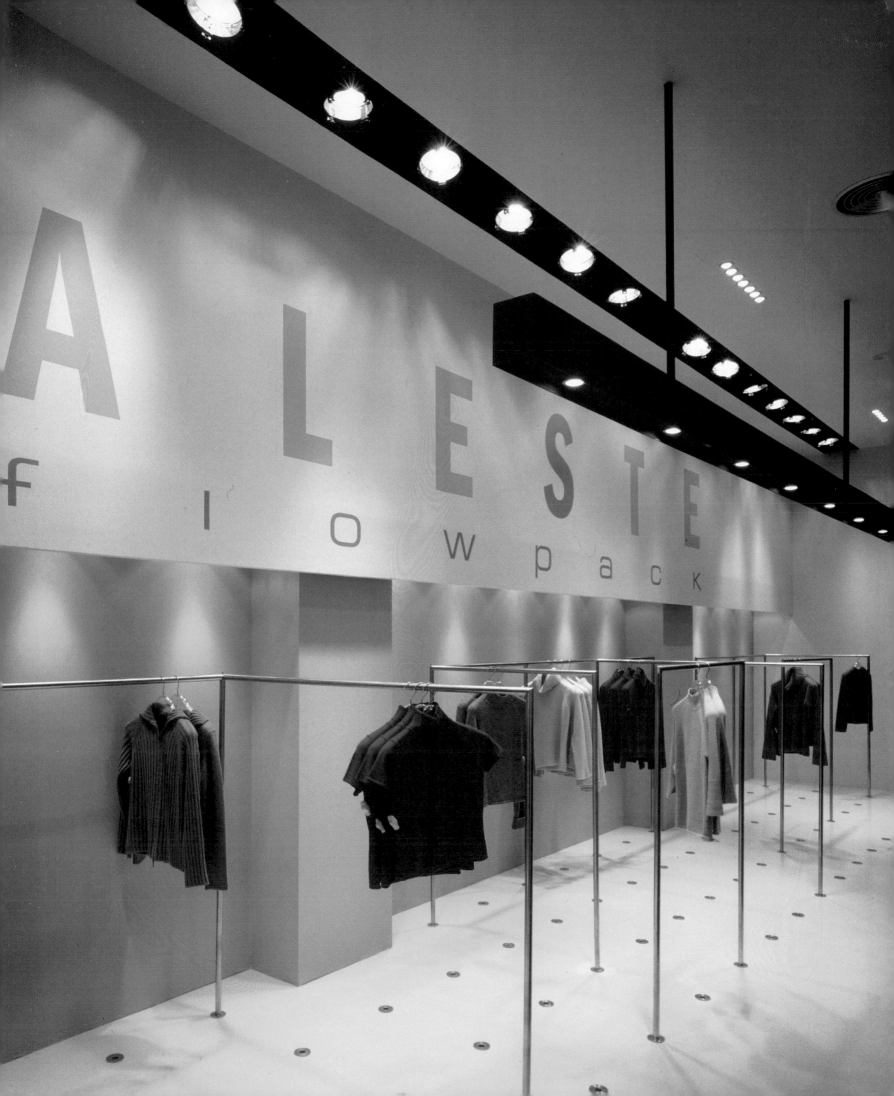

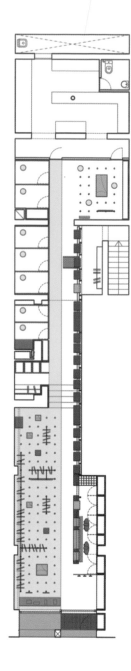

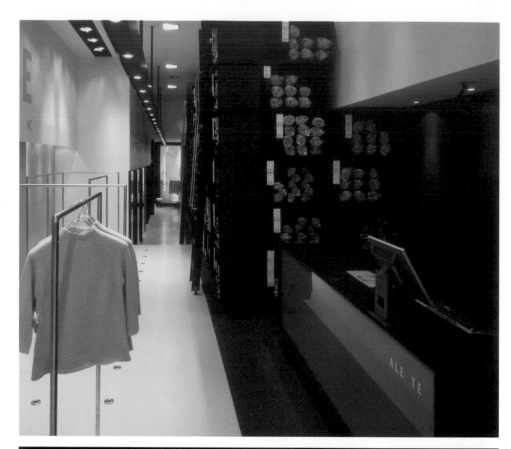

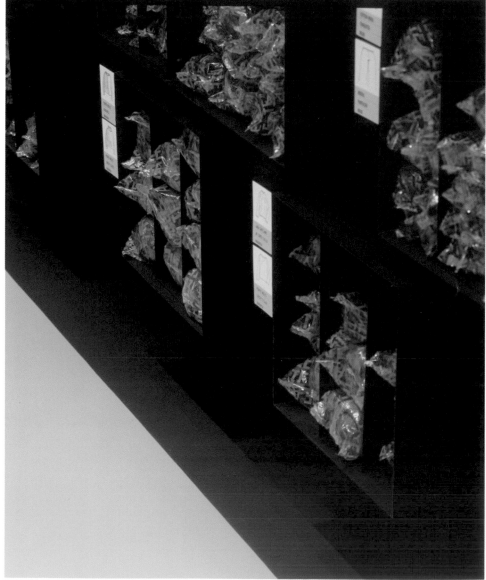

> In the storage area, products are packaged in flowpacks and displayed on mobile shelving.

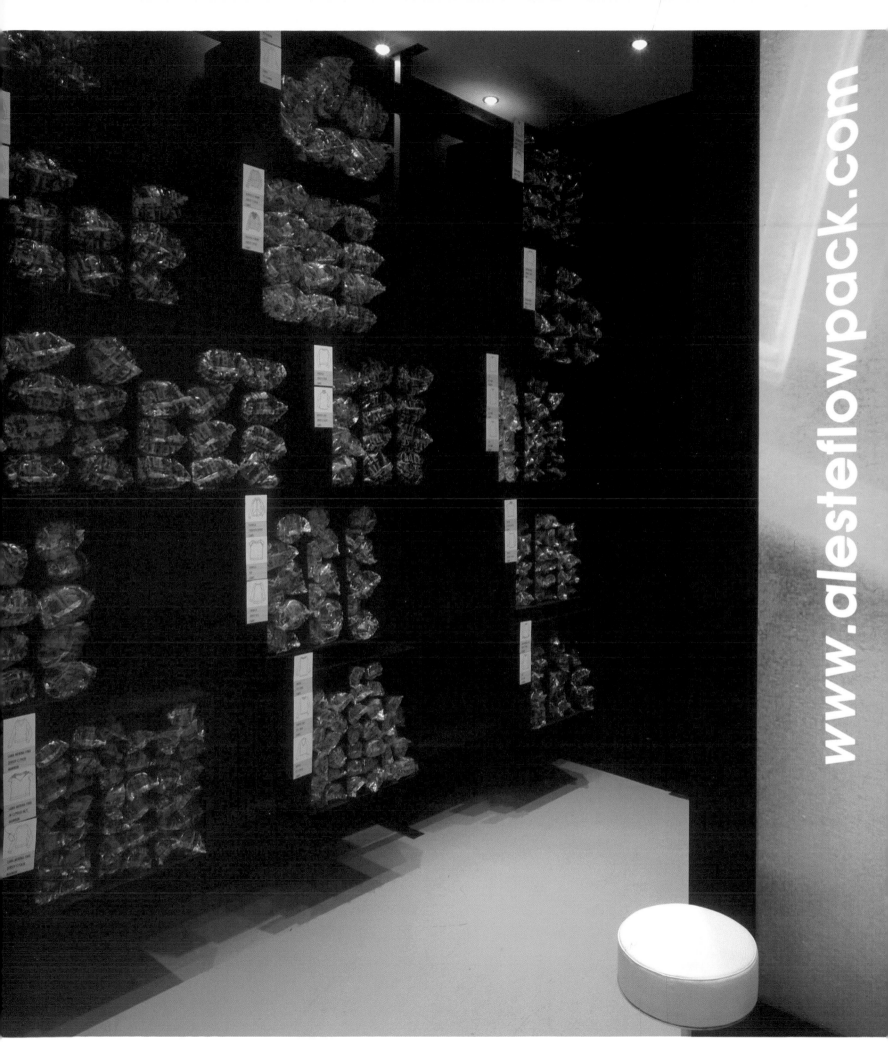

www.alesteflowpack.com

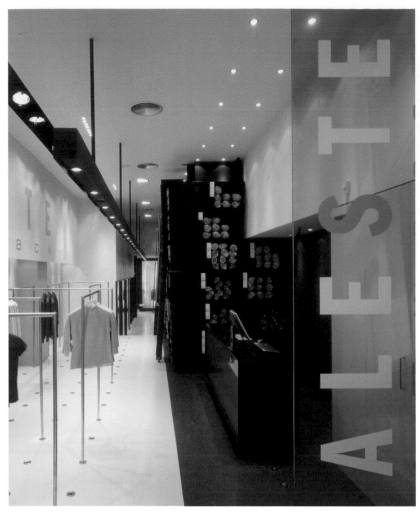
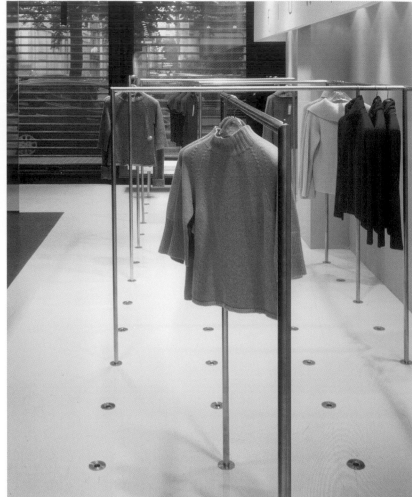

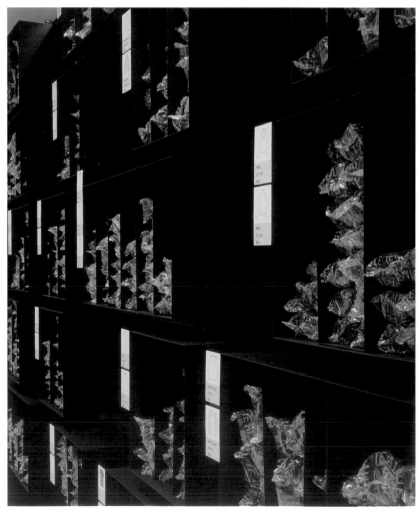

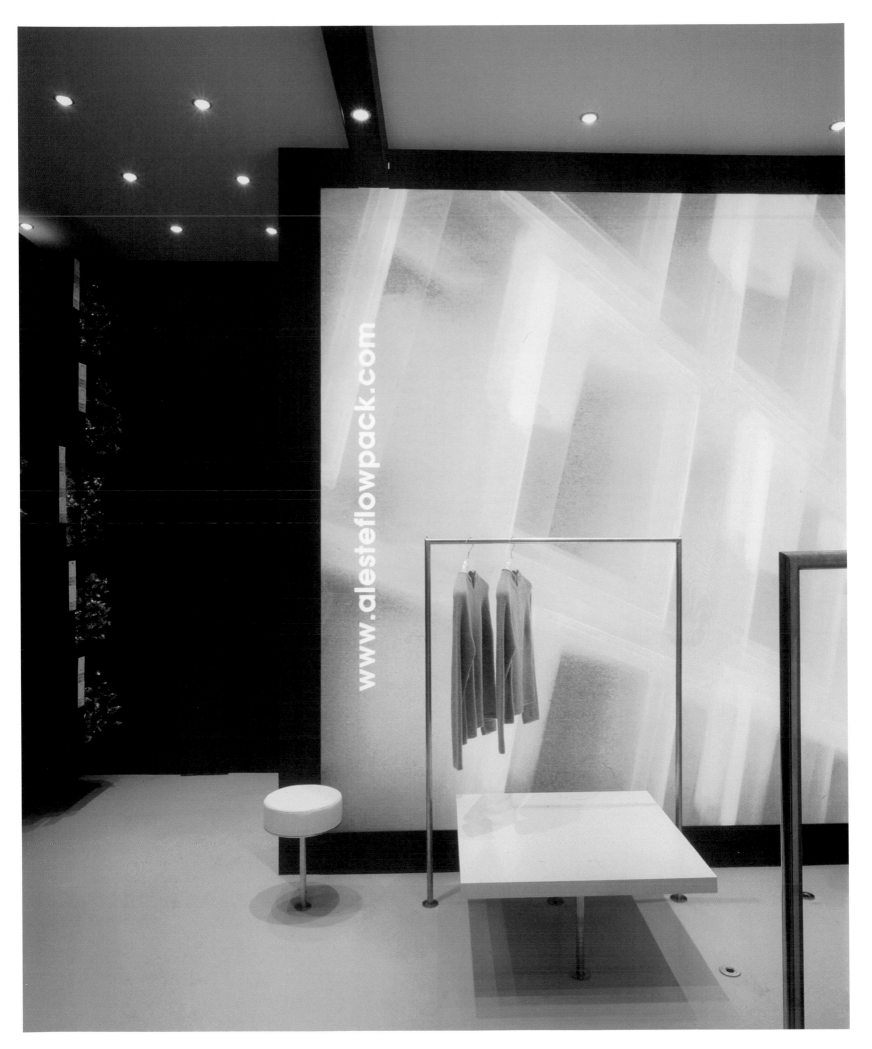

www.alesteflowpack.com

>Basis Wien

Architects: Propeller Z

Location: Vienna, Austria

Photography: Margherita Spiluttini

Basis Wien, an archive for contemporary art, is situated in an eighteenth-century building in Vienna. The goal of the renovation by Propeller Z was to create two functional spaces—offices for the museum and an information area for visitors—while preserving original features of the building such as the vaulted ceiling and the large windows.

Typical of buildings from this period, the space was small and rectangular, but with considerable height. The challenge the architects faced was to create functional areas that make the most of the differentiation between the new and the old. Their solution was to install an aluminum panel in the middle of the space that extends along one of the wings of the historical façade. This occupies the depth of the room and contains a series of drawers and shelves that can open and close in an accordion-like fashion for storing documents and displaying books. A lighting system built into the bottom of this panel channels light into the darker half of the space.

The mobile shelving in this area is adaptable to multiple purposes. Each unit is affixed with wheels and can thus be moved to section off different parts of the larger room for specific functions. The shelving units are covered on one side by a semitransparent material that allows light to filter through to the reading area behind them.

In this way, the architects have achieved a fusion of new and old without sacrificing either the historical charm or the functionality of the space.

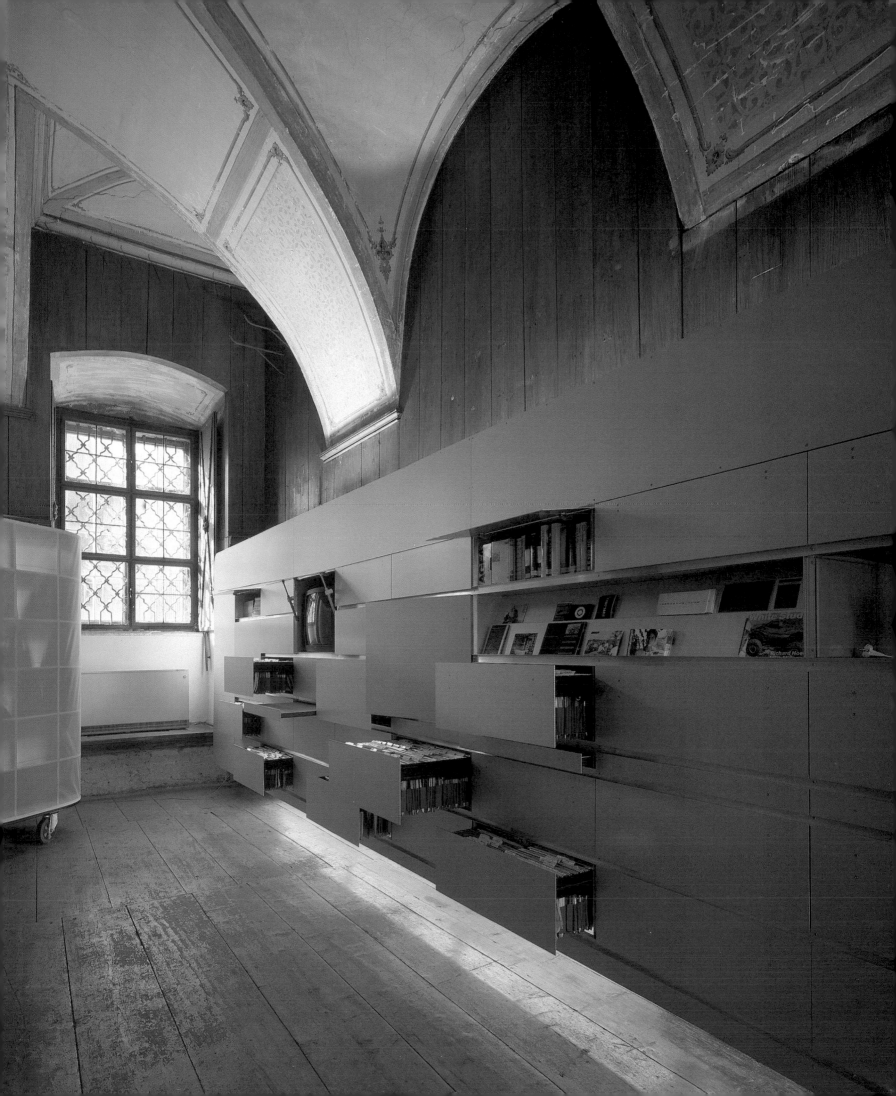

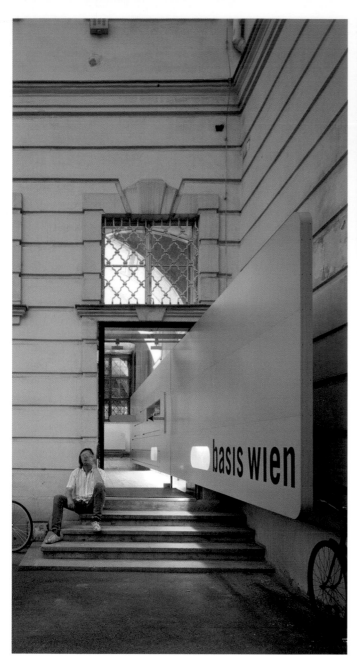

> An aluminum panel with drawers and shelves that extends down the old façade stores documents and displays books that are of interest to visitors.

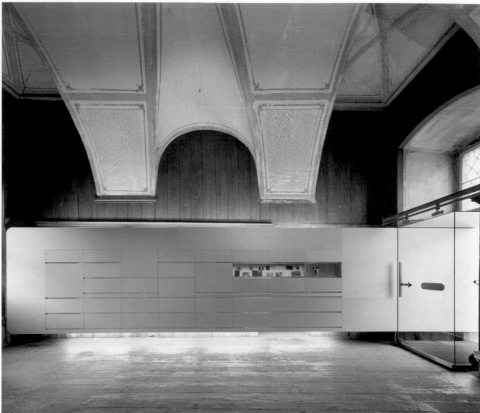

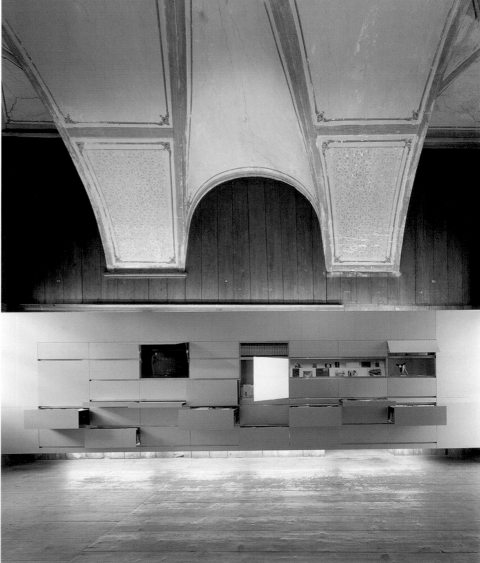

6x05

>Pierre Hermé

Architects: Christian Biecher & Associés
Location: Paris, France
Photography: Roger Casas

Like a snake charmer, designer Christian Biecher, a master of color, carefully calculated the Pierre Hermé shop in Paris to entice customers inside, where the only dilemma is deciding which of the delectable chocolate confections to buy.

Hermé and Biecher, who had already worked together on the Korova restaurant, decided to create a shop that would remind people of their childhood. Thus, they drew inspiration for the color scheme from such brightly colored childhood favorites as Lego toys and M&M's candies. Each display stand consists of a colored base in red, yellow, or gray, which functions as a storage cabinet and incorporates a refrigeration system for maintaining the chocolates in the proper conditions. The upper part of each display is a glass showcase for displaying the chocolates. Each unit incorporates a lighting system into the lower part, which allows light to filter through the base and produces the sensation of floating in a fantasy world.

The shop's ceiling is paneled in resin tiles emblazoned with Pierre Hermé's monogram, picked up from the package design used for the chocolates. Hermé has been heavily influenced by the world of graphic design and typography, and he designed all the graphics, including the packaging, himself.

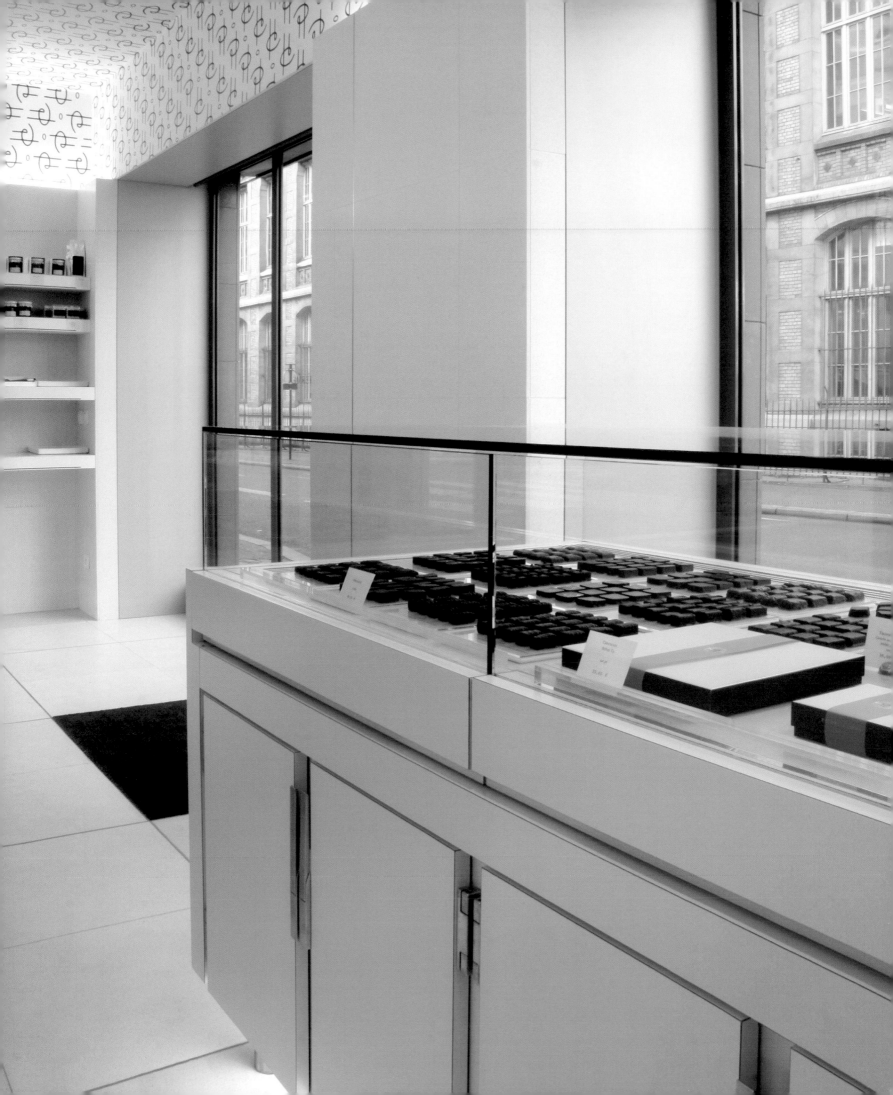

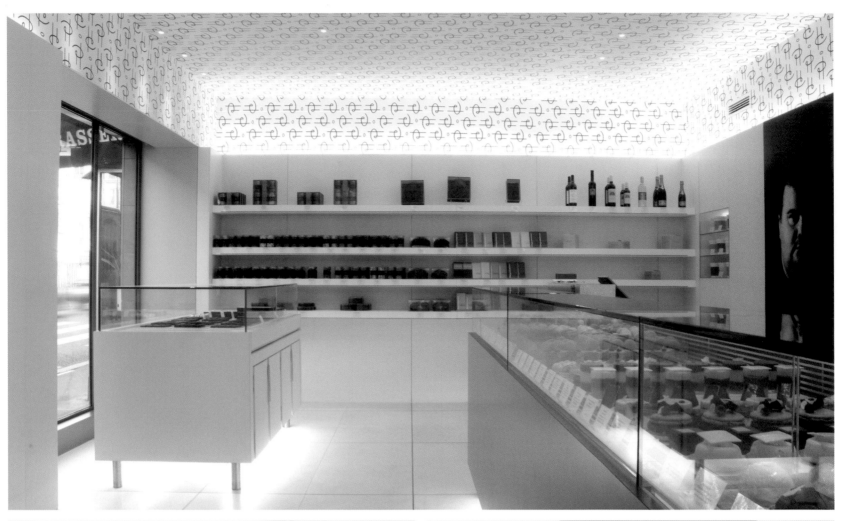

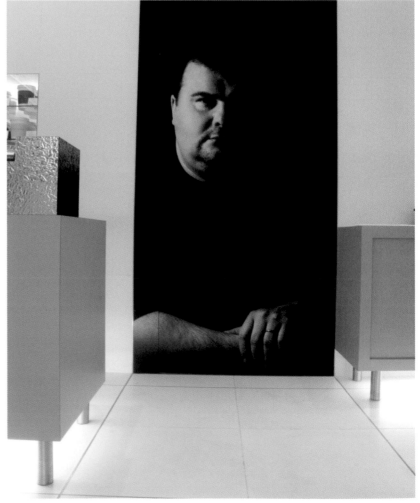

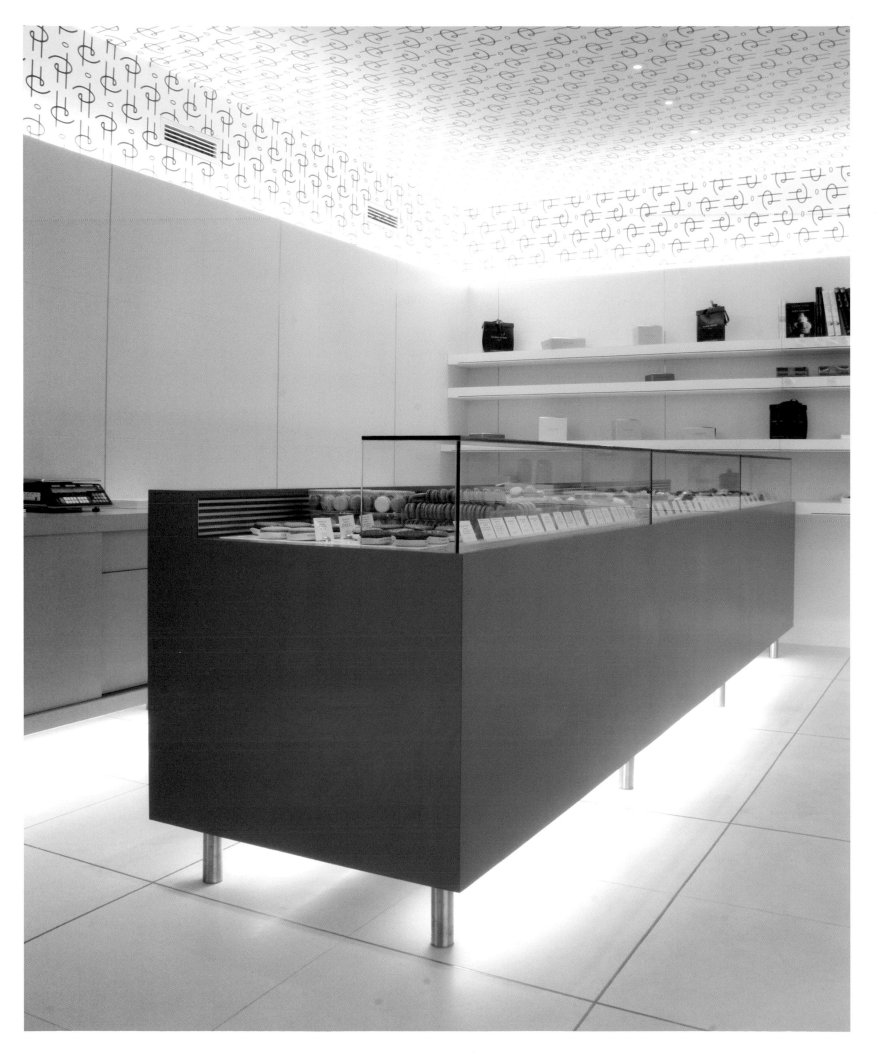

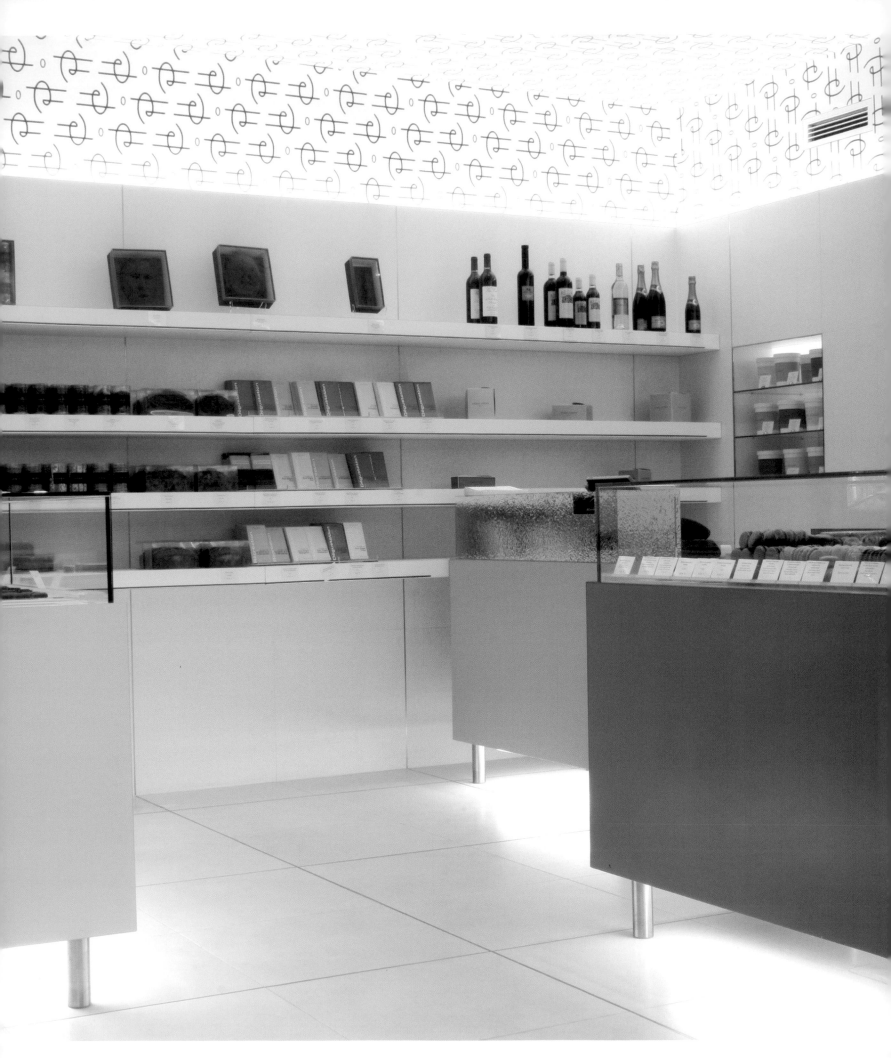

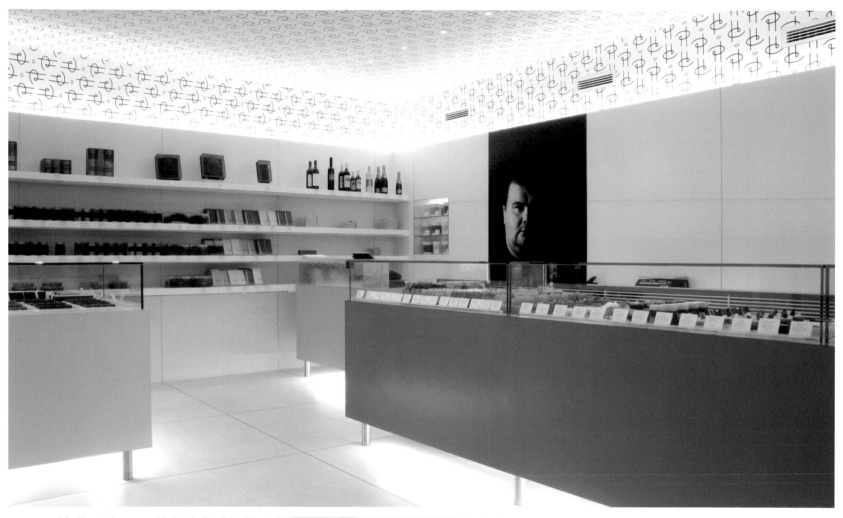

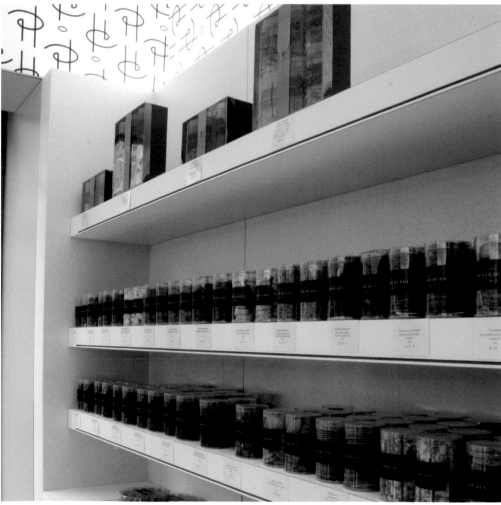

> The shop's shelving, which is totally white, displays some of the Hermé products and contrasts with the intense yet balanced colors of the display stands.

>Marienapotheke

Architects: Purpur Architektur
Location: Eisenstadt, Austria
Photography: Hertha Hurnaus

After discovering that the shop next door was vacant, the owners of Marienapotheke decided to expand their own pharmaceutical shop, commissioning Purpur for the design. The aim was to create a more open space with greater storage capacity.

The primary task was to develop the space within the adjacent vacant shop, which required complete rebuilding. Consistent with the mission of creating an open and transparent space, a glass façade was constructed. Contributing to the open theme is an interior patio in which an olive tree is planted; this brings light into the interior of the shop. The olive tree motif is picked up in the display fixtures, which have been fabricated from natural wooden planks that support white shelving.

The sales area was based on a self-service plan, whereby customers make their own selections from the merchandise on display. The shop also includes a laboratory, a dispensary, and room for offices, and the transition from one functional area to the next is gradual rather than abrupt. The overall theme of the shop is one of balance—in terms of form, product distribution, and color scheme.

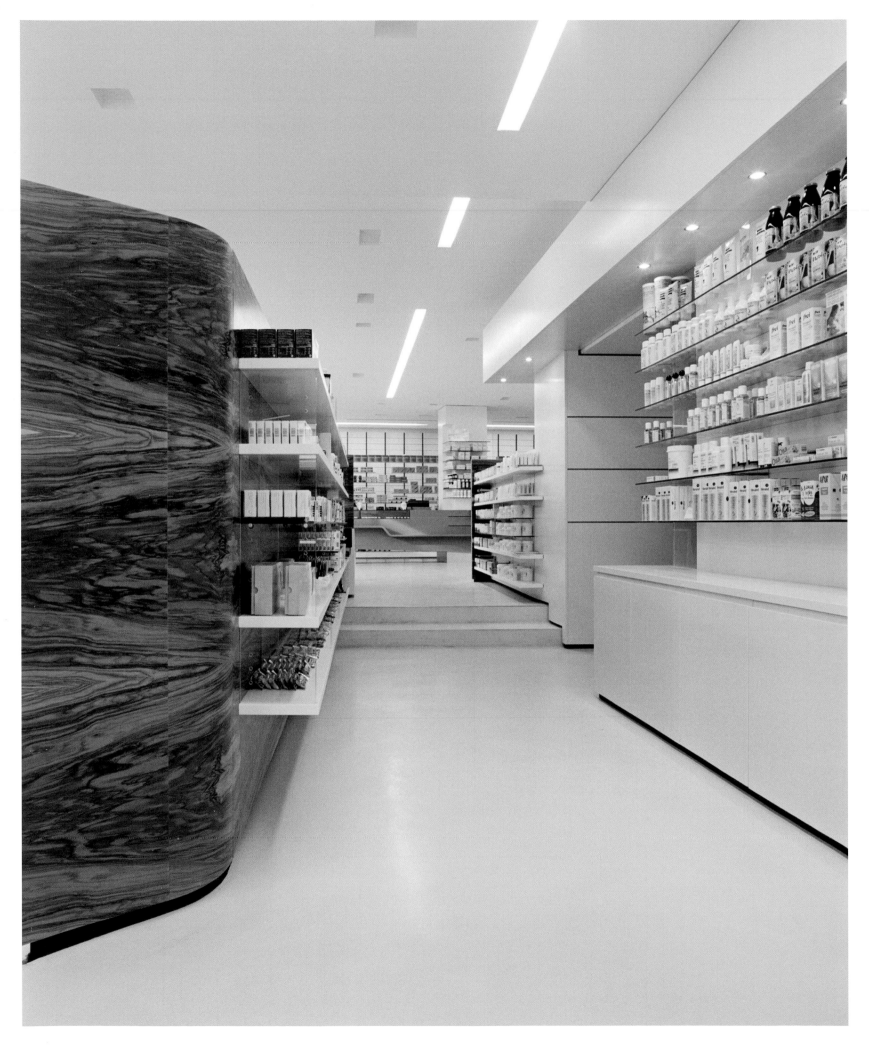

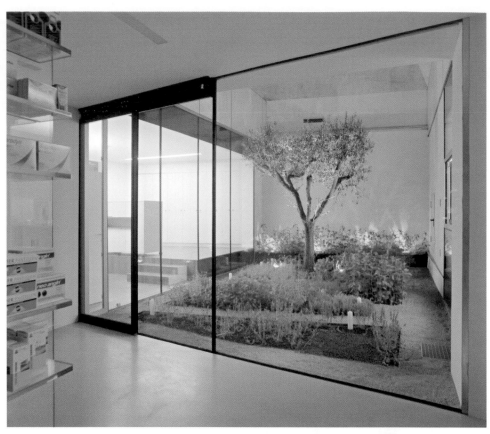

> An olive tree is planted in a patio inside the pharmacy. Some of the display fixtures, all of which combine wooden structures with transparent surfaces, are inspired by this tree.

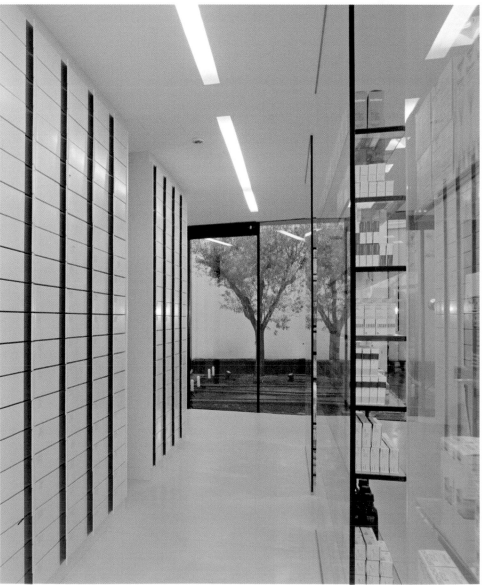

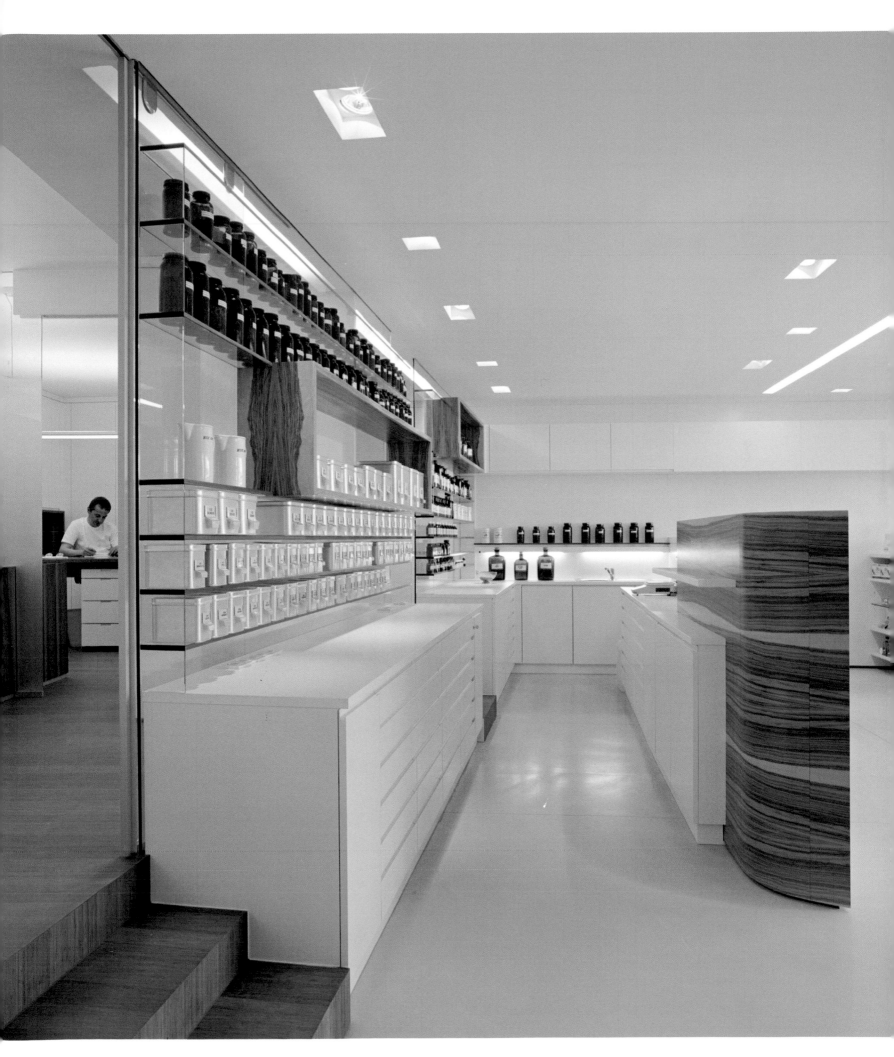

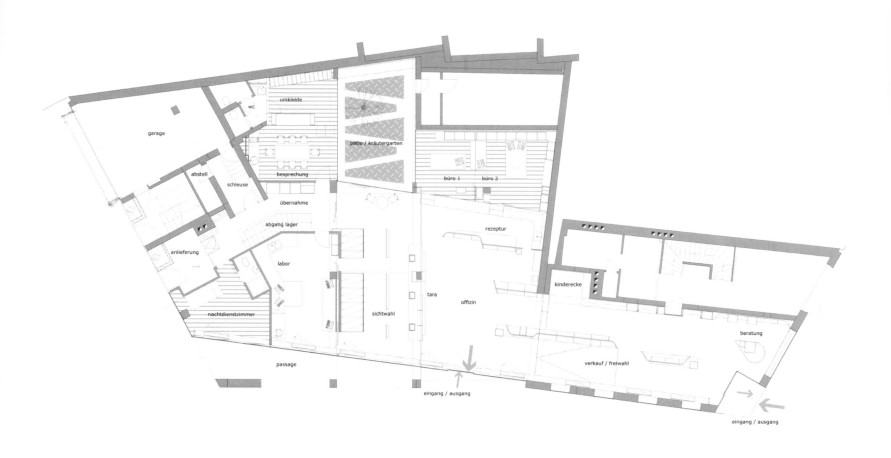

garage

wc
umkleide

abstell

besprechung

patio / kräutergarten

schleuse

büro 1
büro 2

übernahme

abgang lager

rezeptur

anlieferung

labor

kinderecke

tara
offizin

nachtdienstzimmer

sichtwahl

beratung

passage

verkauf / freiwahl

eingang / ausgang

eingang / ausgang

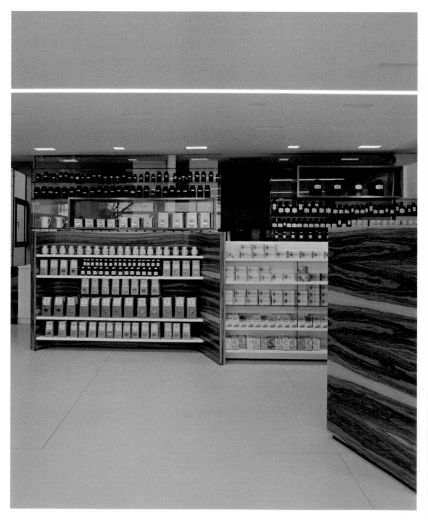

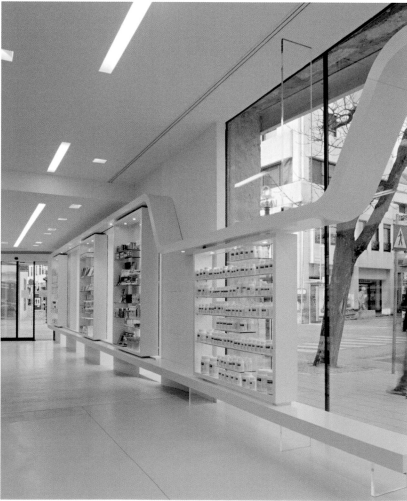

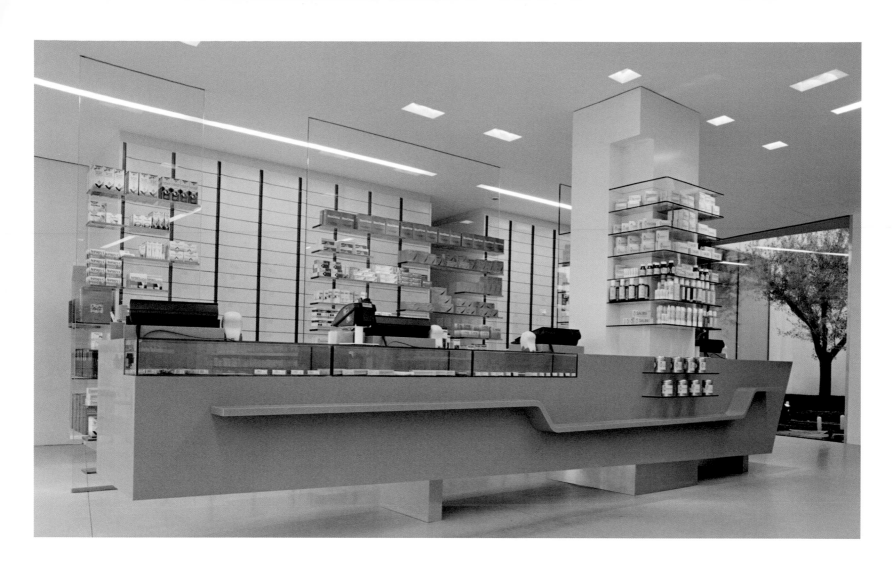

> Behind the trapezoidal-shaped central sales counter, products are displayed in linear and orderly fashion on almost imperceptible transparent shelving.

Directory

Acconci Studio
20 Jay Street, Suite #215
Brooklyn, NY 11201
USA
Tel.: +1 718 852 6591
Fax: +1 718 624 3178
studio@acconci.com
www.acconci.com

Agustí Costa
Plaça de la Creu,3, 2.° 2.ª
08600 Berga
Spain
Tel.: +34 938 211 063
Fax: +34 938 221 105
estudi@agusticosta.com

Arkizon Mimarlik Ltd.
Ahievran cad. Rentas Is Merkezi 80
80670 Maslak, Istanbul
Turkey
Tel.: +90 212 286 48 56
Fax: +90 212 286 48 57
arkizon@superonline.com

Artec Architekten
Am Hundsturm 5
1050 Vienna
Austria
Tel.: +43 1 586 86 70
Fax: +43 1 586 39 10
goetz.manahl@artec-architekten.at
www.artec-architekten.at

Bearandbunny
Zamenhofstraat 150, unit 116
Amsterdam
Netherlands
Tel.: +31 614 667 167
Fax: +31 626 494 852
info@bearandbunny.com
www.bearandbunny.com

Belzberg Architects
1507 20th Street
Santa Monica, CA 90404
USA
Tel.: +1 310 453 9611
Fax: +1 310 453 9166
studio@belzbergarchitects.com
www.belzbergarchitects.com

Block Architecture Ltd.
83A Geffrye Street
London, E2 8HX
United Kingdom
Tel.: +44 020 7729 9194
Fax: +44 020 7729 9193
mail@blockarchitecture.com
www.blockarchitecture.com

Christian Biecher & Associés
14 rue Crespin-du-Gast
75011 Paris
France
Tel.: +33 1 49 29 69 39
Fax: +33 1 49 29 69 30
info@biecher.com
www.biecher.com

Corneille Uedingslohmann Architekten
Roßstrasse 12 D
50823 Cologne
Germany
Tel.: +49 221 577 72 85
Fax: +49 221 577 72 87
info@cue-architekten.de
www.cue-architekten.de

Curiosity Inc.
2-13-16 Tomigaya, Shibuya-ku
151-0063 Tokyo
Japan
Tel.: +81 3 5452 0095
Fax: +81 3 5454 9691
info@curiosity.jp
www.curiosity.jp

Elia Felices Interiorismo
Lepanto, 309-311 L-B
08025 Barcelona
Spain
Tel./Fax: +34 934 354 971
info@eliafelices.com
www.eliafelices.com

El Último Grito
South Studio Arch 1-16
Croxted Road
Brockwell Park
London SE24 9DB
United Kingdom
Tel./Fax: +44 020 8623 9777
info@elultimogrito.co.uk
www.elultimogrito.co.uk

EOOS
Zelinkagasse 2/6
1010 Vienna
Austria
Tel.: +43 1 405 39 87
Fax: +43 1 405 39 87 80
design@eoos.com
www.eoos.com

Francesc Rifé S. L.
Escoles Pies 25 baixos
08017 Barcelona
Spain
Tel.: +34 934 141 288
Fax: +34 932 412 814
f@rife-design.com
www.rife-design.com

Giorgio Borruso Design
333 Washington Blvd. #352
Marina Del Rey, CA 90292
USA
Tel.: +1 310 821 9224
Fax: +1 310 821 9350
info@borrusodesign.com
www.borrusodesign.com

Krüger Wiewiorra Architekten
Wolliner Strasse 50
10435 Berlin
Germany
Tel.: +49 304 005 67 40
Fax: +49 304 005 67 41
ww@kwarchitekten.de
www.kwarchitekten.de

Lantavos Projects
Trapezountos, 33
14565 Ag. Stefanos
Greece
Tel.: +30 210 8834 095
Fax: +30 210 8823 569
contact@lp-architects.gr
www.lp-architects.gr

Martí Guixé
Calàbria 252
08029 Barcelona
Spain
Tel.: +34 933 225 986
info@guixe.com
www.guixe.com

Matali Crasset Productions
26 rue du Buisson Saint Louis
75010 Paris
France
Tel.: +33 1 42 40 99 89
Fax: +33 1 42 40 99 98
matali.crasset@wanadoo.fr
www.matalicrasset.com

Maurice Mentjens Design
Martinusstraat 20
6123 BS Holtum
Netherlands
Tel.: +31 464 811 405
Fax: +31 464 811 406
info@mauricementjens.com
www.mauricementjens.com

Propeller Z
Mariahilferstrasse 101/3/55
1060 Vienna
Austria
Tel.: +43 1 595 27 27 0
Fax: +43 1 595 27 27 27
mail@propellerz.at
www.propellerz.at

Purpur Architektur
Getreidemarkt 14
1010 Vienna
Austria
Tel.: +43 1 920 34 92
Fax: +43 1 920 34 92
Brockmanngasse 5
8010 Graz
Austria
Tel.: +43 316 83 73 23 0
Fax: +43 316 83 73 23 83
a.menge@purpur.cc
www.purpur.cc

Rockwell Architecture, Planning and Design
5 Union Square West
New York, NY 10003
USA
Tel.: +1 212 463 0334
Fax: +1 212 463 0335
www.rockwellgroup.com

Randy Brown Architects
1925 North 120th Street
Omaha NE 68154
USA
Tel.: +1 402 551 7097
Fax: +1 402 551 2033
www.randybrownarchitects.com
info@randybrownarchitects.com

Ron Arad Associates
62 Chalk Farm Road
London NW1 8AN
United Kingdom
Tel.: +44 020 7284 4963
Fax: +44 020 7379 0499
info@ronarad.com
www.ronarad.com

Sergio Calatroni Art Room
Corso di Porta Nuova, 46/b
20121 Milan
Italy
Tel.: +39 02 65 55 816
Fax: +39 02 62 69 43 48
info@sergiocalatroni.com
www.sergiocalatroni.com

Shuhei Endo Architect Institute
5-15-11 Nishitenma Kita-ku
Osaka-city, Osaka 530-0047
Japan
Tel.: +81 6 6312 7455
Fax: +81 6 6312 7456
endo@paramodern.com
www.paramodern.com

Studio Aisslinger
Oranienplatz 4
10999 Berlin
Germany
Tel.: +49 303 150 54 00
Fax: +49 303 150 54 01
studio@aisslinger.de
www.aisslinger.de

Studio 63 Architecture + Design
Via Santo Spirito 6
50125 Florence
Italy
Tel.: +39 05 52 00 14 48
Fax: +39 05 52 00 14 33
info@studio63.it
www.studio63.it

Sybarite UK, Ltd.
322 Fulham Road, Chelsea
London, SW10 9UG
United Kingdom
Tel.: +44 020 7352 4900
Fax: +44 020 7352 4901
mail@sybarite-uk.com
www.sybarite-uk.com

Torafu Architects Inc.
1-3-18 Chuo-cho, Meguro-ku
152-0001 Tokyo
Japan
Tel.: +81 3 5773 0133
Fax: +81 3 5773 0134
torafu@torafu.com
www.torafu.com

Torres & Torres
Muntaner 462-466, E. 2
08006 Barcelona
Spain
Tel.: +34 934 145 172
Fax: +34 934 145 532
torres@torresbcn.com
www.torresbcn.com

Wonderwall Inc.
1-21-18 Ebisu-minami, Shibuya-ku,
Tokyo 150-0022
Japan
contact@wonder-wall.com
www.wonder-wall.com